VISUALITIES

VISUALITIES

Perspectives on Contemporary
American Indian Film and Art

Edited by Denise K. Cummings

Michigan State University Press
East Lansing, Michigan

FILM
E
98
.A 73
V 57
2011

 Michigan State University Press
East Lansing, Michigan 48823-5245

Printed and bound in the United States of America.

17 16 15 14 13 12 11 1 2 3 4 5 6 7 8 9 10

LIBRARY OF CONGRESS CATALOGING-IN-PUBLICATION DATA

Visualities : perspectives on contemporary American Indian film and art / edited by Denise
K. Cummings.
 p. cm. — (American Indian studies series)
 Includes bibliographical references and index.
 ISBN 978-0-87013-999-4 (paper : alk. paper) 1. Indian arts—United States. 2. Arts
and society—United States. 3. Indians of North America—Intellectual life. 4. Indians of
North America—Ethnic identity. 5. Visual communication—United States. 6. Indigenous
films—United States. 7. Indians in motion pictures. 8. Indian motion picture producers
and directors—United States—Biography. 9. Indian art—United States. 10. Indian
artists—United States—Biography. I. Cummings, Denise K.

 E98.A73V57 2011
 700.89'97009051—dc22 2010051908

Cover design by Sharp Des!gns, Inc., Lansing, MI
Book design by Scribe Inc. (www.scribenet.com)

Cover art is "Native Epistemology" by Larry McNeil (www.larrymcneil.com) and is used
with permission of the artist.

green press INITIATIVE Michigan State University Press is a member of the Green Press Initiative and
is committed to developing and encouraging ecologically responsible publishing
practices. For more information about the Green Press Initiative and the use of recycled
paper in book publishing, please visit www.greenpressinitiative.org.

Visit Michigan State University Press on the World Wide Web at:
www.msupress.msu.edu

*For my mother
and fathers*

Contents

Acknowledgments

I AM ENORMOUSLY GRATEFUL TO EACH OF THE WRITERS WHO CONTRIBUTED to this volume—Michelle, Joanna, Theo., Rocío, Penny, Joseph, Dean, Susan, Cynthia, and Molly—for both their fine scholarship and their spirit of collaboration. In particular, I owe special thanks to Molly McGlennen for articulating the importance of the collection, and to Theo. Van Alst for our engaging discussions. And I am profoundly appreciative of Dean Rader, to whom in Puerto Vallarta, Mexico, in 2000, I first presented my ideas about American Indian visual culture (he listened!). I am indebted to him for his contributions to this volume, and I continue to value the ongoing conversation with him, having come to greatly admire his unique blend of incisive wit and ease of manner.

I am especially grateful to the indigenous filmmakers and artists who created the important body of work discussed in this volume. These frontline activists, if I may so call them, understand the scope of historical representation of indigenous peoples and, importantly, help to show us the distinctions between lived identities and identities that are manufactured out of fiction, television, film, and popular art—and the problematic *and* productive tensions that coalesce around perceptions and receptions.

This volume is made possible by Gabe Dotto and the many helpful individuals at Michigan State University Press, all deserving of my praise and thanks. I am grateful to Gordon Henry, in particular, for recognizing the potential of the collection and fostering these kinds of studies in popular media, and to Julie Loehr, my editor, and Travis Kimbel, Kristine Blakeslee, and Annette Tanner, who helped me prepare this volume. I also thank the anonymous readers of the manuscript who offered excellent suggestions for its improvement.

In addition, I wish to acknowledge Rollins College, the Department of Critical Media and Cultural Studies, the Film Studies program, and Lisa M. Tillmann. I also express my appreciation to my students in Native American Media and Cultural Studies for their fresh insights, and to Lee Lines, who has influenced my thinking about film, indigeneity, and the centrality of place in important ways.

My heart-felt and profound thanks are a must, as well, to my parents, Joan and Ed Noto, for their unflagging encouragement. I thank them, along with the Power family, Joyce Nico, and Dick and Eugenie Schott—all for providing me with spaces within which to think about, write, and edit this volume. Finally, I thank J.E.K., for listening.

Preface

OVER THE PAST DECADE, EACH CONTRIBUTOR IN THIS VOLUME HAS PRESENTED her or his work on American Indian literatures and visual and popular culture at such national and international conferences as the Native American Literature Symposium (NALS)—a conference held annually at a continental United States' tribal venue—the Native American and Indigenous Studies Association (NAISA), the Society for Cinema and Media Studies (SCMS), and the National Popular Culture and American Culture Associations (PCA/ACA), to name just a few. (So, too, have the contributors been published widely, including in *Studies in American Indian Literatures* [SAIL].) I have been fortunate to attend many of their presentations and, specifically, to be present at every NALS meeting that has been held to date. I have therefore had the distinct privilege of hearing my colleagues present and take part in the continuing conversations and intellectual excitement that drives and draws from their efforts. Their work, broadly understood, and these conversations provide the inspiration for this book. My own inquiry into this subject is a continuation of my ongoing study of indigenous literatures and cultures, American Indians in and on film, and visual culture in general; these are of a piece with my interest in American culture as a whole.

Many of the ideas presented in the chapters in this book have thus been conceived from papers and visual presentations given at meetings of scholars, writers, theorists, artists, critics, activists, and community members. In particular, NALS—with its "Many Voices, One Center" maxim—is not only a site for the "academic" conversation in which we as academics all partake, but also a site for lived experience and indigenous survivance. Significantly, too, each of the contributors in this volume is an accomplished teacher/scholar. The work they offer here will undoubtedly assist in the classroom, and not just because we are all mindful that popular culture and visual culture have great pedagogical value. Indeed, our work in the classroom—that particular ongoing conversation—is not separate from the imperatives and realities of lived experience. These crucial conversations and how we conduct our daily lives in our communities are really all one and the same.

Introduction:
Indigenous Visualities

THIS COLLECTION AIMS TO HIGHLIGHT THE HYBRIDITY OF VISUAL communication within contemporary Native America, with essays that examine how the visual has become a primary means of mediating identities. With its emphases on Native film-, video-, and art-making, the volume's scope intentionally embraces a visual field perspective in order to examine aspects of the social importance of indigenous visual culture. The work presented here should be understood as part of a larger conversation that aspires to parallel the contemporary moment from a critical perspective; the employed conceptual frameworks and analytical tools that the authors and the artists they study are, of necessity, evolving and responding to changes in social reality.

The link between indigenous aesthetic expression and individual and collective identification was boldly explored in Steven Leuthold's 1998 monograph *Indigenous Aesthetics: Native Art, Media, and Identity*, within which the author acknowledged the centrality of aesthetic expression to native communities by underscoring that "an awareness of and willingness to participate in indigenous aesthetic expression increasingly signify belonging and accountability *within* native communities."[1] As the new millennium approached, Leuthold recognized that the traditional concepts of connection to place, to the sacred, and to the cycles of nature were finding new expression through westernized media, such as Native filmmaking, while also maintaining continuity with earlier aesthetic productions.

The relationships between various forms of aesthetic production, as well as the concept that individual and collective identities are constituted through systems of knowledge production embodied in visual forms— pictures and images—largely inform the essays presented here. In the course of conceiving this volume and in working with its contributors, I have insisted on visuality—practices of seeing the world and the seeing of other people—as an important mode of understanding and mode of our

production as social and cultural beings: a lesson I learned from Margaret R. Miles and S. Brent Plate in their work on an ethical approach to film. I believe engaging visuality in this way is both our intellectual obligation and choice of social commitment.

But what do we mean by visuality? At once I might suggest that the word visuality itself is a kind of convergence term, a neologism, and certainly a word associated with visual culture—that political venture Nicholas Mirzoeff calls "a tactic for those who do not control . . . dominant means of visual production to negotiate the hypervisuality of everyday life in a digitized global culture."[2] In the second edition of *The Visual Culture Reader* (2002), Mirzoeff further describes visuality as "the intersection of power with visual representation."[3] Understood in this way, visuality concerns the field of vision as a site of power and social control. Elsewhere, Mirzoeff traces the etymology of visuality, locating its coinage by the Scottish historian Thomas Carlyle in his lectures *On Heroes* (1841).[4] In demystifying the notion that visuality is a postmodern theoretical term, Mirzoeff writes:

> The centrality of Carlyle's discourse of visualized heroism to Anglophone imperial culture was such that any claim to subjectivity had to pass by visuality. Here lies the contradictory source of the resonance of "visuality" as a keyword for visual culture as both a mode of representing imperial culture and a means of resisting it by means of reverse appropriation. Reading Carlyle in the imperial context leads to a distinction between Visuality 1, which is proper to modernity, and a Visuality 2 that exceeds or precedes the commodification of vision. This tension was played out in the work of Carlyle's admirers Oscar Wilde and W.E.B. Du Bois and in the politics surrounding the abolition of slavery.

Noting this "tension" Mirzoeff describes, we can appreciate visuality, then, as both a mode of representation and means of resisting as it pertains to the constructs, discourses, and practices of the colonial and postcolonial.

In their provocative *Images and Empires: Visuality in Colonial and Postcolonial Africa* (2002), a collection concerning various modes of visuality in Africa, editors Paul S. Landau and Deborah Kaspin astutely identify that the meaning of any communicative medium, including iconic images, is arguably a product of what Stanley Fish calls its "interpretive communities." Landau and Kaspin's essayists are interested in the history of images and items of visual media originating in colonial contact and beyond. By discussing various modes of visuality in and of Africa, they collectively investigate the interplay of visual images with lived personal identity, class, gender, politics, and wealth. In this way, the editors see the body of work as

contributing toward a serious investigation of visual signs, or a theory of visuality, in the colonial and postcolonial world. Power, they argue, is hidden in "ways of seeing."[5]

The authors herein variously explore problems of culture and power, those they locate in media understood as arenas of contestation. These media arenas, these technologies of the visible, are part and parcel of popular culture, the study of which, wrote Ben Agger, should aim at "debunking the stimulations bombarding [people] from every direction," seeking instead "a more stable ground of value from which to engage in dehierarchizing cultural and political practices."[6] The idea of a stable ground of value adds a generative dimension to our working conception of visuality. On this point, I return to Miles and Plate. In their essay "Hospitable Vision: Some Notes on the Ethics of Seeing Film," the authors advance three aspects of their ethical approach to film:

> first, to argue that we must pay attention to the relation between the world on-screen and off-screen, that there can never be a strict delineation of the "real world" from that of film. Second, as a way to think more fully about the specificities of an ethical film criticism, we advocate the necessity of moving beyond narrative analyses of film (treating a movie as just another story) toward more explicitly visual analyses. Finally, we lay out some suggestions for the cultivation of a critical practice of what we will call a "hospitable vision," a mode of viewing film that opens up space for otherness.[7]

They suggest that studies of religion and film should, for example, investigate the quintessentially religious questions, including three that I think help us in our project at hand in conceiving a "stable ground of value." These are: How should we live? What values actually direct our everyday choices in the public world? How are these values circulated?[8] That Miles and Plate identify film as a powerful meaning-making social force is not unexpected. Taking seriously the connections between how we see and how we live, they then stress the importance of visuality. For them, the triad "seeing, believing, and living are intricately imbricated,"[9] a useful and generative perception for our undertaking here.[10] W.J.T. Mitchell puts it this way: "Visuality [is] not just the 'social construction of vision,' but the visual construction of the social."[11] These latter understandings of visuality emerge, then, as perhaps the most congruent with the aims of the collection. It is hoped that you, reader, will connote additional meanings for and of visuality from your reading of the essays and the artists and works they illuminate.

Of the questions I asked the contributors of this volume to consider,

they responded most passionately and thoughtfully to the following: How have individual indigenous artists examined, intervened in, and (re)constructed the shifting pasts of visuality? What is the role of art in the creation and/or contestation of real and/or perceived identities? What is art's role in contemporary cultural revitalization? And, how and in what ways do culturally specific representational practices and receptions challenge the mainstream? The chapters in this book pursue these questions in a variety of ways. In the first part, the authors expressly address indigenous filmmaking and explore the ways indigenous filmmakers revisit media pasts and resignify dominant discourses. Taking an interdisciplinary approach, the volume's essayists draw on American Indian Studies, American Studies, film studies, cultural studies, women's studies, and postcolonial studies. A theme that emerges is the authors' desire for usefulness of the essays to readers—students, scholars, producers, other individuals in tribal communities.

In the next chapter, Michelle H. Raheja draws on her scholarly oeuvre, wherein she has advanced an indigenous film theory focused on two central terms: redfacing, a cinematic form of "playing Indian," and visual sovereignty, exercising self-representation through creative discourse and visual media. In her piece for this collection, "Visual Prophesies: *Imprint* and *It Starts with a Whisper*," Raheja employs visual sovereignty in order to argue that film offers a visual counternarrative for exploring the thematics of history, loss, and the spiritual by overturning nostalgic discourses of the Vanishing Indian. More pointedly, Raheja contends that indigenous filmmakers demonstrate that seemingly discordant discourses of spirituality and prophecy can be put into conversation with each other, without promising access to a fetishistic world of hidden, "authentic," and mystical Native American epistemologies.

Raheja reviews for us that scholarship on Native American filmic representations generally presents a reading of indigenous peoples as victims of Hollywood interests and a national rhetoric of invisibility and disappearance. This is the familiar register, she insists, along which Native Americans inhabit stereotypical roles first scripted during the early colonial period in visual and print culture, and continued along a trajectory through the creation of the Western film genre to the present, as manifested in films such as Terrence Malick's *The New World* (2005) and Mel Gibson's *Apocalypto* (2006). Yet, asserts Raheja, this of course is not the whole picture. As a supplement and antidote to these images, she draws our attention to important recent work on indigenous film that demonstrates how contemporary indigenous filmmakers have resisted Hollywood by employing culturally specific representational practices of visual sovereignty, and sometimes by ignoring or eliding representational conventions and other forms of colonization.

By probing the decolonizing methodologies in *Imprint* (2007) and *It Starts with a Whisper* (1993), Raheja seeks to help us understand how the filmmakers demonstrate that film itself, as a virtual reservation, is an expressive site that can evoke and enact indigenous knowledges (the latter a thematic concern picked up in the final chapter by Molly McGlennen in her work on artist George Longfish). This view of film, Raheja maintains, presents the screen not as a representative window on the putative "real" world, but as a world in and of itself. This cinematic visual world, I would add, is ripe with agency for both filmmakers and viewers alike to structure future real-world identities. As Jonathan L. Beller has argued, "Cinema means a fully-mediated *mise-en-scène* which provides humans with the contexts and options for response. As cinema mediates the apparent world it also structures perception. The becoming-images of the objective world mean that cinematic processes of assemblage and reception (programs for sensual labor) characterize daily life, and not just the concrete interface with the screen."[12]

If we thus embrace the idea that film has become the technology of the self through which Native Americans themselves have structured their lived identities (Raheja), then Joanna Hearne's call for an embedded scene of critical viewing is not only compelling but imperative. In "Indians Watching Indians on TV: Native Spectatorship and the Politics of Recognition in *Skins* and *Smoke Signals*," Hearne insists that film and viewing practices answer back to the history of misrecognition originating, in her praxis, from "Indians on TV," and media circulation and intertextuality. In *Smoke Signals* and *Skins*, Hearne suggests that Chris Eyre visualizes his indigenous audiences and, through sound and mise-en-scène, imagines the potential for indigenous viewers to resignify Western-genre and documentary images of anonymous and stereotyped Indian characters through politicized spectatorship.

Hearne reminds us that Chris Eyre's films mark a breakthrough for Native filmmaking, both in terms of control over an independent production and in their address of (and access to) a broad Native and non-Native viewership. While we know that Eyre's productions were among the first to offer contemporary and nuanced roles for Native actors, Hearne urges us to additionally see that these films simultaneously look back upon the violence of mapping televised Indians onto real Indians, of recognizing oneself or relatives in the face and genealogy but not the costumed role of the televised Indian, and of the staged encounter between viewers and Indians on screen as they negotiate the meaning of a media past. Drawing on cultural studies' concepts of oppositional decoding and disidentification, Hearne emphasizes spectatorship-as-resistance. This "retrospectatorship," a term she borrows from feminist film scholar Patricia White, can be understood as both an aspect of film production and as a form of claiming. Ultimately, Hearne insists that the ways in which spectators

make meaning constitutes a form of ownership that is also politicized instantiation of familial viewing.

By emphasizing popular culture's connections with the public sphere, Hearne's insightful contribution—that images of Native spectatorship model ways of looking that are also forms of claiming—helps prepare us for Theo. Van Alst's meditations on Sherman Alexie's directorial debut film, *The Business of Fancydancing* (2002). Unlike in Alexie's written work, within which Alexie may be speaking to and about Indians but is likely being answered by a mostly white audience, this cinematic work, claims Van Alst, speaks to Indians who interestingly answer back within the narrative of the film. In "Sherman Shoots Alexie: Working with and without Reservation(s) in *The Business of Fancydancing*," an essay that can be characterized as a playful and conversational piece with the reader, Van Alst reveals how Indians answer Sherman Alexie, as well as what they have to say to their "author" when they do. Obviously, maintains Van Alst, as viewers we must first consider what Alexie is saying and how he is doing so. Within that observation, Van Alst instructs us to investigate the cinematic devices that allow this dialogue to circulate. He then integrates these concerns with attention to the reception of the film by its audiences. Notably, Van Alst underscores the importance of considering Alexie's *lived identity*, an attention we are also alerted to by Penelope Kelsey in a later chapter. Alexie's real world profile as writer allows Van Alst to draw our attention to the text/image interplay at work in *The Business of Fancydancing*.

More broadly, to make their points, Raheja, Hearne, and Van Alst examine filmmakers who necessarily branch out beyond what we might call Hollywood-centrism. Yet these authors confront the potential claim that while independent productions may defy Hollywood conventions, they do not attract large audiences and therefore cannot be thought of as circulating values to large and diverse American audiences. (By extension, then, we might ask to what extent contemporary indigenous media makers actually affect more equitable real-world social arrangements.) What the contributors writing about film in this volume endorse is that the creation of the films themselves is vital, as is teaching such films and teaching visual learning to our students. By teaching these films, we can enable students to gradually realize how much we have been trained to see in very specific ways through commercial or mainstream film production. As the authors demonstrate through their analyses of specific indigenous independent productions, films made outside of Hollywood do not conform to the same aesthetic standards that capitalist, industrial film relies upon. By looking at these independent films, and through attention to film form and reception,

the student of these films begins to see the ways other worlds are visually constructed and, more specifically, how Native American ways of understanding the world continue to give meaning to communities through the medium of film. The juxtaposition of visual worlds—the Hollywood constructs, the independent interventions—and ways of seeing these worlds yield great potential. Moreover, as Raheja observes, "twentieth-century mass-mediated images of Native Americans, as inaccurate and offensive as they sometimes are, create the possibility of a virtual reservation where Indigenous people can creatively reterritorialize physical and imagined sites that have been lost, are in the process of changing, or have been retained."

Hollywood constructs, independent interventions, and Native identity are the primary concerns of the next chapter, "Elusive Identities: Representations of Native Latin America in the Contemporary Film Industry." Drawing from her disciplinary background in Latin American colonial and postcolonial studies, Rocío Quispe-Agnoli surveys the representation of what she terms "Latin American nativeness" in a selection of contemporary motion pictures directed by filmmakers who have very different backgrounds, careers, and agendas, but one common goal: their understanding and representation of nativeness in the earlier history of what is today known as Latin America. Film, as we know, is a medium of mass reception that promotes, negates, and generally alters our perception of identities, especially with regard to gender, race, ethnicity, and religion. Through her presentation, Quispe-Agnoli identifies history itself as an important site for the location, creation, and negotiation of identity building.

Positing a cinematic search for Latin American/mestizo identity, and in approaching the representation of Amerindian images/voices in selected films, Quispe-Agnoli advances several propositions: First, that the search of aboriginal, Native, or indigenous identities in the Americas is an unresolved issue in the films she analyzes (and in others). This search, she suggests, remains within the limits of the representation of difference and otherness, as it has been proposed by various scholars of subaltern studies. Second, in spite of the failed search, Quispe-Agnoli asks, how do we use these materials in class when we, educators in the United States, intend to teach about nativeness? Third, she underscores the awareness that film directors, as well as scholars and educators, offer representations of nativeness that are culturally mediated by Western concepts of what is Native and non-Native. Finally, she reflects on the options available to the artist, the scholar, and the teacher in order to be consistent with their own goals, agendas, or programs of giving voice to the historical minorities associated with Natives in the Americas.

The narrative and visual world of cinema as a site for community build-
ing concerns Penelope Myrtle Kelsey in her essay "Condolence Tropes and
Haudenosaunee Visuality: *It Starts with a Whisper* (1993) and *Mohawk Girls*
(2005)." Kelsey focuses on how Haudenosaunee (Iroquois) filmmakers
Shelley Niro and Tracey Deer deploy condolence as a visual trope and
diegetic process, contributing to a larger decolonizing project that seeks to
rebuild and replenish Iroquois communities. Building upon Tuscarora liter-
ary critic Vera Palmer's scholarship on the hagiographies of Mohawk saint
Kateri Tekakwitha, Kelsey examines the centrality of visual images of the
longhouse condolence ceremony in Niro and non-Native director Anna
Gronau's *It Starts with a Whisper* (1993). Here, Kelsey's arguments regarding
the visuality of condolence thematically resonate with Raheja's critical
approach to Niro's privileging of Haudenosaunee epistemes (and both
Kelsey's and Raheja's analyses thematically resonate with Susan Bernardin's
work on Haudenosaunee artists in a later chapter, "Seeing Memory, Story-
ing Memory: Printup Hope, Rickard, Gansworth"). For Kelsey, Niro's
invocation of visual tropes affirms the unsubjugated nature of Haudeno-
saunee political and cultural thought and epistemology, while remaking
those epistemic practices in the present.

Kelsey also illustrates how generic differences (i.e., formalism vs. real-
ism) influence the expression of condolence in visual or narratological
aspects of film by examining Tracey Deer's documentary *Mohawk Girls*
(2005). In Kelsey's analysis, Deer's film narrates condolence in the lives of
four Kahnawake women in a significantly different mode, insofar as Deer
engages the condolence metaphor as a diegetic process instead of an expres-
sion of Haudenosaunee visuality. In a similar gesture as offered by Hearne
when she suggested that Chris Eyre stages his own interaction with viewers,
and also by Van Alst when he noted the importance of accounting for Sher-
man Alexie's lived identity in relation to apprehending *The Business of
Fancydancing*, Kelsey highlights Deer's lived identity: In the film, Deer
herself is, in fact, the fourth woman. *Mohawk Girls* tells Deer's own coming-
of-age in the same community as in the film's diegesis a decade earlier. In her
final section, Kelsey evokes how the condolence ceremony informs the
larger body of Haudenosaunee film and critical theory, basing this epistemic
framework upon icons, language, and storytelling traditions.

As both Kelsey and Raheja show, the imagery of the condolence cere-
mony is invoked by filmmakers as a recuperative trope for articulating
survivance. Turning our attention to survivance in short-format video,
Joseph Bauerkemper focuses on Seminole/Muskogee/Diné photographer
Hulleah J. Tsinhnahjinnie's 2002 digital short *Aboriginal World View* and its

embedded political critiques and stories. By expanding art historian Veronica Passalacqua's notion of "photographic sovereignty" to include what Bauerkemper terms "videographic sovereignty," he proposes a framework for reading a video that, he argues, subverts colonization's westering impulse and rejects the progressivist historical narratives that authorize conquest.

As Bauerkemper informs us, *Aboriginal World View* remains freely available for viewing on Tsinhnahjinnie's website (www.hulleah.com). For Bauerkemper, this accessible and "infinitely brief yet infinitely valuable visual piece provides fertile terrain for mobilizing student discussion concerning current debates in the burgeoning field of American Indian literary criticism."[13] Such scholarship asks students to engage especially with the assertions of the "nationalist" or "sovereigntist" critical tendency that has emerged over the last decade. Represented most notably by Elizabeth Cook-Lynn, Jace Weaver, Robert Warrior, Craig Womack, and Daniel Heath Justice, the sovereigntist school of critics asserts the legitimacy of tribal nationalist positions and encourages substantive engagement with specific tribal histories and epistemologies, colonial materiality, and political imperatives—not the least of which, of course, involves land.

For Bauerkemper, Tsinhnahjinnie's *Aboriginal World View* plays a crucial role in aiding students as they grapple with major critics and theorists of American Indian literatures. While by no means a simple or straightforward work, the piece nonetheless readily enables students to make their own insightful connections between critical commentary and primary text. By taking us through the piece's layers, multiple meanings, and iconography, Bauerkemper models how this same terrain can be traversed in the classroom through discussions concerning what students see going on in the piece and how they respond to it. Members of the class can thereby elaborate a working relationship with critical and theoretical concerns, groundwork that allows for the engagement in substantial and meaningful discussions of various literary texts, making explicit the insights and illuminations that they offer regarding questions of culture, identity, representation, politics, colonization, and nationhood.[14] Bauerkemper's attention to Hulleah J. Tsinhnahjinnie's video project also complements Cynthia Fowler's consideration, in the second part of this volume, of Tsinhnahjinnie's groundbreaking photographic projects concerning the representation of Native women.

In addition to working within, but also against the specific frictions of filmic world- and identity-making, the filmmakers investigated by Raheja, Hearne, Van Alst, Quispe-Agnoli, Kelsey, and Bauerkemper show us glimpses into the potentiality of an indigenous film practice, the subject of a recently published monograph. In *Decolonizing the Lens of Power: Indigenous Films in*

North America (2009), author Kerstin Knopf advances a text that announces itself as the first to comprehensively examine indigenous filmmaking in North America, as it analyzes in detail a variety of representative films by Canadian and U.S. American indigenous filmmakers. Knopf's filmic selections are, I would suggest, powerfully complemented by the subjects of the essays herein.[15]

The work presented here also expands Steven Leuthold's 1998 study *Indigenous Aesthetics: Native Art, Media, and Identity*, mentioned at the outset of this chapter. By concentrating on the relevance of "aesthetics" for indigenous artists and intellectuals, Leuthold teases out "the role of aesthetics in relation to the stated goals of contemporary indigenous peoples: self-determination, cultural continuity, cultural distinctiveness from the larger 'dominant' culture," and, importantly, connection to place.[16] His theoretically informed discussion of "indigenous aesthetics" might serve well as a primer for this volume's examinations of contemporary American Indian film- and art-making.

A major theme in the collection begins from the recognition that Native Americans have a long history of art and aesthetics behind them, whether Westerners have understood them or not. The second part of the book further acknowledges this history and advances new perspectives on contemporary American Indian art-making. I invited Dean Rader to both launch and introduce this part by offering pointers toward a contextual and political orientation. In "Indigenous Semiotics and Shared Modernity," Rader provides a breathtaking review of artworks—historical and contemporary, executed by Indians and non-Indians, found in public spaces and in private places—whose narrative and semiotic visual fields have constructed, deconstructed, or reconstructed Indian identity (sometimes doing all three at once, as in Jaune Quick-To-See Smith's *Flathead Warshirt*). Though not claiming to provide an exhaustive account, Rader nonetheless sweeps us into the world of artists who marry image and text, merge visual and verbal language—their intersymbolic semiotics, he persuades us, a form of dual signification. Rader calls this "word and world," and surveys how indigenous reclamation and reinvention inform the aesthetic practices of the artists that contributors Susan Bernardin, Cynthia Fowler, and Molly McGlennen each study. Like the authors in the first part, Bernardin, Fowler, and McGlennen interact with interdisciplinary methodologies—those that are, as Rader observes, tied to literary and art-historical studies, cultural and American studies, and most importantly, tribally specific traditions.

Without further rehearsing here the contributions that Bernardin, Fowler, and McGlennen deliver, turning over that synthesis to Rader, I leave off with the following rumination: By applying indigenous perspectives,

visual theories, and cultural-studies' concepts to images, identifying and at times denaturalizing assumptions embedded in those images, and revealing the political aspects of vision and meaning-making from an ethical perspective, all of the contributors in this volume and those they study demonstrate how indigenous film practices and the text/image interplay at work in contemporary American Indian artworks contribute toward indigenous visualities. This scholarship and activism, centering on Native American cultural production and identity, responds to the crucial social reorientations that film and art enact in our contemporary lives.

NOTES

1. Stephen Leuthold, *Indigenous Aesthetics: Native Art, Media, and Identity* (Austin: University of Texas Press, 1998), 1.
2. Nicholas Mirzoeff, "The Subject of Visual Culture," in *The Visual Culture Reader*, ed. Nicholas Mirzoeff, 2nd ed. (New York: Routledge, 2002), 4.
3. Ibid.
4. Nicholas Mirzoeff, "On Visuality," *Journal of Visual Culture* 5, no. 1 (2006): 57–79.
5. Paul S. Landau and Deborah D. Kaspin, eds., *Images and Empires: Visuality in Colonial and Postcolonial Africa* (Berkeley: University of California Press, 2002), xi, 12.
6. Ben Agger, *Cultural Studies and Critical Theory* (Washington, DC: The Falmer Press, 1992), 196.
7. Margaret R. Miles and S. Brent Plate, "Hospitable Vision: Some Notes on the Ethics of Seeing Film," *Cross Currents* 54, no. 1 (Spring 2004), at http://www.crosscurrents.org/MilesPlateSpring2004.htm (November 2008).
8. Ibid.
9. Ibid.
10. Put another way, when considering art as representation, professor of anthropology Judith Farquhar notes that there is a difference in seeing cinema as a symbolic text or as an intervention, further noting that the practices we are involved in every day are political. Farquhar's observations were offered on June 8, 2009, at the 2009 Jessie Ball duPont Summer Seminar, "Picturing the Present: Modernity, Postmodernity, and Contemporaneity," led by Terry Smith at the National Humanities Center, Research Triangle Park, NC, May 31–June 19, 2009.
11. W.J.T. Mitchell, "Showing Seeing: A Critique of Visual Culture," in *The*

Visual Culture Reader, ed. Nicholas Mirzoeff, 2nd ed. (New York: Routledge, 2002), 100. It is interesting to note that Mitchell went on to add that visuality "is a problem in its own right that is approached, but never quite engaged by the traditional disciplines of aesthetics and art history, or even by the new disciplines of media studies. That is, visual studies is not merely an 'indiscipline' or dangerous supplement to the traditional vision-oriented disciplines, but an 'interdiscipline' that draws on their resources and those of other disciplines to construct a new and distinctive object of research" (100), perhaps true of the research field to which he was responding—and advancing—over one decade ago. This essay is also included in his more recent *What Do Pictures Want?* (Chicago: University of Chicago Press, 2005).

12. Jonathan L. Beller, "Kino-I, Kino-World: Notes on the Cinematic Mode of Production," in *The Visual Culture Reader*, 2nd ed., 80–81.

13. Joseph Bauerkemper, personal correspondence, September 6, 2007.

14. Ibid.

15. Kerstin Knopf, *Decolonizing the Lens of Power: Indigenous Films in North America* (New York: Editions Rodopi B.V., 2009). With the exception of Eyre's *Smoke Signals*, no other film title is duplicated.

16. Steven Leuthold, *Indigenous Aesthetics: Native Art, Media, and Identity*, 3.

Indigenous Film Practices

Visual Prophecies: *Imprint* and *It Starts with a Whisper*

MICHELLE H. RAHEJA

FOR OVER FIVE HUNDRED YEARS, THE LITERATURE AND VISUAL culture of the Americas has circulated the image of the ghostly Indian as a figment of an American imagination invested in Native Americans as spectral entities of a tragic and mostly elided past within a broader field of historical amnesia. According to Renée L. Bergland, work by European American writers and artists "has been haunted by ghostly Indians" in order to discursively dispossess Native Americans of their land and to deny them a contemporaneous existence.[1] Drawing from Donald Pease's assertion that scholars of American studies, including postcolonial critics, "have fallen into the ideological trap of American exceptionalism by concluding 'that colonialism had little or nothing to do with the formation of the US national identity,'" Ali Behdad argues that Euro-American "anamnestic disavowal" of U.S. national origins and history of genocide against indigenous peoples is both intentional and "a crucial component of its national culture."[2] Native Americans become apparitional excesses in the dominant culture's repressed imagination, which seems perpetually unable to confront the violence of its founding. Native American ghosts haunt the North American literary and visual cultural imagination simultaneously to remind settler nations of the unspeakable, horrific past and to commit representational genocide by writing contemporary Native American people out of the present and future.

Native American writers and visual artists have also deployed the figure of the ghost and representations of the supernatural, although to differing ends. Native American–generated engagements of ghostly images remind the nation of its brutal past, but also give lie to the concerted national effort to render Native American communities extinct. Two recent Native American films perform this double function, at the same time as they provide

3

a way to represent Native American spirituality on tribally specific terms. In Chris Eyre's *Imprint* (2007) and Shelley Niro's *It Starts with a Whisper* (1993), gendered ghostly images invoke a violent past, in order to trouble conventional readings of historical events, but also to reconfigure temporality in radical ways. *Imprint* offers a reading of the horrors of events at Wounded Knee in South Dakota in 1890 as an allegory for a vibrant Lakota future, rather than only as a melancholic elegy of the past. Likewise, *It Starts with a Whisper* evokes spectral Tutelo tribal members as a means to engage with Mohawk aesthetics in the past, present, and future. As Bliss Cua Lim asserts, "The hauntings recounted by ghost narratives are not merely instances of the past reasserting itself in a stable present, as is usually assumed; on the contrary, the ghostly return of traumatic events precisely troubles the boundaries of the past, present, and future, and cannot be written back to the complacency of a homogeneous empty time."[3] Images of Native American ghosts in dominant culture representations can compel audiences to an emotional economy of guilt and remorse, but they do not serve contemporary indigenous communities invested in visual technologies that reflect the creative, robust vitality of living people. I discuss the work of contemporary Native American filmmakers whose projects stimulate discourses that take the figure of the ghost and its attendant evocation of spirituality seriously, attempting not to fall prey to the kind of nostalgic, past-tense vision of indigenous culture that bolsters the myth of the Vanishing Indian. I do so by welding a discussion of indigenous mass-mediated ghosts to discourses of prophecy in order to argue that film and other forms of new media operate as a space of the virtual reservation, a space where Native American filmmakers put the long, vexed history of indigenous representations into dialogue with epistemic indigenous knowledges.

After contextualizing how the virtual reservation signifies in film, and then how indigenous prophecy works as an embodied discourse in visual culture, I examine two films that foreground the importance of spirituality as an enabling tool for combating colonialism and reengaging indigenous epistemologies without attempting to explain particular aspects of specific tribal practices or inviting spectators to partake of indigenous spirituality through commodification and consumption. *Imprint* and *It Starts with a Whisper* are two key films that create and intervene into discourses surrounding the supernatural. These films overturn the image of the static ghostly Indian through indigenous manifestations of the spirit and conflations of time that challenge hegemonic Western understandings of human relationships to the metaphysical and prophetical.[4] As Lim argues, "The ghost narrative opens the possibility of a radicalized concept of noncontemporaneity; haunting as ghostly return

precisely refuses the idea that things are just 'left behind,' that the past is inert and the present uniform."[5]

In this essay, I do not extract "authentic" spiritual traditions of particular indigenous communities. Rather, I emphasize how contemporary Native American filmmakers produce narratives about spirituality that contest national discourses of Native people as primarily concerned and vested with spiritual matters. Additionally, these filmmakers create narratives of Native relationships to spirituality that attempt to represent core principles of the spiritual, in this case Lakota and Mohawk, in a way that does not offer these representations up to a colonial gaze and consumption, but rather invites the spectator to rethink both Native American spirituality on its own terms and the viewer's relationship to it.

I suggest a reading of contemporary Native American cinematic practices through the lens of a particular indigenous epistemic knowledge—prophecy—on the virtual reservation. Discursive prophecy is intertwined with the broader notion that twentieth-century mass-mediated images of Native Americans, as inaccurate and offensive as they sometimes are, create the possibility of a virtual reservation where indigenous people can creatively reterritorialize physical and imagined sites that have been lost, that are in the process of renegotiation, or have been retained.

Because spirituality and the figure of the ghost have been employed to filmically equate absence and alterity, an examination of indigenous filmmakers' use of these images serves as a way to reinhabit and reimagine colonized terrain. I interrogate how Native American filmmakers represent the spiritual realm without either absenting contemporary Native American bodies within the paradigm of the Vanishing Indian or invoking stereotypes of the mystical Indian that offer a spiritual supplement to a non-Native audience at odds with spiritual belief systems practiced by Native Americans. Indigenous filmmakers instead demonstrate that seemingly discordant discourses of spirituality and prophecy can be put in conversation with each other, without promising access to a fetishistic world of hidden, "authentic," and mystical Native American epistemologies.

AT HOME ON THE VIRTUAL RESERVATION

The virtual reservation is as complex and paradoxical as its geographical counterpart. It is a site where indigenous knowledges and practices are displayed in sharp relief against competing colonial discourses. By doing so, it

opens up multiple narratives for dialogue within and outside the community on a site that is less invested in the traffic in authenticity than in reconsidering the relationship between the visual image and larger cultural and political contexts. Indigenous people at the same time recuperate, regenerate, and begin to heal on the virtual reservation directly under the gaze of the national spectator.

The virtual reservation is an imagined space, in this instance, for the film industry, but has also been transformed by indigenous people into something of value, a decolonizing space. Lorna Roth describes "media reservations" as negative sites of segregation, isolation, and the televisual equivalent of the stereotypes structuring representations of reservation/reserve life in North America.[6] For Roth, Native Americans have been consigned to an indigenous form of what amounts to a ghetto. They compete for small pools of funding, and their self-generated images generally appear only on programs broadcast by the Public Broadcasting Service (PBS) and the Aboriginal People's Television Network (APTN).

Gerald McMaster observes that the historical role of the real-life territorial reserve in Canada has been more nuanced. The reserve is, according to McMaster, "a negotiated space set aside for Indian people by oppressive colonial governments to isolate them, to extricate them from their cultural habits, and to save them from the vices of the outside world. Paradoxically, isolation helped maintain aboriginal languages and many other traditional practices. The reserve continues to be an affirming presence despite being plagued by many historical uncertainties."[7] Following McMaster's lead, I suggest that the virtual reservation is a more creative, kinetic, open space where indigenous artists collectively and individually employ technologies and knowledges to rethink the relationship between media and indigenous communities.

For indigenous people, the reservation is a complicated and often vexed marker of the enabling conditions of collective and personal homeland and site of cultural retention and renewal, seemingly far from the intervening pressures of the dominant culture. Often conceived of as bounded, sovereign physical space, Native American spaces also include urban and exurban enclaves, where more than half of the indigenous peoples of North America live, and rural regions sometimes adjacent to reservations. These on- and off-reservation locations serve as places of cultural, physical, and spiritual continuity, improvisation, and survival where "traditional" practices can be protected and revised.

The reservation, often created under punitive conditions that represented a small fraction of traditional tribal homelands or a space to which

Native Americans were relocated, is also in some cases akin to what some have called North America's version of concentration camps—loci of limited mobility, disproportionate rates of alcoholism, drug abuse, violence, unemployment, suicide, and poverty.[8] Located in a historical period of over two hundred years, the reservation has structural and metaphysical similarities to the state of being Giorgio Agamben describes for the European concentration-camp inmate of World War II. "Precisely because they were lacking almost all the rights and expectations that we characteristically attribute to human existence, and yet were still biologically alive," Agamben contends, "they came to be situated at a limit zone between life and death, inside and outside, in which they were no longer anything but bare life. Those who are sentenced to death and those who dwelt in camps are thus in some way unconsciously assimilated to *homines sacres*, to a life that may be killed without the commission of homicide."[9] Isolated from the outside world and created as an inherently unequal simulacrum of Euro-American institutions, the reservation, particularly in its nineteenth-century manifestation, signified the condition of "bare life" as Native Americans were disciplined through state-sanctioned violence to assimilate, with the intention of social death.

As geographically isolated metaphor and physical and imagined space, the reservation exists for the dominant culture somewhere out there, beyond the limits of national and popular memory, a repository of the repressed and spectral, a homeland for America's ghosts. Avery Gordon argues that ghosts act as an indexical critique of still unresolved historical violence and trauma. As such, ghosts have demands, and push us to reckon with such demands "not as cold knowledge, but as a transformative recognition." "If the ghost is a crucible for political mediation and historical memory," she contends, ". . . the purpose of an alternative diagnostics is to link the politics of accounting, in all its intricate political-economic, institutional, and affective dimensions, to a potent imagination of what has been done and what is to be done otherwise."[10] Referencing Native Americans in particular, Susan Scheckel posits that the nation's haunting by Indian ghosts "marks the limits of that forgetfulness out of which the nation arises."[11] The reservation (and its northern cousin, the Canadian reserve) is imagined in popular culture to be a space of dysfunction and defeat. It is a place the nation needs to continually invoke as a metaphor of its own imagined triumph and Native American defeat, and subsequently forget about in order to maintain its originary fantasies.

While the virtual reservation still contains within its permeable boundaries the violent and violating representations that exist on territorial

reservations, it also provides a creative, imagined space with critical ties to physical places that have protected what might be called "traditional" practices and permitted the maintenance of some indigenous languages and knowledges, such as prophecy. Marie-Laure Ryan suggests three modes of interpreting the virtual: "an optical one (the virtual as illusion), a scholastic one (the virtual as potentiality), and an informal one (the virtual as the computer-mediated)."[12] The virtual reservation can be considered to occupy these three modes: the realm of the filmic as a field onto which an alternative vision of the world can be projected; as a meeting space for tribal intellectuals and scholars to workshop, debate, and define new projects for sustaining indigenous knowledges; and as a network of computer-assisted transnational indigenous communities who exchange and create information. Unlike Jean Baudrillard's notion of the virtual as simulacrum, fake, and substitute for the "real," the virtual reservation is a supplemental arena of the possible that initiates and maintains a dialectical relationship between the multiple layers of indigenous knowledge systems—from the dream world to the topography of real and imagined landscapes. The virtual reservation does not stand in opposition to, or as substitute for, the material world, but creates a dialogue with it. It helps us see things in the material world in a different dimensionality, thus enhancing our understanding of off-line and off-screen communities.

On the virtual reservation, which can be located in a multitude of different discourses—from the Internet, where Native Americans meet as disembodied, often anonymous voices and personas to engage in profound and profane dialogue, to films that stage alternate "communitarian" scenarios[13]—indigenous people workshop on sites where they can recuperate, regenerate, contest, and begin to heal, under the radar of the direct gaze of the national spectator. The virtual reservation in its ability to transcend time and space has also been transformed by indigenous people into a utopic geography of possibility and renewal, as films like *Smoke Signals* (1998); the humorous, heterodox sculptures of Santa Clara Pueblo artist Nora Noranjo-Morse; and the exuberant, life-affirming work of Mohawk dancer and choreographer Santee Smith demonstrate.

But beyond their potential to reframe, reappropriate, and reimagine the tribal world joyously with hope and healing, Native American media makers on the virtual reservation also challenge and complicate representations of indigenous people by voicing dissent, offering counternarratives that reveal the often dismal and depressing aspect of inhabiting homelands that are still colonized in an otherwise seemingly postcolonial world. James Luna's performance art, for example, is a scathing indictment of a dominant

culture that renders Native American aesthetic production a safe, exotic, and quaint cog in the wheel of multiculturalism, as well as of indigenous people who surrender to mass-mediated representations of themselves. Luna's *Petroglyphs in Motion* (2001) is a performance piece that animates several different, often discomfiting characters—a lascivious coyote/trickster, an ailing emphysemic pulling an oxygen tank, and a drunken *cholo* panhandler who solicits money from the audience on the catwalk-like stage, among others.

The virtual reservation Luna creates here is self-conscious and ritualized. Luna enters the theater in each character's costume, touches a wall to begin the transformation into character (and against which a spotlight creates an ephemeral shadow petroglyph), and then ends the character's performance with a similar ritual that creates and closes the virtual space of change, possibility, and play with stereotype. Jennifer A. González suggests that Luna's "resignifying practice is an exaggeration of already present, though more subtle, resignifying practices that have been performed by indigenous cultures in contact with colonizing populations for centuries."[14] Other experimental works likewise create agonistic and antagonistic virtual reservations that compel spectators to undergo a radical rethinking of what constitutes community, nation, family, gender, and self. These include films such as Arlene Bowman's *Navajo Talking Picture* (1986), a documentary about the filmmaker's grandmother that is a painful turn on Mary Louise Pratt's notion of "autoethnography";[15] Clint Alberta's *Deep Inside Clint Star* (1999), a study of the lives of six urban Indians from Canada that purports to be "porn" because of the kinds of looking relations it structures; and Thirza Cuthand's *Helpless Maiden Makes an 'I' Statement* (2000), a short that employs clips of Disney female villains to underscore and trouble issues of queer and raced identity, as well as colonial histories, through the discourses of sadism and masochism.

Perhaps the first extant experimental films by Native American artists were those created by anthropologists John Adair and Sol Worth and their Navajo students in 1966. Adair and Worth later published an analysis of the project as *Through Navajo Eyes: An Exploration in Film Communication and Anthropology* (1972). Faye Ginsburg notes that the project "attempted to teach film technology to Navajos without the conventions of Western production and editing, to see if their films would be based on a different 'grammar' based on a Navajo worldview."[16] The films, according to Beverly Singer, "were intended to serve as an anthropological case study and not as films to be publicly distributed," and did feature a Navajo aesthetics of long shots of the landscape, few close-ups of individuals,

and topics of interest to Navajos.[17] Native American experimental cinema that has operated outside the auspices of visual anthropologists includes work by Victor Masayesva, Jr., a Hopi filmmaker who has been creating experimental films since 1980.[18] His film *Imagining Indians* (1992) made connections between what Singer calls "visual genocide,"[19] and the history of representations of Native Americans in film through interviews with Native American actors and clips from Hollywood Westerns.[20] The film is framed by a narrative of a young indigenous woman visiting a white dentist, which further underlines the connection between the various forms of violence endured by Native people, especially during the Columbus Quincentennial year.[21]

Prior to the inception of motion-picture technologies, non-Indians satisfied their visual and experiential curiosity about the indigenous "other" through photography and other methods of travel to indigenous communities. While these remain popular means of representing American Indians, film became the mode through which most people in the world encountered Native North American communities (and mostly still do). And, subsequently, film has also become a technology of the self through which Native Americans themselves have structured their identities. Part of the work of contemporary indigenous filmmakers is to contend with the legacy of mainstream images of Native people from the silent era (including the work of early Native filmmakers James Young Deer and Edwin Carewe) to the present. Yet many recent Native American films refuse to trade in outright corrections or critiques of genres such as the Western. Due to the discursive space film as virtual reservation leaves in its wake, indigenous filmmakers are now able to present fresh representations of Native America. These representations reconnect and refigure indigenous epistemes such as gender complementarity, the role of the spirit, and alternate conceptions of time in contrast to the dominant culture's misunderstandings about atemporal Native "wisdom." Significantly, these epistemes are not stuck in time, but have changed and transformed just as Native communities themselves have. Some of these self-representations include Beverly Singer's *Hózhó of Native Women* (1997), a documentary about the cultural, spiritual, and physical health of Native women; Mary Kunuk and Arnait Video Production's *Anaana* (2001), a celebration of the life of Vivi Kunuk—Inuit hunter, storyteller, and mother of filmmakers Mary Kunuk and Zacharias Kunuk—and her contemporary Inuit community's complex relationship to the land; and Dorothy Christian's *a spiritual land claim* (2006), an experimental short that thematizes trauma, loss, and renewal through reinvigorated connections to a tribally specific landscape.

PROPHECY AND NATIVE AMERICAN DISCOURSES

Native American expressions of prophecy have recently been taken up by contemporary cultural critics as representative of how indigenous epistemes have changed, transformed, and resisted devaluation at the hands of colonial powers over the years. Many contemporary indigenous scholars, activists, and community members argue for an epistemology that considers the role of spirits and the spiritual as a vibrant and integral part of human existence. Dale Turner argues that "indigenous spirituality is central to indigenous philosophical thinking, which European cultures cannot and will not respect on its own terms. In a sense, this is *the* most significant difference between indigenous and European world views."[22] Indigenous spirituality has been elided and suppressed by Europeans in the so-called "New World" because it poses a threat to Judeo-Christian understandings of gender, the primacy of written narrative, and hierarchical genealogies of meaning and power. But it also, importantly, challenges Western conceptions of temporality, something Euro-American governments and cultures have not tolerated.[23]

Turner further describes indigenous spirituality as a kind of personal and collective minefield wherein one of the most crucial elements of indigenous ontologies must also not risk explanation in the field of Native American studies because of the legacies of colonialism. "As indigenous people," Turner contends, "many of us believe that we can explain our understandings of the 'spiritual' and that the dominant culture will some day 'get it.' But history has shown us that at least at this time in the relationship, we must keep to ourselves our sacred knowledge as we articulate and understand it from within our own cultures, for it is this knowledge that defines us as indigenous peoples."[24]

Turner points to the difficulty of making commensurable a key component of epistemic indigenous knowledges and cultures, while at the same time acknowledging that misunderstandings pose a risk to tribal communities. Citing the nineteenth-century war leader Crazy Horse, who resisted having his photograph taken because of a suspicion of the way images circulate in the dominant culture, and refused to discuss Lakota spirituality with non-Natives: "This 'Crazy Horse' approach to protecting indigenous philosophies is necessary for our survival as indigenous peoples. Yet at the same time, we must continue to assert and protect our rights, sovereignty, and nationhood within an ongoing colonial relationship."[25] Native American visual culture, I argue, provides a field on which the tension between representing the importance of spirituality (without either divulging sacred information that could be weaponized by the colonizer, or stressing its

alterity and disengagement with political and cultural movements) and the desire to conceive of indigenous philosophies unengaged with the West can be played out.

Many Native American filmmakers, from the Arctic to Tierra del Fuego, employ ideas about prophecy as a didactic tool in this time of acute global climate crisis. Because vast indices of knowledge ranging from the ethnobotanical to the philosophical are housed in indigenous communities of the Americas (specifically geographical sites typically thought of as resource-rich in the West, but lacking in relevant human communities), it is critical that filmmakers "people" sites under environmental siege in order to preserve these knowledges for future generations. Thus, a film such as Arnait Video Productions' *Ninguira/My Grandmother* (1999) not only teaches Inuit youth in Nunavut, Canada's newest territory, about traditional relationships to the spiritual world, grieving, attitudes toward the land, and the importance of women's roles in the community, it also populates an area many consider *terra nullius*, demonstrating how even the most minute increase in global warming adversely affects complex networks of human communities. Creating films that engage the spiritual realm without defaulting to the ghost effect and romantic notions of Native American spirituality provides indigenous filmmakers with a vehicle to overturn not only the representational history of the Vanishing Indian, but to engage environmental consciousness through visual sovereignty by offering up alternate ways of thinking about and living on the land.

Scholarship on Native American filmic representations has historically presented a reading of indigenous peoples as victims of Hollywood interests, and a national rhetoric and relic of invisibility and disappearance. This is the familiar register along which Native Americans inhabit stereotypical roles first scripted during the early colonial period in visual and print culture, and continue along a trajectory through the creation of the Western film genre to the present. Yet this, of course, is not the whole picture. As a supplement and antidote to these images, important recent work on indigenous film demonstrates how contemporary indigenous filmmakers have resisted Hollywood by employing culturally specific representational practices of visual sovereignty, and sometimes by ignoring or eliding dominant representational conventions and other forms of colonization.

IMPRINT: THE SPECTRAL INDIAN
ON THE VIRTUAL RESERVATION

Cheyenne/Arapaho filmmaker Chris Eyre employs the ghost effect and rep-resentations of prophecy to different purposes than the conventional image of the spectral Indian in his most recent film, *Imprint*. *Imprint* is an ultra-low-budget film produced by Eyre, the best-known contemporary Native American filmmaker. Eyre directed *Smoke Signals* (1998), as well as *Tenacity* (1995), *Skins* (2002), *Skinwalkers* (2002), *Edge of America* (2003), and *Thief of Time* (2004). He worked on *Imprint* in collaboration with Linn Produc-tions, a small, family-owned, non-Native production company based in Rapid City, South Dakota.[26] The film was originally set on a rural white family's haunted farm in South Dakota, but conversations between Eyre and Michael Linn, who directed *Imprint*, resulted in a film that is set and shot primarily on the Pine Ridge Reservation and employs local as well as nation-ally recognized Native American actors. The film also features a plot driven by indigenous epistemes of prophecy and the role of the spirit created in consultation with Eyre, the film's actors, and local tribal members.[27] It is particularly significant that the film is set and filmed on the Pine Ridge Reservation, since this site figures so prominently in Native American his-tory. Pine Ridge not only signifies authentic "Indianness" in the dominant film imaginary (warriors in full headdress riding on horseback, wide hori-zons dotted with tipis, herds of thundering buffalo, etc.), but it is also the site of the Wounded Knee Massacre of December 1890 (and the Wounded Knee Cemetery, where victims of the carnage perpetrated by the United States 7th Cavalry are buried) and what came to be known as Wounded Knee II, the violent seventy-one-day standoff in 1973 between American Indian Movement (AIM) members and U.S. marshals, state police, and supporters of Richard A. "Dick" Wilson's government.[28]

Carole Quattro Levine details the crucial contribution the film makes as a narrative that focuses on the independent, strong-willed main protagonist and her relationship with her equally independent, strong-willed mother.[29] The film's point of entry through an intelligent, articulate, well-educated female lead protagonist overturns Hollywood film conventions of the West-ern, in particular, in which indigenous women are either absent or abject. Both *Imprint* and *It Starts with a Whisper* complicate Native American film history by featuring powerful female characters, as do both films' use of a supernatural plot. *Imprint* overturns the image of the ghostly Indian as a spectral artifact of the past in the service of visual sovereignty through its use of indigenous manifestations of the spirit and conflations of time. Termed

a "thrilling Native American supernatural ghost story," and a "shrewdly moody attempt at an old-fashioned ghost story with a Native American twist,"[30] *Imprint* plays on audience expectations of both the horror film genre and conventional images of the Native American ghost in terms of its use of suspense, setting, diegesis, and technical considerations.

The film's plot centers on Shayla Stonefeather (Tonantzin Carmelo), a Denver-based Lakota attorney from the Pine Ridge Reservation who in the opening scene successfully prosecutes Robbie Whiteshirt (Joseph Medicine Blanket), a Lakota teenager also from Pine Ridge who has been, as is later revealed, unjustly accused and convicted of killing a senator's wife. After the trial, Shayla returns to her parents' buffalo ranch to celebrate the birthday of her father, Sam (Charlie White Buffalo), an artist who appears to be suffering from a catastrophic disease and attendant mental illness.[31]

While she is home, Shayla begins to notice that her parents' ranch appears to be haunted by some kind of unresolved past event that is linked to her father's illness. At night, she glimpses a ghostly figure (a wispy shimmer achieved by low-tech special effects that is nevertheless spooky) accompanied by aural intimations of violence, and a spectral handprint on a wall that quickly disappears. The ghost does not appear to threaten Shayla, but to suggest that these violent acts have taken place recently on the Stonefeather

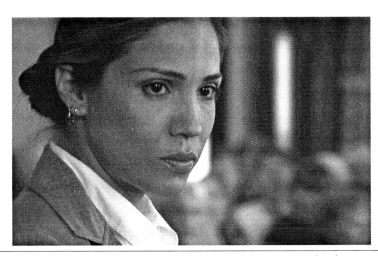

Tonantzin Carmelo as Shayla Stonefeather in a photographic still from *Imprint* (2007). Photograph courtesy of Linn Productions.

property. The spectral figure does not scare Shayla as much as it activates her need to investigate its cause and purpose.

Shayla concludes that the specter may have one of four origins: it may be the ghost of Robbie Whiteshirt, who committed suicide immediately following his conviction; his brother Frank (Russell Chewey), who follows Shayla back to the reservation and seems to be stalking her; the troubled spirits of Lakota people murdered during the Wounded Knee Massacre of 1890, whose bodies have been interred in a nearby cemetery (there is a temporal plausibility to this argument in the text as the film, like the massacre, takes place in late December); or the ghost of her brother, Nathaniel Stonefeather (Gerald Tokala Clifford), who has been missing for two years and is presumed to be deceased, since Shayla's father Sam found Nathaniel and his friend Allen doing drugs in the house.

Shayla intuits the fourth theory to be the most plausible and begins to suspect that her father murdered Nathaniel and Allen. The imagined reenactments of the "murder" scene, which takes place in Nathaniel's bedroom closet, intimate that the two were not only using drugs in the house, but were lovers, and that her father killed them both out of homophobic rage. This theory is corroborated towards the end of the film when Shayla finds Nathaniel's and Allen's motorcycles buried beneath the family's barn, and Sam, in one of his few lucid moments, draws a violent image of an individual hanged in that same barn.

In order to rid the house of its haunted presence, Shayla's mother, Rebecca (Carla-Rae Holland), asks an unnamed medicine man (Dave Bald Eagle) to smudge the house with sage and locate the source of the restless spirit. The representation of the medicine man in the film overturns conventional Hollywood images of Native American medicine people and shamans. Rather than trafficking in alterity, extreme costumes, and incommensurability, as most Hollywood images of medicine people do, *Imprint*'s medicine man sports a cowboy hat, fleece vest, and dress pants. No one in the film refers to him as a medicine man, and the only marker of his profession is his sage bundle.

He speaks both Lakota and English to Shayla, is humble in his approach to spiritual affairs, and possesses a wry sense of humor. He has no special insights into the haunting, except to note that the spirit has a special message for Shayla. Appearing ghostly through the wisps of sage smoke that encircle his face, he tells her that the "past, present, and future all touch each other. Time doesn't exist. For spirits, time doesn't exist." This welding of Shayla's individual experience with those of the women, men, and children murdered at nearby Wounded Knee revivifies an ongoing relationship

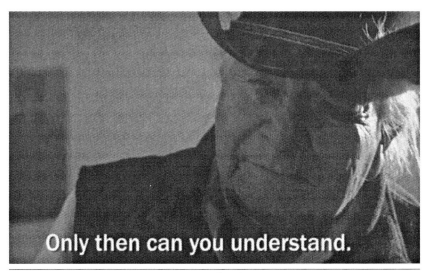

Only then can you understand.

Dave Bald Eagle plays a medicine man in *Imprint* (2007).

and responsibility to the past and future by drawing connections between seemingly disparate events. The title image of the film refers to the ghostly handprint that appears in the house, as well as the story of Wounded Knee victims, whose memory is "forever imprinted on this land," as the medicine man relates. According to Lim, "Ghost films that are also historical allegories make incongruous use of the vocabulary of the supernatural to articulate historical injustice, referring to 'social reality' by recourse to the undead. Such ghost narratives productively explore the dissonance between modernity's disenchanted time and the spectral temporality of haunting in which the presumed boundaries between past, present, and future are shown to be shockingly permeable."[32]

The medicine man comes to the Stonefeather house to assuage the restless spirits abiding there, and locates the source of the supernatural presence in Nathaniel's closet. Shayla's suspicions about her father are thus confirmed. She subsequently confronts Sam with this evidence, and while he is paralyzed from his illness and cannot speak, he communicates by crying, which Shayla reads as an admission to the crime. He dies shortly thereafter, released, as Shayla intimates, from the guilt of his crimes. Perhaps unintentionally, the figure of a speechless Native American elder, able to communicate only through tears, invokes Iron Eyes Cody's performance as the crying Indian in the Keep America Beautiful public service announcement. In *Imprint*, however, the

cause of silence is medical, and Sam prophesies about the future through his tears not to activate guilt on the part of non-Indian suburban commuters, but to save his family and, by extension, his community from further violence. The tears also signify his frustration at being misunderstood and unable to communicate sufficiently through either language or an artistic medium, a frustration that metaphorizes the historical condition of Native Americans whose speech has often been either unheard or misconstrued.

Imprint draws from a long cinematic, literary, and popular-culture tradition of locating Native Americans in the past as ghosts whose political power resides in their function as disembodied reminders of historical violence and injustice. Taken in psychoanalytic terms, Indian ghosts such as Cody's character in the KAB campaign haunt the national imaginary and serve to suggest that guilt can be ameliorated through appeasing spirits who are perceived as easier to placate than contemporary indigenous survivors, whose presence challenges the very foundations of the United States and Canada. *Imprint* likewise leads the spectator to believe that the haunting of the ranch is the result of the unsettled spirit of a Native American for whom a crime needs to be (re)solved in order for it to be released from the ties that bind it to earthly existence.

On the contrary, the film's conclusion reveals a surprising plot twist: the ghost who has haunted the plot is Shayla's future self, who will be the victim of an attempted murder by her Euro-American boyfriend, attorney and aspiring politician Jonathan Freeman (Cory Brusseau). Freeman follows Shayla to South Dakota ostensibly to celebrate her father's birthday, but also to demonstrate to her how hopeless and dysfunctional the situation on the reservation is, a move intended to lure her permanently to the city with him. At Sam's funeral, Jonathan becomes enraged when Shayla confronts him with evidence that their law firm fabricated the case against Robbie Whiteshirt. His political career in jeopardy, Jonathan storms away from the funeral.

Later, in her parents' empty house, Shayla and her childhood sweetheart, Tom Grey Horse (Michael Spears), a tribal policeman who accompanies Shayla home after her father's funeral, sit in Nathaniel's room and discuss a ghostly apparition Shayla believes she saw near the cemetery. She glimpsed what she thought was a spectral image of Nathaniel, which would lend credence to her belief that her father had killed him, and that his spirit would now be released from its earthly moorings. Near midnight, at the exact same time the figure that haunted the house would appear, Jonathan emerges out of the closet with a knife and attempts to kill both Tom and Shayla

The events prophesied by Shayla's spectral future self conclude in the barn,

where Shayla saves herself by becoming entangled with a hook while Jonathan plunges to his death. The image of Shayla dangling from the hook was prophesied by her father's artistic rendering of the same scene, meant to visually warn Shayla about the danger that her father could not verbally articulate. In a chance meeting at the Wounded Knee Cemetery, the medicine man encourages Shayla to "listen." "You have closed many doors in your life. Very little light can shine in," he notes. "Only when you open these doors can you begin to listen. Only then can you understand. There are messages all around us, but few are listening, few understand." The attack serves as pedagogy for Shayla to learn to reimagine spectral temporality and its possible futures. As historical pedagogy, it serves to teach the spectator about the ongoing lessons of the historical past and spectral futures.

Both Tom and Shayla survive the attack, and Shayla's brother, Nathaniel, conveniently returns to Pine Ridge, thereby creating a tidy, if unbelievable ending. By the film's conclusion, Shayla resolves to remain on the reservation to resume her relationship with Tom and reconnect to her Lakota community. A wolf that had appeared previously in the film to present Shayla with a cryptic message rematerializes to lead her to a vista of the village of Pine Ridge. The film concludes with an image of her standing, palms forward, to receive what her future might hold. Despite the film's somewhat romantic notions of a seamless return to life on the reservation, it provides a critical rereading of the Native American ghost figure that allows for an indigenous, rather than Hollywood, perspective on notions of time and space.

MATRIARCHAL TIME/SPACE MACHINES: FILM AS VIRTUAL HEALING

Like *Imprint*, Mohawk artist Shelley Niro's experimental short *It Starts with a Whisper*, provides a critical reframing of Indian ghosts through indigenous-inspired representations of spirituality. The film narrates a day in the life of Shanna Sabbath (Elizabeth Burning), a young Haudenosaunee woman from the Six Nations Reserve in Ontario, Canada.[33] The film simultaneously critiques and elides colonization by supplying humorous Haudenosaunee-generated images that develop what Larry Abbott has called Iroquois "alter egos,"[34] images that do something other than overturning negative stereotypes with "traditional" representations. The film opens midway through her performance of a kind of vision quest that unfolds over the course of the film. Like a traditional vision quest where an individual

undergoes a liminal experience in isolation from other people in order to receive knowledge from the spiritual realm in the service of a broader community, Shanna spends the film in dialogue with spirit beings in human form that console, challenge, and encourage her. The prophetic message she receives from the spirits she encounters about healing from the discursive and physical violences of ongoing colonization is intended not only to benefit Shanna, but also members of the larger imagined community on the virtual reservation each time the film is screened.

One of the spirit voices urges her to draw on "voices of the past, voices of the present" in order to guide her path out of trauma, what the voice describes as "sorrow inside and beyond you." These non-diegetic voices, which the audience is not privy to, do not give Shanna explicit directives for healing from colonialism, but provide her with the support, through communal memory, for negotiating her way towards a new status as a healthy Haudenosaunee woman. The film works to provide encouragement and support to Haudenosaunee spectators through Shanna's example, but also to validate, revive, and reconfigure Haudenosaunee knowledges, particularly gender and prophecy and their attendant relationship to the spiritual world. The opening scene sets the stage for the recovery of a Haudenosaunee worldview that values the balance of equal opposites as a formula for intellectual, spiritual, physical, and cultural health and well-being that the film enacts.

The film commences with an extreme close-up of the distinctive style of Haudenosaunee beadwork displayed against a crackling fire. A female voice-over lists sets of opposites—"whispering waters / raging torrents; earth of bounty / parched and starving land"—followed by a male speaking untranslated Mohawk. These whispered opposites set the stage for a recuperation of Haudenosaunee intellectual knowledge practices in the service of contemporary communities—the "It" to which the title refers. The universe, according to the Haudenosaunee, is divided into equal halves that achieve their optimum state in balance. This balance is not predicated on the Judeo-Christian binary of "good" versus "evil" as the Haudenosaunee dichotomy does not operate ideally in conflict, but in harmony. In addition, the gendered binary, part of a broader set of opposites, is not grounded in a belief that men and the products of their labor are superior to women, but that the two are valued entities in a universe where their intellectual and physical production is respected equally.[35]

The Haudenosaunee origin story, for example, is instructive as a theorization of this notion of balance, as well as a relationship to time that is, in Michel Serres's words, "polychromic, multitemporal, and reveals a time

that is gathered together with multiple pleats."³⁶ In one of the many versions of this story, a woman from the Sky World falls through a hole created by an uprooted tree, and on her way into the abyss grabs corn, beans, and squash seed (known as the "Three Sisters"). As she tumbles through seemingly endless darkness, Canada geese take pity on her and carry her until they become tired and call on a giant, primordial turtle below to assist them. She lands safely on his or her shell, and with the assistance of other animals creates the world on the turtle's back. Her daughter later gives birth to two male twins, Sapling and Flint, who are responsible for creating the earth's topography. Sapling facilitates geographies that ease human existence, such as rivers, lakes, hills, and forests, while Flint engenders challenges, such as mountains, inhospitable climates, and rocky surfaces.

While this single event occurred in time immemorial, it can also be imagined to recur every time a child is born, as it moves from the space prior to its earthly existence ("Sky World"), travels through the birth canal (the abyss through which the Woman Who Fell from the Sky moves), and brings its own special gifts in the form of metaphoric seeds to this world. In Haudenosaunee prophecy, this will continue to happen until the turtle becomes weary, flips over, and dives back under the water to end life as we know it and begin anew. Mohawk scholar Deborah Doxtator posits that Haudenosaunee women "grapple with the uneasy questions of how to think about a world where another culture's mind has super-imposed its own intellectual constructs on the landscape and drastically altered how that land looks to us; of how our cultural metaphors and the way in which we connect to land have become re-interpreted and entangled for us by a 'dominant' Euro–North American ideology grounded in scientific rationalism, new age spirituality, and ecological liberalism."³⁷ She asks if "there can be a healthy act of creation emanating out of our own way of thinking even if we picture and envision the world as fragmented, distorted and in distress."³⁸ Niro's film, I argue, responds emphatically to this question and embodies this sense of prophetic renewal as a moving image that can be replayed endlessly. "The *moving picture*," as Vivien Sobchak argues, "is a visible representation not of activity finished or past but of activity coming-into-being."³⁹ Film, particularly the conventions of experimental film, permit the staging of time that aligns closely with indigenous notions of time.

The nighttime opening scene in the film gives way to its opposite, daytime. Unlike the opening scene, with its warm fire glow and lush, detailed beadwork shots, the day scene is less animated. A pair of disembodied arms throws dirt on the fire, and the ensuing smoke clears to reveal intertitles that relate the story of the Tutelo, an indigenous nation that found shelter on the

Grand River among the Haudenosaunee in the 1840s, and whose survivors were adopted by the Cayuga, a nation whose members currently live on the Six Nations Reserve.[40] The intertitles narrate the story of the Tutelo in the past tense, suggesting a sense of melancholy and loss.[41]

The emotional effect of the intertitles is heightened by the appearance of a woman wearing traditional Haudenosaunee clothing who is revealed in obscured, brief shots of parts of her body—her feet, her head and torso from afar, her face in profile and the sound of rustling through the forest. The appearance of this woman, viewed only in fragments, following the story of the Tutelo, visually suggests the ghostly metaphors of the Vanishing Indian. Is it Shanna, the main protagonist, a person, or the ghost of a Tutelo woman from long ago?

The film offers a counternarrative for exploring the thematics of history, loss, and the spiritual by overturning nostalgic discourses of the Vanishing Indian. Shanna is not trapped outside of time as a lone ghostly figure haunting the frames of the film, but returns from her vision quest to her life in metropolitan Canada. The camera slowly pans the sky and cuts to an image of skyscrapers in Toronto. The call of birds and lapping water are replaced by their opposites: a cacophony of urban sounds (jackhammers, sirens, and car horns). Wearing a business suit, Shanna negotiates this landscape as deftly as she does the banks of the Grand River. The female voice-over spirit

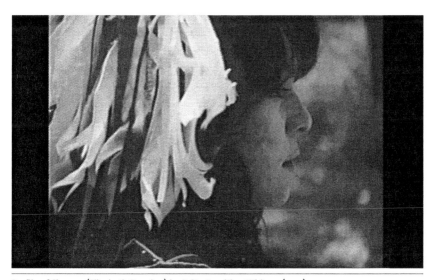

Profile of Shanna (Elizabeth Burning) in *It Starts with a Whisper* (1993).

returns to speak to Shanna again, connecting the politics of geography and removal to the experiences of contemporary Native Americans, rather than severing the past from the present as do conventional representations of the ghostly Indian. The voice instructs Shanna:

> Don't be afraid. The voices of the past are calling you. The voices of the present urge you on. The voices of the dead tell you their sorrow. The sorrow inside you and beyond you. You're so young, Shanna. Where are your years across the centuries? What can you do? Reading, writing, thinking. Too much thinking. Tears that won't come. Peace that won't come. . . . How do you go forward? Who knows what else has been forgotten? Who knows where to look? . . . Listen to the voices, Shanna. Sing your own song. Play your own drum."

In the film, Shanna is not a ghost, but a young indigenous woman grappling with issues of alienation, identity, and the violence of encounters with Europeans and white settlers. The voice-over spirits have no visual representation, but make manifest an unbroken connection across time and space. This strategic use of representations of the spirit not only opens up the possibility for a visual sovereignty that imaginatively performs epistemes that do not easily conform to linear plottings of time and Western juridical notions of property, but also permits creative virtual spaces of community.

The film does not dictate that Shanna make the proverbial choice between the "Indian" and "white" worlds. To be a contemporary Haudenosaunee person, the film suggests, is to interact with an imaged and/ or territorial landscape inhabited by historical and spiritual ancestors. As Darrell Varga writes, "In Niro's films . . . the grim stereotype image of the disenfranchised native typically found on Canadian television is replaced by characters who have a sophisticated historical consciousness and desire to navigate the flux of identity formed out of tradition, everyday reality, dominant media culture, and the creative process of change."[42] The film suggests that imagining this connection with the ancestors is a way of countervailing against the legacy of colonialism.

Shanna leaves this city scene for a weekend road trip to Niagara Falls with her tricksteresque "Matriarchal Aunts/Clowns" (as they are identified in the credits), one of whom has won a romantic getaway to the site popularly recognized as the Honeymoon Capital of the World. The aunts, Emily (Debra Doxtater), Pauline (Beverley Miller), and Molly (Elizabeth Doxtater), each named for a prominent Mohawk historical figure (Emily General, Pauline Johnson, and Molly Brant), gently tease Shanna about her life off the reservation and her passion for reading throughout the journey.[43] Once they

arrive in Niagara Falls, the aunts disappear, leaving Shanna to inhabit what Gilles Deleuze calls an "any-space-whatever"—a dysfunctional, fragmented, and anonymous filmic site.[44]

Shanna confronts a hallucinogenic, intimidating, and terrifying space of whirling neon signs, carnival music, and the ping of a shooting gallery where Indians are the targets. These tourist trappings do not draw Shanna in, but make her feel alienated and alone until the voice-over female spirit intones: "Shanna, don't be sad. We made it through another year. A short five hundred years. Next year will be better. There are so many people who care about you. Look around you. You can see the circle grow."

Shanna then finds herself in a space that signals a suturing of "reading, writing, thinking . . . too much thinking" to a place where she can acknowledge her emotional circuitry during her virtual reservation meeting with Cree political leader Elijah Harper (played by Harper himself, who ironically is wearing a Hollywoodesque full headdress).[45]

This scene deflates again the stereotype of the ghostly Indian because Harper is a living person, not a specter. The space where he and Shanna meet is both deterritorialized and outside the bounds of space, as it is neither part of a dream nor "reality." As a break from the chaos of Niagara Falls, Shanna and Harper meet in a quiet, peaceful, decontextualized space, surrounded by white. This space, which could be read as "heaven" because

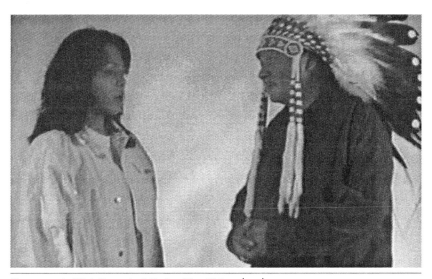

Shanna meets Elijah Harper in *It Starts with a Whisper* (1993).

of its likeness to filmic representations of the Christian afterworld, brings the religion of the European colonizers into dialogue with Native American notions of prophecy. Shanna's last name is Sabbath—the day of rest and completion in the Bible (signaling a representation of both the beginning and the end). Harper's first name, Elijah, refers to a biblical prophet who performs miracles, such as raising the dead. This scene lends itself to a reading of Harper as a prophet bringing wisdom not to a male novitiate, but to a young woman who holds the promise of enacting a rebirth among her people (and reviving the "dead" Tutelos), bringing the world back into balance on Haudenosaunee terms, but through metaphors commensurable to Christians as well.

This time/space marked within the film is what Robert Stam has called "chronotopic multiplicity." The simultaneous rendering of time wherein Harper can occupy both his place in chronological time outside and inside the frame mirrors indigenous oral narrative and the conduciveness of cinema as a technology for expressing indigenous knowledges, a technology Stam has posited "is ideally equipped to express cultural and temporal hybridity."[46] Harper recognizes Shanna and acknowledges the violence conventional film images have inflicted on Native Americans: "I know all the influence the mass media has had on us. We must fight these negative stereotypes. We must be aware and not let them upset us so that we doubt our self-worth." Yet "fighting" stereotypes within the scope of *It Starts with a Whisper* means being receptive to the spirit realm and the promises of prophecy.

After meeting with Harper, Shanna is magically transported to a hotel room to perform a musical interlude with the aunts, all of whom wear fancy gowns and sing what at first appears to be a dreamy girl-power, self-esteem song in front of a kitschy Niagara Falls honeymoon suite vanity whose lyrics begin: "I'm pretty."

But the concluding part of the verse punctures this image of a surface reading. The verse is fully completed with ". . . mad at you." The women go on to critique the Canadian colonizer's policies of the residential school, institutionalizing aboriginal people in mental hospitals for "acting otherwise," and for normative sexual policies that undermine both the matrilineal nature of Haudenosaunee culture as well as the homoerotics of the musical scene itself (the four women are in a honeymoon suite, lie down on a heart-shaped bed together, and perform seductive, synchronized dances whose climax occurs off-stage). The sassy song ends with the verse "I'm survivin'. I'm thrivin'. I'm doin' fine without you," suggesting that colonization has been but a blip on the indigenous radar screen. As Rob Shields has noted,

Niagara Falls "was consecrated as a place betwixt and between one social status and another, passing over all the taboos separating the lives of the respectable single and the married," a "place for transitions and *rites de passage* in the life cycle."[47] Niagara Falls itself constitutes a virtual reservation, as it is both sacred territory to Native Americans and a dominant culture–constructed tourist space, both a location of transformation and the shedding of old selves.

In the concluding scene, Shanna presides over a tea party overlooking Niagara Falls on December 31, 1992, at 11:55 P.M., the very end of the Columbus Quincentennial year. One of the aunts reads a poem by Mohawk writer Pauline Johnson as Shanna cuts an earth-shaped cake (symbolizing the destruction of this "world" in favor of a new one and prophesying similar transformations for other tribal members coping with the trauma of history). As the cake is cleaved in half, fireworks in the background constellate to form an image of a tree sitting atop a turtle—the Haudenosaunee visual icon for the female-centered origin of the world.

This image at the end of the film signifies one world coming to an end (in terms of both its temporal date concluding the Quincentennial, and its

Concluding scene from *It Starts with a Whisper* (1993).

symbolic temporality that privileges indigenous time and space), and a new one beginning in the broadest sense of cataclysmic and metaphoric change.

It simultaneously signals a more personal tectonic shift in the young protagonist from traumatized subject to Haudenosaunee woman—a shift that the film suggests can be replicated for any spectator. In this scene, the film acknowledges an alternate sense of time, wherein "history" is taken to mean the entire scope of Haudenosaunee experiences within which European invasion is a small bump on this longer space/timeline—the "short 500 years" invoked by the female spirit voice who condoles the past at the same time that she offers hope for the future.

The film makes manifest what Jonathan Lear calls "radical hope."[48] Lear discusses the Crow Nation as a people who "ran out of time" as a result of the devastating nineteenth century. Yet under the visionary leadership of Plenty Coups, the Crow exist today as a vital, strong community in the process of revitalizing their traditions. *It Starts with a Whisper* also engages in what might more usefully be called "prophetic hope" by hinging not on an individual leader, but by demonstrating the work of prophecy from the ground up. Rather than relying on a messianic figure or divine intervention, as do millennial and eschatological belief systems, the film reads the indigenous body itself as a prophetic text, much like the Mayan, Hopi, Navajo, and Cherokee narratives of prophecy. The difference here is that the film prophesies an omnitemporal new beginning that takes place simultaneously in several different time/space continuums.

The experimental *It Starts with a Whisper* participates in the indigenous-led aesthetic and cultural efforts to rethink the Columbus Quincentennial. These efforts mobilized along a register that both contemplated and condoled five hundred years of oppression while at the same time commemorated and celebrated what Gerald Vizenor has termed Native American "survivance." As a result, *It Starts with a Whisper* critiques Canadian colonial representative practices that have rendered aboriginal communities either invisible through discursive genocide and the myth of the Vanishing Indian, or hypervisible through mass-mediated images of Native peoples unrecognizable and of little to no value to tribal communities.

While Niro privileges Haudenosaunee systems, she does so by dispensing with the fraught notion of authenticity. Her film is built on scaffolding that understands cultural identity to be fluid, and that a confederacy such as the Haudenosaunee survived and thrived not only its tumultuous birth, but four hundred years of invasion and colonization, through a complex series of diplomatic, philosophical, and epistemological negotiations that relied on the kinetic force of transformation. "Haudenosaunee life began," Niro

states in *Suite: Indian* (2005), "and has remained alive through the need to express one's life and creativity." The creation of the Great Law of Peace at least five centuries before contact with Europeans sets the groundwork for framing what was to come and how Haudenosaunee communities might cope with the resultant changes.

The themes addressed in *It Starts with a Whisper* are also invoked in Niro's co-created exhibit at the 2007 Venice Biennale, The Requickening Project.[49] This project, according to Nancy Marie Mithlo, is a "reference to the Iroquois condolence ceremony that rectifies states of fragility, and ensuring life continues to flourish."[50] Niro's exhibit features an experimental short entitled *Tree* (2006), which, according to Mithlo, "pays homage to the 'Keep America Beautiful' campaign from the early 1970s where stoic actor Iron Eyes Cody gazes at the environment and sees it no longer being cared for or respected. Niro replaces Cody, the perpetual Indian stereotype, with a matriarchal figure who witnesses the same environmental degradation, some thirty years later." One of the main differences between the two moving images, however, is that while Cody's address calls for curbing litter, Niro's silent young woman wears contemporary clothing and appeals for more emotional, political, and psychic investment in the environment as her image is mapped onto that of a bare tree—a signal, according to Onondaga Chief Leon Shenandoah, for the imminent end of the world.[51]

PRESENT PREDICTIONS:
NATIVE AMERICAN DISCURSIVE PROPHECY

Native American media artists Chris Eyre and Shelley Niro employ film as a virtual reservation to foreground, contest, and reinvigorate such key concepts as prophecy, chronology, spirituality, and gender. The logic underpinning recent scholarship on prophecy and its relationship to Native American science and some of the environmental, philosophical, and cultural changes witnessed in the past few years critiques the stereotypical notion of indigenous time as a metaphorical circle that loops back to, and proceeds from, some originary point, as opposed to European conceptions of chronological time that originate somewhere in the past and stretch forward linearly to a future along a single trajectory.[52] Instead, recent work by scholars such as Beverly Sourjohn Patchell suggests a conception of time that conflates these two ways of thinking about chronology.[53]

For Patchell and many Native American writers and media makers, what

is conceived of as the past is endlessly available through cultural modes such as one's relationship to the land, language, dance, song, and stories that have rested in dormancy, despite over five hundred years of colonialism and attempted genocide. These modes have changed, but are nevertheless accessible through embodied memory, dreams, the process of writing, imagination, and most significantly for my work, film.[54]

Leslie Marmon Silko's *Almanac of the Dead* (1991), an encyclopedic, apocalyptic novel that constitutes itself as a prophetic text, exemplifies this critical tradition of pre-1492 conceptions of time and space. *Almanac of the Dead* memorializes the indigenous genocide from the turn of the fifteenth century to the present, as well as prophesies the "death" of Western culture and its attachment to linear time and hierarchical binary oppositions, capitalism, and neoliberalism. Yvonne Reineke draws on the work of Jonathan Boyarin, Enrique Dussel, Gordon Brotherston, and Georg Wilhelm Friederich Hegel to suggest that "despite new directions that physics has posed for our sense of time/space, such as the challenges of quantum mechanics and the theory of relativity, many of us in the West generally operate in the daily world and in our social and political lives as if 'Cartesian space' inhered. That is, we tend to separate out time and space." She contends that, conversely, Silko's sense of the prophetic and its relationship to history, geography, and chronology "insists on time and space as living, and hence, as moving time through space"; therefore, "the novel's insistent message is clear: the passage of time does not diminish indigenous people's call for justice through the return of their homelands."[55] This sense of the prophecy's connection to ongoing struggles for sovereignty is foregrounded at the inception of the novel with a hand-drawn map of the border between what is now known as Arizona, Texas, and California and the northern states of Mexico. The map resembles a womb, concretizing the relationship between women and the land, not as a site to be conquered through sexual and territorial violence, but as a space of generation and recognition of female power through the novel's strong female protagonists.[56]

A key on the map marked "Prophecy" states, "When Europeans arrived, the Maya, Azteca, Inca cultures had already built great cities and vast networks of roads. Ancient prophecies foretold the arrival of Europeans in the Americas. The ancient prophecies also foretell the disappearance of all things European."[57] As tribal historians and scholars have noted, most Native American communities have an oral tradition that foretells the invasion of their homelands by strangers from Europe. These gifts from the past not only warn descendants about the cataclysmic change, death, and destruction that are impending, but assure them of their survival.

Recent scholarship indicates that indigenous people have historically

presented sophisticated reading strategies of prophecy.[58] Indigenous readings of prophetic narratives reassert agency into the historical record and demonstrate the importance of a cosmology that conceives of time, space, and humanity's relationship to the universe in a profoundly different way than European colonizers. In *Storyteller* (1981), Silko narrates one such prophetic text. In an origin story that appears on the page as an untitled free-verse poem occupying the centerfold of the book, Silko describes a convention of "witches" from all over the world who compete in a contest "in dark things." The conventional witches boil gruesome concoctions in cauldrons, but an unassuming, gender-ambiguous witch steps forward to create a monster, using only words—"What I have is a story"—a monster whose genesis appears to be in Europe ("*white skin people / like the belly of a fish / covered with hair*") and whose violent history parallels that of European colonizers ("*When they look / they see only objects . . . The wind will blow them across the ocean / thousands of them in giant boats . . . Entire villages will be wiped out / They will slaughter whole tribes . . .*"). When asked to recant this ritual, the witch replies, "*It's already turned loose. / It's already coming. / It can't be called back,*"[59] indicating the power of language to both create and destroy the world, a theme that recurs in Native American literature. In this narrative, not only is the colonizer's arrival predicted, colonial powers are created by indigenous people. Silko ironically reverses the representational flow in which Native Americans are "discovered" and "civilized" by Europeans.

Indigenous interpretations of prophecy enact ideological work by militating against the dominant culture's reading of Native American prophetic texts. These texts have been employed in dominant culture narratives against indigenous people in order to argue for recognition of their inferiority within the confines of their own discursive traditions. For example, Europeans are often interpreted to be gods or Christ-like in the prophetic narratives, thereby viewed to be light-bearers to pagans living in idolatry.[60] In this view, indigenous peoples, fatalistically aware of what the future might hold, are passive victims, awaiting slaughter without protest.

Another danger of interpreting translated and transcribed narratives of prophecy is that these documents always already exist in a world where Native American spirituality and Christianity have met on the discursive battleground, and it is challenging to parse the two out. For example, the *Popul Vuh*, a codex that contains the Quiché Maya origin story and prophecies, was most likely destroyed by the Spanish in their book-burning frenzy at Utatlán in the sixteenth century. An indigenous survivor of the Spanish invasion transcribed the text from memory in order that the knowledge contained in it would be remembered, yet he acknowledges that he is also writing within a new cultural context where Christianity has been imposed.

The transcribed text elides the role of female divinities in the creation of the world and has parallels with the biblical book of Genesis. But at the same time, it narrates an origin story that departs from Christianity with its stress on creation as a collaborative act.

While text-based interpretations of prophecy do provide the means of strategically constructing or reconstructing temporal circumstances, the realm of prophecy incorporates more than text-based traditions, which are necessarily filtered through particular individuals. Prophecy broadly conceived constitutes a belief system and/or a way of understanding and interpreting history and events where the past, present, and future converge. The best-known indigenous prophecies are those that have been filtered through prominent male historical figures such as Moctezuma, Handsome Lake, Plenty Coups, John Slocum, Wovoka, Smohalla, Tenskwatawa, and Tecumseh.[61] But the types of prophecy that are more compelling for the purposes of this project, because they are unmoored from the personalities of individual historical figures, are those that have multiple interpretations and divergent origins. In his single-nation study of prophecy, Tom Mould locates prophetic discourse in individual memory— "a third kind of time"— rather than books and oral narrative. Mould argues, "As a philosophical contemplation, [prophecy] is the verbal genre devoted to the discussion of change, its focus as much on the past and present as the future. . . . It is a tradition that fundamentally challenges the way historians, anthropologists, and theologians have constructed our understanding of American Indian prophecy."[62] The prophetic tradition in both *It Starts with a Whisper* and *Imprint* follows this more fluid tradition that posits prophecy and transformative power as inherent within individuals, rather than without, in sacred texts and spiritual leaders.

Michael G. Doxtater contends, "Indigenous scholarship argues against the homogenizing Euro-master narrative that seeks to colonize Indigenous knowledge."[63] But indigenous scholarship not only argues against Western paradigms, it also supersedes it.

In his comparative study of American origin stories, Andrew Wiget writes that Native American methods of conceiving time and experience create alternative narratives of power vis-à-vis colonialism, the lens through which Native American history is most often contemplated. He employs the Zuni as his case study:

> Their genres of oral narrative and their collective memory distinguish important moments in the past, such as the coming of Coronado and the first Europeans in the sixteenth century; the Pueblo Revolt in the seventeenth; bad

relations with the Spanish, Navajos, and American soldiers in the eighteenth and nineteenth; and the building of Blackrock Dam at the beginning of the twentieth. But all of these past moments, however important from a Euro-American perspective, did not fundamentally shape or alter the Zunis' view of themselves and of the world, which was brought to completion when they found the center of the world in ages past. Ordained by the Sun Father, their emergence and migration were foundational. That was history; everything else is commentary.[64]

The liberatory politics of prophecy displayed here as indigenous ways of conceiving language, origin, and history are positioned as foundational, rather than marginal. This strategy not only interprets the Zuni as having agency, but decenters Eurocentric historiography, a useful strategy employed by indigenous filmmakers as well.

By visually representing indigenous knowledge production through cultural epistemes such as prophecy, filmmakers like Niro and Eyre demonstrate that film itself, as a virtual reservation, is an expressive site that evokes and enacts indigenous knowledges, much as territorial reservations do. The filmic virtual reservation both critiques conventional representations of Native Americans and demonstrates how the privileging of indigenous ways of understanding, seeing, and representing the world operate outside Western paradigms, thereby diminishing the hegemonic influence of colonialism on Native communities. This view of indigenous film presents a world in and of itself, neither a representative window on the "real" world, nor the Lacanian mirror reflecting back an image that spectators either identify with or become autonomous through.

Thus I have demonstrated that the work of contemporary indigenous media makers does more than resist colonization. Both Niro and Eyre narrativize not only indigenous struggles against the dominant culture, but how Native American ways of understanding the world continue to give meaning to communities, even in the face of seemingly overwhelming odds. Niro, for example, privileges Haudenosaunee epistemes of complementary gender systems (the dual spirit voices, the balanced guidance of the Matriarchal Aunts and Harper), and strategically deploys humor and prophecy in order to demonstrate how Native American communities have remained intact for more than five hundred years. The film as virtual reservation thereby stages a space where aboriginal knowledges are unhitched from colonial discourses, intervening in what Linda Tuhiwai Smith calls "decolonizing methodologies" through staging Haudenosaunee ways of interpreting the world as primary.[65] Niro and Eyre suggest ways of decolonizing knowledge

and methods of interpretation through putting seemingly discordant discourses in conversation with each other, not by promising access to hidden, "authentic," and mystical epistemologies. Both create works in collaboration with non-Native filmmakers, contemplate the relationship between historical archive and oral community wellspring, and reinvigorate ancient knowledges regarding prophecy with a fresh, contemporary idiom.

NOTES

1. Renée L. Bergland, *The National Uncanny: Indian Ghosts and American Subjects* (Hanover, NH: University Press of New England, 2000), 1.
2. Ali Behdad, *A Forgetful Nation: On Immigration and Cultural Identity in the United States* (Durham, NC: Duke University Press, 2005), x and xiii.
3. Bliss Cua Lim, "Spectral Times: The Ghost Film As Historical Allegory," *positions* 9, no. 2 (2001): 287–329, 287.
4. This desire to overturn the image of the ghostly Indian on the part of Native Americans is not unique to filmmakers. Nineteenth-century Pequot Methodist minister, activist, and writer William Apess employed the image of the spectral Indian ironically in his autobiography, *A Son of the Forest* (1829). As a child indentured to a white family as a result of poverty and child abuse, Apess narrates a tale of his fears of dark-skinned Indians who haunted the forests surrounding the clearing where he lived. Apess employs this memory to critique the dominant culture not only for instilling a psychological fear of self in Apess, but for not understanding that Euro-Americans are, in Apess's mind, the lurking monsters of whom Native Americans should be afraid, given historical evidence. Several years later, Apess wrote a political document, *Indian Nullification* (1835), that reads an indigenous graveyard not as the final resting place of a culture, but as a repository of connection between past and present. In *Eulogy on King Philip* (1836), Apess completes the process of turning the ghostly Indian on its head by arguing that "King Philip" (the Wampanoag sachem Metacomet) becomes "immortal" (144) through a prophetic narrative that reinvigorates Native American culture in New England, whereas the Puritans become the villainous, vanished specters of a long-forgotten past. For the collected work of Apess, see Barry O'Connell, ed., *On Our Own Ground: The Complete Writings of William Apess, a Pequot* (Amherst: University of Massachusetts Press, 1992).
5. Lim, "Spectral Times: The Ghost Film As Historical Allegory," 288.
6. Lorna Roth, "The Crossing of Borders and the Building of Bridges: Steps in

the Construction of the Aboriginal Peoples Television Network in Canada," *International Journal of Communication Studies* 62, nos. 3-4 (2000): 251–69.

7. Gerald McMaster, "Living on Reservation X," in *Reservation X*, ed. Gerald McMaster (Seattle: University of Washington Press, 1999), 19.

8. See Carlos B. Embry, *America's Concentration Camps* (New York: D. McKay Co, 1956). For more on the creation and history of reservations, see Vine Deloria and David E. Wilkins, *Tribes, Treaties, and Constitutional Tribulations* (Austin: University of Texas Press, 2000); Donald L. Fixico, *The Invasion of Indian Country in the Twentieth Century: American Capitalism and Tribal Natural Resources* (Boulder: University Press of Colorado, 1998); Klaus Frantz, *Indian Reservations in the United States: Territory, Sovereignty, and Economic Change* (Chicago: University of Chicago Press, 1999); and Richard Parchemin, ed., *The Life and History of North America's Indian Reservations* (North Dighton, MA: JG Press, 1998).

9. Giorgio Agamben, *Homo Sacer: Sovereign Power and Bare Life*, trans. Daniel Heller-Roazen (Stanford, CA: Stanford University Press, 1998), 159. Trans. of *Homo Sacer: Il potere e la nuda vita* (Torino: Giulio Einaudi, 1995).

10. Avery Gordon, *Ghostly Matters: Haunting and the Sociological Imagination* (Minneapolis: University of Minnesota Press, 1996) 8, 18.

11. Susan Scheckel, *The Insistence of the Indian: Race and Nationalism in Nineteenth-Century American Culture* (Princeton, NJ: Princeton University Press, 1998), 3.

12. Marie-Laure Ryan, *Narrative as Virtual Reality: Immersion and Interactivity in Literature and Electronic Media* (Baltimore: Johns Hopkins University Press, 2001), 13.

13. Jace Weaver, in *That the People Might Live: Native American Literatures and Native American Community* (New York: Oxford University Press, 1997), coined the term "communitarian" to refer to the commitment of Native American writers to their respective communities. I propose here that there is a shared "communitarian" impulse on the virtual reservation to interact with, share, and forge connections within one's own tribal boundaries as well as through transnational indigenous movements.

14. Jennifer A. González, *Subject to Display: Reframing Race in Contemporary Installation Art* (Cambridge: Massachusetts Institute of Technology Press, 2008), 36.

15. Mary Louise Pratt defines autoethnographic texts as "instances in which colonized subjects undertake to represent themselves in ways that engage with the colonizer's own terms," in *Imperial Eyes: Travel Writing and Transculturation* (New York: Routledge, 1992), 7. In her film, Bowman attempts to document the life of her grandmother, who is clearly an unwilling participant. The film forces the spectator to occupy the position of the prying, persistent, and

insensitive ethnographer, capturing images of a resistant subject. While this is a productive space through which to rethink the politics of documentary film, the project is controversial and discomfiting because the urban, educated, seemingly progressive filmmaker becomes pathologized in the process.

16. Faye Ginsburg, "Indigenous Media: Faustian Contract or Global Village?" *Cultural Anthropology* 6, no. 1 (February 1991): 92–112, 95.

17. Beverly Singer, *Wiping the War Paint off the Lens: Native American Film and Video* (Minneapolis: University of Minnesota Press, 2001), 34.

18. Masayesva's films include *Hopi Traditions* (1980), *Hopiit* (1982), and *Ritual Clowns* (1988). He has also published *Hopi Photographers, Hopi Images* (Tucson: University of Arizona Press, 1983), and *Husk of Time: The Photographs of Victor Masayesva* (Tucson: University of Arizona Press, 2006).

19. Singer, *Wiping the War Paint off the Lens*, 62.

20. For more on Masayesva's work, see Kathleen M. Sands and Allison Sekaquaptewa Lewis, "Seeing with a Native Eye: A Hopi Film on Hopi," *American Indian Quarterly* 14, no. 4 (Autumn 1990): 387–96.

21. Other Native American filmmakers who have produced experimental work include Jeff Barnaby (Mi'gMaq), Melanie Printup Hope (Tuscarora), Zachary Longboy (Sayasi Dene), Randy Redroad (Cherokee), and Deron Twohatchet (Kiowa/Comanche).

22. Dale Turner, *This Is Not a Peace Pipe: Towards a Critical Indigenous Philosophy* (Toronto: University of Toronto Press, 2006), 110. Emphasis in original.

23. See Johannes Fabian, *Time and the Other: How Anthropology Makes Its Object* (New York: Columbia University Press, 2002).

24. Turner, *This Is Not a Peace Pipe*, 110.

25. Ibid. For more on Crazy Horse, see Mari Sandoz, *Crazy Horse: Strange Man of the Oglalas* (1961; Lincoln: University of Nebraska Press, 2004).

26. Eyre produced *Imprint* while Michael Linn is credited as the director, screenplay writer (along with Keith Davenport, another member of Linn Productions), and executive producer of the film. Other Linn family members, Carolyn Linn, Marc Linn, and Eric Linn, served as production crew on the film. Linn Productions other media include a full-length feature film with a Christian theme, *Into His Arms* (1999), public service videos, television advertisements, and websites. At the West Coast premier of the film in the Zanuck Theater at Fox Studios in Los Angeles, Michael Linn suggested that the film's budget was $50,000, significantly less than most independently produced films.

27. This type of collaboration has historical antecedents in films such as *In the Land of the War Canoes* (1914), *Nanook of the North* (1922), *Dances with Wolves* (1990), and *Black Robe* (1991). *Imprint*'s difference, however, is that

Linn Productions is much more transparent about crediting Native American consultants and collaborators, and the film's success hinges on the reputation of the Native American producer Chris Eyre, who is much better-known than the Linn family.

28. Pine Ridge features prominently in Dee Brown's germinal book *Bury My Heart at Wounded Knee* (New York: Holt, Rinehart & Winston, 1970); Johnny Cash's song "Big Foot" (1972); Redbone's single "We Were All Wounded at Wounded Knee" (1973); Buffy Sainte-Marie's song "Bury My Heart at Wounded Knee" (1996); Michael Apted's *Thunderheart* (1992); Apted's documentary *Incident at Oglala* (1992); the made-for-television biopic *Lakota Woman: Siege at Wounded Knee* (1994); Steven Spielberg's miniseries *Into the West* (2005); and HBO's *Bury My Heart at Wounded Knee* (2007). See also Akim D. Reinhardt's *Ruling Pine Ridge: Oglala Lakota Politics from the IRA to Wounded Knee* (Lubbock: Texas Tech University Press, 2007); and Richard E. Jensen, Eli Paul, and John E. Carter, eds., *Eyewitness at Wounded Knee* (Lincoln: University of Nebraska Press, 1991).

29. Carole Quattro Levine contends that "*Imprint*'s biggest imprint is its portrayal of women; neither victims nor backdrops, they are the force and the soul of the entire story." See "*Imprint* Redefines Native Women in Film," at www.nativevue.org (accessed May 31, 2007).

30. Cited in William Goss, "SXSW '07 Interview: *Imprint* Director Michael Linn," at http://efilmcritic.com/feature.php?feature=2090 (accessed May 31, 2007), and Joe Leydon, "Imprint," *Variety*, April 9, 2007.

31. Sam Stonefeather is played by Charlie White Buffalo, a Lakota actor and language consultant. Sam's disease is left ambiguous in the film to make his catatonic state with intermittent outbursts seem all the more terrifying. The film's website, however, indicates that he has suffered a stroke; see www .imprintmovie.com (accessed May 31, 2007).

32. Lim, *Spectral Times*, 288.

33. *It Starts with a Whisper*, Dir. Shelley Niro and Anna Gronau, Women Make Movies (Canada, 1993). The Haudenosaunee Confederacy (also known as the Iroquois or Six Nations) is comprised of the Seneca, Cayuga, Onondaga, Oneida, Mohawk, and Tuscarora Nations. See Bruce Elliott Johansen and Barbara Alice Mann, *Encyclopedia of the Haudenosaunee (Iroquois Confederacy)* (Westport, CT: Greenwood Press, 2000). The Six Nations Reserve was created in 1784 to shelter the Haudenosaunee survivors of attacks on their villages by George Washington, James Clinton, John Sullivan, and Daniel Brodhead during the so-called American Revolutionary War. The original land grant, known as the Haldimand Grant, was created for the Haudenosaunee followers of Mohawk leader Joseph Brant and is an L-shaped tract of

land that stretches from Mohawk Point on Lake Erie north to the Grand River's head past Dundalk, and six miles west and east on either side of the river. As of 1847, however, the current reserve occupied only 20,000 hectares of land southeast of Brantford. See the Six Nations Reserve's homepage at www.sixnations.ca for more information.

34. Larry Abbott, *A Time of Visions: Interviews with Larry Abbott*, at www.brite sites.com/native_artist_interviews/ (accessed May 25, 2007). This online book is a supplement to Abbott's *I Stand in the Center of the Good* (Lincoln: University of Nebraska Press, 1994).

35. For more on Haudenosaunee conceptions of gender, see Deborah Doxtator, *Godi'Nigoha': The Women's Mind* (Brantford, Ontario: Woodland Cultural Centre, 1997), a collection of essays that grew out of a symposium and exhibit by the same name; Barbara Mann, Iroquoian Woman: The Gantowisas (New York: Peter Lang, 2000); William Guy Spittal, ed., *Iroquois Women: An Anthology* (Ohsweken, Ontario: Iroquois Publishing and Craft Supplies, Ltd., 1990); Sally Roesch Wagner, *Sisters in Spirit: Haudenosaunee (Iroquois) Influence on Early American Feminists* (Summertown, TN: Native Voices, 2001); and Jan Noel, "Power Mothering: The Haudenosaunee Model," in *"Until Our Hearts Are on the Ground": Aboriginal Mothering, Oppression, Resistance, and Rebirth*, ed. D. Memee Lavell-Harvard and Jeannette Corbiere Lavell (Toronto: Demeter Press, 2006), 76–93.

36. Michel Serres with Bruno Latour, *Conversations on Science, Culture, and Time* (Ann Arbor: University of Michigan Press, 1995), 60.

37. Deborah Doxtator, "Godi'Nigoha': The Women's Mind and Seeing through to the Land," in *Godi'Nigoha': The Women's Mind*, ed. Deborah Doxtator (Brantford, Ontario: Woodland Cultural Centre, 1997), 29–41, 29.

38. Ibid., 30.

39. Vivien Sobchak, "The Scene of the Screen: Envisioning Photographic, Cinematic, and Electronic 'Presence,'" in *Carnal Thoughts: Embodiment and Moving Image Culture* (Berkeley: University of California Press, 2004), 146. First published in *Materialities of Communication*, ed. Hans Ulrich Gumbrecht and K. Ludwig Pfeiffer (Stanford, CA: Stanford University Press, 1994), 83–106.

40. The Tutelo are a nation related to the Saponi and Ocaneechi whose original homelands are in present-day Virginia and North Carolina. As a result of displacement by other nations and European invaders, they sought refuge among the Haudenosaunee in the 1740s. They established a village with the Cayuga that was destroyed in 1779 during what is known as the Sullivan/Clinton campaign, a violent sweep through Iroquoia ordered by George Washington. After their homes and crops were burned, they scattered with the Cayuga to Ohio and Canada, settling in Canada on the Six Nations

Reserve. Although they are considered by some historians to be an "extinct" tribe, descendants live in Virginia, North Carolina, and Canada and continue to revitalize their language and culture. See Jay Hansford C. Vest, "An Odyssey among the Iroquois: A History of Tutelo Relations in New York," *American Indian Quarterly* 29, nos. 1-2 (Winter/Spring 2005): 124–55.

41. The intrusion of the documentary film–style text also signals and critiques the ways Native Americans have been conventionally represented on screen. The text not only offers up historical evidence as inscribed, archived "fact," but also contests the privileging of the textual by juxtaposing the past-tense description of the Tutelos with their extant connection to, and influence on contemporary Haudenosaunee people. This text creates what Bill Nichols has called a "discourse of sobriety" that opens up the filmic image to the possibility that "what we say and decide can affect the course of real events and entail real consequences. These are ways of seeing and speaking that are also ways of doing and acting." See Nichols, *Introduction to Documentary* (Bloomington: Indiana University Press, 2001), 39.

42. Darrell Varga, "Seeing and Being Seen in Media Culture: Shelley Niro's *Honey Moccasin,*" *CineAction* 61 (Spring 2003): 52–58.

43. Molly Brant was an eighteenth-century Mohawk leader and older sister of Joseph Brant who married Sir William Johnson and helped broker peace between the British and the Iroquois Confederacy. See Maurice Kenny, *Tekonwatoni/Molly Brant (1735–1795: Poems of War)* (Buffalo, NY: White Pine Press, 1992); James Taylor Carson, "From Clan Mother to Loyalist Chief," in *Sifters: Native American Women's Lives*, ed. Theda Perdue (New York: Oxford University Press, 2001), 48–59; and Thomas Earle, *The Three Faces of Molly Brant: A Biography* (Dallas: Quarry Press, 1997). E. Pauline Johnson was an internationally recognized poet, fiction writer, and stage performer born on the Six Nations Reserve in the nineteenth century. See Veronica Strong-Boag and Carole Gerson, *Paddling Her Own Canoe: The Times and Texts of E. Pauline Johnson (Tekahionwake)* (Toronto: University of Toronto Press, 2000); and Charlotte Gray, *Flint and Feather: The Life and Times of E. Pauline Johnson, Tekahionwake* (Toronto: Harper Flamingo Canada, 2002). Emily General was a twentieth-century teacher and mentor born on the Six Nations Reserve who was fired for refusing to sign the pledge to the Queen in the 1960s. She organized theater productions on the reservation and was considered a traditional spokesperson. For more on Emily General, see Jeffrey M. Thomas, "Six Articulations on Being Iroquois," in *Lifeworlds—Artscapes: Contemporary Iroquois Art*, ed. Sylvia S. Kasprycki and Doris I. Stambrau (Frankfurt-am-Main, Germany: Museum der Weltkulturen, 2003): 45–54.

44. Gilles Deleuze, *Cinema 2: The Time-Image*, trans. Hugh Tomlinson and Robert Galeta (Minneapolis: University of Minnesota Press, 1989), 41, 272.
45. Elijah Harper came to national prominence when he refused to sign the Meech Lake Accords in 1990 because the Canadian government had not solicited aboriginal participation in drafting the agreement. His distinguished career began in 1978 when he served as band chief of the Red Sucker Lake Reserve in northern Manitoba. He has also served as a member of Parliament, was appointed minister of Northern Affairs, encouraged Canadians to work together toward spiritual and cultural healing through national meetings termed "Sacred Assemblies," and was appointed commissioner of the Indian Claims Commission.
46. Robert Stam, "Beyond Third Cinema: The Aesthetics of Hybridity," in *Rethinking Third Cinema*, ed. Anthony R. Guneratne and Wimal Dissanayake (New York: Routledge, 2003): 31–48, 34, 37.
47. Rob Shields, *Places on the Margin: Alternative Geographies of Modernity* (New York: Routledge, 1991), 118.
48. Jonathan Lear, *Radical Hope: Ethics in the Face of Cultural Devastation* (Cambridge, MA: Harvard University Press, 2006).
49. This project was co-created by indigenous artists Shelley Niro, Lori Blondeau, Ryan Rice; curator and scholar Nancy Marie Mithlo; and anthropologist Elisabetta Frasca.
50. Nancy Marie Mithlo, at http://www.nancymariemithlo.com/biennale2007.htm (accessed July 2, 2007).
51. According to one of Shenandoah's visions, the end of the world would be marked by maple trees "dying from the top down." Steve Wall, *To Become a Human Being: The Message of Tadodaho Chief Leon Shenandoah* (Charlottesville, VA: Hampton Roads Publishing Company, 2001), 72.
52. For more on Native American science, see Lori Lambert, "From 'Savages' to Scientists: Mainstream Science Moves toward Recognizing Traditional Knowledge," *Tribal College Journal* 15, no. 1 (Fall 2003): 10–13; and Glen S. Aikenhead, "Towards a First Nations Cross-Cultural Science and Technology Curriculum," *Science Education* 81, no. 2 (1997): 217–38. For more on European notions of time and space, see Stephen Kern, *The Culture of Time and Space, 1880–1918* (Cambridge, MA: Harvard University Press, 1983); Edward S. Casey, *The Fate of Place: A Philosophical History* (Berkeley: University of California Press, 1997); and Johannes Fabian, *Time and the Other: How Anthropology Makes Its Object.*
53. From a talk presented at the University of California, Riverside, February 26, 2007, "Traditional American Indian Medicine: How Culture Can Heal."
54. Jacqueline Shea Murphy's *The People Have Never Stopped Dancing: Native*

American Modern Dance Histories (Minneapolis: University of Minnesota Press, 2007) examines the ways in which twentieth-century Native American dancers access and articulate embodied memory through work performed on stage for multiple audiences.

55. Yvonne Reineke, "Overturning the (New World) Order: Of Space, Time, Writing, and Prophecy in Leslie Marmon Silko's *Almanac of the Dead,*" *Studies in American Indian Literatures* 10, no. 3 (Fall 1998): 65–84, 66, 70, 71.

56. Both Anne McClintock's *Imperial Leather: Race, Gender, and Sexuality in the Colonial* (New York: Routledge, 1995), and Annette Kolodny's *The Lay of the Land: Metaphor as Experience and History in American Life and Letters* (Chapel Hill: University of North Carolina Press, 1984) detail the ways in which the "New World" was figured as female and sexually available for colonial conquest, often drawing on nuanced readings of visual culture to demonstrate how European colonial writers deployed the triangulation of race, gender, and geography in order to mark indigenous peoples as inferior.

57. Leslie Marmon Silko, *Almanac of the Dead* (New York: Penguin, 1991), 14. I find this very truncated description of prophecy to be problematic because it relies on markers of European "progress"—urban spaces and transportation networks—in order to render the Maya, Aztec, and Inca commensurable with their colonizers. Not only does this replicate the historical elision of other tribal groups in the area, it assumes the inferiority of indigenous nations whose social, political, and intellectual traditions do not so easily match up with those considered technologically advanced by European standards, but who nonetheless have profoundly complex epistemological systems.

58. See Tom Mould, *Choctaw Prophecy: A Legacy of the Future* (Tuscaloosa: University of Alabama Press, 2003); Stephanie Wood, *Transcending Conquest: Nahua Views of Spanish Colonial Mexico* (Norman: University of Oklahoma Press, 2003); Lee Irwin, *Coming Down from Above: Prophecy, Resistance, and Renewal in Native American Religions* (Norman: University of Oklahoma Press, 2008); and Peter Nabokov, ed., *Native American Testimony: A Chronicle of Indian-White Relations from Prophecy to the Present* (New York: Penguin, 1992).

59. Leslie Marmon Silko, *Storyteller* (New York: Arcade Publishing, 1981), 130, 132–37, emphasis in original.

60. See Tzvetan Todorov's description of Hernán Cortés by Moctezuma in *The Conquest of America* (New York: Harper Perennial, 1984).

61. See Alfred A. Cave's *Prophets of the Great Spirit: Native American Revitalization Movements in Eastern North America* (Lincoln: University of Nebraska Press, 2006); Scott Peterson, *Native American Prophecies* (Minneapolis: Paragon House, 1999); and Clifford Trafzer, ed., *American Indian Prophets:*

Religious Leaders and Revitalization Movements (Sacramento, CA: Sierra Oaks Publishing Company, 1986).

62. Mould, *Choctaw Prophecy*, xxxi, 2.

63. Michael Doxtater, "Indigenous Knowledge in the Decolonial Era," *American Indian Quarterly* 28, nos. 3-4 (2004): 618–33, 620.

64. Andrew Wiget, "Reading against the Grain: Origin Stories and American Literary History," *American Literary History* 3, no. 2 (Summer 1991): 209–31, 226.

65. Linda Tuhawai Smith, *Decolonizing Methodologies: Research and Indigenous Peoples* (London: Zed, 1999).

Indians Watching Indians on TV: Native Spectatorship and the Politics of Recognition in *Skins* and *Smoke Signals*

JOANNA HEARNE

IN PREPARING FOR HIS ROLE AS THOMAS BUILDS-THE-FIRE IN THE 1998 film *Smoke Signals*, actor Evan Adams (Coast Salish) improvised what would become one of the film's signature lines: "You know, the only thing more pathetic than Indians on TV, is Indians watching Indians on TV!" This joke—uttered while the camera tilts and pans away from the small television playing a black-and-white Western film to follow Builds-the-Fire—was recirculated ubiquitously in reviews as a sign of the film's break from Hollywood's representations of nineteenth-century stoic Indian warriors. Promoted as the first film written, directed, and acted by Native filmmakers, *Smoke Signals* was immediately recognized critically as signifying a paradigmatic shift in Native American film history.[1] This marketing locates the film's primary innovation in its relations of production without fully addressing the implications of an indigenous audience for the film. Yet the richly suggestive line "Indians watching Indians on TV," referring to the Indian characters in the Western and to the characters in *Smoke Signals*, also privately addresses *Smoke Signals*'s indigenous audiences by reflexively positioning itself in their spectatorial field. And by simultaneously inviting *all* viewers to think about indigenous spectatorship, director Chris Eyre (Cheyenne/Arapaho), writer Sherman Alexie (Spokane/Coeur d'Alene), and Evan Adams draw our attention to the problematic relationship between the imagined mass audience targeted by television rebroadcasting and Native viewers' apprehension of mediated images of Indians in the context of home

41

viewing. By characterizing its indigenous audiences in this way, *Smoke Signals* distances itself from the Western—a genre dedicated to representing the erasure of Native nations—and from the idea of a homogeneous mass audience. At the same time, the line embeds *Smoke Signals* in ongoing relation to the larger history of Western-genre and documentary images.

Films in which popular media images of Indians recirculate within Native public and private spaces ask viewers to understand media history in terms of indigenous interpretive frames. Textually embedded, on-screen performances of Native spectatorship involve "retelling the image," or visually reframing aging media through narrative. Visualizing this shift in perception highlights media production and consumption as acts of communication that are socially situated and inevitably engaged politically with relations of power. Staging Native spectatorship and reception on screen, then, distances viewers from Western and documentary fantasies of vanishing and antimodern Indians, aligning audiences instead with indigenous perspectives through these embodied viewers. This chapter considers instances of this dramatization of spectatorship in Chris Eyre's second feature film, the 2002 drama *Skins*, as well as examples from *Smoke Signals* and other contemporary Native feature films, in order to explore the pedagogical, genealogical, and possessory aspects of reclaiming and repurposing archival film footage.

In focusing on films spanning the turn of the twenty-first century, I am interested in filmmakers' processes of retrieval in the historical context of a century of Western-genre media saturation. Traversing a media space structured by damaging representations has involved reappropriating, mocking, and taking political leverage from Hollywood representations through specific strategies: recognizing and "re-crediting" Native actors in Hollywood productions; embedding references to film production and reception processes in film texts while integrating oral storytelling and testimony as compatible modes of transmission and instruction; reworking genre conventions, including Western-genre icons and formulae of familial trauma and masculine vigilantism; and retrieving history by reinterpreting sites of media representation that memorialize the loss or separation of relatives. Since the independent feature films that first departed from Hollywood production of Indian images—Kent Mackenzie's *The Exiles* in 1961, Richardson Morse's *House Made of Dawn* in 1972, and Leslie Marmon Silko's (Laguna) *Arrowboy and the Witches (Stolen Rain)* in 1980, among others—independent filmmaking practices have continued to present opportunities to speak about the impact of media production and reception on indigenous families, and to dramatize and sometimes actively mediate disrupted relations between family members and generations. Images of Native spectatorship—embedded scenes of critical

viewing—model ways of looking that are also forms of indigenous reclaiming. In reflexive scenes of viewing, Native films and coproductions negotiate and comment upon the intrusion of media images of Indians, especially news broadcasts and Westerns, into the homes, families, and childhood experiences of the indigenous focal characters. They employ a "streaming archive" of television rebroadcasting—a virtual repository of shared and continuously circulating representations—to render the past as a collection of mediated memories.[2]

Chris Eyre's feature films mark a breakthrough for Native American filmmaking both in terms of control over an independent production and in their address of (and access to) a broad Native and non-Native viewership. *Skins* extends *Smoke Signals*'s self-conscious claim to indigenous ownership of cinematic practices and the site of film production as a Native place. Eyre allegorizes indigenous audiences in both films, demonstrating the potential for indigenous viewers to claim and resignify Western-genre and documentary images of anonymous and stereotyped Indian characters through politicized spectatorship. *Skins*'s models of viewing unravel the realism and assumed supremacy of older Hollywood representations by revealing them to be constructions. Though far less studied than *Smoke Signals*, *Skins* also engages the Western as a fluid and available sign system, while developing a different, more reparative way of viewing the function of images of Indians on TV.

Through both formal and thematic aspects of his feature filmmaking—including sound, editing, mise-en-scène, iconic Western-genre and nationalist images, and the emotional and realist modes of melodrama and documentary—Eyre's films speak back to the tropes of victimization and narratives of Indian spectrality by envisioning Native consumption of commodity entertainment. The "*pathos*" in the line "the only thing more pathetic than Indians on TV is Indians watching Indians on TV" refers to the Western's period-based exclusion of Indian characters from the apparatus of modernity, and to the irony of indigenous consumption of the very genres that consistently exclude them. That modernity, signaled visually by on-screen technologies of media transmission and consumption, countermands the narratives of primitivism and "vanishing" Indians embedded in the Western's images of savage warriors, and at the same time articulates a coherent integration of assimilation and traditionalism in the narrative.

I am less concerned here with television studies or reception studies per se, or in parsing the differences or similarities between television and film, than in the fluidity of interchange between media as an implicit backstory in representations of reception.[3] Westerns originally shot on film and screened in theaters are later rebroadcast on small television screens situated

in Native domestic spaces. This more intimate and relational setting facilitates the image of television reception as an imagined space of encounter and exchange in Eyre's films, which are themselves shown on both theatrical and, later, television screens playing DVDs. These small-screen versions of big-screen Westerns emphasize the context of viewing; Westerns that erase Indian families are screened in Native family homes that exemplify the very intergenerational future that the genre refused to envision for indigenous nations. Further, in this politicized aesthetic of reception, the location of the "screen" itself becomes malleable, as at the end of *Skins* when the outsized presidential portraits at Mount Rushmore are made to echo televised images and to exaggerate the cinematic technique of the close-up in a literal "interface" of viewer and screen. The film's play with recognition and disguise and with the scale and location of the face-to-screen encounter emphasizes the role of media screens in the identification and misidentification of indigenous identity. My understanding of the scene of reception as a relationship with composite media and with the semiotics of commodity culture not only involves the specificity of TV reception in domestic settings but also extends beyond TV reception to include other forms of technologically mediated dialectic in public space. This proliferation of screens, almost a form of *mise-en-abyme*, functions as a sign of indigenous modernity that further disrupts linear narratives of assimilation, situating Native viewers as contemporary consumers of mass culture.

Visual anthropologist Faye Ginsburg describes indigenous uses of media to access and recover historical events as "screen memories," inverting Freud's paradigm in which adults "screen out," repress, or make invisible the traumas from the past.[4] *Skins*'s attention to images of Indians in the movies targets Westerns as sites of systematic misrecognition that invasively dislocate and disarticulate both familial and political relationships. The film's Western-genre trajectories of masculine action based on the helpless witnessing of trauma followed by vigilantism prove to be self-destructive models of social action for the film's Indian communities.[5] Eyre retrieves, amplifies, and ultimately overturns representations of familial separation, dysfunction, and absence embedded in dominant filmmaking practices and in emblematic Western-genre constructions: the figure of John Wayne and the weeping face of Iron Eyes Cody. In their encounter with (and redeployment of) these commodity images of Indians originally produced for non-Native consumers, characters in Eyre's films redirect the meaning-making process of spectatorship to do the work of historical pedagogy as well as familial and community remembrance. In *Skins*, contemporary filmic scenes of viewing model and stage an intergenerational recognition across the screen, transforming that historical barrier

into a facilitation of familial continuity, even as they interrupt that continuity with images and situations of loss and mourning.

RECOGNITION AND NATIVE SPECTATORSHIP

In the past, film footage and photographs taken by outsiders have signified cultural appropriation in service of salvage ethnography and Western frontier dramas, indexing the unequal relations of power during production, circulation, and reception. In documentary films such as Jeff Spitz and Bennie Klain's (Diné) *The Return of Navajo Boy* (2001), scenes of indigenous viewing de-exoticize Indians on screen through politicized recognition in the context of the history of tourist and ethnographic photography, museum screenings, and the repatriation of footage as a singular event. In film dramas set in contemporary contexts, however, a more mundane, subtle, and continuous recirculation of footage takes place. Fictional characters register the damage (or *pathos*) of generic images of Indians, or in a more optimistic move, resignify and recredit these images using a variety of popular-culture forms.

Examples of the former can be found in scenes from *Smoke Signals* and *The Exiles*, which reveal the way media images exacerbate social oppression and conditions of poverty. An early scene in *Smoke Signals* depicts the impact of pop-culture Indians on young Native viewers in a wrenching scene that is tonally very different from Thomas Builds-the-Fire's later flippant comment about Indians on TV. In one of the film's flashback sequences, the young Victor Joseph (Cody Lightning, Cree) watches a television Western while his mother and father fight over money and alcohol. After striking Victor's mother Arlene (Tantoo Cardinal, Métis), Victor's father Arnold Joseph (Gary Farmer, Cayuga) decides in anger to leave the family and the reservation; Victor will never see him again. Victor's parents, as they fight, share the frame with the television set, so that the young Victor witnesses both the mass-mediated images of the Western and the dissolution of his family at the same time. The film frame links these two scenes of conflict as a single traumatic spectacle, infusing the genocidal violence of the Western with the intimate psychic wounds of domestic violence and vice versa. In a strikingly similar scene from *The Exiles*, a film about members of a Native community in the Bunker Hill neighborhood of Los Angeles, Julia Escalanti (Delos Yellow Eagle) and her children and friends watch a Western on television as her husband Rico (Rico Rodriguez) drops in to get some gambling money to continue a night on the town. The family's bleak circumstances are evident

in the cramped apartment, illuminated by the television playing in the bed-room—which doubles as the family's living room—while the couple argue and Rico takes money from Julia's purse.

Television as a form of social disruption takes a different form in James Luna's (Luiseño) performance in *The History of the Luiseño People: La Jolla Reservation, Christmas 1990* (Luna and Artenstein, 1993), an experimental film documenting Luna's performance-art piece of the same title. In the performance, Luna drinks beers, chain smokes, and watches Bing Crosby's 1954 movie *White Christmas* while he calls members of his extended fam-ily—his brother, mother, nephew, son, and ex-girlfriend—on Christmas Eve. The racialized products of contemporary communicative technologies (*White Christmas*) mediate his isolation in the domestic space of his living room while he lies to his mother ("No, I'm not drinking") and exchanges formulaic holiday platitudes with his children ("Santa got your Christmas list") on the telephone. His consumption of beer, cigarettes, and television equate and indict these consumables as numbing agents that make social detachment a commonplace banality. Kathleen McHugh notes that Luna's film "uses the light from this composite of industry media (we are seeing a film on television that is recorded on video) as one of its primary illumi-nations," for it suggests allegorically that "the primary illumination in the history of the Luiseño people, in the history of Native peoples in the Ameri-cas in general, has been 'the light' of commercial entertainment media and genres, particularly the 'western,' as a central part of domestic décor."[6] The scene of spectatorship in *The History of the Luiseño People* attaches indig-enous domestic life to mass media while signaling its divisive interruption of that same domestic life. Commercial media here is a colonizing, corrosive replacement for human interaction, and the whiteness of its representations have become part of indigenous collective memory. Jane Blocker writes that Luna's "infinite regress of quotation complicates native memory to show that it does not spring solely from pure origins in venerable ancestors, but that it is constructed in part out of its own representations in popular culture, out of what it inherits and redresses from whiteness."[7]

How can we account for the simultaneous oppositionality and accom-modation of these images, their ability to draw affective and political power from the same generic conventions they critique? The theorization of recep-tion in cultural studies credits viewers with a complex range of spectatorial strategies including resistant spectatorship, amplifying local rather than universalized models of encounter with mass media. In Althusserian terms, the interpellative or "hailing" function of cinematic texts as ideological state apparatuses would impose a misrecognition upon indigenous viewers,

but as Hamid Naficy writes, "In addition to 'hailing,' there is much 'haggling' in cinematic spectatorship," for "oral culture's interaction with the screen is neither passive nor unidirectional." The "various forms of spectator counter-hailing of the screen" can include both refusing or disengaging from Western forms and consuming or fetishizing them, thereby "resisting the West through its objectification."[8] The latter strategy is politically oppositional but textually articulated to dominant representations.

Confrontations with popular images of Indians have been described by Native critics as formative experiences.[9] Acoma writer Simon Ortiz remembers his own awkward and uncomfortable feelings of "unreality as an Indian" that came from being forced to identify with popular images of Indians that were "from a different, unfamiliar, unknown Indian culture and place."[10] Tom Grayson Colonnese (Santee Sioux) asserts that

> asking Indians to watch a John Wayne western is like asking someone if they would like to go back and visit the schoolyard where they used to get beat up every day. No—that's too unserious a comparison, though the connection to our childhoods and bad childhood memories is important. . . . for Indians, watching westerns would be like Jews watching films about the Holocaust in which the Jews themselves were presented as the violent, aggressive villains! We were the ones who were slaughtered and destroyed, but that's not usually how we've been depicted.[11]

And in an article about the importance of *Smoke Signals* as an intervention in media images of Indians, N. Bird Runningwater (Cheyenne/Mescalero Apache) details a childhood encounter with the Western:

> I remember the first time I had a connection with an Indian on television. I was eight years-old, and my cousin Cathy and I were watching a stereotypical cowboy and Indian western. The Native characters were dressed like nothing we had ever seen in our world. At one point, two warrior-type characters entered the scene, and when asked by the lead Anglo character how many enemies they had spied, they replied "na'kii."
>
> Cathy and I looked at one another in amazement and began jumping for joy. We ran to tell our family that we had just heard an Indian on television speaking our Apache language. We felt like the world had finally had a glimpse of our lives as they really were, and from that point on, everything would be different. We watched more and more Westerns after that, waiting and hoping that maybe we would see ourselves on television or hear our language one more time. We never did.

The stories recounted by these artists and intellectuals target what Ortiz describes as a painful "unreality." Their memories of televised misrepresentation of indigenous languages, cultures, history, place, dress—the distance from "our lives as they really were"—constitute a collective story about the ways that impressionable early viewing experiences helped to catalyze an active critical voice and oppositional stance.

In his influential essay "Encoding, Decoding," Stuart Hall argues that television reception involves strategies of audience decoding, including an "*oppositional* code" in which "it is possible for a viewer perfectly to understand both the literal and the connotative inflection given by a discourse but to decode the message in a *globally* contrary way." While the form of the audiovisual text is fixed, the viewer's consumption of the program represents an equally important "moment of the production process in the larger sense," since the audience's meaning-making interpretive work also "produces" the content of the programming. Hall locates the potential to resignify dominant discourses in these "active transformations" or appropriations of programmatic content into "meaningful discourse" that can then "influence, entertain, instruct or persuade."[12] With Hall's early theories of reception in mind, anthropologist Sam Pack asserts that for Fourth World viewers, television is the arena where identities are negotiated in the context of power relations: "the question of 'who are they?' directly shapes and informs the question 'who are we?'"[13]

Film scholars working in the area of revisionary identification in cinema have explored oppositional viewing practices in great detail in terms of sexual disidentifications and fantasy. José Esteban Muñoz characterizes "disidentification" as neither assimilationist nor separatist, but rather an interpretive dynamic that works to "transform a cultural logic from within," allowing artists to transform a "B-movie archive" into "antinormative treasure troves."[14] Patricia White, in discussing "uninvited" readings of classical Hollywood films by lesbian viewers, describes film reception that is "transformed by unconscious and conscious past viewing experience," a form of "retrospectatorship."[15] I want to explore instantiations of indigenous viewing in Native cinema by retaining these scholars' attention to oppositionality and the reworking of past cinematic images while moving away from the psychoanalytic models that have dominated film-studies paradigms of spectatorship.

The lens of a playful and politicized process of spectatorship-as-resistance illuminates the ways in which spectators make meaning, and the ways that viewer-driven interpretation constitutes a form of ownership that retrospectively reorganizes the original relations of media production. In the context

of indigenous filmmaking, this process often takes the particular form not of cross-racial/cross-gender identification, but rather of attribution or *recrediting* the primary identities of anonymous Native "extras" in cinematic landscapes. Thus, the politicized and familial meanings of recognition converge in acts of "reidentifying" as well as "disidentifying" with the images on screen. The recognition and naming that characterizes many indigenous cinematic representations of spectatorship and identification has special significance as oppositional work that corrects historical acts of renaming or withholding names from Native students in boarding schools, from Native actors in Westerns, and from "anonymous" Native storytellers in books published by non-Native authors.

To describe this way of looking that is also a form of reclamation, I interpret "recognition" and "misrecognition" here as having intersecting familial and political significance. A form of remembering, recognition accesses mediated stories about the past and acknowledges history's persistent value. Recognition is a key aspect of pervasive cinematic modes such as melodrama, which employs the disguise and revelation of identity as standard plot elements. In the legal, political, and activist frameworks in indigenous studies, recognition refers to and is the basis for diplomatic relations between nations, and it is this recognition of nation-to-nation relationships, formalized in treaty documents, that Native tribes consistently insist that the U.S. government acknowledge (and which is implied in the federal recognition of individual tribes). My interpretation of recognition as a process of recrediting is also influenced by Chadwick Allen's description of indigenous minority acts of "re-recognition" as strategic, politicized performances. This description of certain indigenous performances of identity as "re-recognition" develops the meaning of recognition as a tactical refocusing of colonizing frameworks, in which indigenous activists and artists reenergize and "revalue. . . . rather than deconstruct, the authority of particular colonial discourses, such as treaties, for their own gain."[16] Considering recognition as an artistic choice based in legal history returns us to Jolene Rickard's (Tuscarora) definition of sovereignty, "the border that shifts indigenous experience from a victimized stance to a strategic one,"[17] as a fundamental premise of indigenous art. In cinematic representations, this "shift" is manifested visually in the embodied Native viewer on screen and in cinematic reflections upon the visual as a medium of repatriation. Further, political recognition is also intimately *familial* in film dramas and documentaries that chronicle relations between parents and children or between siblings who have been separated or alienated from one another. Westerns are watched by characters in Chris Eyre's films, in which images

of Indians and family members are claimed and mediated through parallel, and sometimes simultaneous, acts of recognition. The characters' recrediting models a process of historical recovery and ownership of popular-culture production and meaning through a practice of reception involving recognition, identification, and naming. The problem posed for the characters in *Skins*, then, becomes the appropriate response to recognition.

CHRIS EYRE'S "HOME DRAMAS"

Adapted from Paiute author Adrian Louis's novel of the same title, *Skins* dramatizes the difficult love between two Lakota brothers, Mogie (Graham Greene, Onieda) and Rudy (Eric Schweig, Inuit). In frustration over his inability to help his alcoholic older brother and others in his community, Rudy, a Lakota police officer on the Pine Ridge Reservation, turns to vigilantism. In each case, however, he inadvertently victimizes his own relations—first a distant relation and then, devastatingly, his brother Mogie, who is already terminally ill. Fulfilling Mogie's dying wish—to deface the carved figure of George Washington at Mount Rushmore—becomes a way for Rudy to express his grief over his brother's death and the distress of the Pine Ridge community that he sees every day as a tribal cop. Like *Smoke Signals*, *Skins* dramatizes familial relations in a reservation context, and like *Smoke Signals*, the film ends with a memorial service and images of a troubled protagonist mourning the death of a family member (other members of the family include Aunt Helen [Lois Red Elk, Dakota/Lakota] and Mogie's son Herbie [Noah Watts, Crow]).[18]

Rudy's turn to vigilantism is a manifestation of illness—in fact, Rudy knows he needs help and seeks it from a young spiritual leader, Ed Little Bald Eagle (Myrton Running Wolf, Blackfeet).[19] By committing violence outside of his community's social constraints, Rudy acts out the Western's assaults on Indian families, including his own. The Western representational formula of masculine "regeneration through violence" on the frontier, as described by cultural historian Richard Slotkin, is invoked not only through images of Westerns on screen but also in casual references to the transposition of Western-genre vigilantism to racist urban law enforcement in films like *Death Wish* (Winner, 1974) and *Dirty Harry* (Siegel 1971). In *Smoke Signals*, Thomas suggests that Arnold Joseph looks like Charles Bronson in *Death Wish V*, and in *Skins*, Rondella Roubaix (Elaine Miles, Cayuse/Nez Perce) responds to Rudy's veiled threats with a derisive "Fuck you, Clint

Eastwood." But Western-genre models of masculine regeneration don't work for Rudy; rather, they lead him to victimize the Lakota people he wanted to help—his *oyate* (people) and *tiospaye* (clan, family).

Even more strongly than *Smoke Signals* does, *Skins* depicts the fracturing and reconfiguration of families as a product of the way the media tells stories about history, documents contemporary communities, and influences the actions of its audiences. *Smoke Signals* and *Skins* both combine a focus on specific tribes (Coeur d'Alene and Lakota, respectively) with pan-Indian production and casting to focus on issues shared politically across tribes. *Smoke Signals* had a stronger critical reception and was more financially successful, though some critics have argued that both films perpetuate stereotypes.[20] In measuring the distances between intended and decoded meanings for imagined Native viewers, the films explore the different ways that oppositional viewing might be translated to action. Eyre repeats several of his most successful cinematic techniques from *Smoke Signals* in this film, including flashbacks from the brothers' youth, and references to popular media images of Indians through footage of televised Westerns playing in Native homes. Taking up the figure of the "Crying Indian" from a televised public service announcement in the 1970s, *Skins* both engages and parodies the act of mourning. The film's exploration of grieving is importantly different from *Smoke Signals* in its mapping of the characters' feelings of loss onto a monumental icon of American imperialism, and a televised performance in redface in the film's closing images of Mount Rushmore. Further, the emotional funeral at the film's end recalibrates both the melodramatic register of the early "Indian dramas" and the media saturation of romanticized representations in the 1970s to serve what director Chris Eyre describes as contemporary "home dramas." Images of "Indians watching Indians on TV" and of televisions themselves are mediating forces that recur throughout the film, seemingly in the background but in fact acting as visual and aural transitions between scenes, sparking conversations between characters, and motivating Rudy's final vigilante act of violence. Several crucial scenes in the film are bracketed by televisions and television screens, which structure and saturate the representation of the characters' lives.

Mogie's identifications have to do with history, and with testimony as a document of indigenous resistance as he invests the male melodrama of the Western with documentary content about Lakota history.[21] *Skins* itself invests its drama about Mogie as a victim with documentary footage (which Eyre, in the DVD commentary, characterizes as "sad stuff" but "all true"). Eyre's imagined indigenous spectatorship involves viewers who engage in a

form of retrospection that deemphasizes the fantastic, using oral storytelling on-screen to realign Western melodramas with a testimonial realism.

The film's opening images of the Pine Ridge Reservation are almost purely in a documentary mode, comprised of found or stock news footage. This opening sequence powerfully frames the film's dramatic content and invests the family relationships with a larger significance in light of the tribe's historical and ongoing battles for land rights and self-determination. An example is the use of footage donated by Robert Redford from his film about the 1973 occupation of Wounded Knee, *Incident at Oglala* (Apted, 1992); the borrowed footage is especially significant because of its original place in a documentary about the American Indian Movement's confrontation with the FBI on the Pine Ridge Reservation in 1973, a historical activist reoccupation of Lakota land. As images of barbed wire, trash, and weatherbeaten trailer homes and government housing flash on the screen, the soundtrack incorporates fragments from a speech by Bill Clinton promising resources "for your children and their future." Then, in voice-over accompanying shots of Mount Rushmore and the Wounded Knee Massacre site, Eyre's own voice outlines statistics and facts that again orient viewers to the political and historical contexts for the film, juxtaposing the popular tourist attraction of Mount Rushmore with the Pine Ridge Indian Reservation ("the poorest of all counties in the U.S."), and describing the Wounded Knee Massacre of 1890 as viewers see footage of the graveyard and signs. Finally, a news anchorwoman's voice reels off rates of unemployment, death from alcoholism, and other statistics over a montage of news footage depicting impoverished Native men being arrested and jailed. Periodically, tracking shots of Pine Ridge houses from the road both recollect this documentary opening and mimic what Rudy sees from his patrol car.

The film's forays into this documentary montage, with its authoritative narrator (the director himself, at one point), borrowed footage, persuasive political agenda, and verité techniques of location shooting on the reservation in actual homes (not dressed or built for the film), ask that viewers receive this drama differently than the historical fantasies of "Indian Westerns" such as *Dances with Wolves* (Costner, 1990), tapping instead into the conventions of social realism. The opening sequence, interspersed with the credits, seems to be directed towards non-Native viewers who might know little about Native American history or politics, or about the particular history of Pine Ridge. But these sequences also represent a dual address: non-Native viewers receive a historical and political briefing, and an education in the key issues and motifs of the film, while insider viewers are offered

recognizable footage and landmarks that outline the parameters of the film as familiar territory.

The film returns midway to this documentary intertext to present a case against the liquor business in the reservation border town of White Clay, Nebraska. Rudy is beginning to pay attention to spiritual obligations by burning sweetgrass and making tobacco ties in his living room. Later, as he watches television there, he is the audience for the news report on White Clay, where a small number of white-owned stores profit enormously from Lakota customers from the reservation. Eyre intercuts shots of the film's characters and a reconstructed newscast production with fifteen-year-old stock footage from the NBC Nightly News with reporter Monica Red Bear. Mogie and his friend Verdell Weasel Tail (Gary Farmer) watch as the anchorwoman (here played by Jenny Cheng) delivers the story, filmed by her Native film crew. The self-referentiality of the filming as a metaphor for the Native production of *Skins* inserts the film's characters into actual historical footage, putting Mogie on both sides of the screen (as subject and as viewer) over the course of the film, and putting Rudy in a position to recognize his brother on television. From the production of the newscast, Eyre cuts to the outside of Rudy's house and the sound of a Western movie shootout—then inside, to Rudy's face illuminated by the television as he surfs channels, skipping past another Western before arriving at the newscast, which now includes an inebriated Mogie mocking the interviewer. The Western is sonically and metonymically linked to the newscast by Rudy's own editing using his remote. At the same time that the family drama in *Skins* becomes (hypothetically) subject to representation on the news, the segment relates what we see on news broadcasts to the film's "real" or recognizable families.

The final shot of this interior scene, after Rudy has turned off the TV, is his silhouetted reflection on the dark screen. This is a classically reflexive image, like the much-noted shot of Cary (Jane Wyman) entrapped by the "gift" of a television at Christmastime in the Douglas Sirk melodrama *All That Heaven Allows* (1955), and like the shot of Sheriff Ed Tom Bell (Tommy Lee Jones) silhouetted in Llewelyn Moss's (Josh Brolin) trailer-home TV screen in Joel and Ethan Coen's *No Country for Old Men* (2007), a shot that revisits the iconography of the Western, but signals its emptiness in the face of 1980s cross-border drug trade. These viewers' reflections, fixed within deactivated television screens, signal the alienating narrative confines of melodramas and Westerns, and the bankruptcy of their generic promises of emotional fulfillment and cathartic action. A small screen nested within a big screen, television is imagined here as a medium that fluidly extends the

reach of mass culture to the domestic spaces of the characters by mirroring their recognizable countenance in a virtual space. The visual image of the face on screen, then, signals, in these scenes, viewers' ambivalence towards their interpellation within the bounded frame and imposed sign system of television narratives. In *Skins*, the shot forecasts the film's shift in scale from intimate close-up to monumental visage, and from faces on screen to face-as-screen, in its closing images.

For Rudy, the problem of television is its content. He is trapped within the boundaries of vigilante narratives, in contrast to Mogie's ability to read such narratives from outside of their parameters in order to make their clichéd images express his own, specifically Lakota feelings of community, history, and kinship. Rudy's identification leads him to act out prewritten scenarios rather than taking control of television's imposed sign system, while the domestic placement of the television and the isolated conditions of his viewing facilitate his decision to act outside of the community's social constraints. The shot of his reflection in the screen functions as a pivot between Rudy's rising anger as he watches his brother on the news, and his ill-fated decision to take vigilante action by burning down the liquor store. Thus, the shot traverses the space between the passive anger of even oppositional media reception and viewers' actions in the world. Further, the shot "contains" Rudy's silhouette, surrounding his image while implicating television in the film's larger social critique by revealing it to be an organizing force behind Rudy's vigilantism.

This bad-mirror effect is immediately reinforced in the next shot of Rudy reflected in a bathroom mirror, putting on black makeup as part of his disguise. The image suggests the masking essential to the Western vigilante hero's evasion of identification under the law (e.g., *The Lone Ranger*, ABC 1949–1957)—a facial barrier to the kind of reparative recognition that *Skins* will later model for viewers.[22] The racialization of Rudy's impending violence as a performance of whiteness-in-disguise further implicates both Western-genre scenarios of action and news stories about Native victims in Rudy's own psychological imbalance and his alienation from his brother and community. The theatrical makeup, then, also alludes to the tradition of redface (and even blackface) performance that has characterized Westerns, and that *Skins* and other films counteract in their revaluation of Native actors in the casting process. In this case, Rudy's recognition of his brother at this moment leads to wrong action when his anger spills over into vigilante violence: he burns down the liquor store in White Clay, inadvertently injuring Mogie. In a later scene, however, Mogie himself guides the other characters' strategies of reappropriation in viewing media images

towards political and genealogical recovery, using collective memory as well as humor and absurdity to reshape iconic images.[23] By moving between these examples of spectatorship, *Skins* models a range of nonconsenting responses to media images that become decentralized as they are broadcast into individual homes.

Eyre's mainstream film techniques are deployed to cast doubt on conventional film genres and histories. In this case, he uses the television as a sound bridge over the cut from the establishing shot of Rudy's house to its interior in the scene discussed above, framing the private familial space of the home with images from a nationalist cinematic genre. A structurally similar scene takes place later in the film at Aunt Helen's house, where the brothers have gathered for a family dinner with Aunt Helen and Herbie. After an establishing shot of the house, the film cuts directly to the television screen playing a Western: men on horseback are engaged in a shootout. The televised image fills the entire frame, becoming an encompassing "second screen" through which viewers transition into Helen's domestic space.[24] The televised Western is a pivotal reflexive turn both visually and verbally. That is, we enter the scene through Mogie's commentary about what is playing on the television screen, but he speaks only about the actor, not the film itself, as Mogie provides his son Herbie with his own take on the film. "See that retarded knobshiner? That's Joe Thunderboots. Me and him used to be drinkin' buddies, but I haven't seen him for a while. Now, he's supposed to be a direct descendant of American Horse. Least that's what he said after a couple of drinks."[25]

Among the Indians coded as enemies in the Western, Mogie sees friends. Significantly, Mogie recognizes and appreciates the Western on TV not for its myth-making fabrications of frontier history—the function the Western is said to have in much criticism of the genre—but rather in terms of his community networks. That is, the uncredited actor who, along with other anonymous extras, signals a generalized Indian threat in the Hollywood Western is, for Mogie, a named individual with a specific genealogy that links him to the events of this period of history (the second half of the nineteenth century) that the Western typically represents. The Lakota lineage embedded in the very same media that denies the presence of Native families becomes for certain audiences both a coded history and corroboration of survival, a reading that, in its historical specificity, repudiates the Western genre's construction of Indians as ahistorical and atemporal.

In the scene, the Lakota story of Wounded Knee is embedded in a Western story of frontier violence through the physical genealogy of the Lakota extras and the ability of a contemporary Lakota audience to recognize them

on screen as individuals rather than generic "Hollywood Indians." As the characters move to the kitchen table for dinner, Herbie asks, "So, who's American Horse?" and Mogie's reading of the Western on television then becomes a trigger for a recounting of the events of Wounded Knee and the testimony of Lakota witnesses. Uncharacteristically tense and bitter, Mogie tells Herbie to "listen up" while his uncle Rudy begins the story of Wounded Knee. But Mogie is unable to restrain his need to tell the story, and interrupts Rudy to clarify that the troopers designated to disarm Big Foot's band at Wounded Knee in 1890 were from "Custer's old command." He goes on: "The Seventh Cavalry was called in to escort them to the reservation. Then the soldiers disarmed them. Wounded Knee was nothing but a damned massacre of women and children." "American Horse," he explains, "testified before Congress." The U.S. disavowal of historical moments of Lakota testimony becomes part of Mogie's story as well, when Herbie asks, "What happened after American Horse testified?" and Mogie replies, rigid with barely restrained rage, "They [the Cavalry soldiers] were all given a Congressional Medal of Honor." Aunt Helen tries to break the tension by talking about Herbie's football-game scores, to which Mogie replies, "I don't give a rat's ass!" Mogie's belittling of his son's accomplishments stems directly from his overwhelming feelings of anger when remembering Wounded Knee; the story that brings the family together in this scene also furthers their estrangement. Significantly, this estrangement is revealed through close-ups, a cinematic technique designed to elicit audience identification with a focal character's nuanced emotions (usually withheld from "stoic" Indian characters in Westerns, who were more often seen in long shot). While Mogie has the ability to identify Indian "extras" in long shot (as opposed to the closer framing given to white stars in studio-era Westerns), Rudy is forced to recognize his own violence in his brother's disfigured face through the use of the close-up on Mogie during his retelling of American Horse's testimony about Wounded Knee. Later in the scene, when Rudy reveals his vigilante work to Mogie and confesses that he set the fire that burned his brother, Mogie accuses him of being crazy, and Rudy responds, "Don't you think I know that? All I have to do is look at your face." Rudy and Mogie's exchange, and Rudy's final act of vandalism (defacing the George Washington sculpture at Mount Rushmore) intensify the visual discourse of faces and recognition in *Skins* as a form of mediated memory.

For Mogie, the cinematic erasure of Indians, as they're defeated over and over again in the Western, retraces a broader historical and geographical violence: specifically, here, the congressional disregard of American Horse's testimony in 1891, and the public effort to de/face and re-signify Lakota

sacred land (Paha Sapa/Black Hills) as a white American tourist destina-
tion and U.S. national monument (the presidential sculptures at Mount
Rushmore). Mogie's recognition of Joe Thunderboots as a descendant of
American Horse introduces Mogie's own history lesson in which Indians
don't "vanish" from the Western landscape. Instead, the Western on TV
offers evidence of Native survival through the genealogy of the actors. The
"extras" or "remainders" of Hollywood's frontier equations serve as remind-
ers of stories exchanged between generations; Mogie insists that Indians are
present even in films that try to erase them.

Eyre's voice-over commentary on the DVD of *Skins* is especially sig-
nificant in this regard because of his choice to focus on directing viewers'
attention to specific people (actors, nonactors, and community members)
who participated in the production. His narrative recognizes, identifies,
and thanks people for contributing their houses, land, and faces to the
production, presenting an off-screen parallel to the presentation of Mogie's
"Indigenizing" viewing practices by linking actors' roles to audiences' worlds
and narrating the film's political meaning.[26] Connecting the act of viewing
with the act of speaking both acknowledges the damage and silencing of
older and contemporary media images, and makes those media histories
available as resources for recognizing media imperialism and the counter-
project of speech.

Mogie's appropriation of the Western movie as a pedagogical prompt
or mnemonic device for an oral history lesson also forces a non-Native
audience, an audience targeted by some of the film's earlier didactic, doc-
umentary-style footage and voice-over, to acknowledge the copresence
of an indigenous audience. The citation of American Horse's testimony
also further dramatizes the "passionate research" (to quote Frantz Fanon)
that can take place in the revisiting or recuperation of the aged products
of popular culture, archived not in libraries and special collections but in
the process of circulation in television and rebroadcasting. This "streaming
archive" facilitates the restaging of encounters between indigenous viewers
and the Indians on screen as they negotiate the meaning of a media past,
through an oral performative reframing of analog transmission. Stuart Hall
assesses retrospection in the context of colonialism by drawing on Fanon's
concept of the postcolonial "rediscovery" of identity, and the concomitant
process of "passionate research" into Native pasts that have been distorted
or disfigured by colonial oppression. Hall argues that identity resides not
in "archaeology" but rather "in the re-telling of the past": "Far from being
grounded in a mere 'recovery' of the past, which is waiting to be found,
and which, when found, will secure our sense of ourselves into eternity,

identities are the names we give to the different ways we are positioned by, and position ourselves within, the narratives of the past."[27] While keeping in mind the important distinctions between Fanon's "postcolonial" theory and Native American and global indigenous circumstances—including the circumstances of ongoing colonization for many indigenous minority communities—Hall's description of an identity based on active retellings of the past usefully emphasizes the continuous but changeable nature of "recovered texts," as well as the processes of recovery in and through acts of representation.

Eyre envisions an indigenous audience's ability (and even obligation) to view film in a distinctive way, finding the Native presence that was already there, detecting political and historical legacies embedded but disguised in the documentation of victimhood on the nightly news and in Hollywood's attempts at Indian erasure through the Western's acculturating chronicles of settlement. The interdependence of oral and electronic discourses in this scene deconstructs binary oppositions between low-tech and high-tech modes of transmission, but those modes are not conflated. Instead, the scene of storytelling moves from the media storytelling in the living room to oral storytelling at the kitchen table, modeling a strategy for the reeducation of youth through the intertextual relations between two narrative forms.

Only as the scene ends and Rudy leaves the house do we see that the small black television, still playing the Western, is stacked on top of an older, larger model that either isn't working or isn't turned on. This is in fact a long-delayed reverse shot, since we have been viewing much of the action in this scene from the general position or POV of the two television sets. The doubled televisions remind us of the nested screens earlier in the film; the plurality and intensification suggested by the reduplication of the TV as a media vehicle imply the multiple versions of history that reside in the intertextual relationships between Hollywood and independent media, and between media makers and the viewers who make their own meanings from the signals broadcast to their homes. The very composite nature of television rebroadcasting and the tools of its streaming archive seem to facilitate the characters' oppositional readings.

In *Skins*, the scenes of indigenous viewing work to de-exoticize screen Indians, as both viewers and subjects, through the power of politicized recognition—Rudy *recognizes* his brother Mogie on the news, and Mogie *recognizes* his friend Joe Thunderboots in the Western. Far from stereotyped presentations on screen as threatening or victimized Indians, *Skins* presents Native viewers who can generate documentary content from within generic media fantasies of Indians by recognizing the Native actors as part

of their families and communities, and by recognizing the historical and contemporary events behind the stories purveyed by Westerns and by the nightly news. Rather than focusing on the recognizable qualities of white stars (playing cowboy heroes, or in redface playing Indian villains), the cinematic viewers in *Skins* take the "anonymous" extras as primary figures of community identification.

In imagining Native reception, Eyre stages his own interaction with his viewers, shaping relations to families and lands through film production while simultaneously making such private negotiations visible and accessible to a mixed audience in the broader public. In an interview about making *Skins*, Eyre asserts that the act of filmmaking itself incorporates a particular agenda in its address to viewers, and calls the film a "home drama" and "a women's movie for men," referring to the emotional relationship between Rudy and Mogie.[28] "In my movies I'm trying to convince my audiences to . . . go home."[29] "My movie is like me," he says. Adopted by a white family as an infant, Eyre said that seeking out his biological family was "something I just knew I was going to do. . . . I had love out there but I didn't know where it was and I think in my movies what's happening is these characters are yearning for each other—they're home dramas, and ultimately I want my audience not to miss each other."[30] Eyre's desire to film a familial "near miss" is manifested in *Skins*'s rendering of screens as both sites of rupture and sites of reunion.

Like *Smoke Signals*, *Skins* was made with multiple audiences in mind. Eyre brought *Skins* back "home"—to its site of production—in a physical way by showing it to the communities where it was set on the Pine Ridge Reservation. His "Rolling Rez Tour" debuted the film in reservation communities across the country using a semitrailer equipped with a 100-seat theater, air conditioning, and a 35 mm projector. As a metaphor for the Western's performance of social relations and Hollywood's exclusion of Native voices, the bus as a modern stagecoach and dramatic "stage" that Eyre developed so evocatively in *Smoke Signals* is materialized here quite differently, as a Native space, a physical but mobile location where indigenous films and indigenous viewing answer back to the history of cinematic misrecognition.[31] In the content of the film, as well as in its exhibition in the Rolling Rez Tour bus, *Skins* explores what it means to resituate media images onto Native lands.

ACTING OUT (OF) LOSS: TWO MODES OF MOURNING

Both *Smoke Signals* and *Skins* end with scenes of mourning, as Victor (Adam Beach, Salteaux) mourns the death of his alcoholic father, Arnold Joseph, and Rudy mourns for his brother Mogie. Rudy's signature act of vandalism at the end of *Skins* is the defacement of the Mount Rushmore National Monument. As a private commemoration of his brother, he tosses a bucket of red paint over the carved cliff, inadvertently creating a red tear down George Washington's face that echoes the widely circulated image of Iron Eyes Cody (the Italian American actor Espera or "Oscar" DeCorti) in his role as the "Crying Indian" from the 1971 public service announcement. Rudy enacts two mourning rituals for his brother—a formal wake attended by family and community, and a private act when he defaces the Mount Rushmore monument in honor of his brother's request and his own relationship with the Lakota trickster spirit Iktomi. (Iktomi, the spider, is linked with rocks throughout the film, and in Lakota belief is the son of the rock spirit Inyan.)[32]

If Eyre's films ask viewers to mourn lost relatives and damaged families, they also mimic and ridicule other popular-culture representations of weeping Indian victims. The "Crying Indian" and other appropriations of Indian witnessing and mourning in popular-culture imagery make it difficult for indigenous cinematic expressions of loss to avoid the taxidermic significations of vanishing. Eyre engages with issues of tragedy and its mediation by insisting that his audience join him in mocking, as well as in crying, as the physical manifestation of loss. Rudy tosses the red paint over the side of the excessive, monumental face of George Washington in an act of mourning that doubles as an activist prank; George Washington is made to weep for humble Mogie. Like the image of "Indians watching Indians on TV" in *Smoke Signals*, images of weeping signal both pathos and parody in *Skins*, registered on intimate and monumental scales.

In carrying out two different trajectories for memorializing the familial past, Eyre insists on the interdependence of emotion and its mediation in the presence of popular representations. In particular, Mogie's death brings up the power of reenactment as a meaningful revisiting of traumatic events for actors who share their characters' affiliation and heritage. The actor Graham Greene was initially reluctant to "play dead" for the shot of Mogie in his coffin, and the day after the scene was shot, the crew burned the coffin and prayed together. In the DVD director's commentary, Eyre describes the day that the crew shot the scene of Mogie's wake as "a heavy day on the set": "The mood in this room was real. The mood in this room was too close, I

think, for a lot of people. You see this guy crying in the back—he's crying, he's actually really crying. It just brings back memories for so many people, I think. It was a difficult, difficult scene to do." In the same commentary, Eyre declares his wish that *Skins* will be "a place hopefully for healing, and to share family experience . . . and family love." In his focus on the memorial scene as both a traumatic moment in film production and a mode of familial healing for the film's characters, Eyre revisits scenarios of mourning from the media past—a past that is integral to Mogie's character. He reinstates the moral efficacy and urgency of mourning in the act of crying, taking back the work of memorializing as both familial and political recognition and a way to reinterpret mediated images of Indians.

The scenarios and melodramatic tableaux of the silent Indian dramas reemerge here as "disidentifications" that are also reidentifications, projected back upon the nationalist, iconic faces of settler culture. The narrative interruption and emotional intensity amplified by the stasis of the monument is similar to that of the close-up. Mary Ann Doane describes the close-up's contradictory functions in film history and criticism as a problem of magnification. The close-up is "inescapably hyperbolic. . . . the vehicle of the star, the privileged receptacle of affect" that "underwrites a crisis in the opposition between subject and object" and between the identifiable face and its effacement.[33] In *A Thousand Plateaus*, Deleuze and Guattari imagine this face-as-screen to be the very construction of whiteness: "Concrete faces cannot be assumed to come ready-made. They are engendered by an abstract machine of faciality (*visagéité*), which produces them at the same time as it gives the signifier its white wall and subjectivity its black hole."[34] Doane writes of Deleuze's theory of faciality that "the face becomes the screen upon which the signifier is inscribed, reaffirming the role of the face as text, accessible to a reading that fixes meaning."[35] For Cherokee scholar Ellen Cushman, the skin color of the face often forms the premise for racial legibility and the surface of closest public scrutiny, since "the primary text of authenticity is the face."[36]

In Westerns, the system of facial recognition signaled by close-ups of white stars—such as the famous tracking shot that reintroduces John Wayne to the viewing public in *Stagecoach* (Ford, 1939)—suppresses audience recognition of the Native extras seen in long shot, while condensing the genre's national history into a few iconic facial images. In *Smoke Signals*, during Victor and Thomas's bus ride to Arizona, they teach one another the codes of this cinematic regime of Indian authenticity by discussing its facial sign system. Using *Dances with Wolves* as their authoritative text, they practice an Indian "warrior look," the Indian version of the white vigilante, by monitoring and suppressing facial expressivity ("Quit grinning like an idiot—get

stoic!") and managing their hair ("You gotta free it! An Indian man ain't nothing without his hair"). When this carefully cultivated "warrior look" fails to prevent racist treatment in the real world, Victor and Thomas begin to dismantle the cinematic "machine of faciality" and the face as the site of speech by singing a song, "John Wayne's Teeth," that questions the authenticity of the white face (and mouth) that has most often spoken for the Western: "John Wayne's teeth, John Wayne's Teeth, are they false, are they real, are they plastic, are they steel?"

In *Skins*, the close-up of Mogie following Rudy's comment that "All I have to do is look at your face," in order to recognize his own mistaken action, positions the face in close-up—and the monuments later in the film—not as a disguise or mask, but rather as a legible site of rebuke. Damage and illness are literally written on the faces of the characters in the masking, scarring, and painting, the defacement and effacement that seems to disguise but in fact reveals. These close-ups, along with the monumental rock face of the American presidents at Mount Rushmore, infuse intimate family recognition with nationalist discourses. The "white wall" of George Washington's face is the screen upon which triumphalist American history is written; by scarring or "tearing" it with red paint, Rudy reveals the white face to be a mask, the history it memorializes to be in fact a cover for deliberate acts of forgetting.

This movement between small- and large-scale faces and screens welds affect to its commodification within a sign system structured by the history of popular-culture images. In *On Longing*, Susan Stewart writes that the "larger than life" quality of movie stars is a "matter of their medium of presentation. . . . and that formation, that generation of sign by means of sign, provides the aesthetic corollary for the generative capacity of commodity relations."[37] Mogie's immersion in, and appreciation of, popular-culture images of all kinds—not just televised Westerns—signals his status as a contemporary consumer rather than a vanishing primitive. Hence his and later Rudy's ability to transpose the specular sign system of commercial culture to Lakota relations of kinship and love is even more radical. Early in the film, Mogie expresses his love for Madonna by wearing his Madonna T-shirt, and Rudy manifests his affection for his brother in specifically commodity terms at key moments in the film. While Mogie is dying in the hospital, Rudy is at the gas station buying a T-shirt with an image that replaces the four presidents carved into the rock of the Paha Sapa/Black Hills with the faces of historical chiefs Sitting Bull, Chief Joseph, Geronimo, and Dull Knife. The shirts themselves update a resignaling of the land from the AIM movement of the 1970s, and Eyre characterizes Rudy's purchase as an "act of self-love."

In identifying with and consuming commodity images of Indians, Rudy reshapes their meaning-making to do the work of family reunification while also modeling an indigenous market for material products carrying Native portraits, much like the modeling of indigenous viewership earlier in the film. By purchasing the T-shirt, Rudy repositions himself as the driver of cultural products rather than as a product himself. The renegotiation of power at the heart of Rudy's recirculation of images is in line with the idea (but not always the practice) of repatriation as a political transfer of ownership. Like the image of the four chiefs on the T-shirt, the PSA image of the Crying Indian is highly context-dependent, functioning in its production, circulation, and reception rather than in isolation.

The "Crying Indian" PSA that first aired on Earth Day 1971 became one of the most successful television commercials ever produced. A second PSA was developed in which Cody rode into modernity on horseback, and a "Keep America Beautiful" poster circulated with the image of Iron Eyes Cody's tear-stained face. The Crying Indian weeps in a mode of sentiment and romanticized nostalgia. Iron Eyes Cody is an Indian in costume— including fringed buckskin, braids, and feathers—paddling a traditional birch-bark canoe through a natural setting shot in soft focus in a pictorialist style. As he paddles, he enters a modernity signaled by an industrialized landscape, where through silhouette and superimposition he becomes a spectral anomaly, a figure out of time, moving—visible and yet unacknowledged— through a contemporary dystopia marked by factories, cars, highways, and litter. The close-up of Cody's face with its single tear reactivates the melodramatic mode of the sympathetic Indian drama both in its silence and in its *melos*. The music that accompanies the ad, dominated by drums and low, rhythmic string music, recalls the "Indian music" from early Westerns. The image also recalls Edward S. Curtis's photography, with its pictorialist use of silhouette, nostalgic narratives of vanishing Indians, and somber portraiture of often anonymous subjects labeled as types rather than identified as individuals. The close-up of the Crying Indian on "Keep America Beautiful" posters draws on the traditional stasis of portraiture and the melodramatic tableaux, in which the emotional distress of the character(s) models and triggers an audience's own emotional reactions, reactions intended to "move" the audience to action.

Later, in 1998 (the same year that *Smoke Signals* was released), the PSA was updated, with Iron Eyes Cody's image followed by the slogan "back by popular neglect." In keeping with the reflexivity of contemporary advertising, images of people littering as they board a city bus is followed by an image of the Crying Indian poster at the bus stop; we see the tear falling

on the poster, suggesting a magically conscious portrait, truly an Indian removed from time, suffering in the act of helpless witnessing, a frozen face with a tear that has continued to fall for twenty-five years. His weeping denotes a powerlessness that suggests political dependency (or wardship). He is a supplicant, and the ad entreats viewers by shaming them through the moral power of melodrama. In codifying television Indians as land stewards, the PSA's producers returned to historical constructions of Indians as figures for ethical responsibility (the original slogan was "People start pollution. People can stop it."). While the Crying Indian is associated with land in terms of environmental stewardship, he also mystifies land ownership and the transfer of land that is at the heart of his moral efficacy by substituting a generalized emotional appeal for universal good behavior (not littering) for concrete policy analysis and specification of indigenous land rights.

In returning to the image of the Crying Indian, and in mapping that image onto the monumental visage of George Washington, Chris Eyre repoliticizes the mystified television Indian, overlaying the PSA rebuke of U.S. land stewardship upon the celebration of manifest destiny, and reinserting issues of sovereignty and political autonomy that had been disassociated from images of Indians in the media, especially through Western-genre representational displacement. Further, the epic scale of these national symbols is harnessed to do the intimate work of mourning for a single family. At the same time that Eyre repudiates imposed melodramatic sympathy by making a national symbol take back the tears of the televised Indian, he also wields the accumulated power of that figure by claiming this and other televised images as part of a virtual "media past" that is part of a Native experience and thus available for Native use in resisting the very imperialism that it represents. Through the signage of these superimposed portraits, Eyre stages an encounter between symbolic, mediated icons—the Crying Indian and the first president—fusing their visages in a fabrication of nation-to-nation interchange. Further, in this complex exchange, Eyre's image hybridizes the white face of George Washington, which is then made to embody an iconic and representational encounter rather than a purified nationalism.

As a closing image, this "close-up" also materializes the disfigurement of colonialism on the face of the nation as it parallels Mogie's scarred face, seen in close-ups earlier in the film. The recognizable tear/scar/paint imposed upon the recognizable face of Washington (in turn imposed upon the cliff face) registers and parodies the history of white actors "playing Indian" in redface. By painting the cliff face red, Rudy attempts to re-indigenize the rock/screen into which the face is carved, inscribing a complex political history of geographical remapping onto the treaty land of the Black Hills and making the rock of

the (resurfaced) cliff into a visual palimpsest onto which disputed boundaries are projected—boundaries that are figured as recognizable faces. To return to Doane: "As simultaneously microcosm and macrocosm, the miniature and the gigantic, the close-up acts as a nodal point linking the ideologies of intimacy and interiority to public space and the authority of the monumental."[38] In producing images of crying that move audiences, Eyre seems to assert that cinema itself can be a site of mourning; displaced and replaced icons stand not only for nations and land rights but also for neighbors and relatives. Yet at the same time, he playfully appropriates iconic images of U.S. national collective memory as a malleable semiotic system of mediated commodities. The rock-as-screen in this sequence—a space or "place" of encounter akin to what Mary Louise Pratt describes as a "contact zone"—recognizes a Lakota spiritual order in both contested land and the apparatus or materially "contested ground" of popular culture.[39]

Graham Greene and Eric Schweig are actors who have worked on Hollywood productions that insist upon an acting-out of the historically suspended, culturally marked Indian in dramas of settlement. In order to make a living as actors, Greene, Schweig, and others have had to embody film and television Indians in roles that represent endless variants on the image of the crying Indian. Graham Greene's long career has included playing a Lakota medicine man in Kevin Costner's *Dances with Wolves* (1990), and Eric Schweig played Uncas in Michael Mann's 1992 adaptation of that classic of U.S. imperialist frontier adventure literature, *The Last of the Mohicans*. If *Smoke Signals* speaks back to *Dances with Wolves* in the media-saturated banter between Victor and Thomas ("This ain't *Dances with Salmon*, you know"), *Skins* answers *The Last of the Mohicans*'s powerful nostalgia by projecting back a similarly romanticized, silenced witness in the figure of the weeping buckskinned Indian. Schweig says of his role as Rudy that "I was so happy to get up in the morning and put on a pair of pants and put on a shirt, instead of a loincloth and buckskin and all that nonsense, because all it does is perpetuate all the ignorance that we've had to put up with for 500 years" (*Skins* DVD commentary). Eyre's productions were among the first to offer contemporary speaking roles for Native actors, yet these films simultaneously look back upon the violence of mapping televised Indians onto Native people, of recognizing one's self or relatives in the face and genealogy but not the costumed role of the televised Indian, and of the staged encounter between viewers and the Indians on screen as they negotiate the meaning of a media past.

Filmmakers who once watched old Westerns on TV are challenging Hollywood's assumptions of an all-white viewing audience's unified beliefs about the history of U.S. settlement. They retrospectively revise the way

those films have been interpreted, offering oppositional readings of Westerns from an indigenous perspective manifested in acts of speaking and listening. In reflexive instances in the film texts, Native filmmakers and their non-Native collaborators negotiate the intrusion of media images of Indians, especially news broadcasts and Westerns, into the homes, families, and childhood experiences of the indigenous focal characters. They employ mediated memories—a past marked by the circulation of cinematic and broadcast representations, a virtual archive of shared viewing—and imagine indigenous spectatorship in a familial context. Film footage, as both a material object and a representational symbol, is recirculated and returned to indigenous provenance, and through these complex exchanges, the films persuasively intervene in the politics of public memory.

NOTES

1. For more extensive discussions of *Smoke Signals*, see Alexie, *Smoke Signals: A Screenplay*; Hearne, "'John Wayne's Teeth'"; Cummings, "Accessible Poetry?"; and Gilroy, "Another Fine Example of the Oral Tradition?" and "A Conversation with Evan Adams." See Cox, *Muting White Noise*, for further discussion of popular media images in Native American literature, and in Sherman Alexie's writing in particular.

2. By "media archives" I mean not physical libraries or collections, but rather a common heritage of popular images, accumulated memories of images circulated and transmitted through photographs as well as television, advertising, movies, and other modes of broadcasting. The wide availability of images for indigenous repurposing results from cultural saturation through commodification.

3. Theories of new media may best describe this intersection—Henry Jenkins's replacement of models of passive spectatorship with one of active "participatory culture," and Jay David Bolter and Richard Grusin's theorization of new media as "remediation." Bolter and Grusin use this term to argue that the defining characteristic of new media is the enfolding of one medium within another—a "formal logic by which new media refashion prior media forms"; *Remediation*, 273. While Bolter and Grusin reject the other connotation of remediation—that new media "remedy" inadequacies of older media—in my analysis of *Skins* and *Smoke Signals*, intimate domestic space provides indigenous audiences with opportunities to remedy, append, or amend the *content* of Hollywood's misrepresentations even when deploying its conventional forms.

4. Ginsburg, "Screen Memories," 40.

5. *Stagecoach* offers an example of this classic Western narrative in the backstory of Ringo Kid (John Wayne). Having witnessed his brother's murder by the Plummer gang, Ringo seeks revenge outside of the law.
6. McHugh, "Profane Illuminations," 447. As Jane Blocker argues, Luna's performances illustrate the way that "the consumption of whiteness is toxic . . . it is devitalizing the native population." In targeting white fantasies about Indians, she writes, Luna "disillusions their fantasy by showing just what native memory now includes: the remembrance of whiteness remembering nativeness"; Blocker, "Failures of Self-Seeing," 24.
7. Blocker, "Failures of Self-Seeing," 28.
8. Naficy, "Theorizing," 9, 21.
9. In exploring the figure of the indigenous spectator, I am referring neither to psychic spectatorship—the spectator as a subject of cinematic apparatus—nor to empirical studies of the spectator-as-viewer, but rather to an imagined spectator, an embodied viewer modeled in the audiovisual text itself. Studies of actual indigenous reception and of general audience perceptions of screen Indians have generally involved focus groups. JoEllen Shively (Chippewa), for example, compared Native and Anglo perceptions of *The Searchers* (Ford, 1956), finding that while Native audiences appreciated "the fantasy of being free and independent like the cowboy" and "the familiarity of the setting," Anglos responded to the film as an affirmative history, as "a story about their past and their ancestors"; "Cowboys and Indians," 357. S. Elizabeth Bird's useful study *The Audience in Everyday Life* moves away from text-based studies to consider the ways that audiences take up media scenarios, while anthropologist Sam Pack's "Watching Navajos Watch Themselves" describes one Diné family's appreciation for representations that accurately reflect cultural details and language use.
10. Ortiz, "History Is Right Now," 6.
11. Colonnese, "Native American Reactions," 335–36. Colonnese goes on to describe his and his colleagues' reactions to viewing *The Searchers*, in which he notes the historical and economic conditions of the Diné "extras" working in movies "about their own subjugation by whites," as well as the unacknowledged Native prior ownership of the land that makes the Comanche attack on the white ranch in *The Searchers*, in fact, a counterattack (336–37).
12. Hall, "Encoding, Decoding," 517, 509.
13. Pack, "Reception," 4.
14. Muñoz, *Disidentifications*, 26, 11. Muñoz's theorization of disidentification, like Judith Butler's politicization of "the experience of misrecognition, this uneasy sense of standing under a sign to which one does and does not belong," is also engaged (though more distantly) with revisions of Lacanian models (12).

By using the term "misrecognition" in this essay, I do not refer to (and am not attempting to revise) Lacan's model of *méconnaissance*—an infant's misrecognition of itself in the mirror—which has been so powerfully taken up in film studies to theorize a spectator's gendered identification with the gaze of the cinematic apparatus and with the star on screen. Emerging from ideas about the formation of individual identity and the (Western) child's psychosexual development, Freudian and Lacanian paradigms generally exclude non-European kinship, economic and social relations, and the ways that indigenous relational systems have been disrupted or reorganized in the wake of colonization.

15. White, *UnInvited*, 197.
16. Allen, *Blood Narrative*, 18.
17. Rickard, "Sovereignty," 51. Rickard's emphasis on sovereignty in visual arts has been taken up by scholars of Native cinema. Michelle Raheja (Seneca) uses the term "visual sovereignty" to indicate a "reading practice for thinking about the space between resistance and compliance"; 1161. Randolph Lewis describes the documentary work of Alanis Obomsawin (Abenaki) as a "cinema of sovereignty"; 175.
18. See Wood, *Native Features*, 27–40, for a discussion of *Skins* in the context of Chris Eyre's career and his other film and television work.
19. In the novel, Rudy's problems are even more closely connected with his masculinity—his initial impotence and his wife's abandonment of him is transformed by his interaction with the Lakota trickster Iktomi; his temporary derangement after hitting his head on a rock is manifested not only by vigilantism but also by lustiness.
20. Edison Cassadore (Western Apache) describes a screening of *Skins* on a college campus in which, "in a racially mixed audience, young Indian college students found this film unsettling. They deplored the stereotype of the drunken Indian and the impoverished economic conditions. These spectators also felt" that the film "should only be viewed by other Indian people"; *Re-Imagining Indians*, 155. Cassadore also asserts that "the conditions represented in *Skins* . . . on reservations are 'real' though the film's limitations are that it lapses and fixates too long on the theme of angry revenge and regret" (155).
21. See David Lusted's *The Western*, especially pages 181–184, for a discussion of the Western as male melodrama.
22. The specific use of blackface to signal both disguise and masquerade also expands the film's racial discourses to stereotypical African American representations, a visual reference amplified by the film's young criminals, Teddy Yellow Lodge/Mr. Green Laces (Michael Spears, Lakota) and Black Lodge Boy (Gerald Tokala Clifford, Lakota), who identify the vigilante (Rudy in disguise) as a "ghost" or *wanase* with "mud on his face, like part nigger, *hasapa*

guy." The derogatory racial epithet alongside the Lakota words *hasapa* (black skin) and *wanase* (ghost) suggest the young men's confusion about the identity of their attacker (they don't recognize Rudy), while also framing Rudy's vigilantism as a racialized performance.

23. As George Lipsitz describes the work of collective memory in American popular culture, "the very forms most responsible for the erosion of historical and local knowledge can sometimes be the sources of reconnection in the hands of ingenious artists and audiences"; *Time Passages* 261.

24. Director Chris Eyre commented that "I like to show the difference in houses" on the reservation, to counter non-Native viewers' assumptions and stereotypes about how Indians live (*Skins*, DVD, director's commentary). Locations for the film were all actual residences, with the exception of the liquor store, which was built and then burned down for the scenes shot in White Clay, Nebraska.

25. Joe American Horse (Lakota) is cast in a bit part in the film as a panhandler standing outside of a liquor store in White Clay; Rudy hands him a cigarette in a scene near the end of the film. Other important appearances in the film are activists Winona LaDuke (Anishinabe) as Rose Two Buffalo, and Milo Yellow Hair (Lakota) as "Drunk #1." Chris Eyre makes an appearance early in the film as an unnamed tribal cop in the scene after Rudy is knocked unconscious by a rock (in its incarnation as Iktomi). For some audiences, recognizing these activists in their parts as "extras" in the film mimics Mogie's on-screen model of film viewing as recognition.

26. The capitalized term "Indigenizing" comes from Linda Tuhiwai Smith (Maori), who lists "Indigenizing" as one of twenty-five "Indigenous Projects" in her book *Decolonizing Methodologies*. She describes the "Indigenizing" project as one that "centres a politics of indigenous identity and indigenous cultural action" (146).

27. Hall, "Cultural Identity," 705–6. Hall calls identity a production "which is never complete, always in process, and always constituted within, not outside, representation" (704).

28. Eyre, *Skins*, DVD, director's commentary.

29. Chaw, Interview with Chris Eyre, n.p.

30. Chaw, Interview with Chris Eyre, n.p.

31. For a more extended discussion of the bus (the "Evergreen Stage") as a revised stagecoach and a theatrical stage in *Smoke Signals*, see Hearne, "'John Wayne's Teeth.'"

32. Zitkala-sa (Lakota), *American Indian Stories*, 13. Iktomi is a Lakota trickster spirit, a shapeshifter associated with spiders and with language and innovation. His elaborate attempts to trick others often fail or backfire, making him appear foolish even as he sets powerful forces in motion.

33. Doane, "The Close-Up," 91, 94.
34. Deleuze and Guattari, *A Thousand Plateaus*, 168.
35. Doane, "The Close-Up," 105.
36. Cushman, "Faces," 390.
37. Stewart, *On Longing*, 91. Also quoted in Doane, "The Close-Up," 109.
38. Doane, "The Close-Up," 109.
39. Pratt, *Imperial Eyes*, 4; Hall, "Notes on Deconstructing 'The Popular,'" 239.

WORKS CITED

Alexie, Sherman. *Smoke Signals: A Screenplay.* New York: Hyperion, 1998.
Allen, Chadwick. *Blood Narrative: Indigenous Identity in American Indian and Maori Literary and Activist Texts.* Durham, NC: Duke University Press, 2002.
Bird, S. Elizabeth. *The Audience in Everyday Life: Living in a Media World.* New York: Routledge, 2003.
Blocker, Jane. "Failures of Self-Seeing: James Luna Remembers Dino." *PAJ: A Journal of Performance Art* 23, no. 1 (2001): 18–32.
———. *Seeing Witness: Visuality and the Ethics of Testimony.* Minneapolis: University of Minnesota Press, 2009.
Bolter, Jay David, and Richard Grusin. *Remediation: Understanding New Media.* Boston: MIT Press, 2000.
Butler, Judith. *Gender Trouble: Feminism and the Subversion of Identity.* New York: Routledge, 1990.
Cassadore, Edison Duane. *Re-Imagining Indians: The Counter-Hegemonic Representations of Victor Masayesva and Chris Eyre.* Ph.D. dissertation, Dept. of Comparative Cultural and Literary Studies, University of Arizona, 2007.
Chaw, Walter. Interview with Chris Eyre, October 2, 2002. *Film Freak Central.* At http://filmfreakcentral.net/notes/ceyreinterview.htm (accessed May 2007).
Colonnese, Tom Grayson. "Native American Reactions to *The Searchers.*" In *The Searchers: Essays and Reflections on John Ford's Classic Western*, ed. Arthur M. Eckstein and Peter Lehman, 335–42. Detroit: Wayne State University Press, 2004.
Cox, James H. *Muting White Noise: Native American and European American Novel Traditions.* Norman: University of Oklahoma Press, 2006.
Cummings, Denise K. "'Accessible Poetry?' Cultural Intersection and Exchange in Contemporary American Indian and American Independent Film." *Studies in American Indian Literatures* 13, no. 1 (2001): 57–80.
Cushman, Ellen. "Faces, Skins, and the Identity Politics of Rereading Race." *Rhetoric Review* 24 (2005): 378–82.

Deleuze, Gilles, and Felix Guattari. *A Thousand Plateaus: Capitalism and Schizophrenia.* Translation and forward by Brian Massumi. Minneapolis: University of Minnesota Press, 1987.

Doane, Mary Ann. "The Close-Up: Scale and Detail in the Cinema." *Differences: A Journal of Feminist Cultural Studies* 14, no. 3 (2005): 89–111.

Fabian, Johannes. *Time and the Other: How Anthropology Makes Its Object.* New York: Columbia University Press, 1983.

Fanon, Frantz. *Black Skin, White Masks.* New York: Grove Press, 1967.

Gilroy, Jhon Warren. "A Conversation with Evan Adams." *Studies in American Indian Literatures* 13, no. 1 (2001): 43–56.

———. "Another Fine Example of the Oral Tradition? Identification and Subversion in Sherman Alexie's *Smoke Signals.*" *Studies in American Indian Literatures* 13, no. 1 (2001): 23–42.

Ginsburg, Faye. "Screen Memories: Resignifying the Traditional in Indigenous Media." In *Media Worlds: Anthropology on New Terrain*, ed. Faye Ginsburg, Lila Abu-Lughod, and Brian Larkin, 40–56. Berkeley: University of California Press, 2002.

Hall, Stuart. "Cultural Identity and Cinematic Representation." In *Film and Theory: An Anthology*, ed. Robert Stam and Toby Miller, 704–14. Oxford: Blackwell Publishers, 2000.

———. "Encoding/Decoding." In *Culture, Media, Language: Working Papers in Cultural Studies, 1972–1979*, ed. Centre for Contemporary Cultural Studies, 128–38. London: Hutchinson, 1980.

———. "Notes on Deconstructing 'the Popular.'" In *People's History and Socialist Theory*, ed. Samuel Raphael, 227–40. London: Routledge and Kegan Paul, 1981.

Hearne, Joanna. "'John Wayne's Teeth': Speech, Sound, and Representation in *Smoke Signals* and *Imagining Indians.*" *Western Folklore* 64, nos. 3-4 (2005): 189–208.

hooks, bell. "Eating the Other." In *Black Looks: Race and Representation.* Boston: South End Press, 1992.

Jenkins, Henry. *Convergence Culture: Where Old and New Media Collide.* New York: New York University Press, 2006.

Lewis, Randolph. *Alanis Obomsawin: The Vision of a Native Filmmaker.* Lincoln: University of Nebraska Press, 2006.

Lipsitz, George. *Time Passages: Collective Memory and American Popular Culture.* Minneapolis: University of Minnesota Press, 1990.

Lusted, David. *The Western.* London: Pearson Education Limited, 2003.

McHugh, Kathleen. "Profane Illuminations: History and Collaboration in James Luna and Isaac Artenstein's *The History of the Luiseño People.*" *Biography* 31, no. 3 (Summer 2008): 429–60.

Muñoz, José Esteban. *Disidentifications: Queers of Color and the Performance of Politics*. Minneapolis: University of Minnesota Press, 1999.

Naficy, Hamid. "Theorizing 'Third-World' Film Spectatorship." *Wide Angle* 18, no. 3 (1996): 3–26.

Ortiz, Simon. "History Is Right Now." In *Beyond the Reach of Time and Change: Native American Reflections on the Frank A. Rinehart Photograph Collection*, ed. Simon J. Ortiz, 3–8. Tucson: University of Arizona Press, 2004.

Pack, Sam. "Reception, Identity, and the Global Village: Television in the Fourth World." *M/C: A Journal of Media and Culture* 3, no.1 (2000). At http://www .uq.edu.au/mc/0003/fourth.php (accessed May 14, 2009).

———. "Watching Navajos Watch Themselves." *Wicazo Sa Review* (Fall 2007): 111–27.

Prats, Armando José. *Invisible Natives: Myth and Identity in the American Western*. Ithaca, NY: Cornell University Press, 2002.

Pratt, Mary Louise. *Imperial Eyes: Travel Writing and Transculturation*. London: Routledge, 1992.

Raheja, Michelle. "Reading Nanook's Smile: Visual Sovereignty, Indigenous Revisions of Ethnography, and *Atanarjuat* (*The Fast Runner*)." *American Quarterly* 59, no. 4 (2007): 1159–85.

Rickard, Jolene. "Sovereignty: A Line in the Sand." *Aperture* 139 (November 1996): 51–54.

Runningwater, N. Bird. "Smoke Signals." *Yes!* magazine, Education for Life issue (Winter 1999). At http://www.yesmagazine.org/articles.asp?ID=801 (accessed May 8, 2007).

Shively, JoEllen. "Cowboys and Indians: Perceptions of Western Films among American Indians and Anglos." 1992. In *Film and Theory: An Anthology*, ed. Robert Stam and Toby Miller, 345–60. London: Blackwell Publishers, 2000.

Slotkin, Richard. *Gunfighter Nation: The Myth of the Frontier in Twentieth-Century America*. Norman: University of Oklahoma Press, 1991.

Smith, Linda Tuhiwai. *Decolonizing Methodologies: Research and Indigenous Peoples*. Dunedin: University of Otago Press, 1999.

Stewart, Susan. *On Longing: Narratives of the Miniature, the Gigantic, the Souvenir, the Collection*. Durham, NC: Duke University Press, 1993.

White, Patricia. *UnInvited: Classical Hollywood Cinema and Lesbian Representability*. Bloomington and Indianapolis: Indiana University Press, 1999.

Wood, Houston. *Native Features: Indigenous Films from around the World*. New York: Continuum, 2008.

Zitkala-Sa. *American Indian Stories, Legends, and Other Writing*. New York: Penguin Classics, 2003.

Sherman Shoots Alexie: Working with and without Reservation(s) in *The Business of Fancydancing*

THEO. VAN ALST

WHAT IS AMERICAN INDIAN LITERATURE AND WHO IS IT FOR? ONE OF Native America's most prominent and important authors attempts to answer this question in part in an excerpt from Joelle Fraser's *Iowa Review* interview:

SHERMAN ALEXIE: If it's not tribal, if it's not accessible to Indians, then how can it be Native American literature? I think about it all the time. Tonight I'll look up from the reading and 95% of the people in the crowd will be white. There's something wrong with my not reaching Indians.

JOELLE FRASER: But there's the ratio of whites to Indians.

SHERMAN ALEXIE: Yeah. But I factor that in and realize there still should be more Indians. I always think that. Generally speaking Indians don't read books. It's not a book culture. That's why I'm trying to make movies. Indians go to movies; Indians own VCRs.

Alexie's big chance to reach movie-going Indians comes in the film *The Business of Fancydancing*. And unlike in his written work, in which he may be speaking to and about Indians but is by his own admission being answered by a mostly white audience, this cinematic work speaks to Indians who interestingly answer back within the narrative of the film.

> *Somebody give me 12 bucks. I'm gonna make a movie.*
>
> —SHERMAN ALEXIE IN "HOLD ME CLOSER, FANCY DANCER"

This discussion intends to look at both how Indians answer Sherman Alexie, and what they have to say to their "author" when they do. Obviously we must first consider what Alexie is saying to them and how he is doing so. Within that observation, we shall also investigate the cinematic devices that allow this dialogue to circulate. Lastly, we treat the reception of this film by audiences, keeping in mind that Alexie has said (though not about this film in particular): "The creation is specific and the response is specific. Good art is specific. Godzilla is universal. A piece of shit like that plays all over the world. Then you know you got a problem."[1]

Perhaps an intimately personal film would help translate the specific to the universal. Could the story of a reservation boy made good in the wide white world be a story with which everyone might identify? Another excerpt from our earlier interview may provide some illumination:

JOELLE FRASER: What about memoir?
SHERMAN ALEXIE: I've rarely read a memoir that wasn't masturbatory.

Hmmm. The potential for the film is without precedent. We have the promise of what is perhaps America's best-known Native writer, with all his talents brought to cinema. Interestingly, as in *Citizen Kane*, the main character is examined (at least in part) through the eyes of a journalist. Alexie brings a unique blend of aural and visual takes to the story—working through issues of identity and success in a Native world, while telling a tale that strikes universal chords of family and friendship. His approach of total control on the film thus offers at least the potential for greatness, as well as self-indulgent tragedy. A close reading of the film reveals multiple levels of narration and identity and self-reflection, as well as sharp analyses of larger social issues told in an artful and occasionally accessible way.

First let us allow David L. Moore's comment, that "knowledge of self and other, of 'white ideological investments,' may give way to participation in context, in community, an agonistic process in itself."[2] Generously (though we should in no way congratulate ourselves for our munificent mood), we then assume that there is some desire on the part of the author of the text or film for non-Native participation in its reception. This audience is of particular importance in a film such as Sherman Alexie's *The Business of Fancydancing.*

Were one asked to provide an example of a "postmodern Indian" (not to be confused with Gerald Vizenor's concept of "post-Indian") film, *The Business of Fancydancing* would surely make many short lists. Its confused reception by critics is indicative of the difficulty encountered in approaching it. At turns perceived as overwrought, brilliant, lyrical, poetic, and melodramatic, it is nevertheless a work that utterly gives its viewers pause. We would do well to contextualize at least in brief before we move on to our discussion.

2002's *The Business of Fancydancing* was both written and directed by Alexie. It follows on the heels of 1998's wildly successful *Smoke Signals*. After that film, based largely on Alexie's "This Is What It Means to Say Phoenix, Arizona," for which he wrote the screenplay, the author found himself in demand as a screenwriter. Ultimately rejecting, and being rejected by, Hollywood, he decided to produce a film himself. Alexie took filmmaking courses in Seattle at what he deemed "a commie co-op," purposively hired as many women as he could for his crew, and set up the business end so that all (cast and crew included) who participated in its production would share in any profits. Foundationally differing from mainstream film production, *The Business of Fancydancing* itself differs from typical Hollywood fare. As to the intended audience for this unique work, we recall that Alexie said in an interview for the film (referencing his public appearances), "Indians don't read books. Indians go to movies. Indians own VCRs."

Here, then, we have a declared viewership for the film. That audience is American Indian. As such, the film is full of subtleties, jokes (word games and otherwise), and cues that are written for Native viewers (here perhaps we pause to ponder that "confused reception" alluded to earlier). Surely though, given his stature and status as a writer widely read by non-Natives, he assumed that a sizable percentage of that non-Native audience would see this film. For this group, Alexie has written a few scenes, but one that addresses "white ideological investments" in particular might be the most disturbing for them. We note this here.

Fairly late in the film, the characters of Aristotle Joseph and Mouse are driving through what appears to be the dense and cloudy temperate rainforests of the American Northwest Coast, though as the characters smartly say into their handheld camera, "It doesn't really matter. We don't pay attention to borders." As they drive, the figure of a stranded white motorist comes into view. They pull over, ostensibly to lend a hand, and Mouse says, "He thinks we're Sacagawea. Hey Ari, he thinks we're Sacagawea."

The scene then begins to deteriorate rapidly from the moment the motorist asks, "Hey. You guys are Indian, right?" Here Moore's "exchange"

and "engagement" are answered through the boots and fists of Mouse and Aristotle. Though it may not have been the engagement the non-Native audience was looking for (or indeed likely expected to receive), it is absolutely necessary in order for that audience to begin some kind of participation. The author is saying in effect, "Just in case you thought (as a white viewer, or more appropriately "spectator" [i.e., this film is *not* for you as a participatory audience member]) that this film *might* be for you," there is a decided and non-narrative irruption of five hundred years of silenced violence reenacted and revenged in the film.

It is a unique and seemingly disjointed scene in the film, one that conceivably could have been cut (and likely would have been, in another director's hands), and one that would appear as a mere extradiegetic foray to a casual observer. But this film's author has a postmodern consciousness and sensibility that speaks directly to multiple audiences. He and his film are acutely aware of what they are saying and who is listening. The non-Native's understanding of the essentiality and necessity of the scene marks the beginning of their engagement with the work, and even as the white wanderer onscreen crashes to the ground, beaten senseless by Aristotle Joseph and Mouse (whose jacket is pinned with a plastic nametag that reads "Destiny"), these two Native characters manifest an entirely unexpected point of view. It is this intimate relationship between depiction and delineation throughout the film that will be reflected in my analysis; an entanglement of cinematic diegesis and theory coupled with a self-reflective and extradiegetic criticism that is inseparable from the plot and narrative proposals in the film itself requires such an approach.

Where to begin, then, in considering a film this unique in its approach to multiple audiences? Students of cinema might consider the director's credentials or origins in attempting to analyze how and why a scene such as the one previously described might come about. In doing so, they would contemplate the audacity of a filmmaker who would insert such a scene, and conclude that the artist who would do so does not feel limited by traditional narratives or commercial considerations. And while we won't suggest today that *The Business of Fancydancing* is a masterpiece on the scale of *Citizen Kane* (at least not in its current version, though Alexie did say he'd like to re-edit), it is at least a useful entry point to a view of the film.

An artist who has established himself in another medium and who has brought many of his own players to the project, a writer who has total control of his project, a director who has incorporated innovative use of camera, mise-en-scène, and sound to produce a new and powerful work: these phrases sound familiar to students and fans of cinema who know the

film *Citizen Kane*. As we occasionally look at *Citizen Kane* in brief and *The Business of Fancydancing* in much greater detail, we shall inquire as to what painful threads of gain and loss, innocence, guilt, and fractured identity run through these two films. What has gone into the production of these films that distinguish them from standard Hollywood methods? We might even ask, "Has Alexie handed us a masterpiece on '12 bucks'?"

> *Long ago, Rudy had read that some old chief had said, "America is the white man word for greed." He couldn't remember the chief's name or tribe, but he knew those words to be true.*

—ADRIAN LOUIS, *SKINS*

One of the strengths of *Citizen Kane* lies in its indictment of what the United States of America, represented in the character of Charles Foster Kane, have both won and lost (here, we too make the argument that Alexie does this as well in *The Business of Fancydancing*, turning the lens on himself in the microcosm, and the larger body of Native artists in the macrocosm). Orson Welles and Herman J. Mankiewicz powerfully illustrate America's "lost innocence" and fall to the excesses of capitalism and greed. That they were able to do so in the early 1940s is something remarkable to consider. Welles was a director who had established himself in theater and radio, but was unproven in the medium of film. In a time of studio star stables, he brought his own players with him, actors from stage and radio. In fact, as Roger Ebert says:

> It is one of the miracles of cinema that in 1941 a first-time director; a cynical, hard-drinking writer; an innovative cinematographer, and a group of New York stage and radio actors were given the keys to a studio and total control, and made a masterpiece.[3]

The film initially was a flop, losing $150,000 dollars for an already bank-rupt RKO Radio pictures. Though its "discovery" and resuscitation on the Art House scene are legendary, and the work now stands as one of the greatest films of all time, it would be quite some time before this level of control would be relinquished to an individual—a proven director or otherwise—by a major studio.

Citizen Kane
How we are hungry for the word

to rise from our dark belly
past the throat and teeth,

one word

to change or not change
 the world.
It doesn't matter which
as long as our failures are spectacular:

Big Mom lay on her cancer bed and cried out *Frybread*;
Lester slapped his drunk arms and legs and whispered *Snakes*;
Junior sold his blood for the 100th time and asked *Forgiveness*.

Believe me, nothing is forgotten for history.

Rosebud.

Believe me, nothing is innocent
when the camera rolls,
our sins are black and white.

Rosebud.

Listen; when the sun falls
audibly on the reservation
each of us choose the word
that determines our dreams:
 whiskey salmon absence.

 Sherman Alexie[4]

How then to obtain total control in the production of a film? It is no longer sufficient to have established oneself in another medium in order to be "given the keys to a studio." A different approach to finance and production must be taken. Sherman Alexie is an artist who has proven himself as a poet, novelist, and writer of short stories as well as screenplays. After the success of *Smoke Signals* (1998), Alexie worked in and around Hollywood. Though he obtained work screenwriting, he found that "No one wants to make movies about Indians."[5] Frustrated with the Hollywood system and aware that monetary considerations in film production would likely not be what they are in literary publishing, "Alexie had tried over the months that followed

Smoke Signals to adapt his novels to screenplays, but the script notes that came back from big-budget financiers were increasingly contrary to what he was trying to accomplish."[6]

Hoping to overcome this frustration, Alexie returned to his last success in the industry. Along with *Smoke Signals* producers Larry Estes and Scott Rosenfelt of ShadowCatcher Entertainment, Alexie explored possible routes to make the film he wanted to make. Rosenfelt and Estes referred to the simple need to keep costs as low as possible. Rosenfelt himself was more than familiar with the emerging medium of digital video, a much less expensive format than traditional film stock. Production and postproduction facilities in the Seattle area were willing to support the project, devising innovative payment methods for the cash-strapped new company. Friends and family, as well as venues at which Alexie had read, all contributed to the project. Beyond this, Rosenfelt and Estes acknowledged the constraints of the Hollywood system, and made clear the need for a group of individuals who could perform multiple functions as crewmembers in the production of the work. This second part of the plan would be an excellent fit with Alexie's principles. In a film from Sherman Alexie, inspired in part by "the Dogme guys,"[7] we would expect to find a different approach to production. In the following quote from the Weinmann interview (which, though lengthy, is essential to understanding the nature of that production), we will find not only that different view of how to produce a film but also insights as to the vision and structure that Alexie had in mind:

> I hate the sort of cult that surrounds the idea of the director. I mean, it's a hard job and it's a difficult job, but it's not the only job on the set. So, I really wanted to create an atmosphere where everybody was sort of equal in the process. So by being the director, I got to, you know, be communistic leader. I guess in some sense I treated it like film school. I went in with a screenplay, but I went in with a screenplay that was very strange to begin with, very loosely connected. It was more of a series of scenes, images and poems than a typical narrative, and on the set I allowed myself to be as free as possible. I would throw the script away, I would let the actors improvise. And, being a performer myself, I could improvise as the director, and give them new lines and interact with them in new ways, and create situations that hadn't been thought of in the screenplay. So I essentially tried to do everything I could think of to test myself, and to shoot every kind of scene imaginable. You know, I was never sure anybody would see this, so I didn't worry about it.

Though he had worked in Hollywood, Alexie knew little about the actual making of a film. Determined, though, to "make it in a way that agreed

with my politics," he took a filmmaking class at Seattle's 9-1-1 Media Arts Center, a site he described as a "Commie video co-op."[8] After realizing that his initial desire to hire an all-female crew for "artistic reasons" would not be possible,[9] Alexie approached teacher and cinematographer Holly Taylor from 9-1-1 and convinced her to become his director of photography. Though she had not worked with narrative film, Alexie said, "I wanted someone that was just as neophyte to the process as I was . . . I didn't want to have someone tell me every day that I was doing it wrong—that it is done another way in this business."[10]

He may not have wanted someone telling him that he "was doing it wrong," but he certainly allowed for the possibility. Alexie admits that his liberal use of improvisation may have hurt the narrative structure of the film, but insists that he "didn't necessarily want to make a narrative film anyway," and that the "improvising helped the poetic nature of the film." In constructing the workplace, he purposely set out to make the "tone of the set friendly and easy." Not wanting to be another of "those asshole directors," Alexie insisted that the cast and crew ignore hierarchy. Further dismissal of established Hollywood production methods led Alexie to dispense with standard set shots and shot lists, declaring, "You might as well be making a cake instead of a piece of art."[11]

The film itself is something unique to see and hear—indeed, a "piece of art." Beyond its aesthetic qualities, some of which we will discuss later, it picks at the scab of Rosebud that covered the wound in *Citizen Kane*. In *The Business of Fancydancing*'s "postcolonial" America,[12] the main character, Seymour Polatkin, becomes an indigenous Kane/Cain, only able to achieve the American Dream by "selling out" his people. His riches seemingly come from the exploitation of his own people, his appropriation of their stories, which are a resource in the same way that the Colorado Lode was for Kane. Alexie is interested in this conflict. As he says in an interview with Aileo Weinmann:

> But the Western Civ idea of art is, you know, sort of bulldozing your way through everything—that you have absolute freedom. And so that's a serious dichotomy, and there's always a clash; that being a member of a tribe and being an artist are often mutually exclusive things. And so I was interested in that conflict, always have been, I live it. So I wanted to make a movie about it—because nobody had. It's easy to make the movie people want to see. And it's harder to make the movie people weren't expecting. I tried to make one people wouldn't expect.[13]

Alexie's artistic vision has come together in wondrous fashion in *The Business of Fancydancing*, just as Welles's did in *Citizen Kane*. Something, however,

moves these films beyond even that singular achievement. First appearing in the October 1969 edition of *Cahiers du Cinéma*, the oft-printed Jean-Louis Comolli and Jean Narboni essay "Cinema/Ideology/Criticism" sheds additional light on our project. In addition to their argument for a criticism of film grounded in Louis Althusser's work concerning ideology, they established for critical purposes four categories of fiction film, as follows:

a) The vast majority of films, whose form and content both carry and endorse the dominant ideology unthinkingly.

b) A small number of films which attempt to subvert the dominant ideology through both their content and formal strategies that breach the conventions of "realist" cinema.

c) Movies whose content is not explicitly political, but whose formal radicalism renders them subversive.

d) The reverse of category (c): movies whose explicitly political content is contained within the realm of dominant ideology by their conventional form.[14]

Thus, while Orson Welles may have made a "b" movie with *Citizen Kane*, Alexie's *The Business of Fancydancing* appears at times to be a loose combination of b, c, and d. Subversion, transgression, and reversal appear in the content as well as the production of this potential masterpiece.

Throughout the film's production from start to finish, Sherman Alexie was able to maintain his vision—in effect, having "the keys to the studio." The transgressive foundations of the process extended even to the profits made from the film. He says:

> In creating *The Business of Fancydancing*, we adopted a tribal, sovereign, and literary mode of making feature films. By shooting very low-budget on digital video, we were able to retain all creative and financial control, free from the commercial constraints of studio and independent film companies. By keeping this control, we are able to share profit participation in the film with the entire cast and crew, from production assistants to producers, from actors to production designers, thereby making the film a tribally-inspired collaboration of art and capital.[15]

This, then, is Alexie's triumph, at least on paper. A moving and evocative "piece of art" that transcends Hollywood production, it is thematically and structurally political, and able to stand up against anything that has been offered to us, mainstream or otherwise. It is a work that indicts American ideology, and postcolonial and identity politics, as well as the actions of its own author.[16] It is a "piece of art" that is potentially profitable, yet also gives

back to those who crafted it, rather than to those who merely financed it. Let us now examine the film itself, as we search for affirmation of its artistic and political value. Much of the story rests on explorations of identity, and it is there we commence.

We mark the introduction of shifting identity beginning with the credits. In them, the main character, Seymour Polatkin, is shown dancing a woman's shawl dance. *The Business of Fancydancing* then opens with a scene shot like home video, showing two friends at graduation from Wellpinit (WA) High School. The two characters can be read as two distinct versions of the director himself. The first is Seymour Polatkin (who represents Sherman Alexie's future Urban self). The second is Aristotle Joseph (who represents Alexie's Reservation self). They are, of course, the *co*-valedictorians of their class. "Buddies forever!" (Alexie's narrative device binding Urban and Reservation Indians) Aristotle tells the camera, which is held by their friend Mouse. Mouse is a decidedly Indian voice-over—that is, he speaks in a recognizable American Indian accent and rhythm. This accent may not be immediately recognizable to mainstream Euro-American audiences, but would make an impression on many Native American audiences; it is a "voice" they would recognize instantly. Euro-Americans would at least hear its distinctness and make the connection to American Indians based on what they are seeing, i.e., two visually distinctive characters speaking in the same fashion to the camera.

Later in the film, after going off to college, Seymour and Aristotle part ways. Seymour remains in college and Aristotle returns to the reservation (where Mouse has always been in residence). The film will follow the trajectories of these characters—with Seymour obtaining success in the white world, and Aristotle and Mouse absorbing and illustrating at least part of what is wrong with the reservation system in America.

More must be said about the character of Mouse. He is a Trickster in this story: a virtuoso violin player, at home on the reservation, drug-addled, -addicted, and -abused. His girlfriend is white, and his full or "real" name is never known (this is pointedly referred to in the film and is illustrative of a shifting identity); interestingly, though, in the aforementioned scene in which Mouse and Aristotle beat up a lost white man ("Earn that feather!"), we remember that the name tag fastened to his jacket reads, "Destiny." Melancholy and comic, bitter and vibrant, the story largely turns on his degrees of presence. He is the holder of the camera pointed back at Alexie and the audience; his death is the reason for Seymour's return to the reservation, and the acting out of the narrative tension that drives the story.

Mouse is then Alexie's third character and narrator; his Trickster identity allows an unmediated voice to speak onscreen. Like Lear's Fool, Mouse

speaks the truth. We would say that for *The Business of Fancydancing*, all three narrators are instruments of the implied author, Alexie. We are not done here, however. A fourth narrator, Sherman Alexie himself, appears in the film. "Aaaay Sey-mour" (hearkening back to *Smoke Signals* and its oft-imitated "Heyyyyyyy, Vic-tor"), he introduces himself at Mouse's funeral; his voice heralds an irruption in the comparative narrative threads of the film. There is an additional narrator—Steve, Seymour's boyfriend—who would seemingly provide us with a simple lover's view, but it may be more complex than that. Since Steve is non-Native, he becomes a white inquisitor and intrusion, filming Seymour in the bathtub, asking for a love poem, demanding of the author and the character a gift, a token, a sign of love. The figure of Mouse, though, is special. His use of the camera within the film is something unusual; he is a Trickster with a camera, yes, but he is more than a character. He is a truer voice of the implied author—a floating critic of the spectator as well as the writer/director.

Having established that Mouse will be a critic of the writer/director himself, we might be tempted to focus only on what he will have to say in the film. This would be a mistake, however. Alexie himself has written the cinematic version of *The Business of Fancydancing* in a self-critical manner. Let us consider a segment that begins with a close-up of a book entitled *All*

Mouse, Ari, and the Camera, floating critic of the audience and the author. Photo by Larry Estes.

My Relations. The title can be taken as a bit of an inside joke—the phrase is uttered in English or Lakota when one wishes to exit a sweat lodge or *inipi* (the characteristics of which sometimes appear in the film, and at least for Seymour, would likely include the "hot and sweaty" aspects of the pressure he feels all around him). If we are wondering whether or not this occurred to Alexie during the writing or production of the film, we return briefly to the *Iowa Review* interview:

JOELLE FRASER: True. You mention sweat lodges but only obliquely. I'm thinking of the image of the old woman in the poem who emerges from the sweat lodge.
SHERMAN ALEXIE: Yes, I'm outside the sweat lodge. In *Reservation Blues* I'm in it and I realized I didn't like it.

All My Relations is not an actual book of Alexie's—though the other books in the storefront window from which Seymour is reading are (we can see, if we look closely, *Old Shirts and New Skins, The Toughest Indian in the World,* and *The Lone Ranger and Tonto Fistfight in Heaven,* all displayed across the bottom of the window, which proclaims "National Indian Month"). While the character reads actual words written by Alexie, invented and self-reflective criticisms (e.g., "Seymour Polatkin is full of shit") attributed to a real website (indianz.com) appear in intertitles.

This theme of blending cinematic and actual worlds, spoken and seen, read and heard, appears throughout the film. Visual devices include mirrors—standard and beveled—as well as true and false texts and poems. Multiple layers of sound—music and dialogue—mimic multiple identities that often overlap during the course of the film, simultaneously uncovering and masking characters and their words. For example, when Seymour first meets Agnes (Roth, played by Michelle St. John), a half-Jewish, half-Spokane fellow student he has sought out in his capacity as leader (total membership including himself is one) of the American Indian Student Association, he asks her father's name. She replies, "Adams," which is the last name of the actor who portrays Seymour Polatkin (Evan Adams).

Alexie continuously critiques his own work through his characters. As in *Citizen Kane,* a journalist attempts to dig through the layers and lies of the main character. In a particularly tense sequence in *Fancydancing* (complete with visually disruptive 360° camera work), Seymour Polatkin tells the reporter (a real-life journalist who had interviewed Alexie previously), who accuses him of being "evasive," that he is a "a pathological liar." This line in the film provided by its writer/director could be read superficially in one of two ways—either Alexie has given himself a way out of being held to

any autobiographical truths, or he could be denying any responsibility for Indian authenticity (in a narrative nod to his intended Native audience). A third possibility emerges, one that incorporates these discourses. He both attacks himself for moving away from the reservation and indicts his chosen profession—that of writer (and a writer who makes money writing about the reservation, at that).

When the journalist questions Seymour about his Russian last name and asks, "Where does it really come from?" he replies that he'd rather not get into a discussion about "colonialism and the missionary position." The journalist continuously probes, but he refuses to provide the answers she wants, evoking a theme of resistance that appears again and again in the work. Echoing the innocence of Kane and "Rosebud," he tells her there is a place he goes, a dark safe place, like the "belly of a Whale," where he can be surrounded by a thousand people, but can still "just fade away." He says, "My body is still there, but I'm in a completely different place." It is a place that holds all his memories, dreams, and lies, and when they all "spin, spin, spin" together, that's when the stories come. Where these stories that make him so successful come from is in question. Are they a product of his own ability afforded to him in that "belly of the Whale," or are they stories he has stolen from Aristotle and other members of his tribe, a motif of resource exploitation that echoes Charles Foster Kane's riches obtained through his ownership of American mineral wealth (and eventual multifaceted empire) in the guise of the Colorado Lode?

Alexie pursues this reflective image, mining it in a self-critical fashion: "Ari and I are so close our memories have blended," Seymour tells the reporter. This statement would indicate Seymour's (read Alexie's) recognition that his stories written from his Urban perch of privilege are not merely his own. They belong also to those he has left behind on the reservation. His memories of his friend Mouse are, however, no blend at all (and are never alluded to as such); they belong to the Trickster entirely. Seymour proclaims his stories of Mouse to be "lies," and Mouse echoes the sentiment back on the reservation, deftly illustrating this area of contention between Seymour and the people he has left behind, even as he mines their lives for stories that make him successful. Mouse, too, says, "They're all lies . . ." and adds, "They're all *my* stories. It's like I'm not even alive. It's like I'm dead. Sing me a Memorial Song."

We then hear the voice of Mouse reading Seymour's poems; we are shown a stark black screen. The shot reconstitutes on Mouse's handheld camera (Trickster Alexie). He and Aristotle are back on the reservation tearing pages from the *All My Relations* book ("That one story—that's not even *him!*").

Reservation Alexie's voice comes through in Narrator #2: "Forgive him," Aristotle says as he burns the pages in a fire. The film cuts to Seymour (Urban Alexie) in the storefront window yet again; the theme of evasive narrative this time appears in his reading from a "real" (Alexie-penned) poem over other dialogue, words, violin, and drum. Back on the reservation, Aristotle and Mouse offer their own poem (and narrative commentary) in the form of a 24-second film (the length of the short film echoing the twenty-four frames per second of a standard film) entitled *How to Huff Gas*, in which they do just that. The distinctly different lives of Seymour in the city and of the friends that he has left behind on the reservation illustrate the dual existences Alexie continually indicts and questions throughout the film.

This dual existence is constantly under siege in the hands of Alexie. In another scene with the journalist, she mentions to Seymour that he's met "the president, the pope, and Robert Redford, yet 95% of his poems are about the Rez." "Not anymore," he replies. In Alexie's cinematic vision, "not anymore" is refuted by a multivocal recitation of Seymour's poems in the subsequent scene, where Indian voices meld, overlap, and then speak as one—one to the audience that is Seymour, themselves, and Alexie himself.

A few scenes later, we again find Seymour reading another "true" (Alexie-penned) poem from another false book—*Children of the Sun*—while Mouse and Aristotle further descend into a chemical-fueled hell.[17] Back on the reservation, they star in another Trickster-authored home movie/poem called "How to Make a Bathroom Cleaner Sandwich." The following scene contrasts this "homespun" method of self-medicating pain and despair with the "cleaner" accepted form found by Seymour in his life off the reservation. In the end, alcohol is no different in its results. We find Seymour (Alexie himself doesn't drink, having quit earlier in his career) at an Alcoholics Anonymous meeting, holding an eagle feather and surrounded by whites. This recovery program with a quasi-Indian motif is definitely not something in use by Ari and Mouse back on the reservation. The comparative narrative of the film then begins to collapse.

Alexie weaves the untied yet still-related threads of his three storytellers back together through audio and visual means. As Seymour reads from a poem he has written the night before, the voice of Aristotle begins to blend with, and then take over, the telling of the poem. The scene cuts back to Seymour in bed in his apartment, working on this same poem. Aristotle climbs into the bed, singing softly, preventing Seymour from further composition. The two sing and drum together; the scene ends with Aristotle kissing Seymour and saying, "Nice poem." From here (a few scenes later), we flash back to Aristotle (now presumably at peace with Seymour) being

accused of cheating on his college entrance exams, which are being administered at the wonderfully named "Colonial Aptitude Testing Service." As the scene in the classroom quickly deteriorates, it cuts to Ari in the familiar journalist's interview chair. Aristotle refuses to talk, let alone answer her (as opposed to Seymour's sibilant dishonesty), and as Mouse's violin swells in the background, the scene(s) end with him screaming at both inquisitors (and perhaps his audience, as well).

There is then a cut to a scene of another kind of inquisitor: these are people at a book signing surrounding Seymour. Interestingly, the books we assume he will be signing for them are only the two "false" ones, those penned by Seymour—*Children of the Sun* and *All My Relations*. We imagine (though we never actually hear onscreen) questions (from a non-Native audience—we never see, or at least never know in the narrative if there are any Indians in his audiences, with the exception of the appearance of Mouse around the time of his death) that are being asked of him as he weaves and shifts through webs of lies and self-promotion: "I trained as a trapeze artist in Morocco until I was 26 . . ." "You can contact my agent regarding my fee . . ." "This is the number of my hotel room . . . ;-}" This segment can be seen as Alexie's sole discourse with his literary (remember, *white* literary by Alexie's own reckoning) audience. In this context it also speaks to his cinematic (Indian) audience; Seymour (Alexie) lies and fabricates with relish to his literary audience—and they hang on his every word (by way of confirmation, later in the film, back on the reservation, Agnes Roth will ask him, "What's it like when you talk and white people listen?"). His previously admitted "pathological" lying is the one true instance of lying in the film, thus making for the sole appearance of a reliable unreliable narrator.

An unnamed and faceless narrator (representing the voice of the Reservation Indians) disrupts Seymour's placid urban life. Later that night, some time after the last bookstore scene (and after Seymour has given his hotel room number to an adoring fan), he receives a phone call that he knows is from the reservation (according to his white boyfriend Steve, "only Indians call at 3:00 in the morning") and refuses to answer it. Eventually Steve takes the call and tells him that someone named "Mouse" has died. Seymour and Steve argue about his going to the reservation for the funeral. Seymour refuses to take Steve with him, and tells him, "You're the opposite of Rez." Steve loudly whines, "*I'm* your tribe now." Here Alexie is speaking to his Indian audience, laughing with them at white attempts to incorporate Indians into Euro-American society.

Seymour returns to the reservation, where tensions play out. With his new car, and his expensive clothes and haircut, he appears to be hopelessly

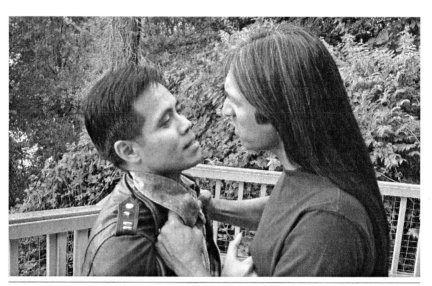

Seymour ("Little Public Relations Warrior") and Aristotle ("Tragic Warrior"). Photo by Larry Estes.

lost to those he left on the reservation. Seymour (in what can be read as an Alexie confessional) distances himself from his "forgotten" family during an argument with Aristotle, telling them, "Do you know how often this happens to me? Every goddamn place I go. Some stupid Indian with an attitude problem that has a bone to pick with me. . . . Think I haven't heard it all before?" Aristotle replies, "I'm not *any* Indian, man. . . . I'm not any Indian." Seymour replies, "Yeah. It was a two way street. Where the hell were you? You left me out there by myself." He continues, saying, "I deserved a better life than I was born into. But I made it better. With nobody's help. . . . I got no help from any of these goddamned Indians here; I had to do it myself." This infuriates Aristotle, who screams at him, "You write about these goddamned Indians! Tellin' me you did it yourself. These Indians that you write about? They're helping you. Every day. Each and every one of them. Every house, every story, every poem. . . . We've been helping you since you were born!" In this scene, Alexie turns the camera on himself in an extremely powerful commentary on the idea of community in identity.

An additional authoritative statement comes to us represented visually. Near the film's ending, Seymour is attempting to deliver a eulogy for Mouse. He is incapable of anything but an internal, unvoiced scream. Alexie, prolific writer, has used a poignant absence of words to say all that can be said at the death of the Trickster. Left with only his silent scream, we see him walk off as

Agnes sings (the song was composed by the actress Michelle St. John, who was told to do so by Sherman Alexie, who [over her protestations] told her that he trusted her to get it right, and put it in the film without so much as a review, let alone a rehearsal). Seymour, now outside, drives off, leaving Aristotle dancing in the rearview mirror. The film ends with Seymour back at his apartment in the city, climbing into bed, embracing Steve. Thus ends "*The Business of Fancydancing*: A Film by At Least 62 People, Indigenous and Otherwise."

To perhaps better understand (or not) what Alexie is saying (or not) in *The Business of Fancydancing*, we need to return to Joelle Fraser's *Iowa Review* interview with the writer/director:

SHERMAN ALEXIE: I guess a witness is all I am. I think as a writer, you're pretty removed. As much as I talk about tribe or belonging—you don't, really. Writing is a very selfish, individualistic pursuit. So in that sense I'm a witness because I'm not participating.

JOELLE FRASER: And literally, you're in Seattle and you're a witness on your old life on the reservation, on the other side of the state.

SHERMAN ALEXIE: Yes, I'm not there. And I'm not in the writing world; I'm outside a lot of circles.

This interview was conducted before *The Business of Fancydancing* was released. The interviewer is not the same woman who would play a journalist in the film. It is possible, though, to read some of Alexie's ambiguity here and wonder if it would appear later in *The Business of Fancydancing*. It is equally possible to read Alexie's last sentence in this section of the interview as a real longing to be inside some circles, and to wonder if this is not something Alexie would attempt to rectify in his cinematic vision.

A review of the literature finds no academic writing on the cinematic version of *The Business of Fancydancing*. A survey of the film's reception in the popular realm finds a wide spectrum of mixed reviews that coincidentally (?) get better the farther they recede from the Metropole, and the closer they get to Washington State (Alexie's "home turf," e.g., he was an ardent fan and supporter of the now-fled Seattle Supersonics) and the Spokane Reservation where the film is set:

"Pretentious when it should be penetrating, spasmodic when it means to be lyrical."—Megan Turner, *New York Post*
"Feels a bit like a racy after-school special."—Janice Page, *Boston Globe*
"The predictable conflicts ensue, often in histrionic dialogue declaimed through clenched teeth."—Melissa Anderson, *Village Voice*

"Four Frybreads."—Geneva Horse Chief, *RezNet*
"Once the viewer understands the movie's cadence and rhythm, the story gets better
and better until it builds into a crescendo that's emotional, dramatic and—best
of all, perhaps—fitting."—Jonathan Curiel, *San Francisco Chronicle*
"It bristles with a passion and intelligence too intense to allow the film's style to
seem pretentious."—Kevin Thomas, *Los Angeles Times*
"Alexie has at the very least proven himself a better director than such other
literary pretenders to the directorial throne as Norman Mailer and Thomas
McGuane."—Shawn Lev, *Oregonian*
"Not everything happens in order, not everything is explained, but it's all told
with a haunting honesty."—Moira MacDonald, *Seattle Times*

What did the author/writer/director have to say after the film's completion?

Fancydancing is not only odd because of its characters—you know, Indians—
but it's odd because of its aesthetic and its structure, so I think *Fancydancing* is
much harder for people to get into it. When I was making it, one of the crew
members said, 'You know, Sherman, you're making a film about a gay Indian
poet—It's too Indian for white people, it's too white for Indians, and it's too gay
for everybody—nobody's going to see this!' So, (laughs), I think he was right.
I thought he was right then, and I'm sure he is right now. It's going to have a
limited audience, always, but I don't care."[18]

Ultimately, we would do best to return to the earlier interview from the *Iowa
Review*. In light of his thoughts about memoir, the last line in the follow-
ing section would likely be the one Alexie himself might sign off with—an
appropriate voice of a Trickster:

JOELLE FRASER: Is it hard for you to switch hats, from poetry to screenplays to fic-
tion? Some people might say you're trying to find your genre.
SHERMAN ALEXIE: It's all the same. It's just telling stories.

The Business of Fancydancing is an example of Native feature-length film, an
exceeding rarity that we as teachers of the subject rush to embrace, and it
is something we long to have be brilliant. In an interview with Dennis and
Joan West, Alexie discussed the nature of Native representation in film, par-
ticularly in *Powwow Highway* (1989). In his opinion, "our expectations of
movies about Indians were so low then that we embraced a movie like *Pow-
wow Highway* simply because there was no other option." With *The Business
of Fancydancing* as a production of one of Native America's best-known

artists, we raise our expectations and hope for a masterpiece. As critics, we give it a close reading. And we find that *The Business of Fancydancing* is a unique and deep film, its professed "autobiographical" nature giving it a universality to which many can respond. That knowledge provides us with complex ways to "read" it. The universal acclaim and admiration for Alexie's National Book Award–winning literary works gives some readers and critics that easy path to follow in describing the successes and example of him as both a singular author and exemplar of the attainable American dream, where anyone regardless of class or ethnicity can "make it." *The Business of Fancydancing* provides another example of Alexie's work—however, one that is not so easily accessible and says some things that his literary readers and critics may not have expected, much less wanted, to hear. As America looks for shorthand ways to communicate with its indigenous neighbors, and would (to be kind) lazily prefer a singular and accessible spokesperson, Alexie powerfully declines this dubious award and pushes back against this misguided designation, saying in effect to America that there is no *one*, no singular person who could speak for us all. We are as varied and unique and complex as you are. The film speaks in many voices, as do we.

NOTES

1. Fraser, "Sherman Alexie's *Iowa Review* Interview."
2. Moore, "Decolonializing Criticism," 22.
3. Ebert, *Great Movies*, n.p.
4. Alexie, *Old Shirts and New Skins*, 53.
5. "Sherman's Sandbox: Behind the Scenes," *The Business of Fancydancing*, DVD.
6. "The Business of Fancydancing," Fallsapart.com.
7. "Behind the Scenes," *Fancydancing*. Alexie is referring to the avant-garde Dogme 95 movement in cinema that was initiated by directors Lars von Trier and Thomas Vinterberg.
8. "Behind the Scenes," *Fancydancing*.
9. Ibid.
10. Ibid.
11. All quotes in this paragraph are from "Behind the Scenes," *Fancydancing*.
12. With nods to others' as well as my own thoughts on this term that would denote the colonial period's having ended, which it has decidedly not, I'll use it here for conversation's sake. I refer to a concept I term "endocolonialism" elsewhere; it seems a far better term for the current state of affairs.

13. Weinmann, "Hold Me Closer, Fancy Dancer."
14. Reprinted yet again, this time in Richard Maltby's *Hollywood Cinema*, 532.
15. "Behind the Scenes," *Fancydancing.*
16. Alexie appears in cameos (not quite the starring role that Welles gave himself in *Citizen Kane*) in the film, mocking the character of Seymour, who is at least a partial representation of the author himself. For confirmation of these acts of self-projection, we can turn to the Aileo Weinmann interview: Alexie says, "It can be so awful making films—18-hour days, you know. I guess I tried to treat it like it wasn't that important, even though I was torn emotionally, because the work got pretty autobiographical." Sherman Alexie, interview by Aileo Weinmann, "Hold Me Closer, Fancy Dancer: A Conversation with Sherman Alexie."
17. "Children of the Sun" is also the name of a history of the Spokane written by David C. Wynecoop, privately published in 1969 at the setting of much of this film, Wellpinit, WA. According to this work, which is available online, "The word 'Spokane' is generally accepted as meaning 'Sun People' or 'Children of the Sun,' although the interpretation is somewhat controversial." See http://www.wellpinit.wednet.edu/sal-cos/cos_ch01.php. In no way wishing to raise any controversy or disrespect the name at all, I will add that given Alexie's penchant for pop-culture references, and his age and sense of humor, he may have merely just liked Billy Thorpe's 1979 radio hit of the same name.
18. Capriccioso, interview with Sherman Alexie.

WORKS CITED

Alexie, Sherman. *The Business of Fancydancing.* Written and directed by Sherman Alexie. FallsApart, 2002. DVD. FallsApart/Wellspring, 2003.
———. "I Hated Tonto (Still Do)." At http://www.fallsapart.com/tonto.html (December 15, 2005).
———. *Old Shirts and New Skins.* Los Angeles: American Indian Studies Center, University of California, 1993.
Bordwell, David. *Classical Hollywood Cinema: Narrational Principles and Procedures.* Madison: University of Wisconsin Press, 1985.
"The Business of Fancydancing." At http://www.fallsapart.com/fancydancing/ (December 15, 2005).
Capriccioso, Robert. "Sherman Alexie." Interview, March 23, 2003. At http://www.identitytheory.com/interviews/alexie_interview.html (May 1, 2006).

Citizen Kane. Directed and produced by Orson Welles. Screenplay by Orson Welles and Herman J. Mankiewicz. RKO, 1941. DVD. Criterion, 2005.

Ebert, Roger. *Great Movies.* May 24, 1998. At http://rogerebert.suntimes.com/apps/pbcs.dll/article?AID=/19980524/REVIEWS08/401010334/1023 (December 6, 2005).

Fraser, Joelle. "Sherman Alexie's *Iowa Review* Interview." 2001. At http://www.english.uiuc.edu/maps/poets/a_f/alexie/fraser.htm (April 29, 2006).

Horse Chief, Geneva. "Fancydancing with Death." *RezNet.* At http://www.reznet news.org/culture/020916_fancydance/ (May 1, 2006).

Louis, Adrian C. *Skins.* 1995. Granite Falls, MN: Ellis, 2002.

Maltby, Richard. *Hollywood Cinema.* 2nd ed. Oxford: Blackwell, 2003.

Moore, David L. "Decolonializing Criticism: Reading Dialectics and Dialogics in Native American Literatures." *Studies in American Indian Literatures*, series 2, vol. 6, no. 4 (Winter 1994): 7–35. At http://oncampus.richmond.edu/faculty/ASAIL/SAIL2/64.html (July 8, 2008).

Weinmann, Aileo. "Hold Me Closer, Fancy Dancer: A Conversation with Sherman Alexie." At http://www.filmcritic.com (December 6, 2005).

West, Dennis and Joan M. "Sending Cinematic Smoke Signals: An Interview with Sherman Alexie. *Cineaste* 23, no. 4 (Fall 1998): 28–32. At http://www.lib.berkeley.edu/MRC/alexie.html (November 14, 2007).

Elusive Identities: Representations of Native Latin America in the Contemporary Film Industry

ROCÍO QUISPE-AGNOLI

THE REPRESENTATION OF LATIN AMERICAN NATIVENESS IN CONTEMporary motion pictures uncovers the consumption of an indigenous subject that is usually victimized, eroticized, infantilized, and/or exoticized in the film industry. I consider each of these processes—victimization, infantilization, eroticism, and exoticism—varieties of the fictionalization that is set in motion when filmmakers intend to transmit their understanding of a pre-European nativeness that developed in the territories today known as Latin America. In spite of different backgrounds, careers, and agendas, U.S., European, and Latin American filmmakers share a common goal when they address nativeness: representing[1] the indigenous difference[2] through the fictional construction of the "Indian" that will convey their understanding of "authentic" nativeness. In this process of representing the indigenous difference, distortion[3] takes place. As Homi Bhabha explains, cultural nationalist criticisms "represent the problem of difference and discrimination as the problem of image and its distortion."[4]

In this article I study this distortion: the representation of the Latin American indigenous difference through processes of cinematic fictionalization that aspire to display Latin American nativeness. To support my analysis, I refer to examples from the U.S. film industry vis-à-vis motion pictures of Hispanic/Latin American production of the last decades of the twentieth century and the first years of the twenty-first century, specifically films within the genre of "historical cinema."[5] The primary investigation deals with the intentions or

agendas that steer the process of fictionalization of Native/indigenous voices and images of Latin America. Does this fictionalization respond to a contemporary colonizing gaze that still repeats the stereotypes and images set by the official European histories of the sixteenth-century *conquistadores*? Or is this fictionalization used to reinvent voices and images of Native Latin Americans who could not be known and/or have been relegated to being mute participants in their "own" historical discourse?

The answers to these questions will frame my analysis of cinematic representations of early Indians of the Americas, with special emphasis on the Andean region. In order to contextualize my analysis, I will refer to Hollywood productions such as *Apocalypto*, directed by Mel Gibson and released by the end of 2006 and intended to explain the fall of the Mayas prior to the arrival of the Spaniards. Compared with Gibson's relative success in the global market, *The New World*, directed by Terrence Malick and released in 2005, offers a contrast with its lack of success in the box office. The second part of Malick's film tells the story of Pocahontas's discovery of urban Europe as a new world. Malick's film will then bring me to a 1989 Mexican production, *Cabeza de Vaca*, directed by Nicolás Echevarría, which refers to the eight-year journey of a sixteenth-century Spanish explorer, and his encounter with several indigenous groups of the southern coasts of North America. This film, as we will see, has been/is misunderstood even within scholarly circles because, as I argue, its visual rhetoric assumes a viewer who expects verbal communication in his/her language.

The review of these films that depict early Amerindians sets the stage for my discussion of the representation of Andean people in the film industry. Departing from the notions of "colonial desire,"[6] "stereotype,"[7] and "ficto-criticism,"[8] I examine the filmic representation of the early sixteenth-century Andeans and the Inca ruler in Irving Lerner's *The Royal Hunt of the Sun* (UK/U.S. 1969), the only film produced on the Spanish-Andean encounter. Lerner's film focuses on the exoticism of the Inca Empire, and its fall incarnated in the tragic end of Atahualpa, the last sovereign emperor of the Tahuantinsuyu, or the Inca Empire. *The Royal Hunt of the Sun* approaches Gibson's representations of early Amerindians as noble savages who must be conquered because they are still "primitive." To address the representation of Andean people in this film, I will also refer to another film that focuses on the early mestizo identity, and a contemporary historical novel that intends to represent Incas, Aztecs, and Taínos. The quite unknown film *The Elusive Good* (*El bien esquivo*, 2001), directed by Augusto Tamayo San Román, intends to portray the ambivalent identity of a mestizo who, after the death of his father, must return to early colonial Peru in search of his Spanish-Andean identity.

The Dogs of Paradise is a 1983 novel by Argentinean writer Abel Posse. I use both texts as counterexamples to Lerner's filmic agenda since both offer, I contend, examples of "fictocriticism," an alternative path to what could happen if authors and filmmakers would "let the Indian speak."

In the scholarly and artistic search of the "authentic" Indian, the specialists locate the indigenous difference under categories of "race," usually defined by phenotypes and purity of blood; "primitivism," that could be understood as barbaric or childlike; "eroticism," where the naked body of the Indian becomes the object of desire; and "land ownership," where the only true Indian is the one who lives in rural areas or communities in Latin America or federally recognized reservations in North America. In approaching the representation of Amerindian images and voices in these films, I propose that the search for aboriginal, Native, or indigenous identities in the Americas remains unresolved in these films, since these representations also remain in the limits of difference and otherness as perceived by Western eyes. In addition, I question the awareness that film directors, scholars, and educators may have of their representations of nativeness that is culturally mediated by their own concepts of what is Native and non-Native. Finally, I reflect on what may be options for the artist, the scholar, and the teacher seeking some consistency with the goal of "giving voice to the historical minorities" associated with Native peoples in the Americas.

Historical cinema, similarly to the historical novel, reproduces historical narratives. It intends to represent historical discourse. Both mediums, cinema and novel, simulate, then, the rhetoric of historical writings and use fictionalization to build their own interpretations of historical records. If we agree with the premise that historical cinema offers a fictionalization of historical texts—which are already a partial representation of past events—we can also understand that historical films use two devices in their construction: intertextuality and fictocriticism. By considering Julia Kristeva's "Word, Dialogue and Novel," Norman Fairclough indicates that intertextuality implies the inclusion of history and society into a text (film or novel in this case). In Kristeva's understanding, the past is rescued and reinterpreted in order to pursue both variations in the new writer and the reader. Kristeva means that the literary text absorbs and is built upon texts from the past. These texts constitute the major artifacts that shape history. By "the insertion of the text into history," she means that the text responds to and reworks past texts, and in so doing helps to make history and contributes to wider processes of change.[9] One can extend this understanding of intertextuality to contemporary cinema, visual, and media studies.[10]

With the current technological globalization of the world, enhanced by the advent of mass media and then the Internet, what Gunhild Agger calls "the intercultural transfers," ideological stereotypes about others, are no longer in the exclusive hands of specialists who acted as mediators (scholars, politicians, educators), but in the direct consumption and negotiations of readers and viewers and their texts:

> The translation of books and plays, the importing and exporting of films, and cross-national radio-listening have all played a major role in international transfers, and will in all likelihood continue to do so. However, during the past few years the more direct links between various cultures have increased, mainly due to global television and the Internet. As a result, the scope of negotiations of a more direct nature among various cultures has increased, from local to national cultures, and from the regional to the transnational. If the concept of intertextuality is to be seen as more than just another abstraction, it must be set in relation to these ongoing negotiations which have to do with questions of national identity and intercultural transfers.

While I concur with Agger's argument on the consequences of the cultural globalization that gives readers and viewers more direct access to texts, I must add that this process also contributes to the maintenance of stereotypes that dominate First World views of indigenous peoples of the Americas. At the same time, that process may open the door to new ways to look at the issue of Amerindian nativeness.

In addition to intertextuality in historical cinema, the concept of fictocriticism may prove useful to understand the contribution of fictionalized representations of nativeness. Fictocriticism may appear when the creator of historical narratives (the filmmaker or the novelist) departs from historical sources that claim to reflect factual events as they actually happened and incorporates them in her textual production. With the creation of texts, fictocriticism develops new options of meaning. Fictocriticism does consider fiction and criticism as a union of characteristics for analysis. Amanda Nettelbeck defines fictocriticism as a union between literature and postmodernism:

> It is here, at the intersection of literature and postmodernism that fictocriticism appears . . . its interest lies in its capacity to adapt various literary forms. Fictocriticism might most usefully be defined as hybridized writing that moves between the poles of fiction ('invention'/'speculation') and criticism ('deduction'/'explication'), of subjectivity ('interiority') and objectivity

('exteriority'). It is writing that brings the 'creative' and the 'critical' together . . . in the sense of mutating both.[11]

Fictocriticism, although it originally emerged in the field of women's writings, is a concept that is useful to explain how the fictionalization of indigenous characters whose voices have been muted in Western official histories are represented within the fiction with a critical view of European discourses. With these concepts in mind, I intend to reflect on cinematic historical narratives that may contain colonial discourses and postcolonial readings, under the lens of fictocriticism, of Latin America's coloniality, as well as the director's struggle in the search for the representation of an elusive Native Latin American identity.

Historical cinema and historical novels are not well regarded by professional historians. For historians, historical cinema is a genre of fictional representation and should not be taken as a means of historical depiction. Donald Stevens explains this clearly by quoting Robert Rosenstone:

> As Rosenstone has written, "Let's face the facts and admit it: historical films trouble and disturb (most) professional historians. Why? We all know the obvious answers. Because historians will say, films are inaccurate. They distort the past. They fictionalize, trivialize, and romanticize important people, events and movements. They falsify history." And some filmmakers are relatively immature, unreflective, disingenuous, even callous about the past. Joffé's *The Mission*, for example, ignores the conventional racism of the Jesuit missionaries in eighteenth-century Paraguay and turns centuries of historical certainty upside down to provide a dramatic and heroic ending for favored characters.[12]

In Rosenstone's view, professional historians seem to still believe that they exclusively hold the truth about the past, while filmmakers narrate freely, and according to their personal agendas, the factual past that only historians seem to be able to decipher, preserve, and transmit. What actually bothers the professional historian is the free circulation of historical information through mass-media channels that have the capacity to reach more audiences than just the readers of scholarly works of history. Filmmakers are not free of guilt in this analysis either: there are those who are captivated by the illusion of the "factual truth" when they intend to present their films not as fictional recreations of the past but rather as alternative ways of telling the truth. If filmmakers accept that theirs is a partial representation and a proposal of what may have been the early indigenous voice of Latin America—that is, if filmmakers accept the constructed nature of their representations—in a way

that most historians do not accept, they are better placed to offer a criticism of the past from the realm of fiction that is more consistent in itself than the presumption of transmitting the "truth" of past events. European histories of Latin America barely question the "truth" of the facts that they integrate into their narratives. European histories proclaim that 168 Spaniards were able to conquer the Inca Empire in one day by taking Atahualpa prisoner in spite of an army of 10,000 men that were, inexplicably to the Spaniards, waiting outside Cajamarca, the site where Atahualpa was captured.

Understanding the fall of the Incas from an indigenous perspective includes explanations on why this army did not attack Cajamarca as soon as the Spaniards arrived there, why they let the Inca be executed, and that the imprisonment and death of Atahualpa did not imply the fall of the Inca Empire. Alternative historians such as John Hemmings, whose work includes documents provided by Andean people that were silenced by the Spanish history, have demonstrated that a war that lasted almost forty years followed the death of Atahualpa in 1530, and it was only after the death of Inca Tupac Amaru I in 1572 that the European authorities of the six-teenth century announced officially that the Inca Empire had been finally subjugated by the Spaniards. Furthermore, newer archaeological findings demonstrate that the numbers of men recorded by Spanish chroniclers—in which usually the Spaniards are outnumbered ten to one by their Inca enemies—are built upon false data, and that if the Spaniards were able to win this or that battle, like the siege of Lima, it was mainly due to the inter-vention of Andean allies who wanted to bring the Inca rule to an end.[13] The control of the circulation of historical information is obviously one of the most crucial keys to the maintenance of the imperial power of the *conquis-tadores* in the New World. This control persists in today's representations of the early history of Latin America.

Latin America's colonial experience did not end with the nineteenth-century wars of independence. Although the emerging Latin American nations gained political independence from European empires, the colonial discourses kept their central place in the ideology and dominating culture of the "new" societies of the New World. The colonial condition of Latin America can be experienced in discourses that are displayed today in a vari-ety of daily situations and formal academic interpretations of our textual legacy of the past five hundred years. The colonizing perception of Latin American nativeness is displayed in the film industry and intends to depict the indigenous past of pre- and post-European Americas. Mimicry of Amer-indian agency seems to be one of the "contributions" of the film industry, such as the global capitalist Hollywood by means of Mel Gibson's *Apocalypto*.

Leaving aside the historical and ethnological misunderstandings that supply this film, Gibson works with the two most known stereotypes about indigenous people of the Americas: the noble savage and the ferocious cannibal.[14] While the main character, Jaguar Paw, belongs to an idyllic Mesoamerican clan and is highly family oriented, the unforgiving Maya hunters are extremely cruel and bloodthirsty in pursuing their selfish purposes. There are no in-betweens in this extreme representation of the pre-Hispanic Indians, and this film has been crafted as action cinema with ostensibly graphic displays of violent acts with gory details of pain and torment. The Hollywood vision of this violent, bloody, erotic, and disturbing pre-Hispanic Mesoamerica, where Indians can only be hunters or hunted, includes in its last scene the salvation of the noble savage by the European Christian newcomer. Gibson's film reproduces in this way the stereotypes of colonizing discourses that justify the "just war" against noncivilized strangers, and pose Christianity as the only means of salvation at apocalyptic times. This film demonstrates that the Mesoamerican Indians were corrupted enough from within in order to end and give place to a new era of civilization: the European Christian modernity. In this way, and within the best tradition of a neocolonial inscription, Gibson's film celebrates and justifies Western colonization of the Americas, and the assimilation of the victimized savage and the barbaric "other" into Christianity. Gibson comes from a Western tradition of colonial practices: observing, deciding for the other, without any possibility of dialogue, negotiation, and interaction. The indigenous Mesoamerican other is then tamed and westernized. In the best Hollywood money-making tradition, the manhunt is designed within the frame of a spectacular and action-filled chase scene. Thus, the Hollywood viewer is satisfied at the end, and the colonizing *Apocalypto* is nominated for a 2007 Golden Globe Award in the category of best foreign-language film. After all, no one has yet filmed a Hollywood film in Yucatecan Maya.

Let's compare Gibson's *Apocalypto* performance in the global film market with another quite misunderstood narrative: Terrence Malick's *The New World*, where the main character is a romanticized Pocahontas. The film explores her relationship with the New World's strangers John Smith and John Rolfe. This film, differently from Gibson's *Apocalypto*, does not perform as a Hollywood success because, according to many of its viewers, it is slow, silent, and boring. The story starts in Virginia in 1607 and culminates with Pocahontas's journey to England, where she is introduced to the Court of King James. Her story is one of the turning points of a Native New World, leading to the establishment of the colonies, and taking the first steps to what became the near eradication of Native American culture. She

is seen alternately by the general viewer as a savior and a betrayer. The film starts out entirely from John Smith's point of view, but it slowly moves to become entirely Pocahontas's point of view. The film stretches out on both sides of the Atlantic, trying to show the English landing in Virginia, and the reactions—ranging from awe to greed—of the people involved when they come to their new worlds: John Smith to America, and later, Pocahontas and Opechancanough to England. Not only John Smith but also the Native Americans in this film conclude that there are other worlds, and Europe, not only America, is regarded as a new world from the Amerindian perspective. As said before, Malick's film has been criticized by the general viewer because of its silence and lack of action. I contend that the film's ongoing use of silence, and the general and continuous misunderstandings as a result of poor communication constitute a featured characteristic of the Amerindian-European colonial experience.

Malick's use of silence reminds us of another equally misunderstood film: *Cabeza de Vaca*, by Mexican director Nicolás Echevarría. The main character of the film, Alvar Núñez Cabeza de Vaca, was a member of an expedition that set out from Spain to the New World in 1527 under the command of Pánfilo de Narváez. After losing their ship off what is now Tampa Bay, the members of the expedition went their separate ways. This was the beginning of the remarkable overland journey for which Cabeza de Vaca is known. It ended in 1536 with his arrival at the Spanish camp at Culiacán on the Pacific coast of Mexico. In the eight years of what becomes a kind of pilgrimage, Cabeza de Vaca lives with various Indian tribes, alternately as a slave and as a shaman of great healing powers. As he teaches his captors, he is taught by them. At the end of his journey, the conquered Spaniard learns to appreciate the sustaining mysticism of a culture that the *conquistadores* have sworn to stamp out.[15] Similarly to *The New World*, *Cabeza de Vaca* is dominated by silence, and by indigenous languages that are not translated with subtitles. Thus, the viewer is forced to experience first-hand the lack of communication with others who do not speak European languages. In addition, as Cynthia Stone indicates when explaining the best features of the filming of colonial Spanish America, films like *Cabeza de Vaca* "encourage a strong physical identification with the experience of people whose lives differed markedly from our own, a sense of disorientation, of beauty and horror, the posing of questions without easy answers."[16] In consequence, this film has not gone beyond the scholarly circle of film studies, and it is usually misunderstood unless one reads Cabeza de Vaca's original 1542 account, *Naufragios*.

In the history of filming Latin American nativeness, few films have

chosen to focus on the indigenous subject as its main character. *Cabeza de Vaca*, as its title indicates, tells the story of the Spanish explorer precisely from the perspective of the Spaniard who gets lost and does not understand the indigenous world within which he is a castaway. Its silence indicates his perplexity before the unknown, in a similar way to Malick's Pocahontas. Gibson's creation of Jaguar Paw, by contrast, falls into the trap of the colonizing stereotypes of the noble savage and justifies the Conquest of Mesoamerica. Another problem that is evident in films that focus on indigenous subjects is the trap of primitivization, which is part of the eroticization and exoticization of the Indian body. Luis Fernando Restrepo has studied the ways in which Echevarría's film primitivizes the "other." Cabeza de Vaca's journey is constituted by his discovery of the primitive other. And the process of primitivization, according to Restrepo, takes places in this film through the focus on the body, which is the site of otherness par excellence: "Amerindian bodies are turned into rich, exotic textures that can be gazed at (consumed) by the metropolitan spectator."[17] In this way, the intended focus on the indigenous subject in these films lacks a critical reflection while creating this fiction. In Restrepo's words, "Considering current scholarship on Colonial Latin America, Echevarría's film does not offer a radically different view of the colonization. It simply reflects a growing concern for a less Eurocentric vision of the Encounter."[18]

Thus far, I have argued that cinematic representations of early Amerindians, like those of the three films mentioned here, use fictionalization to serve different agendas. Gibson's film seeks to validate an ideological agenda, which is the providential role of Christianity in world history. Malick's and Echevarría's films seem to focus mainly on the lack of mutual understanding, and the divergent pathways of Amerindians and Europeans who are forced to converge but do not listen to each other. With these approaches in mind, I address two films that depict early indigenous people of the Andes in the first century of the Spanish Conquest and colonization. My goal is to pinpoint the features that are emphasized in these films to convey "authentic Andean-ness" to their viewers. Seen in this light, I intend to analyze the construction of "Andean-ness" in *The Royal Hunt of the Sun* and compare it with representations in other historical narratives such as *The Elusive Good* and *The Dogs of Paradise*.

The Royal Hunt of the Sun was produced as a Hollywood epic about the Incas in 1969 and preceded all the films on which I have just commented. Directed by Irving Lerner, this film is based on the theatrical play directed by Peter Schaffer and written by Peter Yordan.[19] *The Royal Hunt of the Sun* reproduces many theatrical effects of the play, and the result is a film with

pacing that is slower than can be found in other epic films of its time, such as *Ben Hur, The Ten Commandments,* or *Cleopatra.* The plot tells of the arrival of 168 Spaniards, led by the ambitious Francisco Pizarro, in the land of the four quarters, or "Tahuantinsuyu," the Quechua name for the Inca Empire. Pizarro is accompanied by his second-in-command, Hernando de Soto, and Vicente de Valverde, a Catholic priest determined to spread the shining light of Christianity. Young Martin, a character who seems to work as a page and scribe, serves as mediator between the viewer and the story. At the beginning of the film, Francisco Pizarro is obsessed with chivalry, glory, and honor. "The world is going to remember me," Pizarro thinks while he presents his case to the court of the Spanish King in 1528. Throughout the development of the story, however, the *conquistador* becomes increasingly disillusioned, as his crisis of faith also unravels. The conversion of the Incas by Valverde proves unsuccessful, and the Spanish priests demand that Atahualpa be taken prisoner, whereupon the Inca ruler is seized and his escort murdered. Pizarro asks for a ransom in gold large enough to fill Atahualpa's cell, and as the Incas work to fulfill the demand, Pizarro becomes acquainted with the noble leader and is partially convinced of his divinity. As the ransom is delivered, officers in Pizarro's command, fearing Inca reprisals, threaten to mutiny unless Atahualpa is executed, and the priests, unsuccessful in their attempts to convert the Incas, concur. Although Atahualpa guarantees Pizarro's personal safety, the Spanish soldiers sentence Atahualpa despite Pizarro's protests. The Inca leader dons a golden mask, assuring everyone that the Sun God will not allow him to die. After the execution, Pizarro, with faith in the ruler's prediction, removes the mask to find Atahualpa dead. He then begins to realize the enormity of the crimes he has perpetrated against the Incas.

The representation of Atahualpa, the Inca ruler, and the Andean people in this film are clearly marked by the director's view of the Indians through the lenses of eroticism and primitivism that translate into their exoticization as protagonists of a lost past. Space and musical effects provide the context of the exotic Inca and his people, followed by the design of flat characters that are either good or evil. The two main characters, Atahualpa and Pizarro, are more developed, although they remain within the limits of stereotypes: the noble savage and the greedy *conquistador.*

Once the Spanish army has set foot on the Pacific coast of South America, Andean people are depicted as owners of a vast territory organized as an empire ready to be conquered. The Andean space is at first shown as mainly rural, especially when contrasted with the Spanish cities that make up part of an extensive list of photographed locations at the beginning of the film.[20]

The main action, however, takes places in an Andean urban setting: the main square of Cajamarca and the private quarters where the Inca was held prisoner. Cajamarca, located in the north highlands of Peru, used to be a rest area for the Inca rulers on their way to Quito. Stonework and symmetrical geometric designs characterize the Inca architecture, and Cajamarca is no exception. The *conquistadores*, hidden in the buildings that surround the main square, wait for the Inca and his court to enter the site in a ritual that is actually a trap to capture the Andean ruler. In this way, the sacred space of encounter between the son of the sun and the newcomers becomes the battlefield of an unannounced war.

The construction of the Andean space in this film is accompanied by background sound that reinforces the exotic nature of the distant Andes and its clash with the Spaniards. Lerner uses the music score of the play, composed by Marc Wilkinson, which includes mainly Spanish flamenco music, a female singer who performs opera-like solos, and sounds produced on instruments such as saws, reed pipes, drums, and cymbals. Schaffer's intention was to reproduce sounds that would be strange and disturbing to a Westerner in order to create his understanding of the aural world of exotic sixteenth-century Peru, and Lerner follows his lead in the making of the movie. For example, when Pizarro's group first enters Peru's coast, the music has a fade-out of baroque that was played in the court's scene into a more "natural" style. The instruments are no longer brass; drums, reed pipes, cymbals, and chanting are audible. Such music is used at various times throughout the movie when there seems to be Inca "control"—for example, when the Spaniards are wandering through the mountains, and when Pizarro is waiting for the resurrection of Atahualpa. One memorable scene for the viewer is the first battle between the Spanish and the Incas. The background music is flamenco, associated with southern Spain and easily recognizable as Spanish. This music is played when the Spaniards confront the Incas and gain control over them in what appears to be a Western epic battle between Europeans and barbarians.

As for the characters of this film, most are rather flat; whether greedy or not, all Spaniards seem to fall in the former group, while the Andeans, except the Inca and his closest advisers, remain silent. One should not forget that Lerner's historical film intends to fulfill the epic category of other films in its time. And as an epic film, this motion picture focuses on the interaction of two main and opposing characters: the Inca ruler Atahualpa, and the greedy *conquistador* Francisco Pizarro. Atahualpa's name is introduced in the film by captured Indians or messengers referring to him not only as the lord of the four quarters of the world, but also as the son of the Sun God

and therefore as god himself, while Pizarro questions Atahualpa's earthly illegitimacy according to European standards:

PIZARRO: Is Atahualpa the bastard?
INDIAN: He is the son of the Sun, he needs no mother. He is god.

Revered and respected by his people, the Indian messengers and *curacas* are stunned by the intrusive curiosity of the Spaniards, which translates, in their view, as a lack of respect towards their Sapa Inca. The Indians who answer the questions of the Spaniards kill themselves, and later on, the carriers of the Inca's throne take turns holding him during battle till their death; these instances are examples of Indian respect and unconditional loyalty towards their ruler. A westernized Indian interpreter, Felipillo, appears in the film's first scenes. Felipillo—like Malinche in the conquest of Mexico—is regarded as the first Andean traitor in the history of the Spanish colonization. However, since sound editing takes care of the transition from Quechua to English within the first minutes of the film, Felipillo's presence is no longer needed as a mediator in the remainder of the film.

In general, one can say that this film—like the play from which it is adapted—is an epic exoticization of the Incas and their majestic, although fast, fall to a small group of Spanish soldiers. This exoticization is mostly evident in the representation of Atahualpa as a half-naked, tall, muscular, well-built, and tanned Inca barely covered by a loincloth and sometimes by a long cloak of white feathers, in addition to some royal accessories like the feathered or golden headdress. He wears a chain of bells around his chest. In this film, Atahualpa looks more like the Caribbean *caciques* in warmer tropical islands, with an eroticized half-naked body and natural physical beauty. One must remember that Cajamarca is located in the northern highlands of Peru, approximately 2,700 m (8,900 ft.) above sea level. It has an equatorial climate, so it is mild, dry, and sunny, but not warm enough in November for Atahualpa to be half-naked as portrayed. The Inca did not wear a chain of bells on his body, either. He would usually wear a shirt-tunic, called *uncu*, and would carry in front of his forehead the *mascaypacha*, a scarlet fringe that was one of the royal emblems of the Sapa Inca.[21] None of these elements are part of Atahualpa's representation in this film. In addition, the character is played by British actor Christopher Plummer, whose blue eyes could not be hidden under contact lenses in 1969. In order to reproduce his majesty, Atahualpa appears with a very expressionless face. *The Royal Hunt of the Sun* attempts to transmit the message of royalty as seen in the "other," assumed to be barbarically different from Europeans, and whose intentions cannot be easily decoded in his gestures and body language. In this way, it

is interesting to observe how, in addition to his desirable body, the actor builds his representation of indigenous otherness in Atahualpa. In general, the Sapa Inca behaves very regally, as if he is important and anyone who is watching him would know this just because of the way he moves, talks, and acts. He is very pensive, but breaks into his native language every now and then, and makes whistling, wheezing, and screeching noises. The sounds he makes resemble those made by animals and provide the Western viewer with an immediate association with nature and the wild.

Atahualpa is also shown as curious, naive, proud, and angry. When confronted by the Spanish "requirement,"[22] Atahualpa displays two sets of actions to manifest his Indian ways of knowing and rejection. While Valverde is reciting the religious requirement for conversion to Christianity, the Inca barely looks at him, and when he finally does, he does so with great curiosity. Valverde tells Atahualpa, with the aid of the interpreter, that he is speaking in the name of God, whose word is contained in the Bible. Atahualpa then looks at the Bible, takes it in his hands, and intends to know the object by looking at it; scratching, licking, and smelling it; and trying to hear what it has to say. Unsuccessful in retrieving the word of this god, an angry Atahualpa throws it to the ground and spits on it. This public rejection is the signal that the Spaniards take to start the battle against the Incas. While Atahualpa is trying to know the unknown—the book—his actions resemble those of a small child getting to know the world around her. This childish curiosity shows up again later when he is amazed by the power of writing, and recognizes that it is Martin, the scribe, who is the actual king in the room (Francisco Pizarro, Hernando de Soto, and Atahualpa are in the room with Martin) since he can read and write like no one else. Likewise, Atahualpa seems moved by Pizarro's concern about his announced execution. The Inca believes firmly that he is the son of the sun, and that he will come back to life the next day when the sun rises. His faith in the sun's power is so unconditional that Pizarro believes, for a short period of time, that he might come back from death.

Erotic, exotic, primitively curious, naive, and innocent as a child, the Inca characters in this film are also portrayed as carriers of an enigmatic knowledge of their world that is unintelligible to the Europeans. The following dialogue between friar Valverde, two Inca advisers, and Atahualpa illustrates this point:

VALVERDE: There is no conversion possible for this man. Sin has many forms and this is one. . . . Tell me, I am only a simple priest, as an undoubted god, you'll live forever here, on earth.

INCA ADVISERS: Here on earth, our god comes again and again, one after the other, to protect the people of the sun. Then he goes up to his great place in the sky.

VALVERDE: What if they are killed in battle?

INCA ADVISERS: If it's not the sun's time for them to go, then He will bring them to life back again at the next day's light. . . . This means all gods have died in sun's time.

VALVERDE: Clever.

INCA ADVISERS: No, truth!

VALVERDE: Tell me, how can the sun have a child?

INCA ADVISERS: How could your god have a child since you say he has no body?

VALVERDE: He is spirited inside us.

INCA ADVISERS: Your God is inside you? How can this be?

ATAHUALPA: They eat him. First it becomes a biscuit, and then they eat him.

INCA ADVISERS: We have seen this. At praying you say "this is the body of our God."

ATAHUALPA: And then they drink his blood. Here in my empire we not eat men.

In the former dialogue, the existence and belief in Jesus Christ and Christianity are challenged by Inca thought. It starts out by describing the all-encompassing power of the Inca deity—the Sun—which is also the case for the Christian god. Then the dialogue advances into a discussion concerning the practical existence of God. For the Inca, it is the sun god that is visible and tangible. For the Spaniards, God lives inside of them. Atahualpa finds this amusing since he interprets that the Spaniards eat their god's body and drink their god's blood in the ritual called "communion." The Inca then states that he and his Indians are not as barbaric as the Spaniards since they do not practice cannibalism, and he thinks anyone who does is lesser. He and his advisers find the communion disgusting and degrading. The lack of successful communication between Andeans and Spaniards is made obvious through their perception of their god. Each side talks to and about God within the limits of their religious dogmas: either one believes and accepts them without questioning, or one does not.

At the end of this film, Atahualpa is charged with assassinating his brother, Huáscar; worshipping false gods; being adulterous; and attempting to incite a rebellion against the Spanish kings. He is sentenced to die, and Atahualpa accepts being baptized in order to avoid being burned and to keep his body intact after death. In this way, he will be able to come back the next day. The character of Pizarro seems convinced by the Inca's faith in his powers and remains by his side until the morning after, awaiting his resurrection. In the last scene of the film, the dead body of Atahualpa is sitting on the throne; his face is covered with a gold mask. Several priests, wearing long black cloaks, are waiting for the sun to rise. As the sun rises nothing happens. Pizarro touches Atahualpa's hands, everyone gasps, and the mask falls off his face. The Inca is seen to be dead as his body falls to the ground, and

the priests sing and lament, expressing their grief while leaving the room. This final scene reproduces the theatrical play and corresponds to the end of a classic tragedy: the misunderstood hero—Atahualpa—dies, and it is the beginning of the end for the Inca Empire. In this way, the exotic, erotic, childlike, and curious but naive Inca is represented as a desirable "other" that cannot be reached because his tragic end has to do with unintelligible difference. The idealized Inca has thus been appropriated by the historical cinema as the symbolic hero of a Western classic tragedy.

In Lerner's film, Atahualpa, the pagan noble savage, and Pizarro, the greedy Christian invader, share a journey together in which one seems to convince the other that they may speak the same language when it comes to faith. Atahualpa speaks of faith in his father, the sun god, his people, and himself. The Inca's faith encounters Pizarro's skepticism in the Christian Church and seems to convince him that miracles can actually happen. The otherness of the Inca takes place in the space of miracles and wonders, in the same way Christopher Columbus depicted the New World to the Catholic Kings in his 1493 *Letter to Luis de Santángel*. Moreover, Atahualpa's death seems to teach Pizarro the necessity to believe in oneself. The *conquistador* is redeemed in this film thanks to the fallen Inca. Still, the Inca remains in the otherness. One cannot avoid wondering what would have happened if this film had situated the *conquistador* as "other" instead.

One answer to this question may be found in the most powerful examples of Amerindian agency in early Latin America: the indigenous scribes and intellectuals who became interpreters and informants first, and secretaries and notaries later, for the Spaniards. They rapidly learned to read and write and appropriate the European alphabet and technologies to tell their side of the history. Although the works of Native chroniclers of Mesoamerican (Fernando Alvarado Tezozomoc, Fernando de Alva Ixtlixóchitl) and the Andes (Felipe Guamán Poma de Ayala, Joan de Santa Cruz Pachacuti Yamqui) are well-known among specialized scholars of colonial Latin American studies, their works have not made it to the official narratives of European histories of the Conquest, and therefore their voices remain unknown to the vast majority of readers. To date, the subject of the indigenous chronicler or writer has not been a main theme in historical cinema. However, we find an intriguing approach in a 1999 Mexican film that aims to tell the history of the European Conquest by giving some insight into the indigenous voice.

La Otra Conquista (*The Other Conquest*, dir. Salvador Carrasco, 1999) centers on Topiltzin, an Aztec scribe who survived the massacre of the Main Temple of Tenochtitlan in 1520. His half-sister, Tecuipcho, legitimate daughter of King Moctezuma, becomes the mistress and interpreter

of Hernan Cortés. Topiltzin is baptized and keeps working as a scribe for a Spanish priest who seeks to convert him. Using Topiltzin's abilities to read and write, the two siblings try to discredit Cortés in the Spanish Court, but they are discovered and separated. *La Otra Conquista* is probably one film that breaks the pattern of either the romantic exoticization and/or passive victimization of the Native Latin American; it shows, instead, an active indigenous agent who is finally punished since s/he cannot be subjugated.

Another example of the cinematic search for an Andean mestizo identity may be found in Augusto Tamayo's *The Elusive Good* (*El bien esquivo*, Peru 2001), also translated as *The Good Bastard*.[23] In early seventeenth-century Peru (1618), the mestizo Jerónimo de Avila searches for his indigenous mother and the marriage certificate of his parents to prove that he is not a bastard but the legitimate descendant of a Spanish captain and an Andean chieftain, and thus claim his heritage. Along the way, he meets a young nun named Inés who lives for her love of letters and knowledge and suffers her life in the silence of the cloister. The challenge for both characters, Jerónimo and Inés, consists in the search of what I call "elusive identities" in early Spanish America. I focus now on Jerónimo's search for his legitimate Spanish identity to reach material wealth and a position in Spanish society. This search will bring him through to his Andean past and the *pacarina* (sacred place) where he was born and, according to his mother, where he will find his "other" name. Jerónimo's elusive good, as the film title suggests, is constituted by his searched identities. At the film's end, he is punished with death by the early colonial society. Jerónimo's marginal position in early colonial Peru is defined according to his racial and ethnic background.

The Elusive Good constitutes in my opinion a very interesting approach to the search for a Latin American identity in its origins, but one that unfortunately has been overlooked by scholars due to its limited distribution.[24] While the director, Augusto Tamayo San Román, offers a fictocritical reading of the Latin American search for identity by recreating the story of a mestizo, something that puzzles Latin Americans today, the global market transforms this film into a story of passionate intrigue where even the Inquisition plays a major role.

Fictocriticism is also used in the Latin American contemporary historical novel that intends to deconstruct the indigenous past. In this way, fictocriticism may be used to perform postcolonial readings and rewritings of the colonial experience.[25] I explore now another proposal of fictional indigenous voices and the use of fictocriticism in Abel Posse's *The Dogs of Paradise*. This contemporary historical novel offers the account of the "discovery" and the beginning of a late fifteenth-century New World in four

parts that include several chapters each and through three narrative plots. Each plot corresponds to the fictional point of view for the main groups of characters in this story of encounters and misencounters: (1) The Spanish nobility (Juana la Beltraneja, Enrique de Trastámara) and the future Catholic kings, Isabel and Fernando; (2) a *converso* Christopher Columbus who envisions himself as divinely chosen; and (3) representatives from three pre-Hispanic Amerindian societies: Aztecs, Incas, and Taínos. In *The Dogs of Paradise*, all characters are fictional representations of their official historical counterparts: the Spanish kings and nobility are represented in daily and private situations, usually related to diverse kinds of human passions. On the other hand, Christopher Columbus is represented as a naive sailor who pursues a dream until he is able to find the sources for investment, and falls graciously into the traps of passion of the Spanish nobility. Once relocated in his paradise, this fictional Columbus experiences a spiritual conversion that leads him to a new lifestyle. Meanwhile Aztecs, Incas, and Taínos relate to each other in a series of alliances and negotiations in order to observe and explore the other men who are about to invade their territories. While Aztecs and Incas meet to discuss the otherness and intentions of the newcomers, including potential strategies to make war against them, the half-naked Taínos observe their arrival with childish curiosity. The Taínos are the first Amerindians to make direct contact with them. In this account, one can observe how the Amerindian characters perform in three of the four sections of the novel in order to convey the fictional account of that part of colonization that was never written and therefore is not accountable.

At the end of the first section, "Air," the empires of Tahuantinsuyu and Tenochtitlán meet, when Huaman Collo, the official representative of Inca Túpac Yupanqui, negotiates with the Tlatelolco priest strategies against the white others (*blanquiñosos*) who live in the Smokey Islands (Islas Canarias) and the Jaguar's Mouth (Iberian Peninsula). While the Aztecs insist on invading them "before they invade us," the Inca officers display rational arguments against the waste of human resources: for Huaman Collo, the Aztecs are pessimistically superstitious, religious to the extreme, exploiters of the massive Indian community, and impulsive:

These Aztecs were open to the grace, the inequality and the inexactitude. They might tolerate the free trade and the poetry. The Incas, however, were geometric, statistic, rational, two-dimensional, and symmetrical. In one word: socialist.[26]

Socialist government, technological knowledge, and the illusion of a rational and fair state are some of the stereotypes with which the Incas have

been depicted throughout Western history. Exercising an authoritarian government and enacting violent and bloody crowd control through massive human sacrifices and extreme religious orientation are stereotyped features of the Aztecs and, by extension, of other Mesoamerican civilizations. But, while Hollywood's version of the Mayas reunites in *Apocalypto* these stereotypes of Western religiosity, and exploits the exotic, though threatening, primitive otherness of the Amerindians, Posse's novel sets up all the characters of his New World history at the same level thanks to fiction: all characters in these plots—Europeans and Amerindians—are fictionalized. Each and all tell a different history of this time, their time. Each and all are agents of their own histories. The negotiations between Aztecs and Incas are not fruitful. Even within the Amerindian indifference that the European perceives, Aztecs and Incas see each other as different and, in many aspects, without possibility of fluent communication. The Aztecs are too religiously fanatical for the Incas. According to the Aztecs, the Incas are too aloof and obsessed with rational thinking and have lost the instinctive power to protect their people. Thus the two groups are unable to read each other, and they grow apart. Finally, the Inca representative leaves Tenochtitlán without any resolution, and the Aztecs continue with their massive sacrifices in order to prepare for the beginning of a new era.

Where are the Taínos located in this social map of a pre–New World? They are in the Caribbean islands and, in the official Western accounts, are the first to make contact with the strange others who come from the sea. The Taínos in Posse's novel are featured as the noble savages who innocently fall into the European traps and die. The Taínos welcome the strangers, trade with them, and show the way to Tenochtitlán. How the Taíno paradise turned into European hell in this novel is a consequence of Columbus's fictionalization of the New World. This is the point at which marginal European and Amerindian agencies meet, and where the novel ends. Posse does not tell us what would have happened if the Inca-Aztec confederation had worked and Europe had been invaded by the dark-skinned strangers of overseas, or how two powerful agencies—Inca/Aztec and Spanish empire—would have dealt with each other. But when Posse fictionalizes all the main European characters of this novel and gives equivalent voice to the Amerindian counterparts, he establishes two textual agencies facing each other at the same level. This is the way in which Posse, through fiction, gives agency to the Amerindian voices of the Conquest.

In her classic study "Can the Subaltern Speak?" Gayatri Spivak poses the necessity to question the representations of subjects of the Third World in Western and westernized discourses. These representations correspond to

international economic interests that assume the West as the dominant axis for the rest of the globe. In this way, colonial representations of otherness, the mimicry of the colonizer by the colonized, and the coexistence of colonizing and postcolonial discourses are present in textualizations of the indigenous side of Latin America's identity since 1492 up until today. I therefore ask, how can this search be brought to a successful conclusion? There are two sets of problems that the artist, scholar, and teacher must be aware of in their searches for consistent indigenous representation in the texts they work with. The first one is the ongoing denial of indigenous identity among current Latin Americans, and the colonial mentality that still posits the Indians as an inferior otherness on the social scale. The second set has to do with the ideologically charged search of scholars and artists for the authentic Indian, the original Native of the Americas, as if it were a homogeneous entity, which it has never been. The Latin American indigenous identity that proves elusive in the film industry has been anchored through the distorted lens of colonizing stereotypes. There could be, however, newer readings of this elusive identity in its multiple aspects, in which fictocriticism could be used as a tool for constructing these representations. We should not forget that we are working within the realm of representations, and what is at stake here are the modes that we choose to create and deconstruct those representations. The scholar, the artist, and the teacher must be aware of the stereotypical modes of Western representations, distance themselves, and open themselves to new alternative modes of representing the Indian. In this way, the scholar, the artist, and the teacher will most likely have a better chance to address the other's difference, understand it, and live with it.[27]

NOTES

1. Stuart Hall indicates that the question of representation is "one of the central practices which produce culture and a 'key' moment in what has been called the 'circuit of culture'"; *Representation*, 1. According to Hall, ideas, feelings, and thoughts are represented in a given culture through language; and his understanding of culture is about "shared meanings." Language, then, is the means with which we know our world and transmit information about it. Language helps us to "make sense" of this world and provides the tools to build meanings. These meanings are the basis for the construction of representations. Furthermore, Hall explains that, in this sense, language is a signifying practice: "Any representational system which functions in this way

can be thought of as working, broadly speaking, according to the principles of representation through language" (5).

2. From Hall's understanding of representation and its link to language, we need to consider also the representation of difference that includes the representation of the other and the colonized other. In this regard, Homi Bhabha contends that "to represent the colonial subject [the Indian in our case] is to conceive the subject of difference as an-other history and an-other culture"; Bhabha, "Representation and the Colonial Text," 98. The issue here is the representation of the Indian otherness in the paradoxical search for authenticity and nativeness. For Bhabha, this process "requires a notion of literary representation that does not conceive of the problem of representation as the presentation of different images of the colonial" (98). From here we are brought into the issue of "mimetic inadequacy" that Bhabha explains in the following terms: "the representation—the literary text—becomes the image of the represented—the given reality—which as the essential, original source determines the form and action of its means of representation. The effect of such placing of the text/reality, in terms of the subject/object structure of knowledge, traps the text within what Jacques Derrida calls a violent hierarchy organized by the privileged term (reality) to which the other term (the Text) is both necessitated and subordinated" (99–100).

3. "'Distortion' is the recognition of 'difference' in relation to the pre-giveness of an affirmative image which constitutes the primary cognition of which the literary text is only a secondary elaboration"; Bhabha, "Representation and the Colonial Text," 106.

4. Ibid.

5. "Historical cinema" has perhaps its origins in the idea of the "video public library of historical episodes" as proposed by D. W. Griffith (cited by Stevens, "Never Read History Again?" 2–3). Stevens questions the agent behind the camera—like the writer behind the text: "Who is it who locates and frames that window into the past? Who 'scientifically prepared' the room? Who determines when the window is 'properly adjusted'?" (3).

6. Used by Robert Young in 1995, this term "indicates the extent to which colonialist discourse was pervaded by sexuality. The idea of colonization itself is grounded in a sexualized discourse of rape, penetration, and impregnation, whilst the subsequent relationship of the colonizer and the colonized is often presented in a discourse that is redolent of a sexualized eroticism"; Ashcroft, *Postcolonial Studies*, 40–41.

7. I use Bhabha's definition of "stereotype," which is related to the mode of representation of otherness. Stereotypes in colonial discourse constitute a projection of negative and threatening qualities of oneself (nakedness, erotism,

savagery) onto the "other," and the mischaracterization of the other assuming his fixed image; Bhabha, "The Other Question," 68.

8. "Fictocriticism" is the union of fiction and criticism to reflect and analyze factual events and incorporate them in the production of the text. Historical novels and historical cinema use "fictocriticism" to reinvent historical discourses. As I indicate in later pages, Amanda Nettelbeck defines "fictocriticism" as a union between literature and postmodernism; "Notes towards an Introduction."

9. Fairclough, *Discourse and Social Change*, 102.

10. Agger demonstrates that although the notion of intertextuality emerged originally in the context of literary studies, it has been extended and applied to other areas such as discourse analysis, linguistics, cinema studies, media studies, visual studies, and the philosophy of art; "Intertextuality Revisited."

11. Nettelbeck, "Notes towards an Introduction," 4.

12. Stevens, "Never Read History Again?" 5.

13. See the PBS/NOVA documentary *The Great Battle of the Incas*.

14. Angel Delgado-Gómez explains these concepts in his 1993 article "The Earliest European Views of the New World Natives." Delgado-Gómez indicates that the "noble savage" is understood as an individual without a notion of private property, who lives in a fraternal community without authority. In spite of Colon's use of this idea in his 1493 letter to Luis de Santángel, no other authors of his time, such as Dr. Chanca, Michel de Cuneo, and Americo Vespucci, perceive the New World Natives as noble savages; rather, they are as ferocious cannibals who were aggressive, unhealthy, and uncivilized; "The Earliest European Views of the New World Natives," 5.

15. Cynthia Stone points out the one-sided aspect of this film that does not show the ambitious European side of the *conquistador*: "Noticeably absent from the movie version is the other side to the Cabeza de Vaca narrative: his colonialist ambitions, loyalty to the Spanish Crown, and sense of European superiority"; "The Filming of Colonial Spanish America," 315.

16. Ibid.

17. Luis Fernando Restrepo, "Primitive Bodies in Latin American Cinema: Nicolás Echevarría's *Cabeza de Vaca*," 189.

18. Ibid., 191.

19. *The Royal Hunt of the Sun* had its first theatrical performances at the *Chichester Festival*, prior to its London opening at the National Theatre in July 1964. It was directed by John Dexter, with music composed by Marc Wilkinson. The production was a success, and in addition to its run at the Old Vic, it played at the Queen's Theatre, London, and toured to Aberdeen, Glasgow, Stratford, Leeds, Oxford, and Nottingham.

20. These locations include Madrid, Segovia, Sierra Nevada, and Granada

(Spain); Cuzco, Chincheros, Pisac, Machu Picchu, Pachacamaq, Paracas, Pisco, Ica, Arequipa, Lake Titicaca, and Cajamarca (Peru).

21. "Inca" is the generic term that is used to refer to this ethnicity. "Sapa Inca" is reserved only for the Inca ruler or king.

22. The "requirement" was a declaration of land appropriation and war read by Spanish military forces to assert their sovereignty over the Americas. It was used to justify the assertion that the Christian God held authority as ruler over the entire Earth, and that the Papal Bull of May 4, 1493, conferred title over the Americas to the Spanish monarchs. In this scene, Valverde shows the Bible to Atahualpa and demands his conversion to Christianity.

23. This film won the First Critics Prize in the Lima Film Festival of 2001. It has also received the Best Director Award in the 2002 Viña del Mar Film Festival, and Best Photography Award in the 2002 Santa Cruz Film Festival. It was selected among the best six Spanish language Latin-American films of the last two years for the Luis Buñuel Prize of the Federation of Audiovisual Producers (FIPCA).

24. Michael Hastings refers to it as a "Peru-Romantic Drama/Religious Drama" and describes it in the following terms: "In 17th century Perú, a 'bastard' soldier named Jerónimo searches for birth records to prove that he is not a commoner but the direct descendent of a famous captain. Along the way, his romance with a young nun named Inés sparks controversy, and soon the star-crossed lovers find themselves on the run from the authorities, still seeking the key to Jeronimo's past." At http://movies2.nytimes.com/gst/movies/movie.html?v_id=289395 (July 20, 2007).

25. In the postcolonial studies' theoretical framework, "postcolonial writing" is defined as the deconstruction of the narratives that have supported the European imperial expansion since the sixteenth century. Within this idea of "postcolonial writing," I consider at least two possibilities of textualization: (1) theoretical discourses, and (2) creative discourses such as the contemporary historical novel and historical cinema.

26. Posse, *Dogs of Paradise*, 33.

27. Even more, in my opinion, the current concept of globalization that dominates the spread of academic knowledge departs from this panoptic gaze that still assumes the Western subject as the center of the world.

WORKS CITED

Agger, Gunhild. "Intertextuality Revisited: Dialogues and Negotiations in Media Studies." *Canadian Aesthetics Journal* 4 (1999). At http://www.uqtr.uquebec.ca/AE/vol_4/gunhild.htm (accessed July 20, 2008).

Apocalypto. DVD. Directed by Mel Gibson. 2006; Burbank, CA: Buena Vista Home Entertainment, 2007.

Ashcroft, Bill, et al. *Postcolonial Studies: The Key Concepts.* New York: Routledge, 1998.

Bhabha, Homi. "The Other Question: Stereotype, Discrimination, and the Discourse of Colonialism." In *The Location of Culture.* New York: Routledge, 1994.

———. "Representation and the Colonial Text: A Critical Exploration of Some Forms of Mimeticism." In *The Theory of Reading*, ed. Frank Gloversmith, 93–106. Brighton, Sussex: Harvester Press, 1984.

Cabeza de Vaca. VHS. Directed by Nicolás Echeverría. 1989; Mexico City: Quality Films, 1990.

Delgado-Gómez, Angel. "The Earliest European Views of the New World Natives." In *Early Images of the Americas*, ed. Jerry Williams and Robert Lewis, 3–20. Tucson: University of Arizona Press, 1993.

El bien esquivo. DVD. Directed by Augusto Tamayo San Román. 2001; Lima: Argos Producciones, 2003.

Fairclough, Norman. *Discourse and Social Change.* Cambridge: Polity Press, 1992.

Great Inca Rebellion, The. DVD. Directed by Graham Townsley. 2007; Arlington, VA: PBS/Nova, 2008.

Hall, Stuart, ed. *Representation: Cultural Representations and Signifying Practices.* London: Sage, 1997.

Hastings, Michael. "Movie Guide: *El Bien Esquivo.*" *New York Times* (online). At http://movies.nytimes.com/movie/289395/El-Bien-Esquivo/overview (accessed July 20, 2007).

Hemmings, John. *The Conquest of the Incas.* New York: Harcourt, Brace, 1970.

Kristeva, Julia. "Word, Dialogue and Novel." In *The Kristeva Reader*, ed. Toril Moi, 24–33. Oxford: Basil Blackwell, 1986.

Nettelbeck, Amanda. "Notes towards an Introduction." In *The Space Between: Australian Women Writing Fictocriticism*, ed. Heather Kerr and Amanda Nettelbeck. Claremont: University of Western Australia Press, 1998.

New World, The. DVD. Directed by Terrence Malick. 2005; Burbank, CA: New Line Home Entertainment, 2006.

Nuevo Mundo. DVD. Directed by Gabriel Retes. 1976; Mexico City: Quality Films, 2005.

Other Conquest, The. VHS. Directed by Salvador Carrasco. 1998; Mexico City: ADO Company, 1999.

Posse, Abel. *The Dogs of Paradise.* New York: Simon & Schuster, 1992.

Restrepo, Luis Fernando. "Primitive Bodies in Latin American Cinema: Nicolás Echevarría's *Cabeza de Vaca.*" In *Primitivism and Identity in Latin America: Essays on Art, Literature, and Culture,* ed. E. Camayd-Freixas and J. E. Gonzalez, 189–208. Tucson: University of Arizona Press, 2000.

Royal Hunt of the Sun, The. DVD. Directed by Irving Lerner. 1969; Minneapolis: Simitar Entertainment, 2006.

Spivak, Gayatri. "Can the Subaltern Speak?" In *Marxism and the Interpretation of Culture,* ed. Cary Nelson and Lawrence Grossberg, 273–99. Chicago: University of Illinois Press, 1988.

Stevens, Donald. "Never Read History Again? The Possibilities and Perils of Cinema as Historical Depiction." In *Based on a True Story: Latin American History at the Movies,* 1–11. Wilmington, DE: Scholarly Resources, Inc., 1997.

Stone, Cynthia Leigh. "The Filming of Colonial Spanish America." *Colonial Latin American Review* 5 no. 2 (December 1996): 315–20.

Condolence Tropes and Haudenosaunee Visuality: *It Starts with a Whisper* and *Mohawk Girls*

PENELOPE MYRTLE KELSEY

INDIGENOUS ASSERTIONS OF THE EQUALITY AND COMMENSURABILITY of tribal epistemologies and lifeways have occurred in the context of colonial relations since contact. One of the earliest examples of this indigenist discourse of equivalences is the Two Row Wampum that records a treaty between the Dutch and the Five Nations made in the seventeenth century.[1] The belt is comprised of two purple stripes on a background of white beads, and the two stripes stand for the two ways of life of the Dutch and the Haudenosaunee. The wampum records an agreement to live in relationship with one another as brothers, not parent and child, and to maintain each group's way of life without demanding that the other group conform. This treaty forms the foundation of all Five (and later Six) Nations treaties with European nations, and the implication of this mutual understanding continues to inform much Haudenosaunee intellectual effort today. This belief in tribal ways of knowing and being as viable and vibrant sources of indigenous intellectual production also informs my own arguments about tribal theory. As legal scholar Robert Odawi Porter notes, however, "The United States and Canadian governments have not recognized the politically exclusive arrangements signified by the *Guswentah* and have, instead, tried to assimilate the *Haudenosaunee* as citizens. This has had a corrosive effect on the *Haudenosaunee*."[2] This essay considers how filmmakers Shelley Niro and Tracey Deer work against this "corrosive effect" by invoking

Iroquois condolence practices via decolonizing tropes and processes as an expression of tribal theory.

In *Peace, Power, Righteousness: An Indigenous Manifesto*, Kanien'keha political scientist Taiaiake Alfred defines the Iroquois condolence ceremony as a metaphor for decolonization. He observes that "The Condolence ritual pacifies the minds and emboldens the hearts of the mourners by transforming loss into strength. In Rotinohshonni culture, it is the essential means of recovering the wisdom seemingly lost with the passing of a respected leader. . . . The Condolence ritual heals. It fends off destruction of the soul and restores hearts and minds. It revives the spirit of the people and brings forth new leaders embodying the ancient wisdom and new hope."[3] Tuscarora literary critic Vera Palmer has further built upon Alfred's work by applying the Haudenosaunee condolence ceremony as a methodology for understanding the hagiographies of Mohawk saint Kateri Tekakwitha.[4] Like Palmer, I view Haudenosaunee cosmology and ceremonial cycles as forming the underpinning of much Iroquoian writing and film, especially where writers and filmmakers are clearly invoking and deploying traditional knowledge systems. Two signature examples of this condoling process at play are the filmic narratives *Mohawk Girls*, a 2005 documentary directed by Tracey Deer, and *It Starts with a Whisper*, codirected by Mohawk Shelley Niro and non-Native director Anna Gronau in 1993. Both Kanien'kehaka directors invoke aspects of condolence in their films as either a diegetic process or visual grammar. Michael Doxtater has argued that indigenous scholars who coin neologisms (e.g., "indigenism," "americity") in print forums "demonstrate that Indigenous knowledge remains unsubjugated, sovereign, and ignored. . . . [Further,] this resistance tends to emancipate—or *decolonize*—Indigenous knowledge."[5] Ultimately, by invoking visual tropes and processes originating in the condolence ceremony, Deer and Niro affirm the unsubjugated nature of Haudenosaunee political and cultural thought and epistemology, while remaking those epistemic practices in the present.

Condolence as decolonizing diegesis plays a critical role in Tracey Deer's 2005 documentary *Mohawk Girls*, which narrates the experiences of three teenage women from the Kahnawake Mohawk reserve in Quebec and simultaneously tells Deer's own coming-of-age in the same community a decade earlier. Deer portrays Felicia, Lauren, and Amy in their different environments and invites them to tell their own stories of how they relate to their community; she interpolates their stories with footage Deer took of herself at the same age with a black-and-white video camera, positing a move across time and space and allowing for larger themes to emerge. Deer's professed objective is to find out "what girls these days [in Kahnawake] are

dealing with and how they manage to get through it." She states that she discovered that she "wasn't the only one who had a hard time growing up in Kahnawake."[6]

For each of the young women interviewed by Deer, there are losses that must be faced and condoled that exemplify the stresses imposed upon the Kahnawake Band of Mohawks, which is located only a small distance from the greater Montreal area. For example, Felicia struggles with a progressive eye condition, *retinitis pigmentosa*, that will eventually blind her, and while her academic success is made all the more vital by her deepening disability, she disengages from her courses and tries to remain in ninth grade for as long as possible. Her parents are busy raising her four younger siblings, and because Felicia does not demand their attention, she is left to guide her life on her own. Felicia uses the Mohawk singing group at the reserve survival school in addition to the wrestling team as outlets for her frustrations: she says that wrestling has become a way to channel her anger, and that the traditional singing "releases" negative feelings after a bad day. Similarly, Lauren contends with her outsider identity on the reserve, because she has not been granted status since returning to Kahnawake as a small child; her father's African American identity has forestalled her acceptance as a community member and made her the target of racism within the community. Lauren ultimately heals this wound by insisting upon identifying as Mohawk, learning to speak the language, and working to serve as a role model for her community. Amy is a grandparent-reared daughter of teenage parents, and her struggles center on the loss of her mother through her parents' separation, in addition to her survival of sexual assault. While grounded by her grandparents' upbringing, Amy still longs to recover her parents' roles in her life, and though she embraces her identity as a Mohawk, she is frustrated and marred by her decision not to report her cousin's boyfriend for raping her, owing to community pressure. She recovers from these losses through including both her parents in her graduation celebration, and through seeking a foray off-reserve for her college education that will allow her to see the world outside of Kahnawake ("anywhere but here"). Amy contends that leaving the reserve and temporarily separating herself from the close community atmosphere of Kahnawake will allow her to return with a new vision. Deer herself uses the format of the documentary to narrate her own travel away from the reserve with no desire to return, to reckon with the brutal conditions faced by Natives on and off the reserve, and to condole those losses and move back to Kahnawake. All of the women's losses in *Mohawk Girls* implicate the settler state and its ill effects on the community of Kahnawake—from Felicia's overtaxed parents, to Lauren's exclusion on

the basis of internalized colonialist definitions of race, to Amy's rape while intoxicated. Throughout the exposition of all four narrative threads, Deer uses the principle of condolence as a decolonizing diegesis in her documentary and affirms the women's capacity, and thereby their community's ability, to heal.

For Niro and Gronau, condolence operates as a dominating tropology that informs the larger diegetic process of grief and renewal. *It Starts with a Whisper* centers on the struggles of Shanna Sabbath, a young Mohawk who travels from her home reserve at Six Nations to an unnamed metropolis, perhaps Buffalo or Toronto. Film critic Beverly Singer summarizes the film as the struggle of "a serious young Aboriginal woman who is unsure of herself and taken for a joyride by her amusing spirit aunts."[7] In "Decolonizing Colonial Violence: The Subversive Practices of Aboriginal Film and Video," Janice Hladki argues that Shelley Niro, in addition to filmmakers Alanis Obomsawin and Dana Claxton, "provide a decolonization of both normative media practices and the violences of imperialism and capitalism" in their work; moreover, Niro's works "are theoretical and activist in the sense of Chandra Mohanty's argument that 'theory is a deepening of the political, not a moving away from it.'"[8] I would concur with Hladki and further state that Niro's work constitutes a decolonizing theory based in Haudenosaunee oral and mnemonic traditions, a sophisticated deployment of Iroquois visual tropes and signifiers in the context of remaking visual images of Native peoples, and an insistence upon aboriginal peoples' own perceptions of themselves.

It Starts with a Whisper traffics in Iroquoian culture and symbology as part of a strategy in asserting an intertribal post-genocide and post-contact future and survivance of Native peoples of all the tribal nations of Turtle Island. Aspects of Haudenosaunee culture, symbology, and history engaged by Niro and Gronau include the following: ritual adoption and absorption of indigenous nations seeking asylum as part of the condolence process, condolence as a vehicle for healing and renewal as well as the Midwinter Ceremony of which it is a part, and Gantowisa identity, role, and resilience as shown in the "auntie" figures of Emily, Pauline, and Molly. Indigenous nationalism is complexly defined in the film as seen in Shanna's recuperative pursuit of Tutelo identity on the Grand River Reserve, and it is Oji-Cree activist Elijah Harper whose cameo in the film starts the condoling process for Shanna.

There are six major scenes in the film: the first is the Grand River, where Shanna narrates her birth and origins; the second is the city, where she travels to find work; the third is the car her aunties drive that transports her through the city; the fourth is a state of confusion for Shanna, lost in the bright lights of the city; the fifth is a hotel room at Niagara Falls that her

aunt Emily has won playing bingo; and the sixth and final one is at Niagara
Falls on New Year's Eve, 1992. *It Starts with a Whisper* begins with an image
of "stirring the ashes," a central component of the Midwinter Ceremony in
which dead chiefs are "raised up" and condoled by having their names and
roles passed on to new individuals.[9] The camera pans across dried marsh
grasses, and the narrator evokes a series of images that are snapshots of
genocide, or the Sullivan-Clinton or Denonville campaigns into Iroquois
country specifically, if one searches for historical equivalents: "Whispering
waters, raging torrents . . . breath of air, cyclones sting, fire that warms,
flames that burn," intones the narrator.[10] Flames begin to lick at Iroquois
splint baskets the camera pans to, suggesting the devastation of Haude-
nosaunee material existence resulting from twentieth-century campaigns
against the confederacy as well as those of the seventeenth and eighteenth
centuries. Simultaneously, the white beadwork representation of the Tree of
Light from the Skyworld, as well as the longhouse song and cow-horn rattle
suggest the film's ultimate conclusion in healing.

As the embers of the fire are killed by the ashes thrown upon them, not
unlike earth on a grave, the scene progressively turns to daylight, and we find
ourselves in the forest, near the Grand River. The question of who will be
condoled in the film is quickly answered by a brief encapsulation of Tutelo
history: "The Tutelo Indians were Sioux, who moved to the Six Nations area
with the Hotinohsioni (the People of the Longhouse) and lived there under
the elms and pines along the Grand River. They were highly respected for
their spirituality. But in the early 1800s an epidemic nearly wiped out the
entire tribe. Their bodies had no immunity against these foreign germs.
The Cayugas adopted the last remaining Tuteloes and have preserved their
ceremonies."[11] The camera moves from close-ups of the forest floor to a pan-
oramic shot of Shanna, in traditional Iroquoian dress, journeying along the
river with her waterdrum in hand, while the camera pauses intently upon
the double curve of chiefs' "horns" of her beadwork, which signify the new
knowledge carried forward by "raised up" chiefs. Here is where the whispers
of the film's title begin, embodying the persistent influence of the Tutelos
through Shanna's aunts' voices. Shanna is told not to be afraid, and her
predicament is sketched by these voices who say, "The voices of the past are
calling you. The voices of the present urge you on. The voices of the dead
tell you their sorrow."[12] The ash cloud from the stirring of the ashes engulfs
Shanna as she continues her walk by the river in daylight, connecting her
with condolence and the stirring of the ashes.

The stream of history that Shanna finds herself in and must reckon with is
given filmic form in the milkweed mote–slurried river. The camera's shifting

The chiefs' horns or fern design on Shanna's leggings allude to the "raising up" of new chiefs.

panning from close-ups of wildlife and wild plants back to Shanna's moving profile suggests an answer in the ancestor's voice to the question of where to turn, as well as visually leading the viewer through the Opening Address. Once she has reached the river's edge, Shanna finally speaks, introducing those to be condoled on the journey she will later undertake. She says, "This is where the Tutelo once lived. Tuteloes, Neutrals, Nanticokes, Tobaccos."[13] The voices now entreat her to not be afraid, and tell her they will speak to her from the silence. She looks to the sky and begins her journey, as the camera shifts to a city scene. Shanna struggles with her identity and finding meaningful existence in the city, as shown by her dress, which is now contemporary, and the contrast between the dingy black and white of the city and the colorful interior of her aunts' car. Shanna's own internal conflict about her foray into so-called enfranchisement is illustrated by her irritation with her aunts' good-natured teasing about her high heels and her insistence on reading drab, black-and-white magazines instead of the poetry or political pamphlets that aunts Pauline and Emily suggest. Shanna's directions to her aunt Molly to turn the car west to get out of the city also signifies the aspects of death and condolence with which Shanna must yet reckon.

The next scene portrays Shanna's hopelessness upon arriving in Niagara Falls with her aunts, and her foul mood sends them packing and leaves her alone with the demons of the flashing signs for museums, motels, and reservations at those motels, which overwhelm her and leave her breathless, literally running to escape them. At this point, Shanna begins the act of condoling the tribal nations victimized by genocide, and sets in motion the advice from her grandfather, the owner of the waterdrum she carried by the river. Shanna lists in abbreviated form the five hundred nations irrevocably affected by the conquest, moving from A to Z—"Apache" and "Blackfeet" to "Santee" and "Tuscarora"—ending, though, with the same recitation of tribal names from the Grand River: "Erie, Neutral, Nanticoke, Tobacco, Tutelo." Snow begins to fall, and Shanna visibly swoons under the weight of history. The disembodied voice of one of the aunties calls out, "Shanna, don't be afraid. You made it through another year. Just a short 500 years. Next year will be even better."[14]

The camera's shift from the unfocused and blurry space of a commercialized and occupied Niagara Falls to a light-filled location outside of the reserve-city dichotomy is effected through a special lens that creates large washed-out snowflakes that eventually merge into absolute blinding light. The beginning of a conversation with her grandfather, played by Oji-Cree activist Elijah Harper, is signified by the camera's movement from black-and-white images of the falls and snow to a colorful watery, rippled light surrounding the figure of Harper. Shanna here confesses her preoccupation with the Tutelos to Harper, saying, "I feel defeated. I don't know what to do."[15] As Shanna says this, the waterdrum and longhouse song begins. Harper, the man who in real life stopped the dreaded Meech Lake Accord in his role as a provincial representative, tells Shanna to "Stop feeling guilty about your existence. You are here to live your life."[16] In "Seeing and Being Seen in Media Culture," Darrell Varga notes that "The appearance of Harper invokes the fact that history is made, it is not simply fixed and set in the past."[17] Although Varga also contends that "First Nations culture must not be simply understood as connected with notions of timeless tradition signified by traditional iconography," I would argue that Niro's use of condolence tropes and imagery in contemporary contexts successfully remakes, re-envisions, and innovates Haudenosaunee tradition-keeping to evolving, dynamic effect.[18]

The effect of Harper's speech is shown in the segue to the next scene, a Niagara Falls honeymoon suite furnished with the stereotypical heart-shaped bed, where Shanna sings, "I'm Pretty" with her three aunts, Emily, Pauline, and Molly, whose names condole Emily Pauline Johnson and Tekonwatonti/Molly Brant. Shanna's aunt Molly has won a night in the

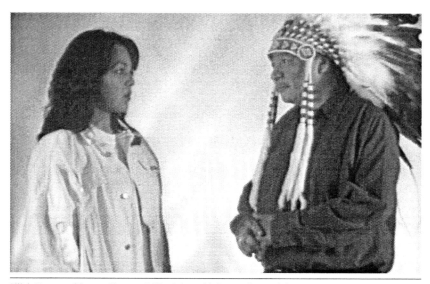

Elijah Harper addresses Shanna Sabbath in a third space beyond the urban/reserve dichotomy.

honeymoon suite playing bingo. The four women's synchronized dance in silk dresses of rose, pink, yellow, and red dismisses the power of Eurowestern imperialism to permanently mar Native society. The lyrics disavow the ability of the colonizer to dominate Shanna's consciousness, in contrast to her earlier hopelessness: "I'm pretty mad at you . . . You said I was crazy and too damn lazy / Then you took me away from my kind / You made me speak gibberish instead of my language / But you can't control my mind."[19] The women's effervescent dancing and sauntering exit deny any totalizing possibilities of genocide and suggest an indigenized 1940s Hollywood musical decolonizing move; the effect is similar to that of Niro's photography series Mohawks in Beehives, whose "references to soap operas, the Canadian national anthem, Hollywood and fifties' lifestyle . . . , articulate an identity that has to do with lived experience rather than some essentialist or nostalgic cultural identity."[20]

The final condolence of *It Starts with a Whisper* is enacted in the closing scene at Niagara Falls, on New Years' Eve, 1992—and its visual elements confirm that Shanna and her aunts are "empowered women who are obviously participants in a society beyond the borders of the reserve and not restricted to a narrowly defined set of cultural referents."[21] The aunts and Shanna assert the survivance of tribal nations through a ceremony that uses color symbolism to affirm tribal worldviews. The four women are still dressed in

Shanna and her aunts dance to "I'm Pretty."

their silk dresses from the hotel room, and they stand with the sight and sound of the falls dominating their conversation. On a black velvet–covered table, Emily pours a cup of tea and places the teapot there while Molly puts down a bright blue and green globe. Pauline recites E. Pauline Johnson's "The Song My Paddle Sings," and afterwards Shanna begins beating on the waterdrum as all four women sing together, repeating the longhouse song from the beginning of the film with the stirring of ashes. Afterwards, all three women hug, and Pauline makes direct eye contact with the camera again, returning the gaze and affirming the reality of the next generation of Haudenosaunee people who are emerging. The last of the film's central symbols is invoked as the New Years' fireworks light up the sky, forming the Great Tree of Peace on top of Turtle's back, as shown on Shanna's leggings at the film's beginning.

In *It Starts with a Whisper*, condolence is invoked via its literal trappings, such as the stirring of ashes, and condolence is rearticulated as a decolonizing methodology in Shanna's journey. Shanna clearly voices a desire for a viable identity that supersedes that narrated in history books and on television, and she struggles under the weight of dominant methods of recording and portraying First Nations. Her own initial internalization of the decimation of the Tutelos, despite their absorption and remembrance/condolence by the Cayugas, seems to mindfully embody how immersion in "too much thinking," as

Shanna, Molly, Emily, and Pauline celebrate New Year's 1992 at Niagara Falls, a site also featured in Niro's *The Shirt* (2004).

Fireworks display at Niagara Falls on December 31, 1992.

Shanna calls it, can leave little space for tribally centered understandings of identity and history.

As set forth by Tai Alfred in *Peace, Power, Righteousness*, condolence operates as a trope for healing within Haudenosaunee culture, and as Vera Palmer points out, it can be seen manifesting in texts as early as the hagiographies of Mohawk saint Kateri Tekakwitha. The condolence ceremony also figuratively transfers into filmic narratives, and in *It Starts with a Whisper* Shelley Niro and Anna Gronau are clearly invoking its imagery and using it as a recuperative trope for articulating First Nations survivance. Cast in the genre of documentary, Mohawk director Tracey Deer traces elements in three young women's life stories that show the principles of mourning, grief, and condolence at work. While this work is only in its beginning stages, I am hopeful that continued investigation into these Haudenosaunee tropes and foundational cosmology will allow for the furtherance of a tribally specific critical theory rooted in Six Nations epistemology. Simultaneously, this epistemic and theoretical project links itself to larger, more concrete efforts to gain recognition for indigenous intellectual and political self-determination. As Mohawk chief Roberta Jamieson contends, "History and law sustain us in our position that we are allies of the Crown. We are a sovereign self-determining people. To those who say we cannot be sovereign in Canada, the fact is, we are."[22]

NOTES

1. The actual year of the treaty is a matter of some debate. Jennings, Fenton, Druke, and Miller give 1613 as the year of the Guswenta (Two Row Wampum). Francis Jennings, William Fenton, Mary Druke, and David Miller, eds., *The History and Culture of Iroquois Diplomacy: An Interdisciplinary Guide to the Treaties of the Six Nations and Their League* (Syracuse, NY: Syracuse University Press, 1985), 158.
2. Robert Odawi Porter, "Two Rows, Two Peoples, Two Nations: The Meaning of *Haudenosaunee* Citizenship," *International Studies Review* 7, no. 3 (2005): 513.
3. Taiaiake Alfred, *Peace, Power, Righteousness: An Indigenous Manifesto* (New York: Oxford University Press, 1999), vii.
4. Vera Bauer Palmer, "Heaven or Earth: A Native Saint Mourns Wa'wa:di:hwane'a: gwa (Sinfulness)," paper given at Modern Language Association Convention, New York, December 29, 2002.
5. Michael G. Doxtater, "Indigenous Knowledge in the Decolonial Era," *American*

Indian Quarterly 28, no. 3/4 (2004): 620. Catherine Higginson has argued that the Haudenosaunee collective insistence upon "self-identification as a separate and sovereign nation precludes this appellation," that of the "colonized." In fact, the thread of political thought embodied by the persistent Guswenta (and many other Haudenosaunee records and cultural institutions) suggests there is a great deal of truth in Higginson's claim. Catherine Higginson, "Shelley Niro, Haudenosaunee Nationalism, and the Continued Contestation of the Brant Monument," *Essays on Canadian Writing* 80 (2003): 150.

6. *Mohawk Girls*, directed by Tracey Deer (Toronto: National Film Board of Canada, 2005).
7. Beverly Singer, *Wiping the War Paint off the Lens: Native American Film and Video* (Minneapolis: University of Minnesota Press, 2001), 13.
8. Janice Hladki, "Decolonizing Colonial Violence: The Subversive Practices of Aboriginal Film and Video," *Canadian Woman Studies* 25, no. 1/2 (2006): 83–84.
9. Paradoxically, the second scene by the Grand River is set in summer, highlighting the dramatic contrast between the bleak midwinter landscape and the lush greenery surrounding Shanna.
10. *It Starts with a Whisper*, directed by Shelley Niro and Anna Gronau (Toronto: National Film Board of Canada, 1993).
11. *It Starts with a Whisper*, Niro and Gronau.
12. Ibid.
13. Ibid.
14. Ibid.
15. Ibid.
16. Ibid.
17. Darrell Varga, "Seeing and Being Seen in Media Culture: Shelley Niro's *Honey Moccasin*," *Cineaction!* 61 (2003): 54.
18. Varga, "Seeing and Being Seen in Media Culture," 56.
19. *It Starts with a Whisper*, Niro and Gronau.
20. Lloyd Wong, "Mohawks in Beehives," *Fuse* 16, no. 1 (1992): 38.
21. Greg Hill, "Fluid Identities: Learning to Swim," *IroquoisART: Visual Expressions of Contemporary Native American Artists*, ed. Sylvia S. Kasprycki, Doris I. Stambrau, and Alexandra V. Roth (Frankfurt, Germany: Amerika Haus, 1998): 46.
22. Roberta Jamieson qtd. in Catherine Higginson, "Shelley Niro, Haudenosaunee Nationalism, and the Continued Contestation of the Brant Monument," 160.

Videographic Sovereignty: Hulleah J. Tsinhnahjinnie's *Aboriginal World View*

JOSEPH BAUERKEMPER

The Indian with a camera announces the twilight of Eurocentric America.

—LESLIE MARMON SILKO

IN A 1998 ESSAY TITLED "WHEN IS A PHOTOGRAPH WORTH A THOU-sand Words?" Hulleah J. Tsinhnahjinnie deploys the phrase "photographic sovereignty" to describe the resistance- and resilience-based process through which she creates and reinterprets images of indigenous peoples.[1] For Tsinh-nahjinnie, photographic sovereignty—a pervasive hallmark of her entire oeuvre—involves a reclamation of "historical indigenous images in an act to resist amnesia."[2]

Portraits Against Amnesia, a 2003 series of images in which photographic sovereignty is especially prevalent, consists of ten early twentieth-century pho-tographs of modern Native persons that Tsinhnahjinnie gathered from family albums and online postcard auctions.[3] By enlarging and digitally altering the images with conspicuous backgrounds and colored forms, Tsinhnahjinnie rec-reates the photographs and makes clear that the people represented are agents rather than objects of the photographic process. Art historian Veronica Pas-salacqua writes of the series:

> Unlike many "collectible" vintage Native American photographs, the gazes in these portraits are not voyeuristic, not anthropological, not part of govern-ment documentation, and not about the photographer. In these portraits, the

authority and power belongs entirely to the subjects, who control their own identities and look directly out of the photograph in the way they wish to be imaged.[4]

Photographic sovereignty, then, is a multilayered process rooted not only in the work of Tsinhnahjinnie as a contemporary fine artist, but also in the dispositions and prerogatives of photographic subjects. Rather than scenes orchestrated to fulfill colonizing fantasies of the vanishing race, the Portraits Against Amnesia emphasize the ongoing sovereignties of indigenous individuals, families, and communities and thus compel viewers to consider the neglected and often willfully forgotten (by colonizers, of course) stories of survivance that the images evince.

In order to pursue a reading of the political critiques and stories of survivance embedded in Tsinhnahjinnie's 2002 digital short *Aboriginal World View*, this essay proposes an expansion or transfer of "photographic sovereignty" to also include "videographic sovereignty." Such a framework informs and enables a reading of the video that accounts for the bold assertions of its subject and of its producer.

Hulleah J. Tsinhnahjinnie was born in 1954 into the Bear and Raccoon Clans of the Seminole and Muscogee Nations, and she was born for the Tsinajinnie Clan of the Diné (Navajo) Nation. She attended the Institute of American Indian Arts and completed her BFA at California College of Arts and Crafts in 1981. She then settled in the Bay Area and established herself as an artist and activist with extensive commitments to Native communities and organizations. Having spent more than three decades as an exhibiting artist, Tsinhnahjinnie is known for dozens of important projects, including the widely discussed and influential Nobody's Pet Indian (1993), an exhibition highly critical of the 1990 Indian Arts and Crafts Act.[5] In 2000, Tsinhnahjinnie was invited to pursue an MFA at the University of California at Irvine. Specializing in digital videography, she completed her degree in 2002 with *Aboriginal World View* serving as the centerpiece of her thesis exhibition. In addition to maintaining a productive artistic profile and an active exhibition schedule, Tsinhnahjinnie currently serves as a faculty member in the Department of Native American Studies and as director of the C.N. Gorman Museum at the University of California at Davis.

Aboriginal World View remains freely available for viewing on Tsinhnahjinnie's website (www.hulleah.com). The striking video is a collaboration between Tsinhnahjinnie and Native Hawaiian performance artist Leilani Chan. At under five minutes in length and unencumbered by dialogue or verbal narration, the video played in a continuous loop during

Tsinhnahjinnie's MFA thesis exhibition. Aside from an introduction that reads "An Aboriginal World View with Aboriginal Dreams" and brief closing credits, the video is also without written text. The primary visual concept featured in *Aboriginal World View* is Chan's performance piece "The Enemy of My Enemy." According to Chan, the piece acknowledges "the mixture of race and religion that exists not only in her blood, but in the very make up of the borders invented and enforced by war and imperialism."[6] In an essay on Tsinhnahjinnie for the catalog honoring the 2003 recipients of the Eiteljorg Fellowship for Native American Fine Art, Passalacqua offers the following description of *Aboriginal World View* within the contexts of its original exhibition:

> In this video, we see a bound woman (Chan) wearing a burka designed of American flags. She surveys land of the Navajo reservation while powwow music pulsates strong and loud, and finally she reaches the distorted sound waves of the Pacific Ocean. Screening the piece on three huge layered panels, Tsinhnahjinnie visually alludes to the layers of political complexities that surround the huge figure who perseveres with her search under oppression.[7]

Viewers of *Aboriginal World View* undoubtedly note the great extent to which U.S. military ventures in Afghanistan and Iraq form indispensable subtexts for the video. Even while Chan's use of the U.S. flag can be given wider interpretation than Passalacqua and even Chan herself suggest, the desert location used for much of the video, and the geopolitical circumstances out of which it arose and within which it is viewed combine with Chan's clothing to oblige associations with southwestern Asia. At the same time, the title of the video and the immediate context in which it is viewed—whether as part of a Tsinhnahjinnie exhibition or lecture, or via the artist's website—clearly indicate that it addresses indigenous issues on a transnational and transhemispheric scale.

In addition to referencing hijab, Islam's code of modesty in women's dress, Chan's costume clearly references the jingoistic, flag-centered patriotism that arose in the immediate aftermath of September 11, 2001. Rather than participating in this trend, Chan subverts the flag and deploys it as a metonym for centuries of Euro-American colonizing oppression. Chan is literally engulfed and smothered by the flag, silenced and made invisible by a facial veil made of the flag, and bound at the wrists by the flag. She is thus figuratively smothered, silenced, negated, and bound by the colonizing and self-righteous nationalism of the United States. Moreover, *Aboriginal World View* makes clear that this oppression imposed upon indigenous peoples is

heavily gendered. As Andrea Smith writes in *Conquest*, "Patriarchal gender violence is the process by which colonizers inscribe hierarchy and domination on the bodies of the colonized."[8] *Aboriginal World View* confronts its audience with the ongoing histories of gendered violence perpetrated by the colonizing state.

The symbolic use of a burqa made of the U.S. flag to critique U.S. colonial and imperial practices is an intentionally fraught artistic strategy. It could be read variously as an unsavory offense against Islam, as a protest against anti-Islamic furor and rhetoric, and as a feminist critique of Sharia, Islamic religious law. Indeed, "The Enemy of My Enemy" and *Aboriginal World View* necessarily depend upon and perhaps perpetuate a direct association between oppression and the burqa.

Layered with testy ambiguities and fascinating contradictions, the video is a complex and multilayered work that assertively connects the current actions of the United States as an occupying force in the Middle East with the United States' ongoing actions as a colonizing force in North America. In doing so, *Aboriginal World View* recalls and underscores the ongoing legacies of histories of genocide, violence, removal, and dispossession that colonizing dominance would rather sweep into the neglected dustbins of ignored history. As Tsinhnahjinnie explains, "The installation encompasses all of those ideas—the complexities of war, land, occupation, and colonialism. Native people can't forget that. Native people must not forget our political history."[9]

While I do not care to induce broad generalizations based on Tsinhnahjinnie's particular interests in Native political histories, *Aboriginal World View* and her comments about its installation lend credence to Steven Leuthold's efforts to theorize an "indigenous aesthetic." Leuthold writes:

> The connection of native artists and directors with the past gives their work coherence and helps forge a link between art and life. It is easy to contrast this attention to the past with the situation in American culture at large where, in artistic circles, there sometimes seems to be specific efforts to ignore the past.[10]

Intertwined with its bold transhemispheric critique of colonization and imperial military adventurism, *Aboriginal World View* conveys a subtle yet profound exploration of the substantive and substantial relationships between historical narratives and (de)colonization. In recent centuries, colonizing cultures have come to imagine history as a linear, developmental process.[11] Having abandoned understandings of history as generational, this prevailing perspective asserts a universalizing narrative in which societies

move from primitivism to civilization, from superstition to reason, and from particular local customs to the common practices of human civilization. This ideology of linear, progressivist history serves as a technology of colonization in several ways. Progressivist history authorizes and rationalizes the dispossession, removal, and destruction of peoples deemed unfit for contemporary society. According to the Eurocentric fantasies of progressivist ideology—many of which have been codified in the laws of settler states—Europeans are more evolved than indigenous peoples and therefore have just claim to indigenous lands and resources. Not only does progressivist ideology authorize the violence and destruction of colonization, it also neutralizes historical, social, and legal claims against this violence and destruction by willfully and relentlessly forgetting the past. Within progressivist ideology, history is thoroughly future-oriented. Events and narratives of the past that do not contribute to the progress of dominance have no place in history. This is exactly why indigenous peoples are often pressured—in the name of progress, of course—to forget the past and move on.[12] Forgetfulness of this sort, of course, would be convenient for the perpetrators and beneficiaries of the violence, dispossession, and exploitation that constitute colonization.

Just as Tsinhnahjinnie's Portraits Against Amnesia employs photographic sovereignty in order to resist the colonizing mandate to purge historical injustice, the videographic sovereignty of *Aboriginal World View* insists that past and present practices of colonization and imperialism are interwoven and inexcusable. *Aboriginal World View* conveys this insistence by perceiving and giving voice to that which sociologist Avery Gordon calls the "haunting" of "ghostly matters." For Gordon, "haunting describes how that which appears to be not there is often a seething presence, acting on and often meddling with taken-for-granted realities."[13] *Aboriginal World View* intervenes in progressivist historical narratives that deny the survivance of indigenous peoples and that naturalize—or take for granted—the primacy of settler states and the ongoing global expansion of Eurocentric dominance. The lively presence of decolonizing indigeneity continues its centuries-old tradition of meddling with and undermining this colonization.

Considered in relation to Gordon's theorization of the ways in which the past always haunts the present and informs the future, we might think of *Aboriginal World View* as evidence of the paranormal. The video is thoroughly laden with subtle and not-so-subtle allusions to various aspects of colonialism's and imperialism's long and meandering histories. These histories haunt Chan's performance, which is haunting itself—especially as portrayed and presented by Tsinhnahjinnie. With its distorted sound, sepia tones, color inversion, color channel manipulation, strobing, posterization,

and superimposition, *Aboriginal World View* conjures up the ghosts of North America's violent colonial encounter and places them in eerie conversation with the terrifying ghosts emerging from the so-called war of terror.

By recovering and aesthetically reasserting indigenous histories, *Aboriginal World View* reveals and confronts the malice inherent in colonization. History has for far too long been a bludgeon in the hands of colonizers. Indigenous histories fruitfully reanimate meaningful pasts that colonizing narratives strategically exclude. *Aboriginal World View* reminds its viewers that there are multiple and divergent ways of looking at the past five centuries of colonization in the Americas. The arrival of Columbus in the Americas, the Puritan calling to establish a City upon a Hill, the establishment of the United States, and the spread of American democracy are all celebrated within progressivist ideology. They are imagined as checkpoints or steppingstones toward freedom, nationalization, and global civilization. Yet as the ghostly matters haunting *Aboriginal World View* reveal, these events—and many others—are assessed very differently from the perspectives of indigenous peoples and their histories. Working "against amnesia," the video insists that histories excised from dominant progressivist narratives be accounted for.

While the video is overwhelmingly a visual affair, there is also a subtle narrative strain present. With its subversion of colonization's westering impulse, *Aboriginal World View* rejects the progressivist historical narratives that authorize conquest and that have long maintained that the manifest destiny of the United States is to march to the Pacific coast and beyond. Like the subjects of Tsinhnahjinnie's Portraits Against Amnesia, Chan's agency remains palpable in *Aboriginal World View* despite the symbolic and material oppression of U.S. colonization. Her veil can be read as the empowering mask of an outlaw freedom fighter, and even while she remains silent, the video's music is a direct assertion of Native voice. With drum group Northern Wind's jingle dress song in the foreground, Chan moves westward from Dinétah to the Pacific. Through this decolonizing counternarrative, it is almost as if the ghosts of colonization's contradictions, like Gary Farmer's Nobody in Jim Jarmusch's 1995 film *Dead Man*, calmly and methodically escort the irrational violence of Eurocentric dominance to its own demise in the ocean waters named for peacefulness.

The jingle dress dance is, after all, a healing ritual.[14] So too, then, is *Aboriginal World View.* It is a powerful, transformative work that confronts its viewers with substantive connections between the past and the present in order to compel a reimagining of a decolonized future. The transformative work at the core of *Aboriginal World View* marks the video as an example of what Choctaw writer and scholar LeAnne Howe calls "tribalography." According to Howe, "tribalography comes from the native propensity for

bringing things together, for making consensus, and for symbiotically connecting one thing to another."[15] *Aboriginal World View* connects European and U.S. colonization of North America with U.S. military initiatives in Asia. The video also connects indigenous peoples from various regions, seas, and continents. Moreover, in its perspective attuned to the ghosts of the past, *Aboriginal World View* develops a tribalographic, inclusive, and decolonized sense of history that accounts for the peoples and pasts with no place in progressivist, colonizing narratives.

By associating indigenous struggles in North America and the Pacific with current U.S. military operations, *Aboriginal World View* works to transform dominant perceptions of indigenous peoples as anachronistic by asserting the ongoing salience of indigenous political, legal, and cultural issues. The video offers a chronicle of ongoing resistance and Native survivance that reject what Gerald Vizenor terms the "manifest manners" of colonization.[16] *Aboriginal World View* pulls no punches in doing so, aggressively confronting, defying, and ridiculing colonizing fantasies of a world in which Native peoples—and thus their claims to land, culture, and politics—are no more. As Laguna Pueblo storyteller, writer, and intellectual Leslie Marmon Silko writes, "The Indian with a camera is frightening for a number of reasons. Euro-Americans desperately need to believe that the indigenous people and cultures that were destroyed were somehow less than human; Indian photographers are proof to the contrary."[17]

NOTES

1. Tsinhnahjinnie, "When Is a Photograph Worth a Thousand Words?" 41.
2. Quoted in Vanmeenen, "A Hunger for Images," 16.
3. The images used in Portraits Against Amnesia can be viewed at http://www .hulleah.com/fineart.htm.
4. Passalacqua, "Hulleah J. Tsinhnahjinnie," 87.
5. Scholarly considerations of "Nobody's Pet Indian" and Portraits Against Amnesia can be found in the following: Archuleta, "Refiguring Indian Blood through Poetry, Photography, and Performance Art"; Harlan, "As in Her Vision: Native American Women Photographers"; Passalacqua, "Hulleah J. Tsinhnahjinnie"; Roth, "A Meditation on Bearing/Baring the Body"; and Vanmeenen, "A Hunger for Images."
6. "Leilani Chan," at teada.org.
7. Passalacqua, "Hulleah J. Tsinhnahjinnie," 86. In the version of Passalacqua's essay available via Tsinhnahjinnie's website at http://www.hulleah.com/essay.htm, this

passage is slightly reworded to indicate that Chan is "wearing a hajib designed of American flags." It seems that "hajib" is likely a misspelling of "hijab." Chan's website (http://www.teada.org/artists-leilani-chan.html) explains that she is "dressed in a burkah made of the American Flag." In *Afterimage* magazine, Karen Vanmeenen describes Chan as "draped in a chador made of American flags"; "A Hunger for Images," 15.

8. Smith, *Conquest*, 23.
9. Quoted in Passalacqua, "Hulleah J. Tsinhnahjinnie," 87.
10. Leuthold, *Indigenous Aesthetics*, 192.
11. For explorations of this assertion, see the following: Baillie, *The Belief in Progress*; Bury, *The Idea of Progress*; Fabian, *Time and the Other*; and Noble, *Death of a Nation*.
12. Examples of this are legion. Consider, for instance, a revealing online "chat" facilitated by ESPN regarding American Indian mascots featuring Cheyenne and Creek writer and activist Susan Shown Harjo (available at http://espn.go.com/otl/americans/harjochat.html). Harjo fields a wide array of questions from ESPN viewers/readers. One of these, a question from "Harry" that is far less incendiary than many of those posted by other participants, proceeds as follows: "I am first to agree that what has happened to the Indians by the Americans was a horrible thing, and it shouldn't be looked over. However, how long are you going to play that trump card? Eventually, you need to move on as a group and realize that things are never going to revert back to the olden days. Eventually you are going to have to take responsibility for yourself and stop pulling out that same card." Harjo responds: "We aren't trying to go back to a bygone era. We seek justice in our own time and in comparison to all the other human beings of our time."
13. Gordon, *Ghostly Matters*, 8.
14. Amik (Larry Smallwood), "The Story of the Jingle Dress."
15. Howe, "The Story of America," 42.
16. Vizenor, *Manifest Manners*.
17. Silko, "The Indian with a Camera," 177.

WORKS CITED

Amik (Larry Smallwood). "The Story of the Jingle Dress." Mille Lacs Band of Ojibwe. At http://www.millelacsojibwe.org/cultureColumn.asp?id=115 (September 2008).

Archuleta, Elizabeth. "Refiguring Indian Blood through Poetry, Photography, and Performance Art." *Studies in American Indian Literatures* 17, no. 4 (2005): 1–26.

Baillie, John. *The Belief in Progress.* New York: Charles Scribner's Sons, 1951.

Bury, J. B. *The Idea of Progress: An Inquiry into Its Origin and Growth.* 1920; New York: Macmillan, 1932.

Dead Man. DVD. Directed by Jim Jarmusch. 1995; New York: Miramax Home Video, 2000.

Fabian, Johannes. *Time and the Other: How Anthropology Makes Its Object.* New York: Columbia University Press, 1983.

Gordon, Avery F. *Ghostly Matters: Haunting and the Sociological Imagination.* 1997; Minneapolis: University of Minnesota Press, 2008.

Harjo, Susan Shown. "Harjo: Get Educated." At http://espn.go.com/otl/americans/harjochat.html (September 2008).

Harlan, Theresa. "As in Her Vision: Native American Women Photographers." In *Reframings: New American Feminist Photographies*, ed. Diane Neumaier, 114–24. Philadelphia: Temple University Press, 1995.

Howe, LeAnne. "The Story of America: A Tribalography." In *Clearing a Path: Theorizing the Past in Native American Studies*, ed. Nancy Shoemaker, 29–48. New York: Routledge, 2002.

"Leilani Chan." Teada Productions. At http://www.teada.org/artists-leilani-chan.html (December 2007).

Leuthold, Steven. *Indigenous Aesthetics: Native Art, Media, and Identity.* Austin: University of Texas Press, 1998.

Noble, David W. *Death of a Nation: American Culture and the End of Exceptionalism.* Minneapolis: University of Minnesota Press, 2002.

Passalacqua, Veronica. "Hulleah J. Tsinhnahjinnie." In *Path Breakers*, ed. Lucy Lippard, 81–97. Indianapolis and Seattle: Eiteljorg Museum and University of Washington Press, 2003.

Roth, Moira. "A Meditation on Bearing/Baring the Body." In *Reframings: New American Feminist Photographies*, ed. Diane Neumaier, 186–200. Philadelphia: Temple University Press, 1995.

Silko, Leslie Marmon. "The Indian with a Camera." In *Yellow Woman and a Beauty of the Spirit*, 175–79. New York: Simon & Schuster, 1996.

Smith, Andrea. *Conquest: Sexual Violence and American Indian Genocide.* Cambridge, MA: South End Press, 2005.

Tsinhnahjinnie, Hulleah J. "When Is a Photograph Worth a Thousand Words?" 1998. In *Photography's Other Histories*, ed. Christopher Pinney and Nicolas Peterson, 40–52. Durham, NC: Duke University Press, 2003.

Vanmeenen, Karen. "A Hunger for Images." *Afterimage* 33, no. 4 (2006): 13–17.

Vizenor, Gerald. *Manifest Manners: Narratives on Postindian Survivance.* 1993; Lincoln: University of Nebraska Press, 1999.

Contemporary
American Indian Art

Indigenous Semiotics
and Shared Modernity

DEAN RADER

"The challenge in writing about Native American art," critic
Margaret Dubin observes, "is to recognize areas of difference, as well as areas
of merging social and cultural practices, as they coexist within and influence
the nature of our shared modernity"[1] Dubin is correct—and then some. In
fact, there may be no more daunting scholarly project than sitting down
to write an introduction on or to American Indian art. The sheer scope of
work, over both time and geography, boggles the mind. Even narrowing in
on "recent" or "contemporary" Native art seems impossible. Where does one
start? What does one focus on? Leave out? Should beadwork and clothing
be included? Photography and graphic arts? Performance art? Comics and
graphic novels? There is so much interesting, innovative, important work
that demands attention and appreciation, it almost seems as though this
project is doomed from the start.

And yet, here we are: author and reader. You, knowing my task is impos-
sible, and me, continuing with it anyway. Given the complex relationship
between artist, galleries, audience, art history, and the cultural and historical
circumstances facing Indian artists, there may be no better metaphor for
Native art in the twentieth and twenty-first centuries than this one.

One reason the practice of summarizing and analyzing Indian art is so
complicated is, in part, due to the many provenances of Native aesthetic
production. According to Charlene Touchette, Indian art "comes directly
from the intricate web of experiences of Native Peoples; ancient, modern,
urban and reservation. . . . But Indian art defies easy categorization because
ndn [Indian] experience is multifaceted. ndn's art's challenges containment
in preconceived notions about America's indigenous people and their art."[2]
Touchette is on the money here, and she unwittingly offers a nice entrée

into the essays that make up the second half of this collection, in that these texts look at important artistic moments that shine light on these diverse but inclusive aspects of Indian art. As Touchette argues, Indian art embodies so many different contexts and communities, so many genres and formats, that it is actually more useful to think of Indian arts, rather than the monolithic and subsumable *Art*. Adding to this diversity are the contributions of the scholar. The critics whose essays close this important book interact with methodologies tied to literary and art historical studies, cultural and American studies, and most importantly, tribally specific traditions. Since these particular artists refer to a plurality of subjects in their work—tribes, historical events, removal, gender and power relations, clichés, issues of representation, commodification, and even other artists—their essays and the work they consider demand some contextualization.

For example, before any Haudenosaunee, Navajo, Cree, or Mohawk artist confronts a canvas, a chunk of granite, or a slab of wood, there is yet another confrontation before her—the long and turbulent history of Indians and Indian iconography in the public sphere. Complicating this issue further are the lingering effects of artistic renderings of Indians created by non-Indians. Consider, for example, all of the paintings of Native Americans hanging in hotels, restaurants, galleries, and gift shops executed by non-Indians—or worse, by those who consider themselves "Western Artists." Think also about all of the statues and sculptures of Native peoples we drive past every day that were created by Anglos. A fine example: Preston Powers's *The Closing Era* (1893) sits outside the Colorado State Capitol complex in Denver. It depicts a shirtless Indian warrior, standing over a recently killed buffalo. The warrior, exhausted but proud in victory, rests one leg on the felled animal, evincing superiority and triumph. For over a century, generations of people have encountered this sculpture and, both consciously and subconsciously, internalized its narrative and its semiotics. This piece along with James Earle Fraser's fatalistic *The End of the Trail* (1894) have performed nearly indelible cultural work by inscribing into the American consciousness the *imago* for Indians in art, and perhaps even more harmful what "Indian art" itself actually is.

Though such sculptures border on the cliché, they are more resilient than mere caricatures because of their realism. Unlike sports mascots or overtly racist stereotypes, these pieces seem to enjoy correlatives in history (or at least lore). Anecdotal and synechdochal, they jibe with what so many have wanted to believe. Grappling with the semiotic legacy of such art is not easy. Part of the project of creating new American Indian aesthetic discourse involves erasing the old. When Picasso claimed that every act of creation is also an act of destruction, he no doubt had something else in mind. But

deconstructing the construction of false Indian identity has always been part of Indian art.

That tension with past and present visual fields makes Native aesthetic production unusually rich and uncommonly provocative. Ledger drawings, for instance, embody this friction in a particularly salient manner. Given ledger books by both missionaries and the military, Plains Indians of the late nineteenth and early twentieth centuries would convert these lined and ruled booklets into mini-anthologies of colored pictographed drawings.

By using the materials of Western capitalism as a canvas, a backdrop for Indian creation, Native artists overwrote the documents, the blueprints of American monetary ideology, as well as colonial modes of classification. A similar enactment can be seen in the art produced during the Indian Occupation of Alcatraz. Though no art historian considers the Alcatraz occupation an important milestone in American art, I see it as a catalyst for contemporary Indian aesthetic expression and, like ledger paintings, a perfect example of the dialogic of destruction/creation that informs much of Indian discourse. If we think of the buildings of Alcatraz as an extended living canvas, and the structures of the American penal system as a meta-phor for American incarceration, imprisonment, and confinement, then the two hundred–plus paintings that the occupants made on doors, buildings,

Pamplin Cheyenne/Arapaho Ledger, circa mid-1800s. Contemporary artists like Simon Chaddlesone and Kevin Red Star re-create or reimagine ledger drawings in their work. Acquired by the Dr. and Mrs. Robert B. Pamplin, Jr. Collection of American Indian Art.

water towers, and signs during the eighteen-month occupation (November 1969 to June 1971) can be seen as a giant mural, an epic example of public art advancing and articulating Indian autonomy and sovereignty. Like the pages of the ledger books, the various buildings of Alcatraz function as an anthology of Indian visual expression, as in the "Red Power" painting. Both projects also use the backdrop of American authority to undermine that authority. The Plains Indians transformed the ledger books from a space of categorization to one of subversion, just as the Alcatraz occupants converted the infrastructure of imprisonment into armaments of liberation. I am reminded of Joy Harjo and Gloria Bird, who argue that American Indian women writers who write stories and poems in English "reinvent the enemy's language." Similarly, the artist occupants of Alcatraz reinvent the enemy's symbology—both in terms of structures and language.

Few scholars of Native studies consider the English language as a symbolic field. When a Native author or artist writes or paints in English as opposed to Hopi or Lakota, that choice carries both linguistic and cultural overtones. Communicating in the language of the oppressor means the artist intends an audience; it means he incorporates Western linguistic symbolism to reach a larger demographic. Turning American English against American policies is a gesture long enjoyed by Indian jokesters and storytellers—but it is also an effective artistic technique, as the Alcatraz occupants discovered. The

This Red Power painting, just off the main loading dock at Alcatraz, is both playful and political. Courtesy of the National Parks Service.

text/image interplay at work in much of the Alcatraz art gets recast later in some of the painting, collage, and sculpture of the best contemporary American Indian artists. One in particular, Hock E Aye Vi Edgar Heap of Birds, a painter and sculptor of Cheyenne/Arapaho descent (and an important artist for Susan Bernardin), embodies the activist aesthetic of the Alcatraz artists with particular alacrity. His "wall lyrics," his recasting of common street signs, and in particular, his unrivaled public art project *Wheel* all draw power from the interchange of word and symbol.

Detail of two "trees" from Hock E Aye Vi Edgar Heap of Birds's *Wheel.* Courtesy of the Denver Art Museum.

A permanent sculpture on the grounds of the Denver Museum of Art, *Wheel* stands as one of the most ambitious and most important instances of American and American Indian public art. Fifty-feet in diameter and circumscribed by twelve 12-foot-tall porcelain "trees," *Wheel* evokes the traditional medicine wheel, pueblo kivas, and the Zapotec standing stelae. On each of the Y-shaped trees are inscribed various words, phrases, images, maps, and symbols, all of which connote or denote Native autonomy and sovereignty. What I find fascinating about *Wheel* is how Heap of Birds, like the Alcatraz occupants, is drawn to structures that exist out in the world. His canvas is not canvas but the built environment—as though "structures" themselves function as metaphors for the constructed networks that undergird the very foundation of American value systems. His emphasis on the trunks of the trees—that which *supports* the branches—underscores this reading. Values and systems have feet in both the connotative and the denotative world. Laws denote, Indian mascots connote; the Indian Removal Act denotes, cigar-store Indians connote; the Red Power image and text do both. Subsequently, I can't help but wonder if Heap of Birds intends a critical intertext with Powers's *The Closing Era* sculpture just down the road from the DMA. Even if he doesn't, *Wheel* creates work similar to the ledger drawing in that it overwrites the value system that informed (and that has celebrated) Powers's art. In Denver, the new boss is not the same as the old boss. Juxtaposition of image and word means double signification. *Wheel* signifies in both realms, reminding viewers how powerful the simultaneity of symbol and speech can be.

The degree to which text and image narrate and illustrate each other also drives the work of two other extremely important artists—Carl Beam (Canadian Ojibwe) and Jaune Quick-To-See Smith (Salish/Flathead). For better or worse, Beam has come to be identified as *the* Aboriginal Canadian artist, and his stunning *The North American Iceberg* as *the* piece of indigenous Canadian Art. This is all for good reason. Until his death in 2008, Beam was likely the most talented First Nations artist working in Canada, and this piece is breathtaking in its scope, its manic energy, and its activist aesthetic. Like *Wheel*, there is a lot going on here. Along the top portion of the piece, three different photos of the artist, resembling mug shots, sequence themselves along a horizontal plane, enabling us to *see* him from three different angles. These photos are counterbalanced by more iconic photographic images of Natives à la Edward Curtis. Closer inspection reveals that two of the Indians in question are Gerry Elbridge and Geronimo. We know this because their photos accompany an encyclopedia entry for both men. Other entries appear, but are smaller and blurred—the corresponding images to

those entries repeated and enlarged. Other black-and-white and sepia-toned images spangle the canvas, as do numbers, vertical lines, dripped and splattered paint, random numbers, and again, text. Toward the bottom left, "Revolving Sequential" suggests that the numbers and lines don't *really* stop at 18 but continue in an unending circularity, as though this iceberg, like Heap of Birds's *Wheel*, is always already turning, like a fancydancer or the spinning chamber of a pistol. In military-esque stencil, a poetic fragment cascades down the upper right quadrant, spelling out the painting's title and offering a kind of epigraph: "Ignored, the force moved unsung because it is so real into the real it knows flash to light." I don't know what that means, and I can't find a reference to it anywhere, but I like it. It evokes, for me, the flash of gunfire, the force of encroaching white settlers and the new millennium.

As fascinating as the images are, they would be lost without the text. The words ground the images, giving them context and concatenation. The encyclopedic entries call themselves—and all attempts by Anglo scholars to classify and explain and reduce indigenous identity—into question. Within the frame of this painting, Gerry Elbridge's mini-bio seems ludicrous, but without the painting, many viewers might continue taking such texts for granted. This painting urges viewers to mistrust any text about Indians created by non-Indians, no matter how "authoritative" or "objective" it may appear.

Like Beam, Jaune Quick-To-See Smith lets the viewers take nothing for granted. She layers image and text, paint and collage for dramatic and political effect. Her map paintings of the lower forty-eight states are some of the most intriguing instances of contemporary indigenous art because they challenge the sanctity of the cartography of manifest destiny. In most of her other work, though, Smith utilizes less geographical and more cultural images. In *Paper Dolls for a Post-Columbian World*, for example, the artist uses the familiar visual symbol of the innocuous paper doll to make a darkly comic comment on how we tend to play at history.

I remember the first time I saw this piece. I was rendered speechless. I found it both humorous and horrific. Ken and Barbie Plenty Horses is a good and easy laugh. And, the Jesuit priest in his long robe (which predicts the robe-wearing basketball Jesuits in *Smoke Signals*) is virtually the poster priest for parody. Even the headdress and its smart commentary on the exchangeability of Indian semiotics—aren't all Indians Plains Indians after all?—feels innocently wry. But the smallpox blankets with their little tabs that a young white girl might bend back over the flat, one-dimensional *wooden Indian* is shockingly bold. Who makes light of genocide? Who pokes fun at mass death? A bold artist—an artist who believes that art has

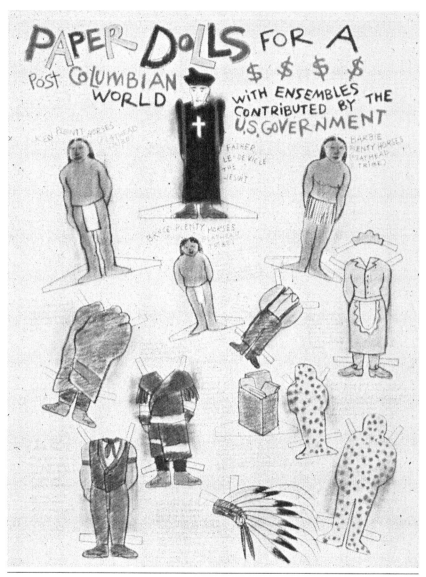

Jaune Quick-To-See Smith's *Paper Dolls for a Post-Columbian World* strikes an uneasy chord with its smart and shocking mix of humor and horror.

the power to alter perception. The layers of political commentary, personal anger, and historical belittlement contained in this painterly detail is a high mark of aesthetic courage.

Part of what works in this piece is its intentionally crude rendering.

Scrawled in pencil (like a child), *Paper Dolls* foregrounds ethics over aesthetics. Quick-To-See Smith makes another bold decision in that she chooses not to display her sense of craft. Message transcends the need to prove technical ability—a characteristic not atypical of Native artists. A similar piece both in structure and significance is *Flathead Warshirt*. In this piece, the artist uses the familiar visual symbol of the Native warshirt to create yet another field of play. Stripped of its typical beaded finery, the warshirt in Smith's painting has been washed out, emptied of its traditional signification. In its stead, the viewer discovers advertisements that incorporate Indian imagery and iconography as well as slogans from mainstream ads. Juxtaposed against an ad that uses an Indian maiden to hawk tomatoes is a tagline in the middle of the shirt that embodies so many commercial clichés: "I've had tailored suits that didn't fit this well." Orbiting the shirt are more images of Indians in the news, notices for powwows, Indian ads, and, like Beam, family photographs. Beneath one of the photographs of an Indian, Smith has pasted a headline from a newspaper: "Look for this symbol"—a command that serves as a sort of thesis statement for the piece.

Perhaps the savviest Indian artist when it comes to issues of Indian symbolism, Smith collates commercial and cultural products that help create, reinforce, and reify Indian identity. As Julie Sasse notes, Smith uses the warshirt as her own symbol of Anglo misreading. Where Europeans and Americans saw the shirt as a glorification of war, it was in reality all about ceremony. For Smith, the warshirt is "a crucible of Native thinking in terms of religious philosophy, democratic ideals, and social wisdom."[3] In both *Warshirt* and *Paper Dolls*, Smith remains interested in the many ways—both consciously and subconsciously—that Americans have internalized the invented Indian into an unexamined but multilayered form of semiosis. In other words, she shows us a variety of ways we have created a glossary of Indian signification; she tell us what Americans have told the world Indians can stand for. To this end, her dark drips and collaged canvas recalls Robert Rauschenberg, who in pieces like *Retroactive I* and *Persimmon* both celebrates and mocks our culture's obsession with icons and symbols. In many of Smith's paintings, the accoutrements of Indian identity—shirts, feathers, canoes, buffalo, Tonto, frybread—receives a reverse iconoclasm. Rather than reuse them as modes of fetishism, commercialism, or tourism, she recasts them as sites of indigenous reclamation and reinvention.

Two other artists—Fritz Scholder and T. C. Cannon—also traffic in Indian symbolism; but unlike Beam and Smith, they tend to avoid text, relying solely on the power that Indians on a canvas can generate. However, like Smith and Beam, they attack the easy assumptions about Indian

representation and Indian-on-Indian art. In fact, Scholder actually vowed early in his career never to paint Indians. "The non-Indian had painted the subject as a noble savage," Scholder claims, "and the Indian painter had been caught in a tourist-pleasing cliché."[4] But, when he started painting Indians, no one was prepared—perhaps not even Scholder—for what he saw. Drunk Indians, dead Indians, ugly Indians, monster Indians. His *Dog and Dead Indian* (1971) infamously captures death with indignity by depicting a splayed and gruesome Indian whose corpse seems to have just been discovered by a curious canine. With head tilted back and mouth agape, and dots and dashes of crimson on the bleached body, the figure looks beaten or crucified. One of his early Indian paintings, *Monster Indian* (1968), evokes a Francis Bacon canvas. Almost cubist in composition, the face is distorted and blurred, the eyes vacant. The painting is *scary*.

One of his most famous images, *Indian with Beer Can*, actually seems to go out of its way to support negative assumptions about alcoholic Indians, and to reassure viewers that Indians may, in fact, be dangerous. With flared nostrils, his eyes hidden behind sunglasses, and his mouth an oval cave of fangs, the subject of the painting snarls at the viewer with a look of contempt. The sunglasses shield his eyes, denying us full access to him, while he enjoys complete access to us. A virtual panopticon of power and surveillance, the painting does not clearly indicate any sense of play, irony, or humor. It is realism on Quaaludes.

Scholder's most important student, T. C. Cannon, inherited both a thematic and aesthetic sensibility from Scholder. Like his teacher's, his paintings tend to feature a solitary male Indian, neither a part of nor separate from his surroundings. And like Scholder, he enjoys playing with clichés and stereotypes about Indian identity. But, where Scholder tackles the weaknesses, struggles, and anxieties of Indians head-on, Cannon attacks from the side, from behind. If Scholder's paintings are declarative sentences, Cannon's are questions. If Scholder's Indians have been deglamorized, Cannon's have been demythologized. Aesthetically, this translates into a softer palette. Scholder's early Indian paintings strive for an anti–Santa Fe, anti-tourist aesthetic. Often flat and almost matted, his color scheme favors dark tones, and the faces of his subjects are impossible to discern completely. They are hidden, indistinct, or nearly erased. Cannon, on the other hand, is more fanciful. He decorates the backgrounds with flourishes of design and color; the facial features of his subjects are sharp and readable. They feature a quirkiness that communicates both accessibility and humor. In *Collector #2*, for example, a self-portrait, a longhaired Indian man dressed in Western clothing stands next to a Van Gogh painting. Like Scholder's *Indian with a Beer Can*, the subject wears a big hat

and sunglasses. He doesn't smile so much as smirk, as if to say, "Sure, I'm an Indian and I collect Van Gogh." Just as Scholder plays with the viewer's assumptions about Indians, so does Cannon; but he twists it even further, merging race and class, high culture and ethnic culture. The Indian is also a collector, and the collector, an Indian. "He's a contemporary artist," writes Julie Coleman Tachick, "aware and proud of his heritage, but also familiar with the masters of European art, as indicated by the small van Gogh landscape painting hanging on the wall. In creating his own works, he draws his strength and knowledge from both."[5]

One of Scholder's sticking points about Indian art was what made it collectible. For him, one set of criteria existed for European and American painting influenced by modernist gestures, the expanse of Abstract Expressionism, and the high camp of Pop Art, and another for "Indian artists" and "Indian art." Where the former foregrounded innovation, transgression, and imagination, the latter was often linked to the kitschy world of curios and trinkets. What's more, Indians were (and still are) *themselves* objects of collection. So, one of the more enjoyable aspects of Cannon's painting is the way it subverts the standard collector paradigm. That postmodern sense of play informs much of the more recent Indian art, not just of people like Quick-To-See Smith but that of emerging artists like Larry McNeil and Tom Jones. Both Jones and McNeil take pages from the sketchbook of Smith, Beam, and Heap of Birds in order to use images of the Land O'Lakes maiden (in the case of Jones's *Commodity II*) or Tonto (in *Native Epistemology*) to make larger statements about the commodification of Indian imagery.

Like Quick-To-See Smith, Jones playfully teases out the racist undertones found in Indian toys and tourist tchotchkes. His fantastic collage, built from both actual images and self-created ones, forces the viewer to ask not just what *real* Indians might be, but what real *representations* of Indians might look like.

Also drawing on the cultural currency of the Indian image in popular culture, Larry McNeil riffs on Tonto and the silly white people who love him. On one hand, he pokes fun at fussy Anglos who prefer soy cheese over the real thing (perhaps a comment on those who prefer the invented Indian over the real thing), and on the other, he reverses the intelligence dynamic of Tonto and the Lone Ranger. Instead of Tonto not understanding English, it's the Lone Ranger who doesn't know what "epistemology" means. For McNeil and Jones, commodity becomes a form of epistemology.

And once again, we are back in the world of image and text—the marriage of visual and verbal language—their intersymbolic semiotics a form of dual signification. It is at this merger of word and world that I would

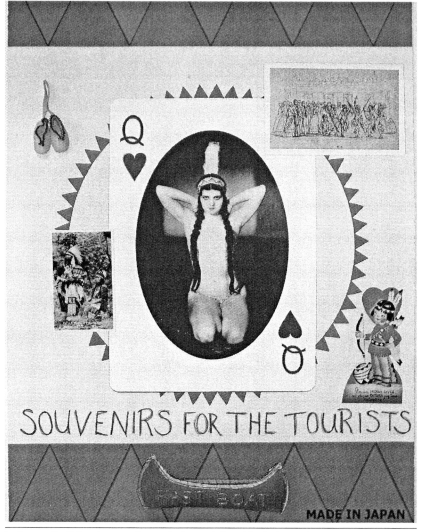

In *Commodity II*, Tom Jones coalesces playing cards (gambling), the Land O'Lakes maiden, and Pocahontas, postcards, and other forms of tourist objectification. Courtesy of Tom Jones.

like to turn to the three remaining essays in this collection. In her fine piece "Seeing Memory/Storying Memory: Printup Hope, Rickard, Gansworth," Susan Bernardin leads the reader through a series of texts whose linguistic and artistic interplay advances provocative arguments about what she calls the "aesthetics of encoding." Bernardin looks closely at the

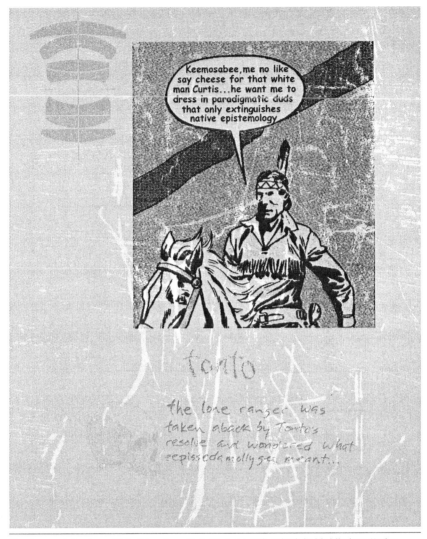

Merging comic books and television, Larry McNeil takes a stab at both in his hilarious *Native Epistemology*. Courtesy of Larry McNeil.

mixed-genre work of three Haudenosaunee artists—Eric Gansworth, Melanie Printup Hope, and Jolene Rickard—in an attempt to show how the aesthetic practice of memory-making enacts a form of continuance. What makes Bernardin's essay so compelling is her ability to show how these three artists incorporate Haudenosaunee-specific gestures in their work through

innovative intertextual dialogue with the protocols of the wampum—"the verbal-visual nexus in Haudenosaunee art." For these artists, collating the verbal and visual is not merely a cool postmodern stance, but a tribal legacy that informs the most basic aspects of communication. For example, in Printup Hope's *My Grandmother Was Calling Me Home*—a collage of photographs, text, and maps—she charts the forced removal of her ancestors from New York to North Carolina. Like Heap of Birds, she deploys signs and symbols as a form of marking; and like Smith, she utilizes maps and the written word. Like much Native literature, Printup Hope's art projects call into question the Western notion of linearity, the false assumption that point A leads to point B, and that time only lunges forward. It is no wonder, then, that Gansworth, an excellent novelist and poet, feels at home in both realms of symbolic discourse. Bernardin does an admirable job of demonstrating Gansworth's wampum aesthetic in his beguiling collection of poems and paintings *A Half-Life of Cardio-Pulmonary Function*, perhaps my favorite book by him. "Gansworth uses his notion of 'indigenous binary code,'" Bernardin observes, "to extend wampum's possibilities as inspiration, creative form, and thematic code." She is spot on here, as she is in the entire essay—all of the artists find uncommon articulation in Bernardin's reading. Many readers will unlikely be familiar with all three of these artists, and it's a credit to Bernardin that through her essay, a cohesive examination of such different artists emerges.

Readers of this book will, perhaps, be familiar with the Seminole/Muskogee/Diné photographer Hulleah Tsinhnahjinnie, an innovative artist and the subject of a much-needed essay by Cynthia Fowler (complementing Joseph Bauerkemper's piece on Tsinhnahjinnie's videography, earlier in this volume). By grounding her reading of Tsinhnahjinnie's work in the Navajo notion of beauty, or *hózhó*, Fowler positions this work within a tribal paradigm, making the photographs not simply a participant in the long history of women and photography but also a participant in the long history of Navajo cultural production. To say that *hózhó* means "beauty" as we think of beauty in Western terms is to oversimplify and flatten its significance. A more accurate (if painfully New-Agey) concept might be holism. *Hózhó* is about harmony, order, balance, and correctness—but not the order of Western classification or the correctness of uptight manners. *Hózhó* animates much of the art of Quick-To-See Smith, the poetry of Navajo writer Luci Tapahonso, and that of Joy Harjo, as in the final lines of "Eagle Poem":

> We are truly blessed because we
> Were born, and die soon, within a
> True circle of motion,

Like eagle rounding out the morning
Inside us.
We pray that it will be done
In beauty.
In beauty.[6]

For Tsinhnahjinnie, balance and imbalance function as both aesthetic and cultural concepts. Part of her artistic project is to harmonize the disharmony of how Indians *are* and are represented in the world. As Fowler correctly argues, "We see beauty and politics are inescapably linked as Tsinhnahjinnie attempts to correct the imbalances in representations of native people from the beginnings of photography in America." One of those imbalances lies in the representation of women, and in particular, indigenous women. Tsinhnahjinnie has some fun playing with the earnest portrait of the earnest Indian maiden, à la Edward Curtis. As critic Lucy R. Lippard rightly notes, "Portraiture is at the heart of discussions about photography by and of Native people."[7] Beam comments, slyly, on this tradition in *The North American Iceberg*, while both Scholder and Canon take the history of Indian portraiture head-on, but through paint rather than photography. Through digital and photographic manipulation, Tsinhnahjinnie tackles this problem with unusual alacrity and confidence. While she does not show formal fidelity to the history of Native portraiture, her execution makes it clear that her photographs are less about the past and more about the present.

One of the many glaring omissions in my opening comments about Native art was any sustained discussion about gender or, more specifically, the representations of Native women by Native artists. In this regard, Tsinhnahjinnie is revolutionary, and Fowler's essay is important in part because she calls attention to Tsinhnahjinnie's groundbreaking work in this area. No other Native visual artist has devoted more time and energy toward deconstructing reductive and prescribed notions of female and cultural beauty. Fowler's most enduring contribution is her persuasive claim that Tsinhnahjinnie's project of beauty has been carried out "on indigenous terms." Though Fowler doesn't really come out and call Tsinhnahjinnie an activist artist, her work does advance an aesthetic and tribal resistance that is at once learned and liberating.

It was the learned and liberating collation of text and image that first drew Molly McGlennen to the work of George Longfish. Like Quick-To-See Smith, Longfish draws much of his inspiration from advertising—logos, slogans, icons—and like hers, his art is filled with the reappropriation of various images. On one hand he loves to juxtapose familiar images that seem incongruent, like giant hamburgers and Indians. But, on the other

hand, like Scholder, Longfish enjoys recalibrating the viewer's notions of what an Indian is, and what our expectations of Indians on canvas might be, as in his startling *Winter Still Life Landscape, South Dakota, 1893.* In this large-scale piece, Longfish creates a bizarre diptych of the frozen body of Chief Big Foot. But, where Scholder's backdrop would remain blank (and bleak), Longfish enlivens his with text that slices across the images. Snippets of dialogue, warnings, and even some black humor ("No Snowboarding") convert this scene of passive conquest into active conversation. McGlennen, who wrote a piece on Longfish for the National Museum of the American Indian, is a shrewd reader of his work because she sees through the many layers of signification to the heart of his project.

According to McGlennen, Longfish's project is to "provide a continuum of healing." One way the artist engenders this sense of restoration is, like Printup Hope, through text. For McGlennen, text encourages dialogue, which encourages interaction, which encourages communication, community, and being in communion. The modernist impulse of Scholder's and Cannon's text-free canvases with their watery colors and nearly cartoonish renderings of Indians (Cannon's self-portrait is a dead ringer for a *Doonesbury* figure) provide clues on how one should read them. The paintings are, after all, figural, but Longfish takes a different tack. His images are actually more complex than Scholder's or Cannon's, but he captions them, in a sense, through his use of text. In an age of email and SMS, Longfish's canvases feel current, even edgy. But most of all, they feel like they want an audience.

This attention to audience informs the work of all of these artists. Obviously, the importance of the verbal and the visual unite all of the artists under consideration here, but beyond that, each one evinces a commitment to the power of healing, of putting things into right relation, through the act of communication. They also demonstrate the syncretic ability of Native artists—the efficacy with which so many indigenous people draw from a myriad of traditions in order to make Native creative expression as layered as life itself. "ndn art is beautiful," writes Touchette. "And confrontational. It is shocking, thought-provoking, awe inspiring and surprising."[8] Thanks to Bernardin, Fowler, and McGlennen, readers from all areas of interest have a much deeper understanding of the ways in which both perception and reception inform and interact with Native visualities.

One of my favorite pieces of recent American Indian art is *Kiowa Aw-Day*, a fabulously beaded pair of Chuck Taylor sneakers, executed by the Kiowa artist Teri Greeves. Almost neon red, and adorned with electric blue laces and a shamelessly cute Indian girl, the shoes are a contemporary version of beaded baskets or decorated pots in that they provide a canny example of

the indigenous marriage of utility and aesthetics. *Aw-Day* means "favorite children" in Kiowa, and the shoes refer to the tradition of children leading the Black Legging Society into dance, a gesture that indicates readiness for adulthood and leadership. But I also like how the shoes play on Indian commitment to basketball—especially the role basketball plays in the life of young women, as documented in Larry Colton's fabulous book *Counting Coup: A True Story of Basketball and Honor on the Little Big Horn.* According to scholar Elizabeth Archuleta, Greeves "adapts the traditional to the contemporary, claiming a difference between whites and Indians who wear sneakers; Greeves's beading on the shoes illustrates this difference visually and ideologically."[9] For me, these shoes bring us back full circle to the ledger drawings as examples of ways in which Indian artists have taken semiotically and ideologically loaded texts and re-signed them, re-coded them so that instead of signifying American culture, they signify American Indian culture. In both cases, Native artists take the accoutrements of dominance and recast them as texts of indigenous semiotics.

Archuleta goes on to note that the shoes "challenge the tendency to privilege text as well as Indians untouched by time."[10] We need the essays in this volume, these re-codings, these challenges to the privilege of text by Fowler, Bernardin, and McGlennen because, when it comes down to it, they do the very same work.

Teri Greeves, *Kiowa Aw-Day*, on display at the National Museum of the American Indian. Courtesy of the National Museum of the American Indian.

NOTES

1. Margaret Dubin, "Sanctioned Scribe," 161.
2. Charlene Touchette, *ndn art: Contemporary American Indian Art*, 7.
3. Julie Sasse, *Jaune Quick-to-See Smith: Postmodern Messenger*, 13.
4. Fritz Scholder and Rudy H. Turk, *Scholder/Indians*, 22.
5. Julie Coleman Tachick, "T. C. Cannon: Challenging the Parameters."
6. Joy Harjo, *In Mad Love and War*, 65.
7. Lucy R. Lippard, "Independent Identities," 134.
8. Charlene Touchette, *ndn art: Contemporary American Indian Art*, 7.
9. Elizabeth Archuleta, "Gym Shoes," 194.
10. Ibid., 195.

WORKS CITED

Archuleta, Elizabeth. "Gym Shoes, Maps, and Passports, Oh My!" In *The National Museum of the American Indian: Critical Conversations*, ed. Amy Lonetree and Amanda J. Cobb, 181–207. Lincoln: University of Nebraska Press, 2008.

Dubin, Margaret. "Sanctioned Scribes: How Critics and Historians Write the Native American Art World." In *Native American Art in the Twentieth Century*, ed. Jackson Rushing III, 149–68. London: Routledge, 1999.

Harjo, Joy. *In Mad Love and War*. Wesleyan: Wesleyan University Press, 1990.

Lippard, Lucy R. "Independent Identities." In *Native American Art in the Twentieth Century*, ed. Jackson Rushing III, 134–48. London: Routledge, 1999.

Sasse, Julie. *Jaune Quick-to-See Smith: Postmodern Messenger*. Tucson, AZ: Tucson Museum of Art, 2004.

Scholder, Fritz, and Rudy H. Turk. *Scholder/Indians*. Flagstaff, AZ: Northland Press, 1972.

Tachick, Julie Coleman. "T. C. Cannon: Challenging the Parameters." *Points West Online*. At http://www.bbhc.org/pointsWest/PWArticle.cfm?ArticleID=156 (summer 2004).

Touchette, Charlene. *ndn art: Contemporary American Indian Art*. Albuquerque: Fresco Fine Art Publications, 2003.

Seeing Memory, Storying Memory: Printup Hope, Rickard, Gansworth

SUSAN BERNARDIN

So much of the story is carried by memory.

—ERIC GANSWORTH, ARTIST'S TALK,
COLGATE UNIVERSITY, OCTOBER 30, 2008

IN A SELF-PORTRAIT ENTITLED *SEEING WITH MY MEMORY* (2000), Mohawk artist Shelley Niro invites the viewer to consider the seen and the unseen. The artist holds onto a tree at Tutela Heights at Six Nations in Ontario. A recurring setting found in Niro's work, including her film *It Starts with a Whisper* and her painting *Tutela*, Tutela Heights memorializes indigenous people forcibly displaced and offered sanctuary at Six Nations. According to Niro, many Tutelos later died of influenza.[1] Taken together, Niro's painting and provocative title beg the question: what are the mechanisms of memory that could make this place, people, and history visible? Looking back at viewers looking at her, Niro stages a scene of layered interaction between the artist's imagination, the lived and shared memories imprinted on and by the land, and the manifold perspectives of viewers who may come into contact with the painting. Do viewers share her vision or do they envision other memory trails? Or is this scene simply elusive? *Seeing with My Memory* balances the primacy of indigenous memory against the ongoing threat posed by forgetting: its reckoning of grief—of almost incalculable loss—shares a clear-eyed, if coded, vision of continuance.

Niro's pairing of title and painting reminds us that the relationship

between the textual and visual is vital not only for eliciting response and unleashing meaning, but also for inviting story. By "seeing" with her memory, Niro echoes an invocation made in N. Scott Momaday's seminal memoir *The Way to Rainy Mountain*. Pairing his father's drawings with his account of Kiowa, settler, and personal memory, Momaday retraces the geographical movement of his ancestors from emergence to ensuing migration through the Plains. Momaday aims to experience firsthand what his own grandmother "could see more perfectly in her mind's eye," despite her never having seen the places carried in memory by Kiowa tribal history.[2] Like Niro, Momaday thus suggests the constitutive power of remembered story, understood as a way of seeing across time and place. At the same time, both artists help us to see what has been invisible for too long in discussions of Native American literary studies: the informing, vital lens of indigenous visual arts. With his mixed-genre works of poems and paintings, Momaday himself has long made visible rich interconnections between the visual and verbal. From Elizabeth Woody to Wendy Rose, Joy Harjo to Gail Tremblay, many Native writers speak in multiple, mutually constitutive languages of literary and visual arts. For their part, diverse Native artists such as Edgar Heap of Birds, Jaune Quick-To-See Smith, George Longfish, and Phil Young have turned to words as equally constitutive features of their versatile visual works.

Yet the active and ongoing communication across these and other aesthetic fields has often gone unnoted in the practice of Native literary studies. How do we access the language(s) of these interconnections? Turning to what Carol Lorenz calls the "verbal-visual nexus in Haudenosaunee art," we can find one method for tracing these relationships.[3] This essay considers how the selected visual work of two Tuscarora artists—Melanie Printup Hope and Jolene Rickard—offers cues for reading the mixed-genre work of Eric Gansworth (enrolled Onondaga, lifelong resident of the Tuscarora Nation and its vicinity). Through their visual and textual stagings of cultural memory, all three artists embrace interactive, richly layered forms of communication with viewers. Like Niro, their work compels viewers to respond by making connections, asking questions, and sharing story. Understood through Haudenosaunee visual languages made particular by Tuscarora and individual memory, these works suggest strategies for reading within shared indigenous systems of meanings. At the same time, the kinship between word and image in Haudenosaunee contexts invites considerations of speaking across indigenous aesthetic systems, or what Chadwick Allen calls the "trans-indigenous."[4] Akin to scholars such as Allen, Malea Powell, Chris Teuton, Qwo-Li Driscoll who locate indigenous literatures as part of

a broader aesthetic system of related practices such as beadwork, basketmaking, and dance, the artists here direct us to the unsung importance of visual arts in indigenous literary practice and interpretation.

VITAL SIGNS

Shelley Niro's invitation to "see with one's memory" calls to mind the works of many Haudenosaunee artists that similarly encode, visualize, and forward cultural memory. Such artists draw on a long legacy of linking aesthetic innovation with what Tom Ball (Modoc, Klamath) calls the imperative of "remembering forward."[5] About the diverse works represented by twenty-two Haudenosaunee artists at the 2007 exhibit Oh So Iroquois, curator Ryan Rice (Mohawk) described a collective effort to "create a presence for what is Iroquois. That we are here, that we are contemporary and we are here, built on foundations that are still strong and still very influential, still important to the way we think and deal with each other."[6] He identified the many "signs and symbols that will guide you through the pieces"—the sky dome, the Three Sisters, white pine, wampum—that signify these artists' living relationship with memory, with "tradition [that] can move through time and space."[7] Signposts of what Michelle Raheja calls "visual sovereignty," they underscore the centrality of visual languages in contemporary Haudenosaunee thought.[8] As Janet Berlo and Ruth Phillips claim, "Visual artistic forms help people conceptualize the social and political bonds (both ideal and actual) that unite them."[9]

A multimedia artist, Melanie Printup Hope explores how visual technologies might "tell our stories in new ways."[10] Her own movement as an artist has been to find ways to claim an identity she has felt she had to fight for, while forging interactive strategies for communicating Haudenosaunee worldviews to diverse audiences. For example, in her Thanksgiving Prayer installation, which fuses beading with computer imaging, viewers choose how and in what sequence to interact with the layers of prayers. Pixel beads carry Haudenosaunee values; multiple access points encourage aural, tactile, and visual entryways into the work. From its presence at the George Gustav Heye Center in New York to its literal motion aboard the ARTRAIN USA traveling exhibit of contemporary Native art, Printup Hope's Thanksgiving Prayer installation highlights her interest in disseminating Haudenosaunee memory into a variety of public spaces.

Printup Hope's interest in finding diverse locales for visualizing memory

continues a centuries-long fight for indigenous survival in New York. If, as Edward Hashima notes, "the establishment of identities requires the appropriation of both place and memory," then the status and stakes of memory still loom large in the aptly named Empire State.[11] For Tuscarora artists like Printup Hope, an undertold, under-remembered story begins in what is now called North Carolina and continues at the western door of New York, home to Niagara Falls and the Tuscarora Nation. Many Tuscaroras journeyed from their homes in the wake of ravaging, brutal losses in conflicts with Anglo newcomers in the early eighteenth century. Along what Printup Hope and others call the Tuscarora Trail of Tears, her ancestors were given shelter by Oneidas and land by Senecas, and later were formally recognized as the Sixth Nation of the Haudenosaunee. That movement, traced in story and long memory, serves as a framework for a digital collage that Printup Hope created in 1998. Entitled *My Grandmother Was Calling Me Home* (1998), the piece splices a dense array of photographs, maps, and written text that both embodies and comments on acts of restorative indigenous memory. Intent on retracing the journey her ancestors took north from Tuscarora homelands in the early 1700s, Printup Hope tracked down maps and documents located in archives stretching from the University of North Carolina at Chapel Hill to Carlisle Indian School.

In July 1997, Printup Hope left upstate New York with her husband and children, following a full moon lighting up the sky—the "Grandmother" of the title. In an interview, she spoke of how the moon's night presence kept her grounded: in variations of Haudenosaunee cosmology, Grandmother Moon is Sky Woman or her daughter, released into the sky by Good Mind, one of her twin sons. As such, the piece's title appropriately launches a story of origins, sought in image and text. Under a sky infused with the past and possibility, Printup Hope drove home to uncover her family and community's genealogies of motion. For the artist, the moon's presence embodies continuity: from creation time to the present time, Haudenosaunee life continues beneath, beyond, and above settler incursions into indigenous spaces. Like the ubiquitous presence of the moon in Eric Gansworth's paintings, the moon of the title similarly serves as a foundational reminder of Haudenosaunee continuance, of being "at home" anywhere under the sky. As Louis Owens writes in his epigraph to *Bone Game*, his novel about the legacy of genocidal loss in Native California: "and still it is the same sky."[12]

For viewers, *Grandmother*'s striking dimensions signal a dramatic recasting of colonial modes of temporality through its counter-emphasis on spatiality. Measuring 15 feet long by 10 inches wide, the piece demands viewers to inch closer, to travel the long path of the collage. Part of the Ottawa Art

Gallery's exhibit Oh So Iroquois, *My Grandmother Was Calling Me Home* was positioned along a wide white wall, accentuating its demand for close interaction. For curator Ryan Rice, this piece communicates that "there's a lot of movement in Iroquois history and territory."[13] Like a Haudenosaunee wampum belt, *Grandmother* shares constitutive features of form, interactivity, layered knowledges, and "visual documentation of a specific message . . . that in its telling, always includes the life experience of its interpreter."[14] Its dimensions also notably evoke a timeline measured in the days of her family trip, the months and years of the Tuscarora forced migration, and the ensuing centuries of displacement and recentering. Yet its internal design refuses the Eurowestern method of "doing time," of conceiving history as a long linear line. In his essay "Keep Your Thoughts above the Trees: Ideas on Developing and Presenting Tribal Histories," Lakota scholar Craig Howe identifies the "conventional academic perspective on tribal histories" as "linear or sequential; in that it is written. Western European languages are read left to right, top to bottom, beginning to end. The result is a 'beginning-top-left' to 'ending-bottom-right' narrative predicated upon the written word."[15] He continues: "Indigenous tribal perspective on tribal histories, on the other hand, is more likely to be recited in relationship to specific landscapes, waterscapes, and skyscapes. This perspective is event-centered: here something happened and a particular person or being was present."[16] Linda Tuhiwai Smith's landmark text *Decolonizing Methodologies* similarly decenters Western fixations on linear temporality by delineating the domineering narrative of progress undergirding it. As her dissection of academic historical discourse reveals, particular ways of viewing time have proved ruinous for indigenous epistemologies. Any visit to standard historical "sites" of colonial contestation can attest to the omnipresence of the timeline, always beginning with indigenous peoples and "progressing" to settlement.

At first glance, the form and format of Printup Hope's "timeline"— apparently moving left to right and from beginning to end—might seem to announce the overriding and overwriting of Tuscarora stories by a settler nation's occupation. A closer look refutes the attempted superimposition of one story over another, thus altering the terms of how *that* story has been told. The piece challenges the finality, even the truth of that story by an unusual layering technique that messes with time, space, and location. First, the sequence of images resembles a film strip whose individual images are both separate and interwoven. The artist's inclusion of photographs featuring her family members in the car, on the beach, and in parks underscores that the work itself is in motion, traveling across time and space. The presence of family members in the piece also insists on the contemporaneity of the Tuscarora story being

told. The visual effect of such strategies echoes Jaune Quick-To-See Smith's description of her own paintings: "Euro-Americans have a linear form of time and their stories have a beginning and an end, but we have a horizontal sense of time which compresses history and present reality. My paintings have no beginning and no end to their stories."[17]

My Grandmother Was Calling Me Home also reorients colonial assumptions of temporal linearity and historical progress through its juxtaposition of graphic sites and signs. Throughout the piece, photographs of foundational settler cartographies remind viewers that "mapping of course is an intensely political enterprise, an essential step toward appropriation and possession. Maps write the conquerors' stories over the stories of the conquered."[18] The map of the "frontier of 1711 and 1713," for example, underlines the ideological construction of mapmaking: after all, it was hardly a frontier for those who considered it the center of the world. Through maps labeled "estimated route and initial resettlement" and "approximate location of Tuscarora villages and forts," Printup Hope produces an investigative text of images and signs. The proliferation of images of roadside markers, posted signs, and maps in *Grandmother* plots a story of presence and dispossession, of submerged, displaced, resurgent memories. For example, the left side of the piece compresses images from the first place Printup Hope landed in North Carolina: an interior shot of the UNC-Chapel Hill library, where she accessed settler maps, overlaps a photograph of a marker commemorating the university and state's conjoined beginnings.

Printup Hope's inclusion of such signs thus compels a meditation on other kinds of origin stories, those that shape historical narratives and signify ownership of the past. For example, in one section, a sign for "Toisnot Recreation" is juxtaposed with marker F-37 for "Nooherooka, Tuscarora stronghold. Site of decisive battle of the Tuscarora War, March 20–23,

Melanie Printup Hope, *My Grandmother Was Calling Me Home*. Digital collage. Courtesy of the artist.

1713, when 950 Indians were killed or captured." When placed alongside a photograph of one of the artist's daughters, the sign's "shorthand" version of this defining conflict is exposed for its partiality. Facing away from the historical marker, the artist's daughter turns her back on a troubled commemoration of absence. Too often, such signs substitute for common knowledge of Native history: casually forgotten along roadsides across the country, historical markers implicitly promote the still-omnipresent story of Native absence. Who even stops? The danger of forgetting is underscored by the preceding image of a state park on the ground of a former Tuscarora community. By itself, the image does not tell us this fact: only viewers with knowledge of ancestral Tuscarora communities will fully recognize the superimposition. After all, indigenous names on signs across the country call out a history that most current residents barely discern, if at all. Printup Hope questions here whether such markers refuse the challenge of other memories, and in so doing, refuse the nationwide reckoning that would be required. Strategically situated in this piece, the road sign's looming presence forces viewers to read between the lines of the inscription: its elliptical statement of grievous Tuscarora losses bears witness against settler national amnesia while also inadvertently underscoring the failure of conquest.

After all, Printup Hope's daughters are there. Her other daughter's presence in the adjoining panel—casting a watchful eye on an archaeological dig at "Nooheroka," or Neoheroka—foregrounds the ongoing stakes of Printup Hope's project. In 1990, Eastern Carolina University established an archaeological dig at Neoheroka—then situated on private property, and subsequently occupied in 2006 by local Tuscaroras laying claim to the site. Recalling Craig Howe's description of tribal historiography, the image is "event-centered": like Shelley Niro at Tutela Heights, the artist's daughter "sees with her memory" the atrocities committed against Tuscaroras at Neoheroka. Moreover, her daughter's very presence on these ancestral grounds—an impetus for the journey itself, as Printup Hope had wanted her children to know "who they were and where they came from"—rejects the implications of the roadside marker as a sign of Native extinction.[19] At the same time, the image of corn plants at the dig resonates at cosmological levels (one of the Three Sisters), historical levels (site of a large Tuscarora community), and personal levels. A Tuscarora icon of sustenance, the corn subtly asserts this space's indigeneity. Akin to HOCK E AYE VI Edgar Heap of Bird's provocative installations of signs in public spaces that instigate debate about indigenous claims to those spaces, Printup Hope here incites questions of ownership over the land, over memory, over the past.

After the fall of Neoheroka in 1713, many surviving Tuscaroras were forced into slavery, a story linking them with other Native and African

nations in all directions. A land imprinted by slavery is shown by photographs of structures—both preserved historic plantation houses and field shacks—and by signs of ownership: "Posted: Private Property. No Trespassing." Trespassing, Printup Hope documented her ancestors' suppressed story of loss, dispossession, and survival. Following old maps and winding creeks, she uncovered the layering of other histories and occupancies: state parks, a golf course, even a private home built on a large burial mound near the New York–Pennsylvania border. Structures of occupation, including homes, parks, pavement, and powerlines, visualize a long story of occupation and colonization. The juxtapositions of these images, maps, and signs require viewers to puzzle together the relationship between *Grandmother's* many constituent parts. In other words, Printup Hope's work, like Niro's painting, asks us what might be known by what can be seen. Multiple photographs of bridges formalize such efforts to forge conceptual connections across time, space, and point of view. These visual bridges are reinforced by a verbal bridge, a one-line story spanning the bottom length of the work:

> My grandmother was shining bright in the night sky . . . she was calling me home. She had me searching every tobacco field, every mound of earth, every dusty book I could find. I was searching for myself. It was a sad journey. My ancestors slaughtered in battle, our women and children sent off to slavery, swept off the landscape. Leaving behind only a small part of us etched in the towns that bear our names. Searching mile after mile, through the fields of North Carolina to the mountains of Pennsylvania, along the rivers and lakes of New York to the thundering falls of the Niagara. We have survived. Nyaw-weh Grandmother for helping me to find part of my past and part of myself. Nyaw-weh Grandmother for taking me home.

Reminiscent of the title words repetitively moving across the bottom pages of Momaday's visual-textual memoir *The Way to Rainy Mountain*, Printup Hope's narrative condenses her search to unearth a personal, familial, and collective Tuscarora journey. In an interview, she described the images in *Grandmother* as "vignettes," or as encapsulated narrative scenes.[20] The motion required of viewers is hence multidirectional: back and forth across the piece; up and down between the narrative sequence at the bottom and the visual vignettes above. Yet, while the sequential narrative, which she felt was needed to tell a fuller story, moves from left to right, the layered story it relates is resolutely circular: going south, going into memory, going home.

In her statement accompanying the publication of *Grandmother* in a media arts journal, Printup Hope says, "I traveled the route my ancestors did hundreds of years ago—from North Carolina to New York. I used a

Melanie Printup Hope, *My Grandmother Was Calling Me Home.* Digital collage. Courtesy of the artist.

digital camera to survey the landscape and words to express my experience. I touched the land and smelled the air. I still feel the loss. Years of relocation and miles of sorrow. I share my journey."[21] Part of that journey involved accessing records from Carlisle Indian School in Pennsylvania, located near the route Tuscaroras took north. Images of Carlisle School and a roster of student names in *Grandmother* memorialize yet another facet of this story of forced relocation. When she discovered her grandfather's name on a student roster, she says she "felt weak in the knees."[22] Growing up, she hadn't known this part of her family story. Part of the story thus unearthed here and in the "vignettes" that make up the far right section of the piece involves finding one's way back from intergenerational silences and memory disruption. In this image, for example, Printup Hope blends familiar landmarks from her childhood growing up in the Tuscarora Nation: the boundary line of the Tuscarora Nation; the Tuscarora Baptist Church, which she attended every Sunday while growing up; and Tuscarora Indian School, which she attended through fifth grade and where, she recalls, she learned little about her culture or history. Touchstones of memory, these structures ground her place at Tuscarora, but also signify the devastating, continuing effects of colonization into her childhood years. In an interview, Printup Hope remembers asking her grandmother, fluent in Tuscarora, to translate for her the (Haudenosaunee) creation story. Her grandmother replied that she would only talk about "the" creation story, meaning the Judeo-Christian one.[23]

Printup Hope also includes the land on the reservation of greatest meaning for her in this image of the road leading to what was once her grandfather's house. After his death, the land went to other family members. The death of her father, and most especially of her grandfather, ushered in a time of loss and of separation from the reservation, a place she had

long struggled to call "home." A photograph of a rusting fridge, covered by vegetation, represents what's left of that home. On a reservation marked by the ruins of burned-down homes, this image also suggests the ongoing losses and threats to collective indigenous memory and survival. This absent house of memory parallels ensuing images of the Lewiston Reservoir, which occupies the western flank of the Tuscarora Nation.[24] In one view, a "No Trespassing" sign borders the water; in another, Printup Hope's mother sits at water's edge. Like so many Native peoples across the Americas, including their Seneca neighbors at Cornplanter's Grant, Tuscarora artists such as Printup Hope contend in their works with the devastation wrought by "water management" projects. In the 1950s, the New York State Power Authority moved to expropriate 1,220 acres, a substantial portion of an already hemmed-in reservation. The Tuscarora Nation fought this expropriation all the way to the U.S. Supreme Court, whose 1960 ruling lessened the acreage allowed, but still granted NYPA the right to submerge 550 acres of Tuscarora land to create the "Lewiston Reservoir" for the massive Robert Moses Power Generating Station.[25] Stories of grandmothers, mothers, and aunts with baby carriages standing against the bulldozers remain strong in Tuscarora memory, even if largely unknown in non-Native society.[26]

Printup Hope's inclusion of the reservoir references this resistance even as it encodes older memories of water, born out of Haudenosaunee creation time. Water greets Sky Woman's vision as she falls from Sky World and is carried by birds to Turtle's back. In an interview, Printup Hope notes that she followed the waterways taken by her ancestors in their flight to a new home. Repeated photographs of the ocean, creeks, and rivers in *Grandmother* help to tell that story, a story at once personal and collective. Although these "vignettes" in *Grandmother* seem to speak of endings—the end of her claim to land on the reservation, the end of her journey back north with her family, the end of the reservoir battle—they are more properly about beginnings. As she stressed in an interview, this project represented a "beginning point, not a culmination."[27] The permeable borders within her work, the word trail at the bottom, and the continued presence of the land, water, and sky affirm that there's no end to these stories.

SIGN LANGUAGE

Water's presence in Haudenosaunee origins, coupled by the region's shaping features of the Niagara River and Falls, the Great Lakes, and the massive

hydroelectric facilities and armies of powerlines in the region, make it a complicated central force in works by Tuscarora artist Jolene Rickard. In one piece from her photographic installation Contact Narratives: An/Other Sacrifice (2001), Rickard places water at the center of visually and conceptually competing worldviews. Images of the reservoir are broken up into six individual frames that link its construction with the centuries-long pattern of containment of Indian peoples and the ongoing diminishment of their lands. In what Rickard calls a "neocolonial contact narrative," the six frames nearly all present "bird's eye" aerial views of the Lewiston Reservoir, highlighting imposed patterns of land design.[28] The point of view calls to mind what Sky Woman might see today were she to fall from the sky. The overlay of beaded birds and canoes on these photographic images underscores what is at stake in losing more land to the Empire State, while as symbols of motion, they also suggest how Tuscaroras refuse to be put in their place by artificial boundaries imposed by others, including the U.S.-Canada border that bifurcates Niagara Falls.

In her essay "Cew Ete Haw I Tih: The Bird That Carries Language Back to Another," Rickard addresses the too-often unseen story of ingenuity and cultural continuance fashioned by beaded works such as these canoes and birds, which were sold for generations at the New York State Fair's "Indian Village," and at Niagara Falls, tourist mecca and indigenous homeland. Rickard's juxtaposition of the beaded birds and canoes with static images of the reservoir connects the Empire State's land grab with a long story of being parted from one's land and livelihood, a parting "that made art commodity sales necessary for the Tuscarora."[29] Yet not only did these items demonstrate Tuscaroras' "ingenuity for survival," they served as culture carriers through the most difficult of times.[30] Rickard writes: "The objects we create are here to serve the memory and meaning of the word. The practice of looking at things to remember is our way."[31] Coming from a family of beadworkers, Rickard calls her photographic work, including her photo collage called *Cew Ete Haw I Tih*, "another bead on the cloth."[32] Beads of memory, the birds and canoes in this installation call out to those who know a richly layered story of survivance rearticulated by every generation. Emblems of flight and movement, they refuse the fixity of borders imposed by the reservoir's construction.

This installation's overall design enacts Rickard's call elsewhere for "strategizing to reconfirm a continuous relationship with a very particular part of the world."[33] Four ears of corn—one of the Three Sisters formed out of the creation time—reframe a story of containment with a story of indigenous, and specifically Tuscaroran, continuance. Corn's enduring presence

in Rickard's installations communicates her efforts to "maintain traditional knowledge in a contemptuous world."[34] A beaded strawberry, which like corn invokes iconic references in Rickard's worldview, similarly works to reframe the focus of this work according to Haudenosaunee sign language. Together, the corn and strawberry make claims for the piece's resistance to regulation, a lesson heightened by the left vertical line of four identical photographs. As in Printup Hope's piece, these photographs mark territory—the two signs defining the embattled yet still sovereign space of the Tuscarora Indian Nation. The repetition of the photograph is echoed by the bilingual "two-row" assertion of "Tuscarora Indian Nation" within the photograph. This technique incites both recognition and resistance: recognition that "the reservation represents the most static notion of how to imagine Native experience"; resistance to colonial regulations of indigenous spaces through visual languages of memory.[35] A mnemonic device, Rickard's visual-narrative text "helps guide you and helps you know what the connection to the land is." Through its relational design, *Contact Narratives* makes visible ongoing threats to sovereign spaces, while pointing out, to those who can recognize them, the restorative signposts of Tuscarora memory.

BY DESIGN

Like Printup Hope and Rickard, Eric Gansworth's eclectic, mixed-genre work is partly grounded in the lasting imprints of catastrophic loss of homeland to the reservoir. In his fiction and poetry, "the weird lives of [his] characters play out in this landscape of diminishing land and an immovable wall of water."[36] Against this story of "losing things again and again," Gansworth envisions

> the reservoir [as] the perfect metaphor for Indian life in America. It is a displacement device, with strictly defined yet permeable borders, where life thrives despite the artificiality—and what are Indians if not displaced peoples who have learned to thrive within the context of explicit permeable borders? The history of the water and organisms within the reservoir offers an amazing parallel to the history of reservation cultures. . . . Three living generations on the reservation have viewed the reservoir in almost exclusively different ways. The first remembers the history of everything that has been lost, the second accepts what exists and makes the best of it, and the third confronts injustices of the past, infusing the collective memory with the warning that what has happened before could happen again if we do not remain vigilant.[37]

This traumatic, tangible loss provides the plot for both his first and third novels, and the reservoir itself (or "dike" as his characters call it) figures as a narrative locus in both texts. Yet strikingly, the reservoir itself makes no direct appearance in his paintings that make up a constitutive part of his novels and books of poetry. However, what it represents—threats to collective memory, to survival, to sovereignty—permeates the interrelated design of his visual and verbal works. Gansworth's work repeatedly takes up the challenge posed by the reservoir's existence: the imperative of sustaining communal and personal memory. Embodying the paradox of visible absence, the reservoir, like Niro's *Tutela*, raises anew the challenges of seeing with one's memory.

In a discussion about the exhibit Oh So Iroquois, curator Ryan Rice cements a particular relationship between seeing, knowledge, and memory by declaring that "we see two row on the highway every day."[38] Referring to the Guswentah, or Two Row Wampum Belt, a founding treaty with Dutch colonists in the seventeenth century, and enduring document of Haudenosaunee sovereignty, Rice indicates the ongoing power of seeing the world on one's own terms. Seeing "two-row" on the highway, Ryan affirms a vision of parallel and separate existence for settlers and indigenous peoples. Such a statement acknowledges impositions on indigenous land, whether in the form of highways or reservoirs, while still confirming an unbroken relationship with indigenous homelands. Just as the Two Row Wampum was forged out of astonishing changes taking place after the arrival of Europeans in the seventeenth century, so too does Rice's observation signify the ongoing relevance of wampum as both the medium and the message of sovereignty. As constitutive modes of communication for the Haudenosaunee, wampum harnesses multimedia powers that are simultaneously oral and visual, tactile and textual. Like Haudenosaunee beadwork, which Jolene Rickard calls "an island of memory in the fog," wampum both embodies and elicits memory.[39] As living records of significant events in the life of the Haudenosaunee, wampum strings and belts require an ongoing relationship of active, reciprocal engagement on the part of those who can see, read, touch, hear, and thereby renew their messages. In her essay "Wampum as Hypertext," Angela M. Haas notes that "wampum embodies memory, as it extends human memories of inherited knowledges via interconnected, nonlinear designs with associative message storage and retrieval methods."[40] Her essay reminds us that intergenerational memory is at the heart of wampum.

Since his first book, *Nickel Eclipse: Iroquois Moon*, Eric Gansworth has turned to wampum as both a thematic and structuring device in his mixed-genre works. In his third collection of poems and paintings, *A Half-Life of Cardio-Pulmonary Function* (2008), Gansworth extends wampum's possibilities as inspiration, creative form, and thematic code. Most importantly,

perhaps, is how he draws on wampum's graphic power as mnemonic device, as well as its formal flexibility and responsiveness to a world in motion.

In *Half-Life*'s preface, Gansworth credits multimedia performance artist Laurie Anderson with inspiring the aesthetic framework of the book, which he calls "indigenous binary code." A scheme for organizing, compressing, and representing information, binary code unfolds the sounds of our time. Strings of binary code carry song, voice, story, and knowledge across time, distance, and space. As building "beads" of Haudenosaunee life, wampum also works by organizing, compressing, and representing information. Encoded beads of signification, wampum has long functioned within and across shared systems of meaning. Like the zeros and ones of binary code, the two shell colors of purple and white might seem at first limiting; yet to those who can read, sound out, hear, and trace the patterns of meaning created by their alternation, rich possibilities emerge. In *A Half-Life of Cardio-Pulmonary Function*, Gansworth uses his notion of "indigenous binary code" to embrace a wampum aesthetic that sees survival through creative adaptation. This "indigenous binary code" constellates "images borrowed from popular culture, medical texts, family members willing to be models, friends, traditional imagery, formal western representation, objects from my home, all in communication with one another, creating hybrid new narratives by illuminating old ones with different light sources."[41]

As a crossover, cross-pollinating artist working simultaneously in painting, prose, and poetry, Gansworth challenges conventional, limited methods of reading visual and narrative art. His work invites, or rather demands, multisensory reading practices. The multiple relational texts that make up *A Half-Life of Cardio-Pulmonary Function*—visual, textual, graphic—ask us to seek out, test, and explore different access points into this work. For example, a triptych entitled *Cross-PolliNation: Imagination* wraps around the book jacket. Triptychs, or three hinged panel paintings, are foundational forms in European art history, rooted in Christian iconography. As altarpieces, they were meant to fold in the center: embodying the Trinity, the three in the one. Gansworth's triptych uses the form's intimate interrelationality instead to embody Haudenosaunee values of interdependence, signified in part by the number three or multipliers of three, from clan divisions of earth, air, water to the Three Sisters. Gansworth's formal preoccupation with threes is especially prominent in the narrative and visual design of his third novel, *Mending Skins*. A triptych entitled *Patchwork Life* frames the novel, which in turn unfolds in three major sections, each comprising three chapters dated by the passage of three years or multiples of three. Three panels of the painting frame each of the three sections, thus reinforcing Gansworth's interactive conception of image and text.

Eric Gansworth, *Cross--PolliNation: Imagination*. Oil on canvas, 3 x 14 in. Courtesy of the artist.

Similarly, the painting *Cross-PolliNation: Imagination* offers a visual template for the book's project. The first part of the title cues us on interpretive strategies for accessing the visual and narrative components of *Half-Life*. The title's word play, a signature feature of Gansworth's work, highlights cross-traffic of the three panels while expressing that the aim of visual sovereignty is no game, as indicated by that capital "N" in "nation." Like Shelley Niro's *This Land is Mime Land* triptych series, or three-banded visual works by Jolene Rickard (*I See Red in '92*), this work provokes what Gansworth calls "communication across multiple sets of ideas."[42] For Shelley Niro, whose work in this form inspired her movement into film, "the triptychs are very animated. If you start following the line of the imagery, it creates a feeling of movement, and if you start looking at the images, it tries to create a dialogue. I think that's the part that's most interesting and exciting for me because you can start feeling that rhythm in the work. It creates a continuity that I like, that feeling of that rhythm."[43] Gansworth's *Cross-PolliNation*, as its title suggests, also compels interactive motion across the three panels, a point reinforced by the strings of wampum. Measuring 14 feet across and 3 feet wide, the painting *Cross-PolliNation* demands attention; like Printup Hope's *Grandmother*, its dimensions demand motion. As suggested by its cover painting, *Half-Life* also invites dialogue about the challenges and potentialities of visuality. How do we see? What are we seeing? How do "we" see differently?

And what viewers immediately see is the unusual palette. Like most of Gansworth's paintings, *Cross-PolliNation* is dominated by the two colors of wampum: purple and white. In the center panel, a stylized self-portrait of the artist confronts viewers, not with rose-colored glasses, but with gold ones, the lenses replaced by one of his favorite motifs: the buffalo or "Indian head" nickel from the early twentieth century. The triptych counters such counterfeit values with those represented by the strings of wampum that connect the self-portrait with two iterations of the Three Sisters. Three of the artist's nieces appear on the right side (on the front of the book), whose grouping recontextualizes the corn, beans, and squash on the left side (or back of the book). The nickels in the painting comment on the politics of value: not only the continued currency of stereotypes that give nickel Indians their "worth" in the U.S. culture, but the continued erroneous equation of wampum with money. In his essay "Beads, Wampum, Money, Words—and Old English Riddles," Carter Revard says, "There's an old chestnut that Indians traded Manhattan for beads. . . . Wampum, as I understand it, was not necessarily beads, nor was it "just" money; it was more a historical record, in beautiful form, of matters held sacred."[44] In *Cross-PolliNation*, strings of wampum, like

the beadwork frames of Niro's triptychs, serve as portals to resilient memory and creative adaptation.[45] The presence of Gansworth's three nieces in the triptych enhances these links between cultural memory and contemporary life by helping to visualize connections between what he calls "iconic cultural figures and actual, living members of my culture."[46] According to Deborah Doxtator, "Indian writers and artists are constantly mixing and juxtaposing the past with the present, because, from their viewpoints, it is the connections rather than the divisions that are important."[47] Similarly, Gansworth's triptych imaginatively rearticulates the stories that sustain the Haudenosaunee world, and in doing so, replenishes them.

The book cover's visual design communicates with the second poem in *Half-Life*, which shares the title of *Cross-PolliNation*:

Cross	PolliNation
And look here, you three	how you pull in opposition you
sisters grow together	jerk on the string of beads
each providing things	like seed in the wind
the others lack: support,	leaning in unforeseen directions
food, protection, and each	moment, hour, day, week, in another
time you pull away from one	place you land
another, risking everything,	and for what, to start over
you tear apart your world,	reforming yourselves as
our world. Each time you offer	us in endless variation,
the line up, we will add one	dark color, light color,
purple bead to your white strand	diluting your heritage
reminding you of the ways	we disappear for that moment
you put us all in danger	then strengthen, regenerate ourselves,
with each small tug	and embrace.

What's immediately striking about this companion text is its fluidity: a note on the page instructs us that the poem can be read vertically or horizontally. The strings of words offer up different patterns of telling the story, but it's still the "same" story being told. In the prologue to Gansworth's second novel, *Smoke Dancing*, the narrator retells part of the Haudenosaunee Creation Story, while acknowledging the fluidity of the story in its many variations. We are told that the Three Sisters came out of the murder of Sky Woman's daughter and "are supposed to sustain the rest of us, but also one another."[48] As with Printup Hope and Rickard, text and image compel a storied interaction. The poem reprises the story of the Three Sisters Wampum, comprising five purple strands entwining the beans, corn, and squash

(in the left panel of the painting) and the six "connected" white strings (or three loops), representing, "on the one hand, the true lives of the sisters and on the other, the potential lives of the sisters. If they continue to feud, the community will move a purple bead over to the white side, to remind the sisters how feuding risks the destruction of the culture."[49]

Together, *Cross-PolliNation*/"Cross-PolliNation"—both the painting and poem—represent the dangers of standing alone, and the power and sustenance in standing together. The formal interdependence of the constituent parts of both painting and poem thus embodies the message of interdependence shown by the story of the Three Sisters. Gansworth's narrator elaborates on this theme in the prologue to *Smoke Dancing:*

> The corn, she supplies the stalks for the beans to climb; and the squash, she protects the roots, shading them with her big tough leaves; and what the beans supply, that's less obvious. She looks like she is just hanging on, something extra, but her magic seeps below the surface, flowing out through her roots, feeding the other two silently, providing for them something they can't generate themselves, making them strong, so that when the wind and the rains come, they'll dance with the fury, but in the end, they will still be standing. Maybe some holes are punched through their leaves, some silk torn from their lovely heads, but they survive their dance, and that's the story.[50]

The stringing together of painting and poem sends a message both synchronous and asynchronous. In our time and across time, Gansworth's aesthetic collaboration of text and image reaffirms foundational Haudenosaunee ways of knowing aimed at ensuring survival.

In his original conception for an installation of paintings constituting *Half-Life*, Gansworth wanted to place the left side of the poem "Cross-PolliNation" to the left of the painting and the right side of the poem to the right of the painting: viewers would by necessity have to travel back and forth across the work to complete their readings. In *Half-Life*, reader-viewers also have to travel between cover and interior to access the "full" text of "Cross-PolliNation." Like Printup Hope and Rickard's works, then, *Half-Life* advocates the primacy of process in the making of meaning. Like the visual works of Niro, Printup Hope, and Rickard, Gansworth's thirteen paintings in *Half-Life* similarly create and require communication across "multiple knowledge systems."[51] While the paintings reference the poems, they also recombine elements from a densely cross-pollinated iconography of Haudenosaunee stories and referents drawn from popular culture and music, the body, personal and family life.

For example, in the multiple-panel painting entitled *Where the Dawes Act Finds Its Voice*, an anatomically rendered heart in the center—complete with arrows—directs vital blood flow to eight individual panels. In turn, graphic images of complicated interconnection abound, compressing concepts about relationships, health, life, and community. In the lower right panel, two wampum figures incite multiple associations, from Haudenosaunee treaty-making to the ubiquitous powerlines of western New York.[52] Linking the two figures is a spiking QRS wave of an EKG, the graphic representation of a heartbeat. The peak of the heartbeat touches two cornhusk dolls balancing a strawberry between them. Strawberries, celebrated in Haudenosaunee ceremony, resemble hearts when cross-sectioned. Such layered resonances—common in Gansworth's paintings—reinforce the process of making connections and discerning relationships. The visual markers in this painting, from Grandmother Moon to the Three Sisters, strawberry plants to corn, stage Gansworth's ongoing creative translation of Haudenosaunee knowledges. Each of the panels in *Where the Dawes Act Finds Its Voice* thus offers up visual shorthands for a wealth of meaning within Haudenosaunee cosmology and epistemology. When viewed alongside the poem in the book that shares its title, such wealth balances the latter's account of familial loss of cultural knowledges, a legacy of the Carlisle School. Even if the Dawes Act does "find its voice" in the story told within the poem, resilient voices of interconnected knowledge systems and continuance sound through the painting.

If the wampum strings in the cover painting did not make the point, the book's purple ink on spacious white pages, coupled with the purple and white palette of *Half-Life*'s paintings, does. Driving this book are the many forms and many ways to communicate memory, from the cellular to the cultural. As its evocative title suggests, the book breathes and beats. The rhythms of the cardiopulmonary system structure the book's movement in sections beginning with "Inspiration" and continuing to "Beat," "Pause," "Beat" and ending in "Expiration." Graphics of EKGs and anatomical hearts in several of the multiple-panel paintings reinforce that the book is animate and animated. Thematically, the poems and paintings ask how we tell stories of the heart: of relationships, family, community, and nation in the face of so much ongoing loss. Shaped by grief both immediate and personal (the death of Gansworth's brother) and writ larger in mass culture (the murder of John Lennon, the fall of the Twin Towers), the poems and paintings in *Half-Life* remember without ever forgetting the fragility and tenuousness of memory. Like the alternating colors of wampum beads, speakers in the poems leave and return, are absent and present, breathe in and out.

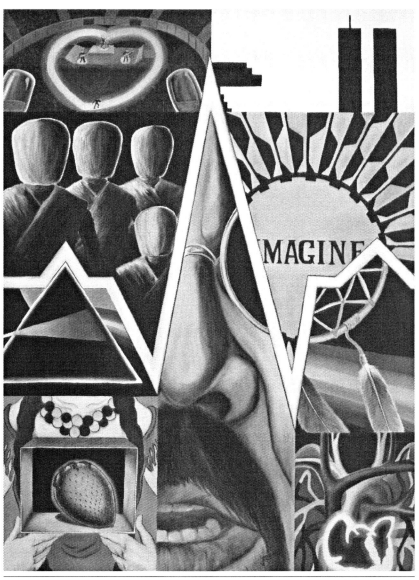

Eric Gansworth, *Keeping the Beat: Imagine*. Oil on canvas, 48 x 36 in. Courtesy of the artist.

Voices of Gansworth's music icons, especially Pink Floyd and John Lennon, also sound out *Half-Life*'s efforts to breathe life into loss, presence out of absence. In the painting *Keeping the Beat: Imagine*, Gansworth replaces the anatomical heart of "Dawes Act" with a monumental EKG spiking the

heart of the painting. Referencing Pink Floyd's concept album *Dark Side of the Moon* (a reference reinforced by an image of the record cover next to it), this dramatic focal point is echoed by the cross-section of a heart and the heart-shaped stage of a concert. A circular mosaic memorial to John Lennon, located in Strawberry Fields in New York's Central Park, appears on the right side of the painting, overlapping a dreamcatcher and the artist's "eye." Here imagination acts as a cross-pollination of personal vision and collective memory come together: the artist's "eye" occupying the same space as the "I" of "imagine." The linkage between strawberries and memory is reinforced across cultural dimensions with a partial image of a "Land O' Strawberries Girl"—a playful revision of the poem "Loving That Land O'Lakes Girl."

Keeping the Beat: Imagine is a painting rich in multilayered references to *Half-Life*'s sequence of poems charting personal and collective memory and loss in New York City. Its most arresting visual embodiment of those stories makes up the upper right panel. Two narrow vertical lines, parts that stand for a whole, serve as instantly recognizable shorthand for the Twin Towers. The nose of a plane approaches from the left. Represented as a wampum design, this image indigenizes a still unfolding story of grievous loss and its repercussions. In his discussion of the exhibit Oh So Iroquois, Ryan Rice explains that "condolence is an important part of our society . . . getting over grief . . . that makes your nation strong."[53] The origins of wampum in Haudenosaunee life are indissolubly linked with grief condoled by healing words and the promise of a renewed community and nation.[54] The creation and use of wampum belts has long accompanied changing worlds and new contexts. In a world unstrung once again, *Half-Life* shows the continued power and vitality of wampum aesthetics in healing grief of both recent and longstanding origin, not only in Haudenosaunee worlds but also in the worlds linked to them. In this way, Gansworth not only models the continued vitality of Haudenosaunee aesthetics but also imagines the possibilities of storing and storying memory within and across nations. In doing so, *A Half-Life of Cardio-Pulmonary Function* brings together "on the same page" multiple media representations of Haudenosaunee grief, memory, and continuance dispersed across galleries, temporary exhibits, and catalogs. When located within the cross-pollinating visual works of contemporary Haudenosaunee artists such as Shelley Niro, Melanie Printup Hope, and Jolene Rickard, *Half-Life* demonstrates a vital kinship of literary and visual forms. In doing so, Gansworth also makes dramatically visible both the presence and potential of interrelationality in Native literary studies. Just as these artists ask what viewers miss by not seeing with one's memory, so too do they spell

out in multiple languages of memory the interdependence of the visual and the literary. In doing so, they demand of their viewers and readers multiple layers of knowledge as well as multiple possibilities of response— a beckoning of and to memory, a call to creative renewal, and a challenge to hear, see, and listen to stories of survivance and sovereignty that are always in motion.

NOTES

1. Shelley Niro, Artist's statement, *River: Grand!*, Kitchener-Waterloo Art Gallery, September 12–November 14, 2004, electronic catalog: 12 (1–23). In her Artist's statement, Niro writes: "The site at Tutela Heights in Brantford is a favourite, inspirational location. I've used it in films, paintings and photographs. Many people from the Six Nations see Tutela as a spiritual place. In the late 1800's, the remaining Tutela Indians arrived here after the Indian Wars out west. Six Nations let them stay at this spot overlooking the Grand River. Many of them died from influenza." In an online interview with Lawrence Abbott, Niro explains the beginning of *It Starts with a Whisper*, which invokes this story: "With that narration I started describing the Tutelos, who lived around a part of the Grand River, because I think many of the stories that you see in film festivals, or any kind of festivals about stories, try to remember history and have us learn, and relearn, that history. If you make an effort to try to piece little things in your own memory together eventually those memories will become whole and you can feel that the past makes sense to you"; see *A Time of Visions: Interviews by Larry Abbott, 1994–96*, at http://www.britesites .com/native_artist_interviews/sniro.htm. Also see Lee-Anne Martin's discussion of Niro's painting installation *Tutela* as commemoration of genocide, in *Divergences: Rebecca Belmore and Shelley Niro*, curated by Lee-Anne Martin, MacKenzie Art Gallery, Regina, Saskatchewan, March 29–June 2, 2003.
2. N. Scott Momaday, *The Way to Rainy Mountain* (Albuquerque: University of New Mexico Press, 1990), 7.
3. Carol Ann Lorenz, Introduction, *Creation: Haudenosaunee Contemporary Art and Traditional Stories* (Stone Quarry Hill Art Park, Cazenovia, New York, May 23–June 27, 2004), 6.
4. Chadwick Allen, "Engaging the Politics and Pleasures of Indigenous Aesthetics." *Western American Literature* 41, no. 2 (Summer 2006): 146–75.
5. Welcome address, Indigenous Literatures and Other Arts: A Symposium and Workshop, University of Oregon, Eugene, May 2–3, 2008.

6. Ryan Rice, "Oh So Iroquois," Curator's talk, Ottawa Art Gallery, June 22, 2007.
7. Ibid.
8. Michelle H. Raheja, "Reading Nanook's Smile: Visual Sovereignty, Indigenous Revisions of Ethnography, and *Atanarjuat* (*The Fast Runner*)," *American Quarterly* 59, no. 4 (December 2007): 1160. Her essay details how "the visual, particularly film, video, and new media is a germinal and exciting site for exploring how sovereignty is a creative act of self-expression that has the potential both to undermine stereotypes of indigenous peoples and to strengthen what Robert Warrior has called the 'intellectual health' of communities in the wake of genocide and colonialism" (1161).
9. Janet Catherine Berlo and Ruth B. Phillips, Introduction, *Native North American Art* (New York: Oxford University Press, 1998), 18.
10. Interview with author, January 25, 2007, Albany, New York.
11. Edward Hashima, "Natural Men in a Natural Setting: The Local Geography and History of Indian-White Relations in New York State, 1830–60," *Centennial Review* 41, no. 3 (1997): 499.
12. Louis Owens, *Bone Game* (Norman: University of Oklahoma Press, 1994), 4.
13. Rice, "Oh So Iroquois."
14. See Lee-Ann Martin's discussion of Shelley Niro's "Indian, by Design" (1995), an intermedia work of photographs and paintings, in *Divergences*, 22.
15. Craig Howe, "Keep Your Thoughts above the Trees: Ideas on Developing and Presenting Tribal Histories," in *Clearing a Path: Theorizing the Past in Native American Studies*, ed. Nancy Shoemaker (New York: Routledge, 2002), 161–62.
16. Ibid., 162.
17. Jaune Quick-To-See Smith, interview, in *I Stand in the Center of the Good: Interviews with Contemporary Native American Artists*, ed. Lawrence Abbott (Lincoln: University of Nebraska Press, 1994), 218.
18. Louis Owens, "Mapping, Naming, and the Power of Words," *Mixedblood Messages: Literature, Film, Family, Place* (Norman: University of Oklahoma Press, 2001), 211.
19. Interview with author, June 6, 2008.
20. Telephone interview with author, November 25, 2008.
21. Melanie Printup Hope, "She Was Calling Me Home," *Felix voyeurism* (fin de siècle) 2, no. 2 (1999): 58–59.
22. Interview with author, January 25, 2007.
23. Ibid.
24. This phrase references a section title "By Our Hand, Through Memory, The House Is More Than Form" in Elizabeth Woody's *Seven Hands/Seven Hearts: Prose and Poetry* (Portland, OR: The Eighth Mountain Press, 1994). Her words also provide the title—By Hand Through Memory—for an ongoing

exhibition on Plateau Indian peoples at the High Desert Museum, located in Bend, Oregon.

25. For two non-Native representations of this history, one a tourist/educational website, the other an "official" website of hydroelectric power in this region, see "Niagara Falls History of Power," at http://www.iaw.on.ca/~falls/power.html. While this website does include a brief mention of the expropriation battle, the website for the New York Power Authority does not mention it at all. Instead, its brief history details that "In 1957, Congress passed the Niagara Redevelopment Act, which granted the Power Authority a federal license to fully develop the United States' share of the Niagara River's hydroelectric potential. Within three years—on exactly the day predicted by Robert Moses, the 'Master Builder' and then chairman of the Power Authority—the Niagara project produced first power." See "Niagara Power Project," at New York Power Authority's website: http://www.nypa.gov/facilities/niagara.htm (May 2009).

26. See Eric Gansworth's novel *Mending Skins*, which includes a narrative scene that honors the women's resistance; or Barbara Graymont, ed., *Fighting Tuscarora: The Autobiography of Chief Clinton Rickard* (Syracuse, NY: Syracuse University Press, 1973).

27. Interview with author, January 25, 2007.

28. Jolene Rickard, Artist's statement, "Contact Narratives: An/Other Sacrifice," in *What Are We Leaving for the 7th Generation? 7 Haudenosaunee Voices* (The Gibson Gallery, College at Potsdam, October 9–November 10, 2002; Iroquois Indian Museum, November 26–December 31, 2002), 20. For similar "bird's eye" aesthetic, see Shelley Niro's short film *The Shirt*, which was inspired in part by her own bird's eye view of our gridded middle-American earth from her plane window.

29. Ruth B. Phillips, *Trading Identities: The Souvenir in Native North American Art from the Northeast, 1700–1900* (Seattle: University of Washington Press, 1998), 276.

30. Jolene Rickard, "Cew Ete Haw I Tih: The Bird That Carries Language Back to Another." In *Partial Recall: Photographs of Native North Americans*, ed. Lucy R. Lippard (New York: The New Press, 1992), 105–111, 107.

31. Ibid., 108.

32. Ibid., 111.

33. Jolene Rickard, quoted in Faye Ginsburg, "Resources of Hope: Learning from the Local in a Transnational Era," in *Indigenous Cultures in an Interconnected World*, ed. Graeme K. Ward and Claire Smith (Vancouver: University of British Columbia Press, 2000), 34–35. The full quote reads: "At a time when the fashions of contemporary discourse, and the world itself, seems to point toward the globalization of space and human experience, Native Americans

and other indigenous activists are advocating the importance of specific cultural enclaves, of choosing to remain. We are strategizing to reconfirm a continuous relationship with a very particular part of the world."

34. In an artist's statement for her installation *The Corn Blue Room* (1998), Rickard writes, "Corn is the central element in this piece because it is the way that my family has maintained their understanding of these traditions. Knowledge is in the seed. Corn is also a metaphor for the Americas in that it is an indigenous seed. . . . It has been handed down since Sky woman fell from upperworld to this world. These seeds represent the power of the 'good mind.'" In *Native Nations: Journeys in American Photography*, ed. Jane Alison (London: Booth-Clibborn, Barbican Art Gallery, 2000), 301.

35. Jolene Rickard, "Sovereignty: A Line in the Sand," in *Strong Hearts: Native American Visions and Voices, Aperture* 139 (Summer 1995): 50–59.

36. Personal communication, September 25, 2005.

37. R. D. Pohl, "Native Son: Interview with Eric Gansworth," *Buffalo Spree* magazine, online edition, December 2005. Gansworth also notes in this interview: "The reservoir was complete by the time I was born, and as a child, I had only known it in positive contexts. It had a certain permanence; it had always been there and it always would be there. It was a place where we went to swim and party, though I understand that is generally no longer true. Perhaps the young people on the reservation are more politically aware than we had been as children."

38. Curator's talk, June 22, 2007.

39. Rickard, "Cew Ete," 110.

40. Angela M. Haas, "Wampum as Hypertext: An American Indian Intellectual Tradition of Multimedia Theory and Practice," *SAIL* 19, no. 4 (Winter 2007): 77–100, 80–81.

41. Eric Gansworth, *A Half-Life of Cardio-Pulmonary Function* (Syracuse, NY: Syracuse University Press, 2008), xvi.

42. Artist's talk, October 30, 2008.

43. Interview with Larry Abbott, "A Time of Visions," at http://www.britesites .com/native_artist_interviews/sniro.htm (May 2009).

44. Carter Revard, "Beads, Wampum, Money, Words—and Old English Riddles," *American Indian Culture and Research Journal* 23, no. 1 (1999): 177–89, 177.

45. See, too, Shelley Niro's recent visual work, where she uses wampum designs as framing techniques.

46. Artist's talk, October 30, 2008. This practice also recalls Niro's use of photographs of family members in her triptych series *This Land Is Mime Land*, among other works.

47. Deborah Doxtator, "Reconnecting the Past: An Indian Idea of History," in

Revisions, ed. Joane Cardinal-Schubert (Banff, British Columbia: Walter Phillips Gallery, 1992), 26.

48. Eric Gansworth, *Smoke Dancing* (East Lansing: Michigan State University Press, 2004), 1.

49. Email communication with author, March 4, 2007.

50. Gansworth, *Smoke Dancing*, 1–2.

51. Lucy R. Lippard, "Independent Identities," in *Native American Art in the Twentieth Century*, ed. W. Jackson Rushing III, p. 145. The full quote reads: "In accordance with the necessity to recognize multiple knowledge systems, Rickard frequently uses multiple images in bands, combining black and white and color, for a layered effect reflecting different levels of chronology, existence, and metaphor."

52. For a related demonstration of aesthetic revision of imposed structures on indigenous spaces, see Joe Feddersen's twined basket *High Voltage Tower* (2003) as well his "urban vernacular" linocuts, shown and discussed in *Joe Feddersen: Vital Signs* (Seattle: University of Washington Press, 2008).

53. Rice, "Oh So Iroquois."

54. In Shelley Niro's cycle of paintings Journey of the Peacemaker, she also features the cultural power of wampum. In her painting *The Healing of Hiawatha*, she describes the "Peacemaker's [placing of his] hand on Hiawatha's head, absolving him of grief. With the application of wampum to his forehead, the Peacemaker brings him out of the state of confusion [following the deaths of his wife and daughters]. They begin their journey, bringing healing to the other people who are also in the same state." From Niro's Artist's statement accompanying "Our Stories Made Visible": Two Mohawk Women Artists: Katsitsionni Fox and Shelley Niro, Seventh Contemporary Iroquois Art Biennial, curated by G. Peter Jemison, April 1–July 5, 2009, Fenimore Art Museum, Cooperstown, New York.

WORKS CITED

Abbott, Lawrence. *I Stand in the Center of the Good: Interviews with Contemporary Native American Artists* (American Indian Lives). Lincoln: University of Nebraska Press, 2004.

Allen, Chadwick. "Engaging the Politics and Pleasures of Indigenous Aesthetics." *Western American Literature* 41, no. 2 (Summer 2006): 146–75.

Ball, Tom. Welcome address. Indigenous Literatures and Other Arts: A Symposium and Workshop. University of Oregon, Eugene, May 2–3, 2008.

Berlo, Janet Catherine, and Ruth B. Phillips. Introduction. *Native North American Art*. New York: Oxford University Press, 1998.

Doxtator, Deborah. "Reconnecting the Past: An Indian Idea of History." In *Revisions*, ed. Joane Cardinal-Schubert, 25–33. Banff, British Columbia: Walter Phillips Gallery, 1992.

Gansworth, Eric. Artist's talk. Colgate University, October 30, 2008.

———. *A Half-Life of Cardio-Pulmonary Function*. Syracuse, NY: Syracuse University Press, 2008.

———. *Smoke Dancing*. East Lansing: Michigan State University Press, 2004.

Haas, Angela M. "Wampum as Hypertext: An American Indian Intellectual Tradition of Multimedia Theory and Practice." *SAIL* 19, no. 4 (Winter 2007): 77–100.

Hashima, Edward. "Natural Men in a Natural Setting: The Local Geography and History of Indian-White Relations in New York State, 1830–60." *Centennial Review* 41, no. 3 (1997): 499–506.

Howe, Craig. "Keep Your Thoughts above the Trees: Ideas on Developing and Presenting Tribal Histories." In *Clearing a Path: Theorizing the Past in Native American Studies*, ed. Nancy Shoemaker, 161–79. New York: Routledge, 2002.

Lippard, Lucy R. "Independent Identities." In *Native American Art in the Twentieth Century*, ed. W. Jackson Rushing III, 134–48. New York: Routledge, 1999.

Lorenz, Carol Ann. Introduction. *Creation: Haudenosaunee Contemporary Art and Traditional Stories*. Stone Quarry Hill Art Park. Cazenovia, New York, May 23–June 27, 2004.

Martin, Lee-Anne. *Divergences: Rebecca Belmore and Shelley Niro*. Curated by Lee-Anne Martin. MacKenzie Art Gallery. Regina, Saskatchewan, March 29–June 2, 2003.

Momaday, N. Scott. *The Way to Rainy Mountain*. Albuquerque: University of New Mexico Press, 1990.

Niro, Shelley. Interview with Larry Abbott. In *A Time of Visions*. At http://www.britesites.com/native_artist_interviews/sniro.htm (May 2009).

———. Artist's statement. *River: Grand!* Kitchener-Waterloo Art Gallery, September 12–November 14, 2004. Electronic catalog: (12) 1–23. At http://www.culture-connection.net/kwag/catalogue/catalogue1.pdf.

Owens, Louis. *Bone Game*. Norman: University of Oklahoma Press, 1994.

———. *Mixedblood Messages: Literature, Film, Family, Place*. Norman: University of Oklahoma Press, 2001.

Phillips, Ruth B. *Trading Identities: The Souvenir in Native North American Art from the Northeast, 1700–1900*. Seattle: University of Washington Press, 1998.

Pohl, R. D. "Native Son: Interview with Eric Gansworth." *Buffalo Spree* magazine, online edition. December 2005.

Printup Hope, Melanie. Phone interview by author, November 25, 2008.

———. Interview by author, Albany, New York, June 6, 2008.

———. Interview by author, Albany, New York, January 25, 2007.

———. "She Was Calling Me Home." *Felix voyeurism* (fin de siècle) 2, no. 2 (1999): 58–59.

Quick-To-See Smith, Jaune. Interview. In *I Stand in the Center of the Good: Interviews with Contemporary Native American Artists*, ed. Lawrence Abbott, 209–31. Lincoln: University of Nebraska Press, 1994.

Raheja, Michelle H. "Reading Nanook's Smile: Visual Sovereignty, Indigenous Revisions of Ethnography, and *Atanarjuat* (*The Fast Runner*)." *American Quarterly* 59, no. 4 (December 2007): 1159–85.

Revard, Carter. "Beads, Wampum, Money, Words—and Old English Riddles." *American Indian Culture and Research Journal* 23, no. 1 (1999): 177–89.

Rice, Ryan. "Oh So Iroquois." Curator's talk. The Ottawa Art Gallery, June 22, 2007.

Rickard, Jolene. "Cew Ete Haw I Tih: The Bird That Carries Language Back to Another." In *Partial Recall: Photographs of Native North Americans*, ed. Lucy R. Lippard, 105–11. New York: The New Press, 1992.

———. "Contact Narratives: An/Other Sacrifice." Artist's statement. In *What Are We Leaving for the 7th Generation? 7 Haudenosaunee Voices.* The Gibson Gallery, College at Potsdam, October 9–November 10, 2002; Iroquois Indian Museum, November 26–December 31, 2002.

———. "Sovereignty: A Line in the Sand." In *Strong Hearts: Native American Visions and Voices. Aperture* 139 (Summer 1995): 50–59.

Aboriginal Beauty and Self-Determination: Hulleah Tsinhnahjinnie's Photographic Projects

CYNTHIA FOWLER

Multimedia artist Hulleah Tsinhnahjinnie (Seminole/Musk-ogee/Diné) has directly examined the notion of beauty in several of her key works from the 1990s. Her interest in this subject coincides with the so-called "return to beauty" that established itself in art historical discourse beginning in the early part of the same decade. Tsinhnahjinnie's work must be evaluated on its own terms, but the 1990s discourse on beauty provides an interesting context for Tsinhnahjinnie's exploration of beauty. Grounded in the politics of self-determination, the Diné concept of *hózhó*, and a critique of Western constructs of Native identity, Tsinhnahjinnie engages beauty within a political framework that addresses some of the key concerns of Native peoples in the United States.

Beginning in the early 1990s, art historians and critics embarked upon a self-described investigation of what they perceived as a "return to beauty" in 1990s art.[1] Critic Dave Hickey's book of essays *The Invisible Dragon* laid the foundation for this discussion.[2] It was soon followed by additional writings and several key exhibitions. For example, in 1998, *Uncontrollable Beauty: Toward a New Aesthetics* was published, a compilation of essays that attempt to comprehend the absence of beauty in twentieth-century art and its resurfacing as the century came to a close.[3] As these new examinations of beauty explain, beauty had been absent for a reason. Identifying beauty as a construct rather than an unmediated aesthetic experience, poststructural-ist critique of the 1980s called for an "anti-aesthetic" that rejected Western

constructs of beauty.[4] Taking a different angle of attack, feminist critique seriously challenged the long history of Western art that defined beauty as the passive, sexualized female body.[5] As art historian Elizabeth Prettejohn observes in *Beauty and Art*, the inherent danger in the "return to beauty" was that it would yield a return to "nostalgic, if not positively reactionary" art and art criticism if these important negative critiques of beauty were simply pushed to the margins.[6] Regarding Beauty, a 1999 Hirshhorn Museum exhibition, grappled with the problematic nature of the new search for beauty by examining works by postmodern artists known for challenging Western constructs of beauty, including photographs by Cindy Sherman and Lorna Simpson.[7] Noting that "postmodernists have critiqued aesthetics as an expression of elitist culture,"[8] co-curator Neil Benezra explains, "Here beauty is not considered a traditional aesthetic ideal to be sought after for its own sake, but rather a complex cultural construct."[9] Art historian Wendy Steiner adds another layer of complexity to the problematic nature of beauty, arguing that the absence of beauty in modernist art was not due to a progressive agenda that questioned social constructs or challenged the exploitation of the female body, but a "resistance to the female subject as a symbol of beauty" that was "related to real-world struggles during the past century—the past two centuries, in fact—as society learned (and continues to learn) to consider women as fully human."[10] For Steiner, the modernist rejection of beauty was a flat-out rejection of women. She too calls for a return to beauty, but one in which artists and art critics "imagine beauty as an experience of empathy and equality."[11]

It is within the context of this debate about beauty that Tsinhnahjinnie's work will be considered. Like Sherman and Simpson, Tsinhnahjinnie presents a powerful challenge to Western constructs of beauty. Even more, her celebration of women's beauty serves as a powerful corrective to the rejection of female beauty that Steiner uncovers in her book. However, Tsinhnahjinnie's project does not end there. Anticipating Steiner's call for a beauty grounded in "empathy and equality," she defines the beauty of women in terms of their empowerment, grounded in her own perspective as an indigenous woman.

Tsinhnahjinnie's collage *When Did Dreams of White Buffalo Turn to Dreams of White Women?* (1990) is one of a group of works to be considered in which the artist raises questions about definitions of beauty in relation to Native women. In the Lakota tradition, White Buffalo Calf Woman was an exceptionally beautiful woman who introduced the pipe ceremony to the Lakota people. The title of this work directs our attention to the historical shift from an indigenous definition of beauty before colonization,

represented by White Buffalo Calf Woman, to a neocolonial one. The face of a white woman, located in the top right of the collage and reminiscent of a 1940s Hollywood version of white feminine beauty, highlights this shift. Tsinhnahjinnie's selection of a dated, commercialized version of beauty for white women reminds us that white women are also subject to stereotypes of beauty that are promoted by the media. Photographs of two Native women taken by Tsinhnahjinnie are included in the collage and serve as a corrective to this anachronistic, commercialized model of the feminine. The women's names are Carol Webb and Idelia Moore,[12] both of whom Tsinhnahjinnie knows personally. The 1940s white woman contrasts markedly with the two 1990s Native women dressed in tribal clothing and portrayed as comfortable in their individual identities. Carol Webb (Nez Perce), herself an artist, sits on a couch at the bottom of the collage surrounded by her beadwork displayed on the Pendleton blanket that covers the couch. Her broad smile and confident pose suggest a vibrant personality. She appears relaxed in her environment, which is broadly defined by the map of the world behind her. A small portrait of Idelia Moore (Diné/Nez Perce) is positioned in the top right above all the others. Moore's sincere expression, like Webb's genuine smile, contrasts markedly with the white woman located below her. The largest figure in the collage is a man, identified as Uriewich Indian Jack Tendoy, represented here in a turn-of-the-century photograph.[13] His expression is one of awkwardness and uncertainty, while his dominating size reminds us of the pervasiveness of male figures in photographic representations of American Indians from the nineteenth and early twentieth centuries. However, in spite of Tendoy's large scale in relation to the women in the collage, Carol Webb remains the commanding presence through her vibrant energy and the comfort with which she presents herself to the viewer.

The photograph of Jack Tendoy hints at what would become a familiar strategy used by Tsinhnahjinnie in her work: the appropriation and recontextualization of historical photographs of Native Americans. In her essay "When Is a Photograph Worth a Thousand Words?" Tsinhnahjinnie discusses the importance of nineteenth- and early twentieth-century photographs of Native people like the one used in her collage. Reflecting upon the photographs of her own family that had been lost or destroyed over time, she reminisces, "But in my mind, my imagined photographs, the men are strong and handsome, the women strong and breathtaking, lustrous warm dark skin, lightening [sic] sharp witty eyes, with smiles that could carry one for days. A photographic album of visual affirmation."[14] This passage is significant not only for documenting the intrinsic value that Tsinhnahjinnie holds for these photographs, but also for clearly stating Tsinhnahjinnie's

Hulleah Tsinhnahjinnie, *When Did Dreams of White Buffalo Turn to Dreams of White Women?* (1990). Photocollage, 24 x 28 in. Courtesy of the artist.

definition of indigenous beauty. Both women and men are strong, their wit emanates from their eyes, and their smiles suggest their empowerment, not their objectification, even as they are viewed by others. Throughout her essay, Tsinhnahjinnie points out the beauty of the individual American Indian men and women seen in nineteenth- and early twentieth-century photographs, a beauty that has been romanticized, overlooked, or dismissed in colonialist discourse.

Tsinhnahjinnie also gives evidence of the ways in which she defines beauty by her varied responses to the old photographs that she discusses in her essay. First, she defines beauty as resistance to oppression. For example, when describing Edward Curtis's photograph *Acoma Woman* (1904), Tsinhnahjinnie writes:

> Curtis photographed a beautiful Acoma Pueblo woman staring into the lens, it is an intense moment, not exactly an endearing stare. . . . It reminds me of the summers when my father, a painter, would travel to Monument Valley or Canyon de Chelly to paint the landscape and sell paintings to the tourists who were

watching him paint. My brother, sister and I would play nearby, climbing red rocks, playing in the sand. The tourists would call us over and take our picture, sometimes giving us a quarter, the look I perfected was the look that the Acoma woman is giving Curtis, "Take your photograph and. . . ."[15]

The resistance that Tsinhnahjinnie reads into Curtis's photograph can be seen in her own self-portrait titled *Census Makes a Native Artist* from her series Creative Native (1992). Just as the Acoma woman resists the colonizing gaze, Tsinhnahjinnie resists attempts to regulate Indian identity by the federal government. The image is a direct response to the 1990 federal law that required Indian artists to register with a federally recognized tribe

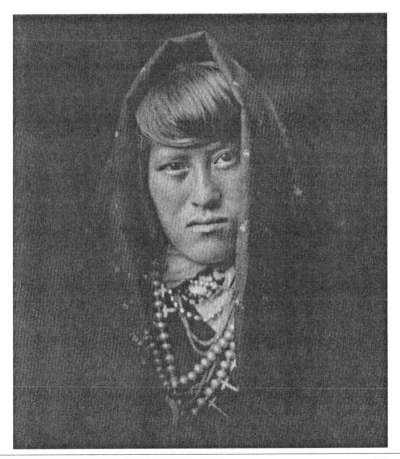

Edward Curtis, *Acoma Woman* (1904). Photogravure from the folio accompanying vol. 16 of *The North American Indian*. Emmanuel College Library, Boston, MA.

if they wanted to label their work for sale as Native-made; it is also a clear mockery of the law. Tsinhnahjinnie's artist identification number, 111–390, branded across her mouth to suggest an attempt to silence her, conveys the absurdity and even fascist potential of efforts to define indigenous identity by governmental decree.

For Tsinhnahjinnie, tattoos similarly operate as key signifiers of aboriginal beauty by their resistance to colonialist efforts at regulating identity. She describes tattoos as a "brazen illustration of identity."[16] More specifically, she celebrates A. P. Niblack's late nineenth-century photograph of *Johnny Kit Elswa* (Haida/Gwaii) (1886) for documenting the tattoo tradition. Elswa

Hulleah Tsinhnahjinnie, *Census Makes a Native Artist,* from series Creative Native (1992). Digital print, 20 x 24 in. Courtesy of the artist.

appears strong and confident in the photograph; a large tattoo on his chest identifies him with the Bear clan, while dogfish adorn his arms. Again, Tsinhnahjinnie relates beauty to politics, this time through the tattoo tradition. She explains:

> Tattoos went under the skin to survive, encoded beneath the skin, programmed to resurface when the time is right, this is also how I perceive the art of aboriginal tattoo, latent images. I have been considering tattoos for years. The Muskogee, my mothers people[,] adorned themselves with tattoos to signify status of power spiritually and socially. From Atearora [*sic*] to Florida there was a submergence of moko, tattoo. Today there is a healthy resurfacing.[17]

Albert Parker Niblack, *Johnny Kit Elswa* (1886). Albumen print, 5 x 8 in. Courtesy of the National Anthropological Archives, Smithsonian Institution, SPC Nwc Haida NM 16912 00037600.

Based on the high value that Tsinhnahjinnie places on tattoos, it is not sur-prising that she has marked herself with tattoos in another self-portrait. In *Indigena,* from her series Blueprint for Aboriginal Beauty (1998), Tsinh-nahjinnie has digitally manipulated her self-portrait, adding tattoos to her face. The letter "b," located directly above her head, references another source for her exploration of tattoos: a book on Mojave tattoos in which tat-tooed individuals were marked with letters from the alphabet.[18] In this case, Tsinhnahjinnie reclaims the tattoo tradition, once used by anthropologists to categorize Native people as specimens, to celebrate indigenous identity. The comfort with which she wears her tattoo transcends any attempt to categorize her with these markings. Indeed, these indigenous markers of identity serve to counter the imposed external markers of identity Tsinh-nahjinnie challenges in *Census Makes a Native Artist.*

In the series Aboriginal Beauty (1995–1998), Tsinhnahjinnie focuses exclusively on the beauty of Native women. As with *When Did Dreams of White Buffalo Turn to Dreams of White Women?* Tsinhnahjinnie personally knows all of the women included in the series, and she has described the photographic shoots that resulted in the images as relaxed and casual rather than staged and contrived.[19] One can assume that the friendly nature of the relationship between artist and model had an impact on the photographic process. Clearly, these are not meant to be staged constructs of identity in the tradition of Cindy Sherman, but representations of real women who personally matter to the artist. On the artist's website, Tsinhnahjinnie uses her own words to define Native beauty as it specifically relates to women: "Native women are beautiful. They need not be subjugated to be appreci-ated. When I encounter strong brown women, I photograph what already exists, the power of Aboriginal Beauty."[20] Just as she writes in her essay "When is a Photograph Worth a Thousand Words?" Tsinhnahjinnie defines beauty in terms of strength.

In two photographs from the Aboriginal Beauty series—*Nizhoni Luna* and *Della Tsosie*—Tsinhnahjinnie conveys her notion of beauty as strength by relating her subjects to the large, solid boulders on the landscape that they inhabit. In *Nizhoni Luna,* Luna appears completely relaxed in her envi-ronment. The curves of her body mirror the lines of the rocks on which she sits, connecting her to these solid, immovable forms. The rock formations in *Della Tsosie* locate the subject squarely and unequivocally in the land of the Diné. The Navajo blanket wrapped around her body falls upon the rock at her feet to create an almost symbiotic relationship between Tsosie and the rock. Just as the boulders around her have survived the test of time, this woman, too, is an immovable and powerful force.

Hulleah Tsinhnahjinnie, *Indigena*, from series Blueprint for Aboriginal Beauty (1998). Digital print, 30 x 24 in. Courtesy of the artist.

An inescapable characteristic of the photograph of *Della Tsosie* is its romantic appeal, created by the rich color of the orange sky, and the lone individual inhabiting the rugged, unspoiled landscape. In this way, the photograph engages the visual language of the once-popular image of the "vanquished Indian," who was also depicted alone in a similarly pristine and beautiful natural environment—an image that established itself in the late nineteenth century, and by the early twentieth century was a pervasive symbol of the

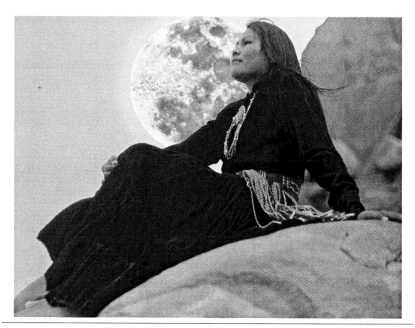

Hulleah Tsinhnahjinnie, *Nizhoni Luna*, from series Aboriginal Beauty (1995–98). Digital print, 24 x 28 in. Courtesy of the artist.

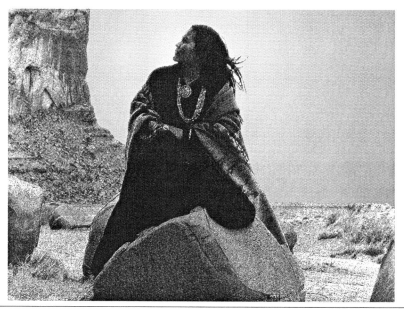

Hulleah Tsinhnahjinnie, *Della Tsosie*, from series Aboriginal Beauty (1995–98). Digital print, 24 x 28 in. Courtesy of the artist.

perceived end of American Indian culture.[21] Tsinhnahjinnie employs the visual language of this historical image, but with the obvious replacement of the defeated male Indian with a strong, assertive Indian woman who has a real and specific identity. This shift from a fictionalized model to a real individual is a highly significant change. Indeed, as Steiner observes in her consideration of the female model, in this case women with whom Tsinhnahjinnie had personal relationships, "The model—a person who 'poses'—is an important link between reality and artwork, since she is both a human being and an idealization, abstraction, representation of herself. She is reality mobilized for art, her appearance participating in both realms."[22] Thus, it is through these specific women as models in the photographs *Nizohni Luna* and *Della Tsosie* that the viewer experiences beauty, in which Tsinhnahjinnie presents real women within a context of idealization. As Steiner defines beauty, "Beauty can be both a fostering experience of mortal existence and an elevating ideal written over reality."[23] Indeed, for Steiner, and in the case of Tsinhnahjinnie's photographs, it is defined as a convergence of both.

Tsinhnahjinnie's reworking of nineteenth-century photographs that are currently perceived in art-historical discourse as stereotypical images might

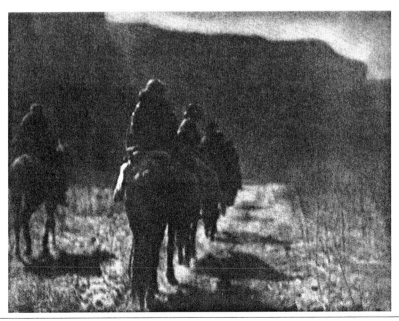

Edward Curtis, *Vanishing Indian Types*. Published in *Scribner's* magazine (June 1906). Widener Library, Harvard University, Cambridge, MA.

also be considered within the context of what postmodern theorist Andreas Huyssen describes as a "reworking of a regressive, even reactionary vocabulary" in his analysis of works by German painter Anselm Kiefer. [24] Indeed, Kiefer has successfully incorporated into his art some of the most highly charged imagery of Nazi Germany. According to Huyssen, Kiefer creates an "aesthetic lure" in his work that functions as a "critique of the spectator who's caught up in a complex web of melancholy, fascination, and repression."[25] Tsinhnahjinnie's appropriation of the "aesthetic lure" of the "vanquished Indian" imagery might also function in a similar way. Viewers of *Della Tsosie* may find themselves experiencing conflicting feelings: seduced by the image of the beautiful figure of Tsosie in a gorgeous landscape, yet at the same time uncomfortable with its association with the stereotypical vanishing Indian. Although previously stated in this essay, it is worth repeating that Tsinhnahjinnie has consistently argued for a re/locating of the missed beauty in even the most stereotypical historical photographs of indigenous peoples. From this perspective, viewers may alternately perceive this image as one that recognizes the history of the Diné people and their powerful connection to their homeland. These multiple, simultaneous readings of *Della Tsosie* add a level of complexity to Tsinhnahjinnie's photograph that goes far beyond what might at first appear as a straightforward replacement of one Indian type for another.

Like *Della Tsosie*, *Nizhoni Luna* is also a celebration of the beauty of women, but in this photograph Tsinhnahjinnie gives direct historical, if not mythical lineage to the identification of beauty with women. The subject's name, a combination of Diné and Spanish respectively, translates to "beautiful moon." Suitable to her name, Luna is sitting on gray rocks reminiscent of the moon's surface. The moon serves not just as a marker of her name and individual identity, but since ancient times, it has been viewed as a symbol of female power due to the direct connection between the lunar and the menstrual cycle. Tsinhnahjinnie has acknowledged the importance of the moon's symbolism in understanding Luna's photograph.[26] From the Greek goddess Artemis to the Mayan moon goddess Ix Chel, the moon has been perceived as a healing power, a protectress, and a controller of destiny. Tsinhnahjinnie has also included moon imagery in this and other works for the additional purpose of raising the issue of colonization. In *Hoke-tee*, from her series Portraits Against Amnesia, a young Indian child stands confidently on a chair as if she is riding a space ship, while an astronaut turns his back on her and walks away. Tsinhnahjinnie provides a political interpretation of this photograph: "Man going to the moon trying to claim it, but when he gets there, there is a little aboriginal baby floating around on her little space scooter. So Colonismo Spaceman picks up his bags and takes off because it

is just too much!"[27] Art historian Veronica Passalacqua describes the moon as a symbol of transcendence in this and other photographs by Tsinhnahjinnie, explaining, "Her moon imagery suggests an ability to transcend the limited geographical boundaries."[28] With these combined interpretations in mind, *Nizhoni Luna* connects Luna's specifically female beauty to a political message about freedom from colonization.[29]

A final consideration of Tsinhnahjinnie's exploration of beauty is related to the Diné philosophy of *hózhó*.[30] Roughly translating as "beauty," *hózhó* is an organizing principle of Diné culture and refers to living one's life in order, harmony, and balance. According to artist and critic Gail Tremblay (Onondaga/Micmac), Andrew Tsinajinnie (Diné), an important Diné painter and also Tsinhnahjinnie's father, was an artist whose paintings

Hulleah Tsinhnahjinnie, *Hoke-tee,* from series Portraits Against Amnesia (2002). Digital print, 30 x 20 in. Courtesy of the artist.

"celebrated the beauty and harmony of the Navajo world in the face of a hostile outside world that devalued it."[31] His art may be described as an expression of *hózhó*, and from this perspective, Hulleah Tsinhnahjinnie continues in her father's tradition. She has written about imbalances in the field of photography—a lack of *hózhó*—and the need for these imbalances to be corrected. In her essay titled "Compensating Imbalances," she explains that the history of photography is characterized by an "imbalance of information presented as truth" that will only be corrected when "we [indigenous peoples] document ourselves with a humanizing eye."[32] Anthropologist James Faris connects Tsinhnahjinnie's philosophy of *hózhó* to both her life and photography. In his book *The Navajo and Photography*, he explains, "For Tsinhnahjinnie the use of the term *imbalance* is complexly interesting, for it refers both to the Navajo notion of imbalance (a condition of being out of order and thus potentially dangerous and ugly) and to the imbalance of relative power between the classic subjects of photography and photographers (and between Native Americans and the West)."[33] Again, we see beauty and politics are inescapably linked as Tsinhnahjinnie attempts to correct the imbalances in representations of Native people from the beginnings of photography in America.

In contrast to the twentieth-century rejection of beauty that characterized the non-Native art world, key Native artists and critics have recognized that beauty has consistently played a central role in indigenous artistic production. As early as 1985, artist and curator Jaune Quick-To-See Smith (Flathead) organized a show on art by American Indian women, titled Women of Sweetgrass, Cedar, and Sage. In her essay for the exhibition catalog, Quick-To-See Smith described the exploration of beauty as a common thread among the women included in the show. As she explained: "Another significant similarity [among the women in the exhibition] is the use of beauty throughout our work. There is a need to beautify life—rather than dwell in the difficulties. . . . When all else in our lives had failed, our ability to produce beautiful work has been the sustenance that carries us through. That process takes us to an inner world, uplifts our spirit, and nurtures our soul."[34]

Considering Native art historically, Tremblay has recognized beauty as a central element in works by Native artists trained at boarding schools during the early twentieth century. She argues that art historians and critics have failed to see this beauty because of their consistent focus on the white teachers at boarding schools rather than the art created by the Indian students who trained with them. As Tremblay explains: "Euro-American writers have made much of the fact that the art teachers in boarding schools were white, and the market addressed was also white. They have talked too little to the artists themselves about the importance of finding a way to do

something that celebrated Native culture, asserted one's beauty and humanity in a world that was always denying it."[35] Perhaps this failure to see beauty in Native art is tied as well to the Western rejection of beauty in general. As Western critics and art historians struggle to find ways of (re)considering beauty in art, they would be well served by studying the tradition of beauty in indigenous art.

The observations of Quick-To-See Smith and Tremblay remind us that Tsinhnahjinnie is not alone among Native artists in her focus on beauty. Indeed, Quick-To-See Smith tells us that a focus on beauty has sustained efforts at indigenous cultural survival, and Tremblay points out that the presence of beauty in early twentieth-century indigenous art has been overlooked by the untrained eyes of critics and art historians. From this perspective, it is not surprising that Tsinhnahjinnie would devote some of her art projects to revealing the missed beauty in images of Native peoples.

Hulleah Tsinhnahjinnie's art is clearly political in its insistence that beauty be defined in indigenous terms. For Tsinhnahjinnie, beauty is defined as empowerment and is grounded in self-determination. She eloquently weaves her own constructs of beauty with her politics of self-determination for indigenous peoples. Her art does not represent a return to beauty, since beauty has not been a taboo subject in indigenous art. To the contrary, it has served as a sustaining element in the face of oppression. From this perspective, Tsinhnahjinnie connects beauty and politics in a way that has been inconceivable in the Western tradition, revealing the limitations of Western art-historical discourse. She moves beyond postmodern challenges to Western constructs of beauty to create an indigenous space that is free from these limitations. Her success in her project to define beauty in indigenous terms is perhaps best explained by her own gaze, most poignantly defined by Tsinhnahjinnie herself as "when the eye of the beholder possesses love for the beheld."[36]

NOTES

1. For an excellent summary of the scholarship on this subject, see Julie Johnson, "The Return of Beauty in Contemporary Art," *Rendezvous* 36, no. 1 (Fall 2001): 1–21. See also Ivan Gaskell, "Beauty," in *Critical Terms for Art History*, ed. Robert Nelson and Richard Shiff, 2nd ed. (Chicago: University of Chicago Press, 2003).

2. Dave Hickey, *The Invisible Dragon: Four Essays on Beauty* (Los Angeles: Art Issues Press, 1993).

3. Bill Beckley and David Shapiro, eds., *Uncontrollable Beauty: Toward a New Aesthetics* (New York: Allworth Press, 1998).

4. See, for example, Hal Foster, ed., *The Anti-Aesthetic: Essays on Postmodern Culture* (Port Townsend, WA: Bay Press, 1982).

5. For a discussion of the problematic relationship between women and beauty, see Wendy Steiner, *Venus in Exile: The Rejection of Beauty in 20th-Century Art* (Chicago: University of Chicago Press, 2001).

6. Elizabeth Prettejohn, *Beauty and Art, 1750–2000* (Oxford: Oxford University Press, 2005), 202.

7. *Regarding Beauty: A View of the Late Twentieth Century*, curated by Neil Benezra and Olga Viso (Washington, D.C.: Hirshhorn Museum and Sculpture Garden, 1999).

8. Neil Benezra, "The Misadventures of Beauty," in *Regarding Beauty*, 32.

9. Ibid., 19.

10. Steiner, *Venus in Exile*, xix.

11. Ibid., xxv.

12. Portraits of Idelia Moore reappear in Tsinhnahjinnie's Aboriginal Beauty (1995–1998) and Portrait Against Amnesia series (2002).

13. Gail Tremblay, "Constructing Images, Constructing Reality: American Indian Photography and Representation," *Views: The Journal of Photography in New England* (Winter 1993): 12. The photograph is in the collection of the Smithsonian Institution National Anthropological Archive, Bureau of American Ethnology.

14. Hulleah Tsinhnahjinnie, "When Is a Photograph Worth a Thousand Words?" in *Native Nations: Journeys in American Photography* (London: Barbican Art Gallery, 1999), 41.

15. Ibid., 53.

16. Ibid.

17. Ibid.

18. Hulleah Tsinhnahjinnie, conversation with author, April 17, 2004.

19. Hulleah Tsinhnahjinnie, interview by author, April 19, 2004. This, of course, is in direct contrast to the many staged photographs from the nineteenth and early twentieth centuries.

20. At http://169.237.88.100/nas/hulleah/gallery1.html (August 2009).

21. This image was popularized by James Earle Fraser's *End of Trail* (1915), but is evident in imagery of American Indians from the late nineteenth century through the twentieth century.

22. Steiner, *Venus in Exile*, 220.

23. Ibid., 218.

24. See Andreas Huyssen, "Anselm Kiefer: The Terror of History, the Temptation of Myth," in *Twilight Memories: Marking Time in a Culture of Amnesia* (New York: Routledge, 1995).

25. Ibid., 223.

26. Hulleah Tsinhnahjinnie, conversation with author, April 17, 2004.

27. Hulleah Tsinhnahjinnie, as quoted by Veronica Passalaqua in "Hulleah

Tsinhnahjinnie," *Path Breakers: Eiteljorg Fellowship for Native American Fine Art, 2003* (Seattle: University of Washington Press, 2003), 96.

28. Ibid.

29. The title *Nizhoni Luna* is a clear reference to the sitter's combined Diné and Spanish heritage and thus also raises the issue of hybridity. Indeed, over the years, Tsinhnahjinnie has repeatedly expressed a deep interest in hybridity as a positive force in the development of art and culture. Cultural mixing does not negate the beauty of *Nizhoni Luna* or any of the women of color celebrated in the Aboriginal Beauty series. For a more complete discussion of hybridity in the work of Tsinhnahjinnie and other native artists, see my article "Hybridity as a Strategy for Self-Determination in Contemporary American Indian Art," *Social Justice* 34, no. 1 (2007): 63–79.

30. For a discussion of *hózhó* and its implications for Diné artists, see Tryntje Van Ness Seymour, *When the Rainbow Touches Down: The Artists and Stories behind the Apache, Navajo, Rio Grande Pueblo and Hopi Paintings in the William and Leslie Van Ness Denman Collection* (Phoenix: Heard Museum, 1998).

31. Gail Tremblay, "Reflections on *Mattie Looks for Steve Biko*," 117.

32. Hulleah Tsinhnahjinnie, "Compensating Imbalances," *Exposure* 20, no. 1 (1993): 30.

33. James Faris, *The Navajo and Photography: A Critical History of the Representation of an American People* (Albuquerque: University of New Mexico Press, 1996), 295.

34. Jaune Quick-To-See Smith, *Women of Sweetgrass, Cedar, and Sage: Contemporary Art by Native American Women* (New York: Gallery of the American Indian Community House, 1985).

35. Gail Tremblay, "Reflections on *Mattie Looks for Steve Biko: A Photograph by Hulleah Tsinhnahjinnie*," in *Partial Recall: Photographs of Native North Americans*, ed. Lucy Lippard (New York: New Press, 1992), 116–17. This essay is an excellent discussion on Tsinhnahjinnie and her photograph titled *Mattie Looks for Steve Biko*.

36. Hulleah Tsinhnahjinnie, "When Is a Photograph Worth a Thousand Words?" 53.

WORKS CITED

Beckley, Bill, and David Shapiro, eds. *Uncontrollable Beauty: Toward a New Aesthetics.* New York: Allworth Press, 1998.

Benezra, Neil, and Olga Viso. *Regarding Beauty: A View of the Late Twentieth Century.* Washington, DC: Hirshhorn Museum and Sculpture Garden, 1999.

Faris, James. *The Navajo and Photography: A Critical History of the Representation of an American People.* Albuquerque: University of New Mexico Press, 1996.

Foster, Hal, ed. *The Anti-Aesthetic: Essays on Postmodern Culture.* Port Townsend, WA: Bay Press, 1982.

Fowler, Cynthia. "Hybridity as a Strategy for Self-Determination in Contemporary American Indian Art." *Social Justice* 34, no. 1 (2007): 63–79.

Gaskell, Ivan. "Beauty." In *Critical Terms for Art History*, ed. Robert Nelson and Richard Shiff. 2nd ed. Chicago: University of Chicago Press, 2003.

Hickey, David. *The Invisible Dragon: Four Essays on Beauty.* Los Angeles: Art Issues Press, 1993.

Huyssen, Andreas. *Twilight Memories: Marking Time in a Culture of Amnesia.* New York: Routledge, 1995.

Johnson, Julie. "The Return of Beauty in Contemporary Art." *Rendezvous* 36, no. 1 (Fall 2001): 1–21.

Passalaqua, Veronica. "Hulleah Tsinhnahjinnie." In *Path Breakers: Eiteljorg Fellowship for Native American Fine Art, 2003.* Seattle: University of Washington Press, 2003.

Prettejohn, Elizabeth. *Beauty and Art, 1750–2000.* Oxford: Oxford University Press, 2005.

Quick-To-See Smith, Jaune. *Women of Sweetgrass, Cedar, and Sage: Contemporary Art by Native American Women.* New York: Gallery of the American Indian Community House, 1985.

Steiner, Wendy. *Venus in Exile: The Rejection of Beauty in 20th-Century Art.* Chicago: University of Chicago Press, 2001.

Tremblay, Gail. "Constructing Images, Constructing Reality: American Indian Photography and Representation." *Views: The Journal of Photography in New England* (Winter 1993): 8–13.

———. "Reflections on *Mattie Looks for Steve Biko*: A Photograph by Hulleah Tsinhnahjinnie." In *Partial Recall: Photographs of Native North Americans*, ed. Lucy Lippard. New York: New Press, 1992.

Tsinhnahjinnie, Hulleah. "Compensating Imbalances." *Exposure* 20, no. 1 (1993): 29–30.

———. "When Is a Photograph Worth a Thousand Words?" In *Native Nations: Journeys in American Photography.* London: Barbican Art Gallery, 1999.

Van Ness Seymour, Tryntje. *When the Rainbow Touches Down: The Artists and Stories behind the Apache, Navajo, Rio Grande Pueblo and Hopi Paintings in the William and Leslie Van Ness Denman Collection.* Phoenix: Heard Museum, 1998.

Text-Messaging Prayers:
George Longfish and
His Art of Communication

MOLLY MCGLENNEN

I FIRST MET GEORGE LONGFISH IN 2000 WHEN I WAS A GRADUATE
student at the University of California, Davis's Ph.D. program in Native
American Studies. He had been at that time a professor there for over
twenty-five years, and I was researching my way through the field of Native
American literature—in particular, contemporary indigenous poets—and
writing my own poetry. We came together because of an independent study;
I wanted to learn more about contemporary Native art, and Longfish's art
specifically, because of his use of text in certain pieces, and the way his
work and others (like Jaune Quick-To-See Smith and Edgar Heap of
Birds), like a strong pair of eyes, would not let me ignore it. My initial,
provincial understanding of Longfish's pieces entailed a gut response to
the confrontation his art produced, as if he were putting issues in-your-
face and, oddly, in-your-ear. However, I would later discover that the text
that Longfish spreads across his canvases are snippets of conversation, are
moments of dialogue that create a verbal landscape—"something for the
viewer," he says, "to hang on to."[1]

In our meetings together, we talked about his use of text in his work,
why he chose to do so, and how I related my understanding of Native poetry
to the "verse" I saw on his canvases. Like poetry, his lines of text tell a story,
identify him as the artist (like a graffiti tag or a signature), and ultimately
function as moments of resistance and agency. And like poetry floating on a
bed of lines, images, and color, the text opens up a moment and a space for
a listener. It is that space that hangs around the words—a space of medita-
tion, of quiet, of clarity, he would later tell me—that opens up another level

to the painting; it is that which makes the connection between the past and the present.[2]

In 2003, I was commissioned by the National Museum of the American Indian to write a short exposition of Longfish's body of work, which would be part of an exhibit at the museum entitled Continuum 12 Artists. Because it serves as a basis for my understanding of Longfish's work, I want to include that small piece here as a way to introduce the artist's use of text in his images; from there, I will elaborate on this analysis by showing how his messaging works as a form of communion with the viewer in a way that both acknowledges the sacred origins of indigenous creative expression and provides an avenue toward personal and communal autonomy. In this respect, the communication that is shared between the artist and viewer, through the medium of artistic expression, acts as a declaration of artistic sovereignty complicating and debunking the often romanticized and stereotypical imagery that depicts contemporary Native American life.

DISPLACING THE LIES

It is with spirit that George Longfish enters the creative act, and it is with spirit that he is guided through and beyond it.[3] As he steps into a painting, he and the work create dialogue, a space mutually respectful and adaptable. During his initial attempts at drawing the Pawnee chief Pitaresaru (Man Chief), who would eventually occupy the third panel of his distinguished triptych *The End of Innocence* (1993), Longfish was frustrated by his inability to re-create him. Longfish saw that something was awry: "The painting was guiding me as much as I was guiding it; my original idea was drastically changing as I tried to begin."[4] This flexibility, ironically, enabled Longfish to meditate and readjust. He saw what he had taken for granted: Longfish had not asked for permission to draw him.[5] Longfish honored Pitaresaru and said hello to his spirit, and the chief then agreed to take the first step. In three days, Longfish had finished the drawing.

Longfish has often asserted that Native people must own their cultural knowledge: "The more we are able to own our religious, spiritual, and survival information, and even language, the less we can be controlled. . . . The greatest lesson we can learn is that we can bring our spirituality and warrior information from the past and use it in the present and see that it still works."[6] This compression of history and present reality subverts linear constructs of time and allows Longfish to reappropriate cultural images and words in order to discern the truth from the lie in a way that has always

George Longfish, *The End of Innocence* (1993). Courtesy of the artist.

been innate to Native philosophies and religions. In *The End of Innocence*, for example, Longfish juxtaposes past and present figures (like Crow and Pawnee warriors with golf balls and Ninja Turtles), creating a space where the nostalgic and the romantic are undercut by humor and irony. Longfish's paintings complicate the notion of the contemporary Native condition while debunking the myths and stereotypes that have stood for more than five hundred years as the colonizer's agenda of erasure.

Longfish's use of bold colors and crosscutting words brings a vitality that "speaks to the size of the issues" his paintings exhibit.[7] His work engages political issues that have a long history, and the paintings necessarily work on a large and uncensored scale—with colors that strike, not appease; with text that complicates, not explains. Within the color and language is a psychic and spiritual expressiveness that both aligns Native American art with Western modernism and upholds resistance to it. Longfish examines the idea of what he calls "soul theft" by acknowledging the strength in reowning one's spirituality. For example, in *Modern Times*, three seemingly disparate images are linked by loaded textual commentary running across them. The first image, a self-portrait with the words "Twentieth Century, Tribal, Seneca, Warrior, Artist, Healer" positions the artist as a multidimensional human being, far from the stereotypical "Indian" of popular culture. The middle panel, a painting of a jar of "100% natural Seneca apple sauce" with the words "Progress, Acculturation, Assimilation" makes subversive commentary on American culture's appropriation of things Native, and the government's political agenda that ironically equates modernity with homogeneity. Finally, the third image, a photo of a powwow fancy dancer with the words "America, White Bread, Mom, Apple Pie, The American Dream" emphasizes the gap between Native America and the non-Native United States while satirizing the affirmed tenets of what constitutes an "American." According to David Penney, "Tradition in its purest sense functions by persisting as a culturally rooted filter that interprets the world on its own terms."[8] In this way, tradition is delineated as evolutionary, as powerful and enabling, rather than fixed, stoic, or sentimentalized as Westerners' images of "Indians" would make it out to be. Tuscarora scholar Jolene Rickard writes, "As an ongoing strategy for survival, the work of indigenous artists needs to be understood through the clarifying lens of sovereignty and self-determination, not just in terms of assimilation, colonization, and identity politics."[9] Longfish's art asserts the traditional and spiritual energy that, in Rickard's words, "jumps track and cuts a new swath for indigenous expressions."[10]

Longfish's paintings, moreover, work from the inside out by creating a literal dialogue of humor, irony, and reappropriation. His paintings— manifested through both image and language—produce a renewal of the

orality grounded in Native traditions, a reinvigoration of dialogue and discourse. Embedded in that, of course, is the position of the receiver or listener, and it is from here that the story and message become realized, for it is only through the exchange that the aesthetic is passed, the truth discerned from the lie. Ojibwe scholar Gerald Vizenor argues that although the English language has been the tongue of colonialism, racial domination, and stifling tribal simulations, it has also been a language of paradoxical reinvention, subversion, and renewal when employed by Native people.[11] He likens Native people's appropriation of colonialist tools to a new "Ghost Dance literature"—a challenge, a prayer, a song, a dance, an aesthetic that subverts dominance and continually re-creates Native survival and tradition. Longfish's language—whether image, form, color, or text—renews Native consciousness and imagines indigenous people in North America as they really are: living peoples.

In *Winter Still Life Landscape, South Dakota, 1893*, two images of Chief Big Foot's frozen body mirror one another, with a soldier and a tent in the distance. Phrases framed as questions and answers, "Old men, women and children," "Dead 300+," "Posed Death," and "No Snowmobiling," appear as text both framing and cutting through the images. Humor subversively hints at the absurd; more importantly, however, the text writes through the narrative that the images create by reasserting a moment of history with truth. As the onlooker is pulled into the narrative, the story of Wounded Knee is turned on its head. Specifically, Longfish's piece defies fixedness by bringing a sense of orality to the experience that necessarily demands perpetual reinvention, with the speaker and listener, the artist and onlooker as mutual partners in the artistic encounter. And within this ever-flexible dialogue, a healing spirit enters into the memorial of a horrific massacre.

Whether it is his overlay of the modern and the traditional, his skewing of past and present iconic images, or his employment of text, Longfish's art draws on a sense of honor that allows truth to be pulled from all directions, and the spirit to emerge from within the work in a way that heals the very wound it addresses.

AIR-QUOTING TRADITION

Since I wrote that piece, I have been thinking much about what the term "traditional" means in relationship to Native peoples' lives, communities, and work. It is a term that is used a great deal, but often has to be accompanied by qualification. I've seen the word air-quoted more times than I

would like to. When viewing Native American art, scholars and critics commonly seek out and divide the work of Native artists into camps such as traditional, or arts-and-crafts, or contemporary—frequently providing definitions for what they mean by this fraught category. In general, mainstream viewers continue to insist on the paradigm that locks Native art in some sort of traditional past. All of this points to how complicated the undoing of these tenuous conventions can be. To be traditional or to view something as traditional becomes a relative and indeterminate action and term because, first, there are over five hundred cultural and linguistic indigenous traditions in North America, and secondly, contemporary Native people's lives vary greatly in terms of Western influence, cultural practices, education, and reservation versus urban living.

Longfish's work, however, cuts through these categories by speaking directly to the historical, cultural, and spiritual issues that "Native people look at."[12] Longfish says, "I deal with perception and issues and that may include spiritual aspects, but in that communication I try to provide information."[13] Through his ability to cross contemporary, recognizable images and text with images and text that point to political turning points for Native people, Longfish illustrates how Native art and artists can interrogate this simplistic understanding of tradition that leans on a one-dimensional past and a monolithic definition of identity, thereby asserting autonomous and self-determining knowledge about indigenous lives and communities. In addition, Longfish's use of text in his work provides the space for a dialogue to occur, and from there, he says, "people can go get answers."[14] The text in his work, therefore, provides a continuum of healing.

From this point on, I want to continue to look at the artwork of Longfish as a means to understand his use of text toward spiritual, cultural, and historical healing; additionally, I want to show how Longfish complicates notions of tradition, and how that, in turn, questions the definition of Native American art. Longfish's use of text enacts dialogues on many levels. And one of the dialogues taking place is stepping Native ancestors and Native people and their creative work "through the next door."[15] Much like in his experience with drawing the Pawnee warrior, Longfish acknowledges the amount of spiritual and intellectual work that must be done in order for people to understand their pasts and their presents. Understanding the text in his work as a dialogue, a verbal landscape, therefore, brings communication—being in communion, in unity, in close association with the truth.

The tone or connoted meaning of the text in many of his pieces suggest subversive acts toward colonial and genocidal policies, tactics, and representations created by imperialistic courses of action enacted by the United

States government toward Native peoples. Through dissident and ironic moves, Longfish advances a type of "artistic sovereignty." Karen Ohnesorge describes this term in relationship to Jaune Quick-To-See Smith's use of text and image in her collage-on-canvas work *Buffalo*:

> Quick-To-See Smith and many other Indigenous U.S. artists decolonize the theory and method of landscape within the broader context of visual art to construct what might be named an artistic sovereignty.[16]

She also goes on to say that she is rereading the conventional definitions and renderings of landscape that are

> employed to mimic the perception of deep space, include establishment of a vantage point (from bird's eye to snail's eye), figures' relationship to the landscape, "scientific" or naturalist representationalism (painting directly from vision with the mythical optic I/eye), dominance and subordination of elements, indications of depth [and so on].[17]

In relationship to Quick-To-See Smith's *Buffalo*, the notion of landscape materializes quite literally because of how clearly the image of the American bison signifies the American landscape; however, I would like to use Ohnesorge's argument of artistic sovereignty in relationship to indigenous landscape so as to include Native American cultural, historical, and spiritual representations. I want to do so because the notion of landscape in relationship to Native people is particularly encumbered, not only because of Native people's culturally and spiritually based associations to land, but also because Native people's history since contact is centered around a series of connotative connections to land, such as "land grab," "land theft," removal from and returning to land, and parceling of land, to name just a few. Such a loaded term demands such broadening in an analysis looking at expanded notions of sovereignty. Thus, in his pieces that incorporate text, Longfish offers a vision of sovereignty through what I am calling a verbal landscape.

As I earlier state, Longfish says that Native people must begin and continue to own their own cultural information, and I believe this includes how one understands his or her relationship to historical representation. In other words, Longfish's work suggests how communication can take place within a landscape that has marked an entire race of people historically invisible and culturally voiceless to nonindigenous North Americans.

In *Blood Line or Accepted Federal Government Standard for Blood Quantum* (2005), six square panels are lined horizontally, each with text in black

George Longfish, *Blood Line or Accepted Federal Government Standard for Blood Quantum* (2005). Courtesy of the artist.

on a red background. From left to right they read "RED MAN," "FULL BLOOD," "½ BREED," "¼ BLOOD," "⅛ BLOOD," "9/16 BLOOD." At first glance, the title and the text across all six panels suggest the systematic measuring of blood that the United States government first fully endorsed with the Dawes Allotment Act of 1887, and that nonindigenous Americans have sanctioned since then. Naturalized in mainstream Western culture, blood quantum was a totally foreign concept to Native people before contact. Ironically, some tribes now utilize the system in order to determine tribal enrollment. Indeed, the piece calls into question the racist, complicated underpinnings of identity politics.

In our most recent conversation, however, Longfish told me a story about *Blood Line or Accepted Federal Government Standard for Blood Quantum*, which is completely missed in the above rendering of the piece. At an exhibit of Longfish's work at the Montana Museum of Art and Culture in 2007, many indigenous people made their way through the show and by this piece. Longfish laughs as he tells me "all the Indians were smiling and laughing and taking pictures by the work, standing next to their 'appropriate' quantum. They felt totally validated." He continues: "That's who I paint for; that's community building."[18] Longfish and I began laughing ourselves as we discussed how it is not overgeneralizing to say that Native people understand the irony of the piece on a whole other level—a level that penetrates political correctness and the off-putting contradictions of the political relationship between Native tribes and the U.S. government. Historically, the United States' creation of federal policies originated from colonial and state-sponsored land and resource theft. *Blood Line or Accepted Federal Government Standard for Blood Quantum*, a visual work of art, thus helps build a verbal landscape that recoups the sovereignty tied to indigenous land in a powerful and comprehensive way, because it speaks to so many issues and people at once.

(LONG)FISH ON A BIG SCALE

Because he works on a grand scale (many of his pieces 4 to 6 feet wide and 5 to 8 feet long), Longfish's pieces confront the viewer in an immediate and visceral way. A viewer cannot help but feel challenged on a physical level due to Longfish's use of strong primary colors on large-scale templates. For example, *Who's Gonna Ride Your Wild Horses* (2001–2006), a digital print, 47 ¼ x 61 ½, meets the viewer with five warriors, each with a label next to them: "Death," "Decay," "Gestation," "Germination," and "Rebirth." Above them, "Heaven" is printed upside down, and "No Indians Allowed" and "Freedom of Religion" (in all capital letters) span across the top of their heads. In addition, the phrases "Ghost Dance Wounded Knee," "How 'bout getting off these antibiotics?" and "No Skateboarding" line the bottom and side edges. The piece demands the viewer's attention because of the amount of material to absorb at once: fiercely sketched figures, a mass of striking colors, and heavy-type set text that fills every possible blank space. The effect, then, like a thousand-piece jigsaw puzzle spilled upon a table top, is for the viewer to put the pieces together.

Nez Perce/Chicana scholar Inés Hernández-Ávila says, "A word that comes to mind [when thinking about Longfish's work] is a spiritual puzzle."[19] Longfish positions the pieces in such a way that we cannot help but be drawn into the communication happening. As participants, however, we have to inform ourselves—with the help of Longfish's compositions—of the implications of such text. *Who's Gonna Ride Your Wild Horses* highlights the United States' inhumane and constitutionally dubious ban on Native religions, but it also suggests the long-term ramifications of such out-and-out racism: nations of unhealthy people living in an imposed sense of cultural limbo—in which Native people continue to live to this day. When asked in a 2004 interview for *Indian Country Today*, Longfish explained:

> The idea was that, historically, the Indians have lost their sense of direction on a spiritual level. What you are seeing in the painting are five figures, which relate to the concept of life, death, rebirth, and if you look above them it says 'Freedom of Religion.' That's what the country was built on, and now we have the Indians who are trying to reclaim their own religion. Above it shows the concept that there are no Indians allowed in heaven.[20]

Marked by a history of political and cultural paradox, Native American lives are suspended in this liminality in peculiar ways, such as being forced to be Christians while at the same time occluded from Christian heaven; deemed

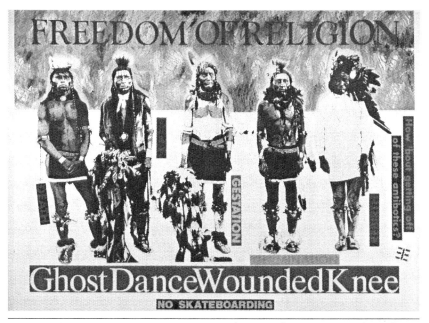

George Longfish, *Who's Gonna Ride Your Wild Horses* (2001–2006). Digital print, 47 ¼ x 61 ½ in. Courtesy of the artist.

savage-like and repulsive while at the same time desirable and romanticized for spiritual identity; stereotypically understood as magical healers while at the same time health and drug problems pervade Native communities. In *Who's Gonna Ride Your Wild Horses*, Longfish depicts the extension of spiritual trauma—what happens amidst the cycles of spiritual loss: deception and sickness.

Like always, however, Longfish is working on several levels at once. When asked about the "No Skateboarding" line, Longfish answered, "I know these issues, I make them large, but you also need some humor with them."[21] Humor is just another puzzle piece. "No Skateboarding" seems inconsequential next to suggestions of genocide, but that ironic line allows a moment to laugh at ourselves, despite ourselves, because of ourselves. And as I alluded to earlier, humor challenges the rage in order to provide healing.

As Longfish and I talked just recently over the phone about the beginnings of his use of text, I began to see the origins of his "verbal landscapes." Longfish said, "I first started using text in my work [back in the 1970s] because I didn't think anyone would get it."[22] He originally hoped that the text would help make some connection with the viewer. The trajectory of

his use of text has now developed so that even how he titles his pieces sets up a conversation, preps the viewer/listener, and extends the narrative beyond the canvas. In his 2004–2005 piece *Looking for the Supreme Buffalo Burger*, Longfish continues to address the loss of survival information, questioning what literally, spiritually, and culturally feeds Native people. The use of numbers in this case both highlights and trivializes people's need to label and contain ideas, qualities, and living beings, as it at the same time points toward the flexibility of indigenous knowledge (all of the numbers referring to "the meditative practices of a form of mysticism called Merkaba"),[23] which can sustain personal healing. All in all, through this piece that presents two large buffalo burgers alongside a Native hunter, Longfish asks the questions "What have people been seduced into?"[24] and what can keep communities healthy?

INDIAN NINJA TURTLE

In Japanese historical culture, the ninja is a warrior who specializes in nonconformist arts of war: assassination/espionage, stealth, camouflage, and specialized weapons. Years ago, when I first had a conversation with Longfish about his work, I asked him why Ninja Turtles turned up in his paintings, in particular the third panel of *The End of Innocence*. He simply said, "'Cuz I'm turtle clan."[25] At that time, his response took me aback for its candor, but after more encounters with the piece itself and getting to know Longfish and his work better, his humor proved transformational. Like ninjas of Eastern cultures, the Teenage Mutant Ninja Turtles of *The End of Innocence* suggest stealth and camouflage[26]; however, the cartoon characters, as the satirical representations they are, say something else. Through that imagery, Longfish confronts the long history of caricatures of Native peoples, and simultaneously gives them craftiness, agency, transformation. This may not immediately be understood by a viewer, though Longfish's triptych suggests to us that we must communicate with the scope of his work. By doing so, one begins to see not only the ironic comedy in depicting the 1980s cartoon craze juxtaposed with the Pawnee warrior (and a Crow warrior in the first panel), but also the force that the turtles represent. Once again, Longfish shakes up our expectations of what is traditional.

Tuscarora artist and scholar Richard Hill looks into the question of how "historic Native art" and "Indian art of today" match up, and if contemporary Native artists are informed by "the aesthetic traditions of their ancestors":

> The search for the connections between contemporary art and historic art involves investigating the sacred origins of art. . . . Within the native philosophical context, culture must be seen as a problem-solving mechanism that applies certain values and principles to any situation. The artist transforms materials into a cogent statement of those values and principles.[27]

Contemporary Native artists like Longfish pull from their own indigenous origins so to be informed by those values and principles, and through these autonomous moves, they assert artistic sovereignty. Thus, the text that runs in all different directions all over the third panel of *The End of Innocence* seems as if it is radiating from the turtles and their warrior energy. Words that name different tribes, and terms that denote moments in Native history are honored, remembered, spoken in a space that illustrates the inheritance contemporary Native artists have: a fierce history of being certain that Native people, in the words of John Trudell (Lakota), "can deal with this [U.S.] government."[28] Longfish, as a Turtle Clan artist, holds culturally specific strengths in order to do so.

P IS FOR POETRY

I feel I should come back around to what lured me to Longfish's work in the first place: He uses text in his paintings like a poet uses the alphabet. I am a poet, and I know my tools. We splice, invent, and jumble language in order to find honesty and compassion, to revolt against injustice, to enact resistance against ills. In the words of Joy Harjo (Creek), "The poet in the role of warrior is an ancient one. The poet's road is a journey for truth, for justice."[29] So we pull language from our origins like calling upon a revenant. Longfish's *I is for Indian* (1998) is in itself textual.

Longfish plays on the (hopefully extinct) schoolroom banners that displayed the English alphabet with associated images along classroom walls across the country. For example, A is for apple, B is for bear—and for a long time in this country, and perhaps still so, I is for Indian. I won't go into the troubling effects this has on both Native and non-Native children, and the numerous other questionable pedagogical tools teachers and school districts have employed over the years, but I will say Longfish gets to the heart of the historical narrative that has reduced Native peoples, their nations, their experiences, their languages, to ubiquitous stereotypes that are flatter than lines on a chalkboard.

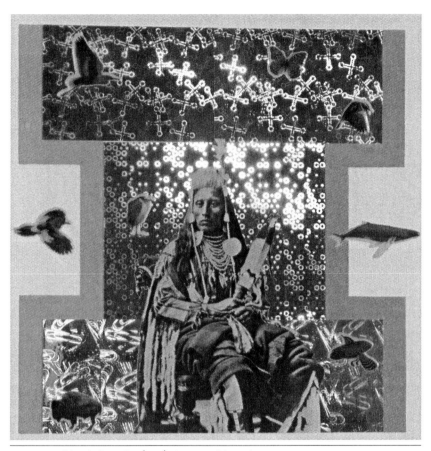

George Longfish, *I is for Indian* (1998). Courtesy of the artist.

In the piece, the Crow warrior appears again and is situated within the "I." He is surrounded by natural things: birds, a whale, a bison, and a butterfly. This draws attention to the very unnatural, manufactured invention of the concept of "Indian"—for that points to no one real person or specific groups of people. Indian is an imagined concept by outsiders, by newcomers, by the miscalculation of one C. Columbus some five hundred–plus years ago. And the irony is that in the classroom, that "I" stands for precision, for a teaching model, for exact (re)presentation. However, Longfish's piece shows just how perverted that invention is, and how hurtful. The "I" itself floats in fluorescent images of jacks, paperclips, and what could be little rubber balls: a representation of schoolwork and child's play. Such seemingly innocuous images as these that occupy the "I" are disrupted by

the implications of what the image in total suggests. This particular perversion of truth is unnatural and destructive. Through the conversation or messaging that Longfish creates, however, Native people are emboldened by a warrior legacy to call upon their political, spiritual, and cultural histories, and to confront injustice and misinformation.

In this way, Longfish acts within a birthright of intellectual and creative tradition. Tradition, as I now understand it, is Native people expressing themselves and their cultures in any way they know best, in any way they see helping to shape future indigenous generations. Longfish says we have to know ourselves and our history, but we also have to "acknowledge the [Native American] culture for what it is."[30] Longfish creates at the confluence of origins and change, and he does this when his work forms a communion with the viewer/listener, sending these messages, these notes, to direct all who would join in the conversation with him down the right path toward healing and truth.

Currently, Longfish is working on a new series that is entirely text. *Buffalo Grass I* and *Buffalo Grass II*, as he describes them to me, consist of a single word in color on each of three panels. The words, he says, "become the image or picture or landscape that's being created." He talks about how the viewer/listener "really needs to get involved in it" as a story is created through the landscape the triptychs present.[31] Decoding the text, ultimately, is up to the viewer, but it is not without guidance. Understanding how communication works is how learning takes place and grows into broader awareness. Hill says, "Art is another form of storytelling by which each succeeding generation adds its experiences to the collective consciousness."[32] Longfish's text-messaging brings forward the truth about Native histories and realities in a way that we all have the potential to learn from. And due to this, Longfish's work plays a crucial role in decolonizing hurtful and misguided information disseminated about Native peoples and their lives.

NOTES

1. George Longfish, personal correspondence, December 5, 2008.
2. Ibid.
3. This section was first published for the exhibit Continuum 12 Artists at the National Museum of the American Indian in New York City. Pairing two artists at a time, the museum exhibited twelve contemporary Native American artists, running a total of two years. For each collection shown, a student or

scholar of Native art was asked to write an exposition to accompany the work; I was commissioned to write for Longfish. A collection of his work ran from February through May 2004 at NMAI. I have edited parts of this section in order to explain some generalizations made in the earlier version, and to better complement the tone of the rest of the essay.

4. George Longfish, personal correspondence, June 15, 2003.

5. Longfish recently told me that in that meditation when he called Pitaresaru's spirit forward, Pitaresaru told Longfish that to draw him would be like taking his picture and therefore stealing his spirit. Longfish explained to him that he would be drawing him to honor him as a spirit and to put out truthful information. In a way, each allowed the other to "take the next step," as Longfish puts it.

6. George Longfish, personal correspondence, June 15, 2003.

7. Ibid.

8. David Penney, *Native American Art Masterpieces* (Westport, CT: Hugh Lauter Levin Associates, 1996), 107.

9. Jolene Rickard, "Sovereignty: A Line in the Sand," *Aperture* 139 (1995): 51.

10. Ibid.

11. Gerald Vizenor, *Manifest Manners: Narratives on Postindian Survivance* (Lincoln: University of Nebraska Press, 1999), 105–6.

12. George Longfish, personal correspondence, December 5, 2008.

13. Ibid.

14. Ibid.

15. Ibid.

16. Karen Ohnesorge, "Uneasy Terrain: Text, Landscape, and Contemporary Indigenous Artists in the United States," *American Indian Quarterly* 32, no. 1 (2008): 43.

17. Ibid., 45.

18. George Longfish, personal correspondence, December 5, 2008.

19. Inés Hernández-Ávila, as quoted in *Humor and Rage*, a ten-minute biographical video essay produced by Juan Avila on Iroquois painter George Longfish, Caixa Cataluna Bank–La Pedrera Museum, Barcelona, Spain, January 30, 2001. This short piece looks at the work of George Longfish in terms of what indigenous creativity means, and how his art comes into being.

20. Wilhelm Murg, "An Interview with Artist George Longfish," *Indian Country Today*, May 5, 2004, D1.

21. Ibid.

22. George Longfish, personal correspondence, December 5, 2008.

23. Kate Morris, "The Emergence of Tsha' De Wa's," in *George Longfish: A Retrospective* (Missoula: University of Montana Press and Montana Museum of Art and Culture, 2007), 43.

24. George Longfish, personal correspondence, December 5, 2008.

25. George Longfish, personal correspondence, June 15, 2003.

26. The Teenage Mutant Ninja Turtles are also named after infamous Italian artists: Michelangelo, Donatello, Leonardo, and Raphael. Therefore, Longfish is drawing from another historical bank as well. The figures are warrior artists to Longfish.

27. Richard Hill, "Art: The Old and the New; Different Forms of the Same Message," in *Native Americas*, ed. Cornell University's American Indian Program (Ithaca, NY: Akwe:kon Press, 1994), 75.

28. John Trudell, as quoted in *Alcatraz Is Not an Island*, directed by James Fortier, produced by John Plutte, Independent Television Service and KQED, 2001.

29. Joy Harjo, *How We Became Human* (New York/London: W.W. Norton and Company, 2002), xxvii.

30. George Longfish, personal correspondence, December 5, 2008.

31. Ibid.

32. Hill, "Art: The Old and the New," 75.

Contributors

Joseph Bauerkemper is an Andrew W. Mellon Postdoctoral Fellow at the University of California–Los Angeles. Before joining the Mellon program at UCLA, he was a Chancellor's Postdoctoral Fellow in American Indian Studies at the University of Illinois. Joseph is currently completing a scholarly book on indigenous writers, political theory, and philosophy of history.

Susan Bernardin is associate professor of English at SUNY Oneonta. She is a coauthor of *Trading Gazes: Euro-American Women Photographers and Native North Americans, 1880–1940* (2003) as well as articles on contemporary and foundational Native writers, including Eric Gansworth, Louis Owens, Gerald Vizenor, Mourning Dove, and Gertrude Bonnin. She is currently working on a new edition of *In the Land of the Grasshopper Song* in collaboration with Karuk tribal members and non-Native scholars in northwestern California.

Denise K. Cummings is assistant professor in the Department of Critical Media and Cultural Studies at Rollins College, where her areas of teaching and research interest include film history, theory, and criticism; twentieth-century American and American Indian literatures, cultures, and film; critical theory; cultural studies; and Florida studies. At Rollins she co-coordinates the Film Studies program, and annually leads student immersion courses and service learning experiences in the Global Peace Film Festival (Orlando, FL) and the Florida Film Festival (Maitland, FL). She is currently at work with LeAnne Howe and Harvey Markowitz on a new edited collection on American Indians and the cinema.

Cynthia Fowler is an art historian and associate professor of Art at Emmanuel College. In 2003 she participated in a six-week program sponsored by the National Endowment for the Humanities titled "Working from Community: American Indian Art and Literature in a Historical and Cultural Context," where she was inspired to begin doing research on contemporary American Indian art. Since then, she has published several essays on this topic, including "Gender Representation in the Art of Jaune Quick To See Smith," in *Aurora: The Journal of the History of Art* 6

(2005); and "Oklahoma: A View from the Center," coauthored with Maria DePriest and Ruthe Blalock Jones for *Studies in American Indian Literatures.*

Joanna Hearne is assistant professor of English and Film Studies at the University of Missouri. She has published articles on Native American film, video and animation and on documentary film genres in *Screen,* the *Journal of Popular Film and Television,* and *Western Folklore,* as well as the collections *Global Indigenous Media* (2008), and *Hollywood's West* (2005). She is currently completing a book that traces images of indigenous familial separation and reunion in film from 1908 to 2001, and another that addresses the emergence of Native American cinema.

Penelope Myrtle Kelsey is associate professor of English and Ethnic Studies at the University of Colorado at Boulder. She is of Seneca descent (patrilineal) with familial roots in western New York and Pennsylvania. Her book *Tribal Theory in Native American Literature* was published at the University of Nebraska Press in 2009. She has edited a collection on Maurice Kenny's poetry and fiction. She is also working on an examination of Haudenosaunee literature, visual culture, and intellectual history.

Molly McGlennen (mixed-blood Anishinaabe, French, Irish) is assistant professor of English and Native American Studies at Vassar. Her scholarship and interests include Native American literature, feminisms, art and contemporary experience, and creative writing.

Rocío Quispe-Agnoli is associate professor of Latin American Colonial and Postcolonial Studies in the Department of Spanish and director of Portuguese in the Center for Integrative Studies in the Arts and Humanities at Michigan State University. Her areas of teaching and research include Spanish American colonial literatures and cultures, literary theory applied to colonial and postcolonial texts, women's studies, Spanish American indigenous literatures and cultures, and Latin American historical narratives. Her book *La fe indígena en la escritura: Identidad y resistencia en la obra de Guamán Poma de Ayala* was published in Lima in 2006. She is currently working on a book-length manuscript about the textual agency of Spanish and Indean "encomenderas" (land-grant owners) of sixteenth-century Peru.

Dean Rader is professor in the Department of English at the University of San Francisco. His areas of teaching interest include twentieth-century American poetry, Native American literature, writing, and film. He and coauthor Jonathan Silverman are preparing a fourth edition of *The World Is a Text,* and his book of poems entitled

Works & Days won the 2010 T. S. Eliot Poetry Prize. He also recently curated a special issue of *Sentence* devoted to American Indian Prose poetry.

Michelle H. Raheja is associate professor in the Department of English at the University of California, Riverside. Her book *Reservation Reelism: Redfacing, Visual Sovereignty, and Representations of Native Americans in Film* (2011) is an examination of the discursive tactics of Native American directors and film actors from the silent era to the present. She is currently working on a book project that investigates indigenous visual culture representations of education and boarding schools in three transnational contexts—Australia, Canada, and Sápmi (the northern European Sami homelands). Her areas of teaching and research include indigenous visual culture production, Native American literature, and early American literature.

Theo. Van Alst (mixed-blood Sihasapa Lakota and Cherokee) is assistant dean of Yale College and the director of the Native American Cultural Center at Yale University. He is a former assistant professor and co-chair of Comparative Literary and Cultural Studies in the Department of Modern and Classical Languages and the Department of English at the University of Connecticut. He also served as the faculty advisor for the Native American Cultural Society at UConn. He is currently at work on a book length project focusing on representations of American Indians in European film.

Index

Abbott, Lawrence [Larry], 18, 182n1
Abenaki People, 68n17
Aboriginal World View (Tsinhnahjinnie,
 film/installation), 132–37, 138n7
Acoma Pueblo, 47, 192
Acoma Woman (Curtis), 192–93, *193*
actors, 77, 79, 81; casting, 10, 54, 57; as
 community members, 58; in *Imprint*, 13,
 16; Lakota, 35n31, 50, 55, 65, 68n22,
 69n25; Native extras as, 49, 55–57, 59,
 61, 67nn9, 11; Native female, 10, 14,
 19, 22–23, 132; Native male, 14, 41–42,
 49, 55, 58, 65, 120; speaking roles for,
 65; uncredited, 55; white redface, 59, 64,
 106. *See also names of specific actors*
Adair, John, 9
Adams, Evan, 41, 84
aesthetics: activist, 136, 148, 150, 162;
 Alexie's, 80, 90; ancestor, 217–18; of
 beauty, 189; commodification and, 62;
 of encoding, 154–55; Gansworth's, 156,
 174, 178, 181; Ghost Dance, 211;
 indigenous, 9, 134, 143–45, 150;
 innovation, 163; Kiefer's, 200; Mohawk,
 4; Navajo, 10; postmodern critiques of,
 190; Scholder's, 152; truth and, 211;
 Tsinhnahjinnie's, 149, 157, 200; utility
 and, 159
Agamben, Giorgio, 7
Agger, Gunhild [Ben], 98, 115n10
AIM, 13, 52, 62
Alberta, Clint, 9
Alcatraz: art at, 136, 145, 147; *Red Power,*
 146, *146,* 148
Alexie, Sherman, 66n1, aesthetics of, 80,
 90; on art, 74, 80–81; cameos by, 90,
92n16; film director, 73, 75, 76, 84; on
 filmmaking, 73, 79–81, 84; Fraser
 interview, 73, 74, 84, 89–90; Holly-
 wood and, 75, 77, 78–81; on Indian
 literature, 73, 89; indigenous spectator-
 ship and, 41; literary audience of, 87;
 *Lone Ranger and Tonto Fistfight in
 Heaven,* 84; National Book Award won
 by, 91; *Old Shirts and New Skins,* 84; as
 poet and novelist, 73, 78–79; *Reserva-
 tion Blues* by, 84; reviews of, 76–77, 89;
 Rosenfelt and Estes and, 76, 79;
 schooling of, 75; screenplays by, 41–42,
 73–76; "This Is What It Means to Say
 Phoenix, Arizona," 75; *Toughest Indian
 in the World,* 84; Weinmann interview,
 74, 79, 80, 92n16; West interview, 90;
 on writing, 89. See also *Business of
 Fancydancing, The*
Alfred, Taiaiake, 120, 129
allegory, 4, 16, 43, 46
Allen, Chadwick, 49, 162
allusion, 54, 75, 85, *124,* 133, 135, 216
Almanac of the Dead (Silko), 28, 39n57
Althusser, Louis, 46, 81
American Horse, 55–57
American Horse, Joe, 69n25
American Indian Movement (AIM), 13, 52,
 62
Anaana (Kunuk, film), 10
Anderson, Laurie, 174
Anishinabe People, 69n25
Apess, William, 32– 33n4
Apocalypto (Gibson, film), 96, 101–3, 112
Apted, Michael, 52
Arapaho Tribe, 147